UNFOLDING
PICTURES

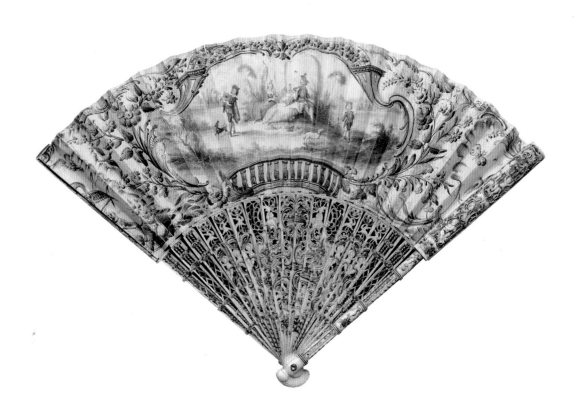

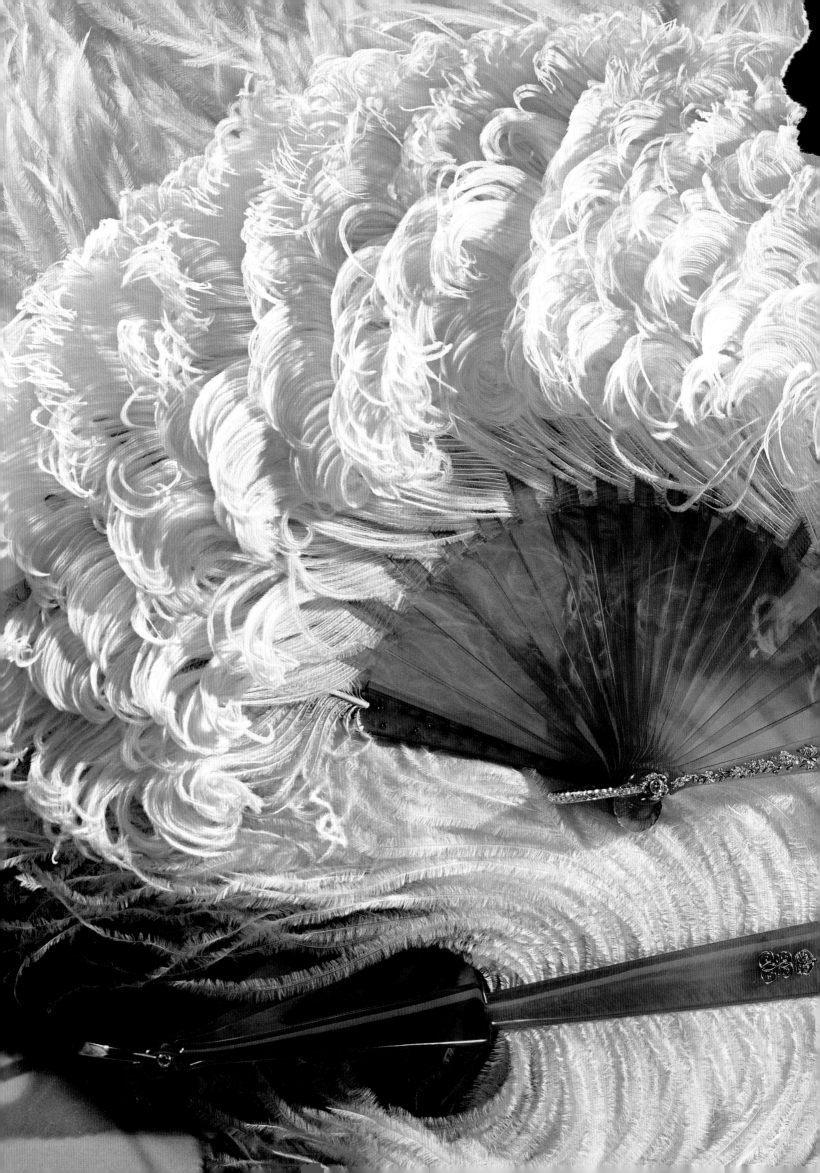

UNFOLDING PICTURES

FANS IN THE ROYAL COLLECTION

Jane Roberts · Prudence Sutcliffe · Susan Mayor

ROYAL COLLECTION PUBLICATIONS

Published by
Royal Collection Enterprises Ltd
St James's Palace, London SW1A 1JR

For a complete catalogue of current publications, please write to the address
above, or visit our website at www.royalcollection.org.uk

143420

ISBN 1 902163 16 8

British Library Cataloguing in Publication Data:
A catalogue record for this book is available from the British Library.

Designed by Karen Stafford
Editorial project management by Johanna Stephenson
Production by Debbie Wayment
Printed and bound by Studio Fasoli, Verona

Front jacket: no. 12 (detail)
Back jacket: no. 72 rear guard
Back jacket flap: no. 56
Page 1: no. 10
Pages 2–3: nos. 72, 82
Opposite: no. 34 (detail)
Pages 6–7: Eugène Lami, *The Grand Staircase at Buckingham Palace*, 1848;
watercolour (RL 19902; detail)

PICTURE CREDITS
All works reproduced are in the Royal Collection unless indicated otherwise.
Royal Collection Enterprises are grateful for permission to reproduce the
following:

fig. 7 Photograph Courtesy Peabody Essex Museum;
fig. 11 HRH The Prince of Wales/Duchy of Cornwall;
fig. 17 Reproduced by kind permission of Tom Hustler;
fig. 27 V&A Images/Victoria and Albert Museum;
fig.28 Photograph by Yousuf Karsh, Camera Press London;
plate 7.1 Copyright The Trustees of the British Museum;
plate 61.1 The Fan Museum, Greenwich.

Every effort has been made to contact copyright holders of material
reproduced in this publication. Any omissions are inadvertent, and will be
corrected in future editions if notification of the amended credit is given to
the publisher in writing.

This publication has been supported by **Schroders**

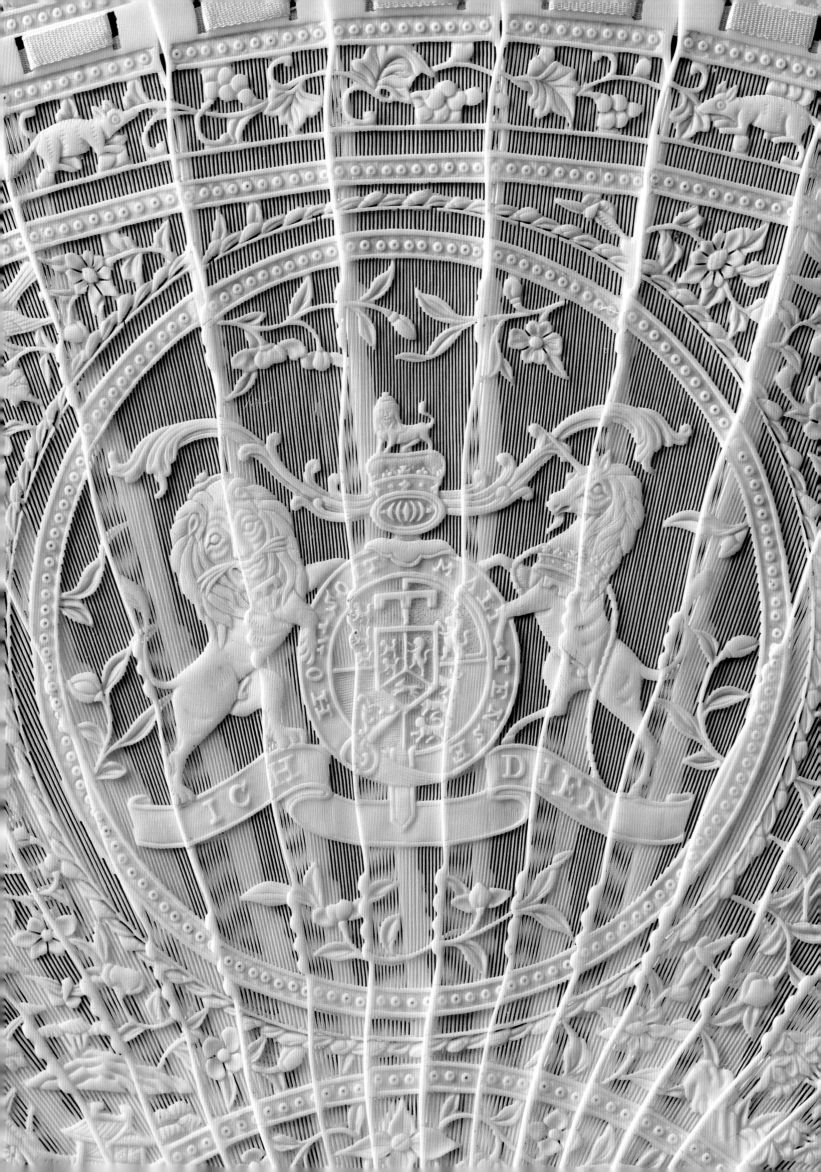

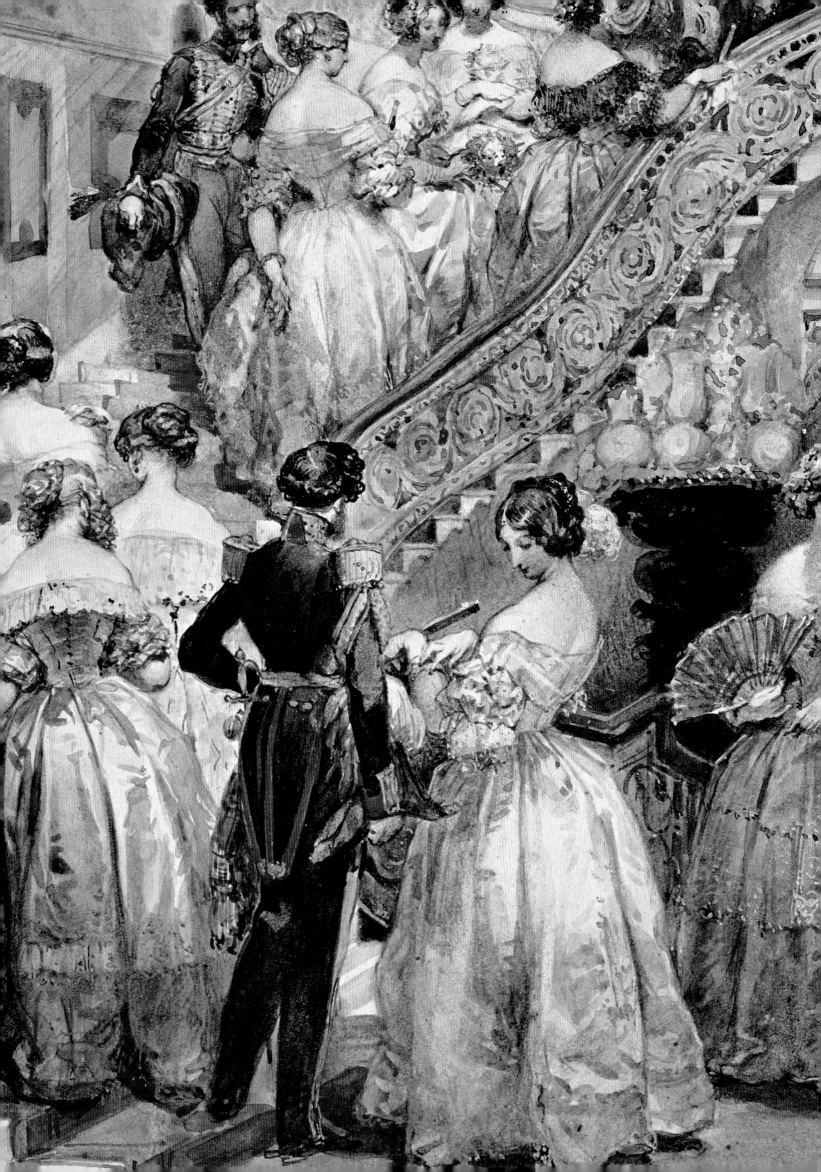

CONTENTS

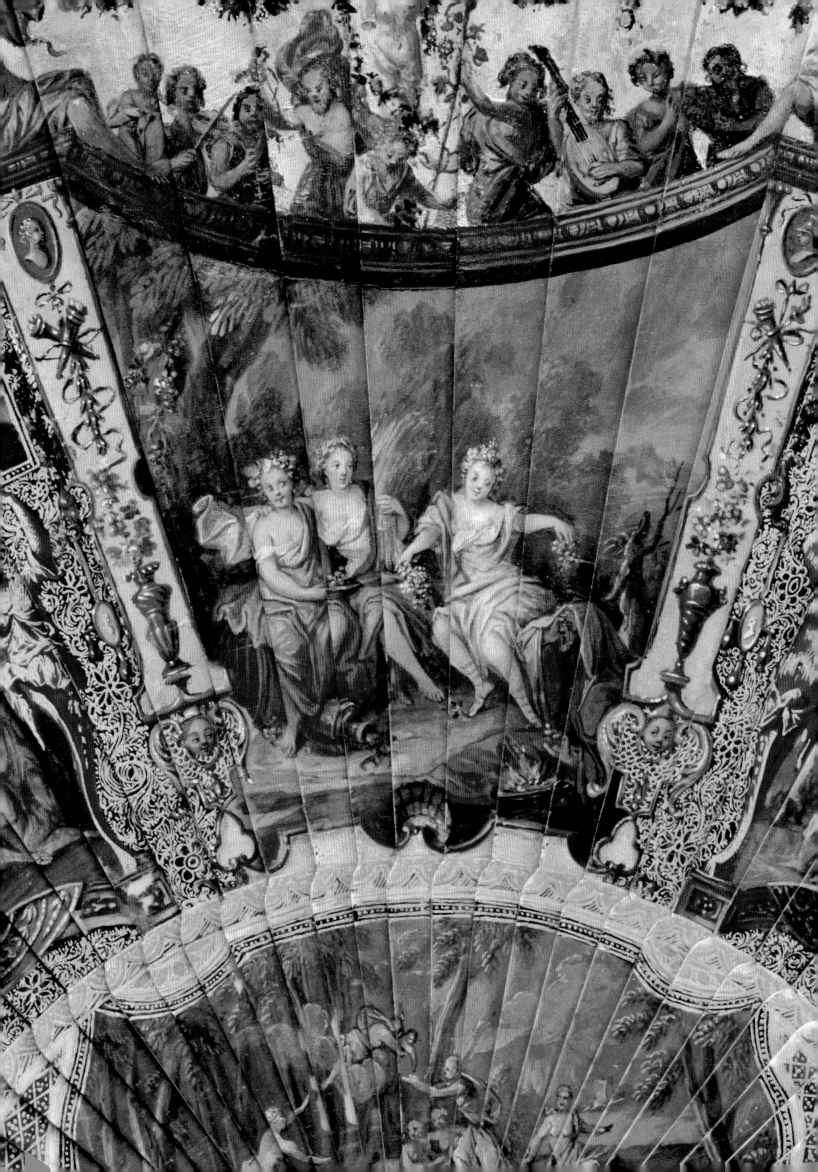

INTRODUCTION

THE FAN – A BRIEF HISTORY

In the course of a visit to Ireland in 1903, Queen Alexandra received a fan made of lace, the design of which included the words 'I cool, I refresh, and I can keep secrets'.[1] These words neatly summarise the chief uses to which fans have been put. Firstly, they have served the practical purpose of cooling and ventilating, and occasionally of keeping flies at bay. In the mid-seventeenth century, one of Wenceslaus Hollar's etched personifications of the seasons (fig. 1) demonstrates how, in an English summer, ladies

> . . . are vayl'd to keepe our faces faire
> And lest our beautie should be soyl'd with sweate
> wee with our ayrie fannes depell the heate.[2]

Other prints by Hollar show that fans were also used as fashionable – rather than purely practical – accessories: 'Autumn' carries a rigid feather fan, although the seasonal temperature in England would rarely have required its use.[3] A century later Diderot explained that fans were used in winter *'pour servir de contenance'*.[4] By this time fans had become essential fashion accessories for a well-dressed lady and attractive accompaniments to courtly attire, particularly because the holding of a fan showed off a lady's hand to advantage. In painted portraits fans were frequently held by a female sitter, in place of gloves, a handkerchief or a bunch of flowers – just as a male sitter might hold a commander's staff, sword, book or letter. By 1848, it was entirely natural that all the ladies attending Queen Victoria's State Ball would have carried a fan (see pages 6–7).

The third stated purpose of the fan, to conceal – and to keep secrets – is well shown in John Phillip's painting *The letter-writer of Seville* (fig. 2), in which a lady hides her face from the letter-writer to whom she is dictating her message.[5] A lady could conceal herself behind a fan while observing a romantic dalliance (see fig. 12), or while confiding in another without the possibility of her lips being read. One of Queen Victoria's granddaughters, Princess Marie of Edinburgh, recalled how while attending a performance of *Carmen* in the 1890s, the Queen communicated her opinion of the heroine's morals – in private, behind a fan.[6]

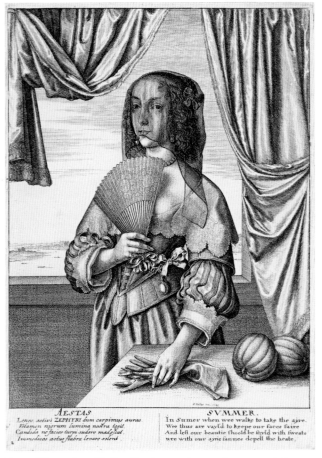

Fig.1. Wenceslaus Hollar, *Female personification of summer*, 1641; etching (RCIN 802410)

Very few fans before the mid-nineteenth century are dated or securely datable. However, the evidence of portraits and contemporary written records provides valuable information about the appearance and types of fan used in each period – and indeed how they were used. In the West fans have evolved principally as an accessory to female dress, and all but one of the examples featured in this publication would appear to have been made for women rather than men. The exception is no. 34, produced in Canton for George IV, with a broad manly grip. In China the practical purpose of fans – to cool – evidently applied as much to men (particularly those working outside) as to women, and Chinese paintings (for instance the front leaf of no. 40)

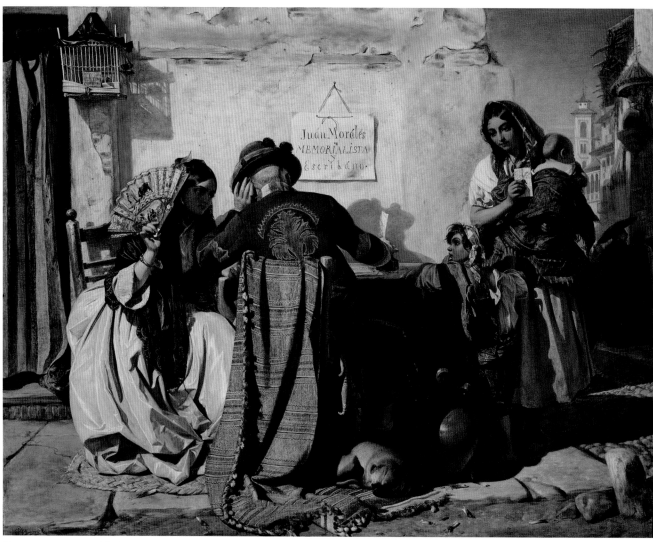

Fig. 2. John Phillip, *The letter-writer of Seville*, 1854; oil on canvas (RCIN 401188)

frequently show men using fans. Male use of fans in ancient civilisations in Africa (particularly Egypt) is also well documented. Meanwhile, in Western Europe fashion rather than climate led to the occasional use of fans by men as well as women.[7]

Fans are essentially ephemeral objects – to be thrown away and replaced when worn out. However, when made for a special occasion – or for sacred, ceremonial or royal usage – the materials will be more precious, and the construction more complex. The earliest surviving fans originated in Egypt, in the second millennium BC. These early fans are indeed made of precious – or at least, robust – materials; simpler fans of the same date will have perished. The examples from Egypt and China, and the *flabella* used by priests in the early Christian Church – like those still used in the Orthodox and Coptic liturgies today – are all either rigid or cockade fans, fixed onto an upright handle. But the type of fan most commonly used in the West – the folding fan – probably originated in Japan, whence it was taken to

China in the ninth century, and on to Western Europe in the years around 1500. The practical advantages of folding rather than rigid fans are clear: they could be closed and stored flat with ease, and could conveniently be tucked into a cuff or pocket. Folding fans incorporate sticks gathered onto a single pivot at the lower end, to allow the upper end to 'fan' out as the fan is opened. The upper part of the sticks will generally support and be fixed to a 'leaf', the folds of which further help to ventilate as the fan is moved through the air. Alternatively, the sticks themselves, connected at the upper end by a ribbon, will form a fan; such fans are described as *brisé* fans. In either case, folding fans are more prone to damage than rigid ones because of the stress caused by repeated opening and closing.

Within the basic category of folding fans, there is an infinite variety of shapes and forms: from the cockade fan, which opens to 360° (see nos. 34, 56), to fans opening to 180° (nos. 11, 12, 14, 28, 40, and most of the later fans), or to only just over 90° (nos. 1, 10). By the nineteenth century

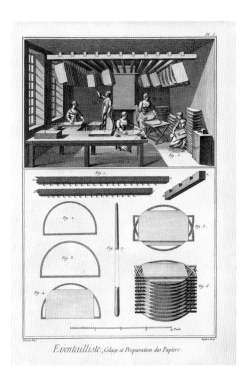
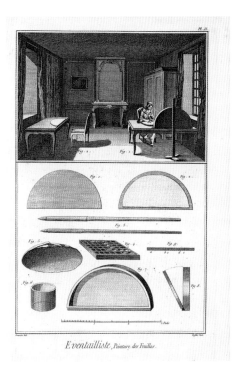
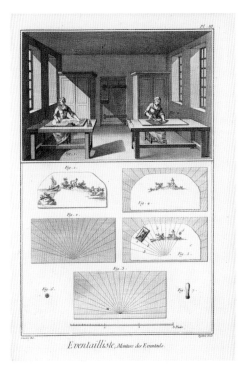
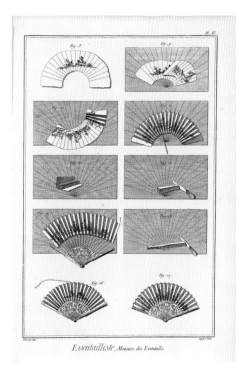

Figs. 3–6. Illustrations concerning the processes used by the fan-maker (*éventailliste*), from Diderot's *Recueil de planches*, 1765 (RCIN 1195942), issued to accompany his *Encyclopédie*.

First, individual sheets of paper were pasted to the edges of a fan-shaped frame or stretcher (fig. 3). The front surface of the paper was then painted and decorated (fig. 4), before being detached from the frame and scored with fold lines, the number depending on the quantity of sticks, and the desired shape (fig. 5). A pair of matching or complementary leaves (one for the front, one for the back) was required for each fan; the fold lines would be carefully matched. The leaves were then pasted together; the pleats were introduced, and the tops and bottoms of the tightly folded package were trimmed (fig. 6, central diagrams).

Finally, the ribs (the upper part of the sticks) would be inserted between the two leaves, the guards would be fixed to either end of the leaves, and a narrow binding strip would be applied at the outer edge to join the painted leaves (fig. 6, lower diagrams)

it is possible to judge the date of a fan by the size of the fan leaf, because fans were made to accord with contemporary female fashions. Thus the largest ones (nos. 58, 62) date from the late nineteenth century when skirts were full, while the smallest (no. 36) dates from 1805, a time when waist-lines were high, skirts were narrow and sleeves were short – and therefore tiny fans were appropriate.

From earliest times, European folding fans were made of a variety of different materials, with the sticks of bone, ivory, wood, tortoiseshell or mother-of-pearl, between which would be stretched the leaf, made of a more pliable material such as leather,[8] vellum, paper, silk or lace – and occasionally a combination of these. From time to time (particularly in the seventeenth century), court etiquette required that fans were kept closed in the presence of the Sovereign. The outer sticks – or guards – were therefore richly decorated, with paint, silk rosettes, or jewels inset in gold or silver. And in the eighteenth and nineteenth centuries the gorge – the lower part of the sticks, visible only when the fan is open – was enriched with virtuoso performances of carving and gilding. But the fan leaf itself usually provided the principal opportunities for decoration. Designing a composition in which the centre foreground and the upper left and right corners are effectively missing required particular talents of the painters involved. A high-quality fan would of necessity engage the skills of a wide variety of different craftsmen, including jewellers and painters – both professional painters and specialist fan painters[9] – to decorate the leaf. Special effects were created by the addition of other materials such as mica (no. 2), fragments of mother-of-pearl (no. 39), sequins and spangles (nos. 27, 28, 73, 74, 76). A clear demonstration and explanation of the method for making a folding fan with paper or skin leaf are provided in illustrations, published in 1765 as part of Diderot's *Encyclopédie* begun fourteen years earlier (figs. 3–6). Separate plates cover the preparation and folding of the leaf, the addition of painted decoration (including the application of gold, where necessary), and the mounting of the leaves onto the sticks (or *monture*). The coat of arms of the Fan Makers Company includes a 'shaving iron' and 'framed saw' for planing down sticks to the correct thickness, and then shaping them, each operation requiring meticulous attention to detail. The success of a fan will depend on the combination of fine materials, skilled craftsmanship, appropriate decoration, well-matched colouring, and graceful balance, so that the fan – whether open or closed – will sit happily in a lady's hand.

Although fans were sold in all the chief cities of Europe throughout the eighteenth and nineteenth centuries, it is often difficult to say precisely where, when, and by whom

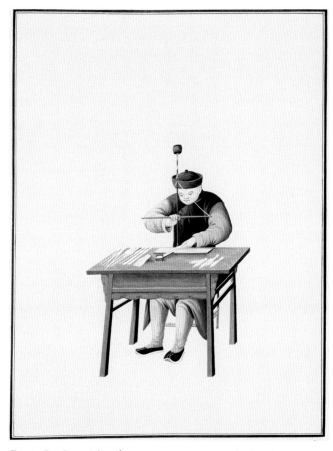

Fig. 7. Pu Qua, *A bone fan repairer, c.*1780–1800; bodycolour on paper (Peabody Essex Museum, Salem, Massachusetts; Museum purchase, E83/895.88)

an individual fan was made.[10] Even in an old and well-documented collection such as the Royal Collection, relatively few fans will be signed; and when a leaf is signed, it will usually be by the painter of the fan leaf rather than the maker of the fan (but see no. 51). In the present selection, there is a single signed eighteenth-century fan, by Giuseppe Trono (no. 23). The remainder of the signed fans are from the nineteenth and twentieth centuries.[11] The different materials and parts of each fan were often assembled from widely disparate parts of the world, where particular skills had evolved and specialist materials were available. Chinese ivory-carvers produced quantities of fan sticks for export to the West (fig. 7). Already in 1699, a London East India Company trader is recorded placing an order in Canton for 80,000 fans.[12] When – in 1792 – Queen Charlotte asked her son, Prince Augustus, then resident in Italy, for 'some Italian Fan Leather, quite white for to paint on, and if besides you will send us some Naples fan mounts I shall be much obliged to you',[13] she was evidently aware that Italy produced the finest leather for making fan leaves. The Queen's letter also demonstrates that fan leaves were often exported – from Italy, but also from France – unmounted.[14] Likewise, old sticks were frequently reused,

with leaves being cut down to fit the number of sticks available. And old guards would often be replaced: the fan depicting Bacchus and Ariadne (no. 16) has an eighteenth-century leaf and nineteenth-century jewelled guards, while the original diamond-set gold guards on a late eighteenth-century ivory *brisé* fan (no. 33) were soon replaced with the present ivory guards, decorated with cut-steel beads. Each fan is indeed the product, internationally, of 'Arts and Trade United' – the motto of the Worshipful Company of Fan Makers in London.

THE FAN IN GREAT BRITAIN

In the last quarter of the sixteenth century it was claimed that – with masks, muffs, periwigs and bodkins – fans were first used in Italy by courtesans; and that the fashion for these female accessories moved from Italy to France, and

from France to England at around the time of the St Bartholomew's Day massacre in 1572.[15] Whatever the basis for this story, among the New Year gifts received by Queen Mary in 1556 were seven fans, one of which was made of white silk,[16] while by the 1570s Queen Elizabeth I had enough fans to need caskets or boxes to protect them.[17] A number of portraits of this period show the Queen holding a rigid fan – with splendid coloured feathers set in a bejewelled handle (fig. 8)[18] – and some of the Queen's female subjects are depicted holding similar but simpler fans from the following decade.[19] Queen Anne of Denmark, consort of King James VI and I, is often shown carrying a rigid feather fan with a jewelled handle,[20] as is their daughter Elizabeth, the 'Winter Queen' of Bohemia.[21]

In addition to these rigid fans, folding fans would have entered the Queen's wardrobe before 1588, when repairs are recorded on fans 'with braunches of Iverye' or 'blacke

Fig. 8. Anonymous English artist, *Queen Elizabeth I*, c.1585; oil on panel (RCIN 405749)

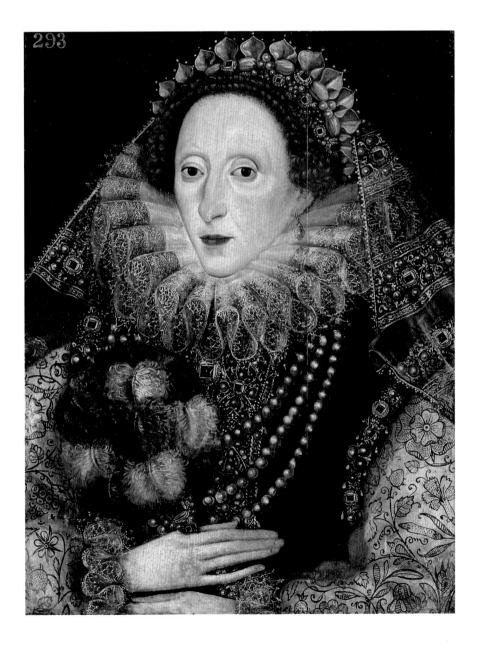

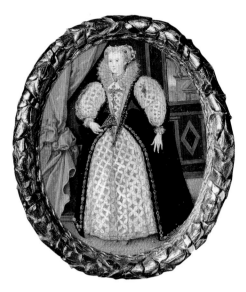

Fig. 9. Nicholas Hilliard, *Portrait of a lady, possibly Penelope, Lady Rich,* *c.*1590; watercolour on vellum (RCIN 420020)

woode'; the fans were occasionally described as 'Indyan', and with leaves of 'perfumed lether'.[22] Like the rigid fan, the folding fan was introduced to England via France and Italy. Catherine de' Medici is credited with having imported the folding fan to France on her marriage to Henri II in 1533.[23] There are illustrations of folding fans in France in the 1580s, and soon after a small number are shown in royal and aristocratic portraits in England. Two portraits of Elizabeth I holding a folding fan have survived from the years around 1590.[24] Hilliard's tiny miniature of the same period shows a richly clad lady holding a small bejewelled folding fan (fig. 9).[25] However, folding fans do not appear to have enjoyed a wide currency in England until the reign of James VI and I, whose daughter Elizabeth was shown carrying one in 1603.[26] Henrietta Maria (daughter of Henri IV of France), who married King James's son and successor Charles I in 1625, was frequently portrayed holding a folding fan (fig. 10) and may well have popularised the use of these fans in England.[27] In the inventories of royal possessions taken after Charles I's execution in 1649 an ivory brisé fan ('A Fann of Curious worke wrought, and cutt out of white Ivory in a redd leather Case', valued at £5) was noted at Denmark House, while at her death the Queen left a box of Italian fans which are also likely to have been of the folding rather than the rigid variety.[28] The first fan in the current selection (no. 1) has a traditional association with Charles I. Although the connection cannot be proved, the fan would have been in existence in that King's lifetime. Without this association, such a modest and un-remarkable folding fan is unlikely to have survived.

The exotic materials and description of fans as 'Indyan' clearly indicate the strong links between fan-makers and the East, even before the end of the sixteenth century. Around a hundred years earlier exotic fabrics and goods, including fans, began to be imported into Europe, particularly by Portuguese traders. The East India Company (founded in 1600) and its Dutch counterpart the Vereenigde Oost-Indische Compagnie or VOC (founded in 1602) institutionalised the importing of Oriental goods into Europe over the following two centuries. Rather than originating in India, the fans brought into Europe would mostly have come from China. Typically, they would have had sticks of ivory or bone, carved with more or less intricacy by skilled Chinese craftsmen (see fig. 7). Quantities of such sticks were imported into Europe, there to be made up into fans. We have already seen how, by 1699, complete fans were being exported from China in vast quantities.[29] The detailed accounts from the last year of Mary II's life (1694) include several references to 'India fans' with white bone sticks supplied by John van Collema, an India goods merchant based in London.[30] This may be the same man as John de Colima, who in the 1730s supplied fans (including several 'Indian' fans) to Queen Caroline, wife of George II.[31] In the following reign, 'Thirteen Fans called in Italian Ventaroli [*sic*]' and 140 'Fans of divers sorts', were listed in 1793 among the gifts from the Emperor of China to George III in the course of Earl Macartney's embassy.[32] By this time a high point in technical proficiency had been reached by the Chinese ivory-carvers, one of whose masterpieces must be the large Cantonese cockade fan (no. 34; one of a pair) made for the future George IV.

Fig. 10. Daniel Mytens, *Charles I and Henrietta Maria,* c.1630–32; oil on canvas (RCIN 404771; detail)

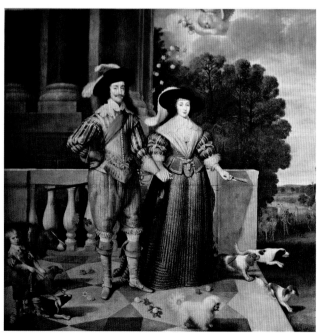

The import of fans from the East continued through the nineteenth century. A fine 'applied faces' Cantonese fan with richly decorated sticks and leaf was a gift to Queen Victoria (no. 40). From the middle of the century Japanese exports – including fans – began to flood Western markets. In 1891 a staggering 15 million fans were exported from Japan, of which over 7 million went to the United States, around 2 million to France, and nearly 1.5 million to the United Kingdom.[33] Although many of these will have been low-quality fans with paper leaves, a number of superb lacquer fans also reached the United Kingdom: for instance, the ivory *brisé* example presented by Princess Chichibu in 1937 (no. 57). It is likely that the *brisé* fan had evolved in the Japanese Imperial court, before being introduced to the West via China in the eighteenth century. While the surviving Japanese examples are partly lacquered, the European imitations were painted (no. 5) or carved (no. 33), and occasionally both painted and carved (nos. 31, 32), or with plain wooden sticks in place of ivory ones (no. 52).

Partly inspired and influenced by these Oriental imports, the fan industries of Western Europe evolved through the sixteenth and seventeenth centuries, before following the example of other trades and crafts by establishing their own guild. The charter of the London Guild (now Company) of Fan Makers was awarded by Queen Anne in 1709, after the establishment of the Paris guild in 1673, with Louis XIV as patron. The flight of Protestant craftsmen from France to London after both the St Bartholomew's Day massacre in 1572 and the revocation of the Edict of Nantes in 1685 served as a considerable stimulus to British craftsmanship and industry, and helped to establish a manufacturing base for luxury trades. The protective legislation introduced by the Fan Makers Company, in an attempt to curb – or even halt – the import of fans, also served to promote native production. The considerable technical proficiency, combined with scientific advances, led a writer to claim in 1723 that English ivory-carving was as good as that of the Chinese, and that English fans were as good as – if not superior to – French fans.[34] A fan such as no. 33 is ample testimony to the carving skills of native craftsmen by the end of the century. While the French artists and artisans were closely monitored to ensure (for instance) that no mere fan-maker could paint a fan leaf,[35] in England the craftsmen's activities were less restricted.

But it was in Paris, where there was a vast demand for luxury goods for use at court, that the making of fine fans particularly flourished (nos. 5, 9–12, 16–18); and Paris – the international fashion centre – was also the centre of fan production in Europe throughout most of the eighteenth,

nineteenth and early twentieth centuries. Many works by the great French eighteenth-century painters – particularly Watteau, Lancret, Fragonard and De Troy – show ladies seated or standing, with a fan, usually open, in their hands. Meanwhile, in hot countries such as Spain and Italy fans of high quality were made throughout the seventeenth and eighteenth centuries (nos. 2–4, 6). An English writer observed in 1747 that 'Italian Mounts are much more in Request than anything of our own manufacture, and large Prices are given for them'.[36] Fan leaves of both native and foreign production were mounted up in London,[37] generally using a single leaf (à *l'anglaise*, rather than the double leaf used in France[38]), and with the back of that leaf painted to incorporate the (bare) ribs in the overall design. Continental and English stick-makers used an increasingly wide variety of decoration, involving gilding, mother-of-pearl (including crushed shells: see no. 14), varnish, *clouté* and *piqué*, and many other variants. By the end of the century, further ornamentation such as Wedgwood plaques and cut-steel beads – produced in the new industrial centres in England – could also be used to decorate the guards (see nos. 31, 33). In addition to their mounting à *l'anglaise*, another feature of fans produced in England at this time was the decoration of the 'reserves' (at either side of the fan leaf) with richly painted floral motifs (see nos. 7, 8).

By the end of the seventeenth century it had become usual for the fan leaf – and often the back of the fan too – to be decorated with figure subjects. The evolution of fan-leaf design from purely ornamental patterning at the start of the century can be seen by comparing the early leather fan (no. 1), and the fan shown in Hollar's etching (see fig. 1), with the fine patterned leather fan, decorated with figure subjects painted in vignettes (no. 2). As in that example – showing Diana with her nymphs at play – the majority of the subjects chosen for the fan leaf were associated with romantic love; others show Bacchus and Ariadne (nos. 16, 22), Cupid and Psyche (no. 13), or Aurora and Apollo (no. 23). Ancient history also supplied appropriate subject-matter: the Continence of Scipio (no. 3), Claudia proving her innocence (no. 6), and the Abduction of Helen (no. 14), intended as examples of morality, chastity, valour or stoicism.[39] Such subjects were used whether the fan was produced in Italy (nos. 2, 3, 6, 22, 23), Spain, France (no. 16) or England (nos. 13, 14).

Biblical subjects were also considered appropriate – not least because fans became a normal accessory for ladies in church, with particularly lavish ones for special ceremonies such as weddings and baptisms. A fine mid-eighteenth-century fan (no. 15) records Jacob's first encounter with Rachel; the meeting led to their marriage seven years later, but Jacob had to serve her father Laban

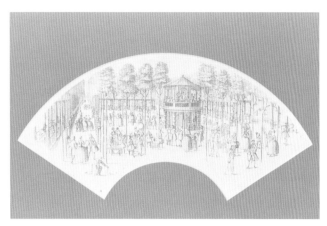

Fig. 11. M. Harris, *The Vauxhall fan leaves*, 1736; etching, printed in blue (Duchy of Cornwall)

for a total of fourteen years as a bride price – an example of extraordinary patience and forbearance by a lover. By the mid-eighteenth century many fans were made specifically for marriage (nos. 12, 18, 20, 27). A contemporary description of the preparations for Queen Charlotte's wedding to George III in 1761 mentions that there were 'a Dozen of Fans now preparing at Margarets in Bucklesbury', presumably as part of her wedding trousseau.[40] By the mid-nineteenth century fans – particularly fans decorated with flowers (no. 63)[41] – were an essential accompaniment to the actual marriage ceremony (see fig. 23), and quantities of fans would be received by royal brides as wedding gifts.

Although in the eighteenth century most high-quality fans had painted leaves, printed leaves – sometimes printed in colours (fig. 11),[42] but otherwise hand-coloured later (nos. 19, 29) – were also available. Now that fans were widely used both outdoors (fig. 12) and indoors,[43] a heavy demand had to be satisfied each season. Printed leaves, mounted on mass-produced sticks, provided infinite possibilities as novelties. They were ideal for the transmission of political propaganda, social scandal and other topical news, such as the King's recovery from illness,[44] or the royal family's visit to the Royal Academy in 1788 (no. 29).[45] Other printed leaves explained the rules of a royal card game (no. 35), or displayed Neoclassical designs (no. 26). Printed fan leaves – and painted ones such as nos. 22–25 – would also show the most popular tourist sites on the Grand Tour.

Fans were available in London from a variety of suppliers. In 1694 Mary II obtained her fans from John van Collema, an India goods merchant, and from Thomas Charratt (or Charett), a milliner. Other suppliers concentrated specifically on the production and sale of fans. The trade card issued by the fan-maker Francis Chassereau in c.1740 indicates that he operated from the Crown & Fann in Hanover Street.[46] In the following decade 'Bar, Fisher & Sister', at 'Gordon's Old Fan Ware-House, the Gold Fan & Crown in Tavistock Street, Covent Garden', advertised 'all Manner

of Fans Wholesale & Retail'.[47] And in the 1760s Dorothy Mercier (widow of the painter Philip Mercier) advertised 'Fanns for Ladies, in a New & Elegant Manner', along with prints and artists materials.[48] Both Chassereau and Mercier belonged to the Huguenot community, who made such an important contribution to English life in the seventeenth and eighteenth centuries. By the 1790s printed fan leaves were being issued by silk mercers, as well as print publishers (see nos. 26, 35).

The role played by jewellers – particularly court jewellers – in the production of fans was also important. Although few jewelled guards have survived from the eighteenth century, it is known that both Queen Caroline and Queen Charlotte owned fans with guards encrusted with jewels.[49] Royal jewels have frequently been unpicked and reused in

Fig. 12. Anonymous English artist, *St James's Park and the Mall*, c.1745; oil on canvas (RCIN 405954; detail)

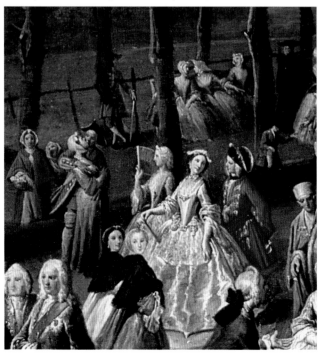

Fig. 13. The trade label of Duvelleroy's London branch, inside the lid of the fan box for no. 58 (RCIN 25197.b)

other settings. The gold guards of Queen Adelaide's fan (no. 39) are still set with amethysts and rubies, but the first diamond-set guards to survive in the Royal Collection in their original settings date from the late nineteenth century.

In the course of the seventeenth and eighteenth centuries, there evolved an elaborate (but actually quite obvious) system of usage which came to be known as the 'language of the fan'. In 1675 a character in a play by William Wycherly complained that 'women . . . make men do all foolish things . . . 'Tis common with lovers as playing with fans.'[50] Early in the following century John Gay hinted at how 'each passion by the fan be seen / From noisie anger to the sullen spleen' – merely by the different ways in which a fan was folded, unfolded, fluttered or waved.[51] Fans had become 'accessories in the oldest game, when dalliance was a major preoccupation'.[52] The subjects painted on fan leaves were occasionally also part of this 'game'. But for the painted subject to make an impression on an observer, it would naturally have to be turned around – so that the decorated side faced out. In 1797 printed fan leaves were published by Robert Clarke with the rules of the game 'Fanology', and the comment that 'with these Fans Ladies may converse at a distance on any Subject without speaking'.[53] In the nineteenth century Duvelleroy issued – as a form of amusement – lists of 'signals' which could be made by holding a fan in different ways. A fan held in the left hand in front of the face meant 'I'd like to get to know you'; a fan drawn across the cheek indicated 'I love you'; a fan twirled in the right hand meant 'I love another', while a fan drawn through the hand meant 'I hate you'. A half-opened fan pressed to the lips meant 'You may kiss me', while the left ear covered with an open fan meant 'Do not betray our secret'.[54] Although it may be hard to imagine royal ladies behaving in the coquettish way demanded by the 'language of the fan', that language is clearly relevant to our theme. It also demonstrates the further uses to which fans were put. By the end of the nineteenth century we know that fans had occasionally assumed the role of a gentle weapon,[55] or – in the hands of the Queen – would be 'up-lifted' to give an instruction (for instance, that a sermon should end[56]), or tapped to indicate satisfaction with a musical performance.[57]

With the hardships that accompanied the Napoleonic Wars, in the early nineteenth century fan production dwindled in England. Improved communications between

England and the Continent meant that – in spite of the attempts of the Fan Makers Company – quantities of high-quality fans were imported, particularly from Paris. These were both antique fans (such as no. 5, acquired in Paris for Queen Victoria in 1839) and contemporary ones, conforming to the latest fashion. Prince Albert was one of the moving spirits behind the Great Exhibition of the Arts and Industries of All Nations, held in London in 1851. Not a single fan of British manufacture was exhibited in 1851, and it was perhaps inevitable that seven years later Prince Albert commissioned a fan from a Parisian – rather than a British – fan-maker, Madame Rebours, as a gift for Queen Victoria's birthday (no. 45).

The magnificent display of French fans at the Great Exhibition led to a resurgence of interest in and use of fans, both in England and in France. The firms of Alexandre (no. 44) and Duvelleroy were the most successful of the Parisian fan-makers. Jean-Pierre Duvelleroy, who had founded the firm in Paris in 1827, won the first prize for fan production at the Great Exhibition; and at around the same period he was appointed fan-supplier to Queen Victoria.[58] In 1861 Madame Thomas-Gontier bought the name of Duvelleroy and opened a shop at 167 Regent Street, supplying it with fans from Paris; her son-in-law Léon Tourneur continued the business until 1881. The trade label inside a fan box dating from the end of this period announced that *éventails artistiques, modernes, antiques et pour mariage*, together with a fan-repair service, were available from the Regent Street store (fig. 13). The business later transferred and reopened – again, as Duvelleroy – in Bond Street.[59] Until the 1950s most of the fans sold in the London branch continued to be made (or at least mounted) in Paris. Queen Victoria herself placed commissions with the London branch in 1877 and 1881 (nos. 54, 58), while a number of fans presented to the future Queen Mary on her wedding in 1893 were also supplied from there (nos. 61, 63, 64).[60] The box containing the *'Fontaine de Jouvence'* fan still contains the description of the fan with which it was sold, on Duvelleroy's headed writing paper (plate 61.2). Robert Gleeson, who made the guards and sticks for Queen Victoria's Diamond Jubilee fan in 1897, was an employee of Duvelleroy; the firm supplied the box in which the fan is still contained. Somehow, however, the Queen was assured – when this fan was first offered to her – that it was entirely the work of British subjects (see no.

69). The close links between Duvelleroy and the royal family were doubtless strengthened through Queen Mary's fan-collecting activities. Numerous fans – both old and new – were added to her collection through purchases made by different members of her family via the firm's London branch.[61] Two French eighteenth-century fans from this source were presented to HM The Queen at the time of her wedding in 1947 – one from the Fan Makers Company, the other from 'Mr J. Duvelleroy' but probably instead from the London branch of the firm (nos. 12, 18); a sequinned marriage fan, also from the London branch, was acquired by members of the royal family as a gift to Queen Mary in the following year (no. 27). Other fan boxes in the Royal Collection indicate that the fans were supplied from Duvelleroy's main base in Paris;[62] this was naturally the case with the two dolls' fans supplied (for the dolls France and Marianne) in the course of the State Visit to Paris in 1938 (nos. 80, 81).[63]

Another Parisian fan-maker with a London branch was V. Givry, who operated from 39 Conduit Street; this was the source of Queen Victoria's autograph fan, presented to her in 1887 (no. 60). In 1903 the Russian Imperial jeweller Carl Fabergé followed the French example by opening a branch in London, from which Queen Alexandra made numerous purchases, including the fan (no. 75) given to her daughter-in-law Queen Mary at Christmas 1912.

The technological advances of the nineteenth century resulted in the production of quantities of printed (particularly lithographed) fan leaves (see no. 46), and in the issue of numerous patents for novelty devices – such as lorgnettes hidden within the guards (also no. 46). Souvenirs of specific places or events continued to be popular subjects for fan leaves: royal residences such as Osborne and Sandringham (nos. 47, 55), and episodes from the visits to France by Queen Victoria and Prince Albert in 1843 and 1855 (nos. 41, 42). When the Prince of Wales laid the foundation stone of Reading School in 1870, a fan recording the building was presented to the Princess of Wales (no. 51). Views of Macao (no. 40) and other Oriental locations were also depicted on fans intended for the British market, as if to take the place of the views of Rome produced for the eighteenth-century tourist market.

At the same time, fans with more light-hearted decoration were produced. Many of these incorporated the symbolism of flowers: for Queen Victoria's birthday in 1856 her eldest child, the Princess Royal, painted a fan leaf with a delightfully symbolic design (no. 43), and by the end of the century many of the large fan leaves – of paper, satin or lace – were painted entirely with flowers (nos. 58, 68). Birthstones were also reflected in fans: thus the pin of Princess Alexandra's Danish fan (no. 49), presented to her on her marriage, is set with a turquoise (her birthstone), also signifying prosperity in love. The often personalised sentimentality implicit in these fans was also present in the idea of autograph fans, produced from the 1870s (see no. 60), and in the fans with photographic portraits associated with the owner (nos. 47, 52). Meanwhile, the basic stories of love and life continued to feature on fan leaves: the ups and downs of romantic love are inherent in 'La Balançoire' (no. 44), while in 'La Fontaine de Jouvence' (no. 61) aged figures are transformed into youthful ones after bathing in a magic spring.[64]

Both the last two examples were produced in France but entered the British Royal Collection in the years around 1900: indeed the majority of the finest nineteenth-century fans are French products. Like Prince Albert, Queen Victoria was keenly aware of the need to encourage art and industry – including fan-making – in the United Kingdom. After 1851 successive initiatives and exhibitions were organised to promote British fan production. The first competitive exhibition for fans painted by students in the Female Schools of Art was held in 1868, with Queen Victoria's encouragement. In 1870 the Queen was also one of the moving spirits behind the Loan Exhibition of Fans held at the South Kensington Museum (now the Victoria and Albert Museum), to which she lent seventeen fans.[65] This was the first time that a major exhibition had been devoted to fans in this country; it preceded by eight years the first competitive exhibition organised by the Fan Makers Company. Other royal loans were made to the fan exhibitions held in Dublin in 1872, in Edinburgh in 1878, and to the fourth competitive exhibition at the Fan Makers Hall in London in 1897, the year of the Queen's Diamond Jubilee (see no. 69).

In the course of the nineteenth century different materials were introduced for the making of fans, particularly for the sticks which combined to make brisé fans. Thus an Austrian fan presented to the future Queen Alexandra in the 1860s has brisé sticks covered with leather (no. 50); while feathers are used for other brisé fans (nos. 66, 67, 72, 82). Lace leaves are a feature of northern European fans in the late nineteenth century. Both Queen Adelaide and Queen Victoria were anxious to protect the products of native lace-makers from an influx of foreign lace – particularly from Belgium. Although Brussels lace fans were owned by both Queen Charlotte and Queen Mary (nos. 21, 63, 79), many of the lace fans presented to royal ladies in the late nineteenth and early twentieth centuries were produced in the United Kingdom, either in Honiton (nos. 65, 78) or in Ireland (no. 64).

Already in the eighteenth century it was said that a lady could be recognised by her fan, and in the nineteenth

century fans came to be increasingly personalised. Portraits of members of the royal family were shown on a number of fans produced in England in the second half of the eighteenth century (nos. 31–33),[66] but it is seldom known whether these were produced for the subjects and their families (as was the case with no. 33), or as popular (though high-quality) souvenirs. At this period carved ivory fans with coats of arms and initials of British and continental owners were produced in China specifically for export (no. 34) and the fashion was imitated by the English ivory carvers (no. 33). Such marks of ownership became widespread on the guards of late nineteenth- and early twentieth-century fans. This was particularly the case with fans produced for presentation to royal ladies, where initials, coats of arms, even first names, were incorporated. The guards of Queen Adelaide's fan (no. 39) of c.1830 include her monogram, and Princess Alexandra's coat of arms is shown on the guards of a fan presented on her marriage in 1863 (no. 48). The name *ALEXANDRA* appears on the front guards of an Austrian fan made for the Princess of Wales in the 1860s (no. 50), just as her daughter-in-law's familiar name – *MAY* – was applied to the guards of several fans supplied as wedding gifts in 1893 (no. 66).[67] Among Queen Victoria's fans, the imperial monogram *VRI* first appears in the year of its initiation (1877) on the guards of the 'National Progress' fan (no. 54). First names or initials were also painted on fan leaves – *VICTORIA* on no. 43, and *ALIX* (for Alexandra) on no. 58 – or incorporated into the design of lace leaves. But royal ladies were not alone in owning 'named' fans. The plot of Oscar Wilde's play *Lady Windermere's Fan*, first performed in 1892, revolves around the fact that the fan bore the heroine's name, Margaret.

The use of fans at the British court is a particularly important subject with regard to the fans in the Royal Collection. In the seventeenth century it was already understood that ladies at court should carry fans, and John Evelyn mentions a French woman who sold fans at court – in the Queen's bedchamber.[68] Pictorial evidence indicates that fans were used by those attending services in the royal chapels (fig. 14), or receptions and balls in the royal palaces (see pp. 6–7), as well as by débutantes at the time of their presentation at court. The open fans shown in the painting of the Princess Royal's marriage in 1858 demonstrate that the 'rules' about not opening a fan in the presence of the Sovereign no longer applied. Although the carrying of white feathers at court is generally assumed to have been part of court etiquette, it was never insisted upon. The printed regulations dating from the late nineteenth century clearly indicate that either a floral bouquet or a fan could be held. Magazines such as *Queen Magazine* and *The Illustrated London News* inform us whether in a particular year fans or flowers predominated. If a fan was carried, there was nothing to dictate that it was a feather fan – although in the 1920s rigid feather fans were favoured. The fan could instead have a painted, embroidered or lace leaf. By the time that presentations ceased, in the late 1950s, the royal

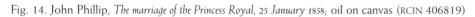

Fig. 14. John Phillip, *The marriage of the Princess Royal, 25 January 1858*; oil on canvas (RCIN 406819)

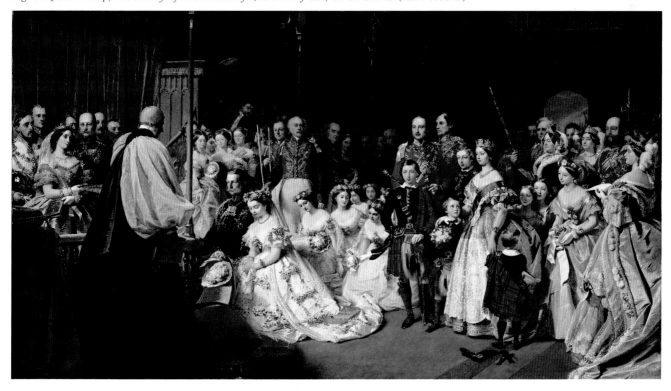

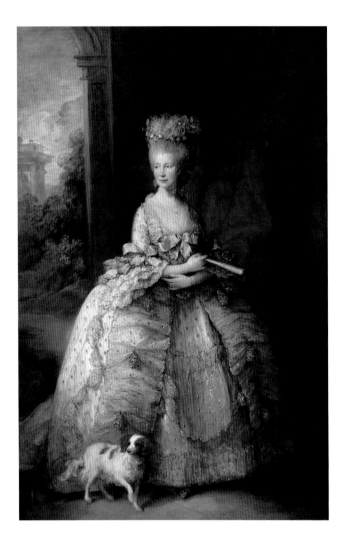

Fig. 16. John Partridge, *Queen Victoria*, 1840; oil on canvas (RCIN 403022)

Fig. 15. Thomas Gainsborough, *Queen Charlotte*, 1781; oil on canvas (RCIN 401407)

palaces would have been the only place where quantities of fans could be seen in use. Even after formal court dress was abandoned in 1939, senior female members of the Royal Family continued to carry fans at court. Photographic portraits taken in the first decades of The Queen's reign show Her Majesty holding a partly opened fan (figs. 17, 28).

ROYAL OWNERS AND COLLECTORS

Fans have been owned and used by royal personages since the introduction of the fan to Britain in the sixteenth century, although few have survived from before the reign of George III. While the first collections of paintings were made in the Renaissance, and collections of drawings followed in the sixteenth and seventeenth centuries, it is far from clear when the first collection of fans was made. Fans are essentially objects of dress that changed with fashion. If these were not discarded, would the retained fans constitute a collection? The question is particularly hard to answer in the context of the British Royal Collection, much of which remains 'in use' to this day. In this respect,

as in many others, it is quite distinct from other museum-type collections.

From the start of the reign of George III we have quite detailed information about the acquisition and use of fans by members of the King's family. In 1761, the year after his accession, the young George III married Princess Charlotte of Mecklenburg-Strelitz. Soon after the Princess's arrival in England she was portrayed holding a fan by the King's painter, Allan Ramsay. A contemporary commented on this feature: 'Lord! How she held that fan.'[69] A similar comment could be made about the way in which the Queen holds her fan in Gainsborough's full-length portrait of 1781 (fig. 15).[70] Meanwhile the splendid rayment and jewels worn by the Queen at her coronation in September 1761 included a mother-of-pearl fan, the guards set with emeralds, rubies and diamonds.[71]

At the other end of the spectrum are the fan leaves decorated by the royal ladies at this period. There are several descriptions of fans being painted by the princesses: in 1786 the Princess Royal had 'worked very hard' (or so she informed her brother Augustus) 'for to complete four fans and two muffs' for the King's birthday celebrations,[72] and

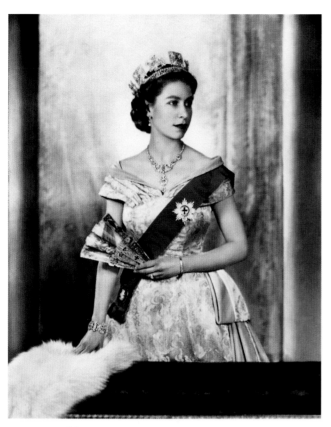

Fig. 17. *HM The Queen*, 1953; photograph by Dorothy Wilding
(RCIN 2912661)

both painted and embroidered; also some lace fans and ostrich feather fans; but a number of lower-quality fans – including a single green garden fan[78] – were also listed in the catalogue. Her eldest son, the Prince Regent, was anxious that the finest should be retained for the royal family and he purchased around thirty at the auction, including many Oriental fans and the majority of the most expensive lots. (The Prince's accounts also show him patronising fan-makers such as William Bryan and William Cook – presumably for fans to be given to his female relations or friends.[79]) The other purchasers at Queen Charlotte's sales were more often merchants than private individuals: already by this date there was evidently a brisk trade in high-quality second-hand fashion accessories.

George III's immediate successors were his first and third sons, who reigned as George IV from 1820, and William IV from 1830. George IV was estranged from his wife, Queen Caroline, and William IV's wife, Queen Adelaide, was renowned for her thrift and for her simple lifestyle. There are therefore relatively few fans in the Royal Collection dating from the first three decades of the nineteenth century. An exception is the splendid chinoiserie fan made for Queen Adelaide (no. 39).

Following the death of William IV in 1837, the crown passed to his niece, the pretty 18-year-old Queen Victoria, in whose wardrobe fans already played an important part. She is portrayed holding a fan – either open or closed – in numerous portraits, from Partridge's half length of 1840 (fig. 16) to the full lengths by Winterhalter in 1845 and by Von Angeli in 1885, and in Benjamin Constant's portrait of the enthroned Queen in 1899.[80] Although most photographic portraits after Prince Albert's death in 1861 show Queen Victoria holding a black mourning fan, when the occasion demanded (for instance, in a photograph taken to mark the marriage of her grandson in 1893: plate 21.2), a white lace fan was held.

In 1836, the year before her accession, she had received one fan from her cousin Princess Sophia Matilda of Gloucester,[81] and two others from her uncle Duke Ernest I of Saxe-Coburg and Gotha.[82] As we have seen, initially the young Queen was not averse to finding her accessories outside England, obtaining a fan from Paris in 1839 (no. 5). Some of these Parisian purchases may have been put to practical use at the various 'costume balls' organised by Queen Victoria and Prince Albert.[83] Another early acquisition was a fan from Queen Charlotte's collection, presented to Queen Victoria by her lady-in-waiting, the Duchess of Bedford (no. 23).

On the eve of the Queen's marriage in 1840, Prince Albert gave her four 'old fans' (including no. 9) from the ducal collection at Gotha. That collection had been

four years later she was described 'finishing a beautiful fan for the Queen, with feathers, flowers, insects and shells . . . figures and landscapes'.[73] The talented third daughter, Princess Elizabeth, decorated fans to celebrate the King's recovery from his first serious bout of illness in 1789 (see no. 30).[74] The small blue silk fan produced to commemorate the Garter Installation at Windsor in 1805 (no. 36) may well have been made by one of the princesses.

In order to make the painted leaves into fans, the Queen, her six daughters and her six daughters-in-law, would have needed to engage the services of professional fan-makers, many of whose names appear in the royal accounts,[75] while the trade cards of several fan-makers proudly proclaim their royal associations. Four of Queen Charlotte's fans are included here (nos. 4, 11, 21, 23); the fine painted leaf of *c.*1740 (no. 6) may also have belonged to Queen Charlotte before passing to her granddaughter, Charlotte, Princess of Wales.[76] Unfortunately it is not possible to link any of the Queen's surviving fans with particular makers. Her lace fan (no. 21) is said to have been used at the christenings of her children. Although that fan passed by descent, the majority of the Queen's possessions – including nearly four hundred fans – were dispersed at auction in 1819, the year after her death.[77] The catalogue descriptions include numerous fine Western examples,

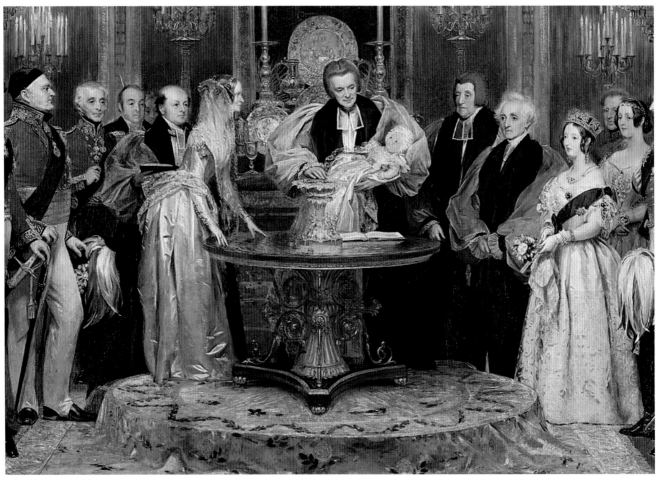

Fig. 18. Charles Robert Leslie, *The christening of the Princess Royal, 10 February 1841*; oil on canvas (RCIN 404467; detail)

established nearly forty years earlier by the Prince's maternal grandfather, Duke Augustus of Saxe-Gotha-Altenburg, in the Chinese Cabinet at Schloss Friedenstein. It must be one of the first 'collections' of fans to have been created, but was soon depleted both by Prince Albert and by his father (Duke Ernest I) and brother (Ernest II), through the gifts which they made to Queen Victoria.[84] Later in the same year, 1840, Queen Victoria inherited a small group of fans (including no. 25) from one of her unmarried aunts, Princess Augusta. This bequest included some of the small *brisé* fans that had been so fashionable at the start of the century.[85] Queen Charlotte's lace fan (no. 21) was a gift from Queen Victoria's uncle, the Duke of Sussex, shortly before the christening of her first child (the Princess Royal) in February 1841. It is possible that this is the fan which the Queen is shown holding in Leslie's painting of the christening ceremony (fig. 18). Many years later, she is seen holding the fan at the wedding of her grandson, the Duke of York (fig. 23); the official photograph taken at this time (plate 21.1) was reissued four years later, at the time of the Golden Jubilee.[86] Queen Victoria received gifts of fans following her visits to France – from Marie-Amélie, Queen of the French in 1843 (no. 41) and from Empress

Eugénie in 1855 (no. 42). Other fans were given to the Queen on her thirty-seventh and thirty-ninth birthdays, in 1856 and 1858 respectively (nos. 43, 45): in the latter case the leaf was painted by the Princess Royal. In 1861, on the death of Queen Victoria's mother – the Duchess of Kent – the Queen inherited many more fans, including an eighteenth-century French fan from the Coburg family collection (no. 10). And in the Golden Jubilee year of 1887 the Queen's family presented her with a large fan decorated on both sides by Francis Houghton, with a large area left deliberately undecorated for the addition of autographs (no. 60). Ten years later, at the Diamond Jubilee in 1897, the Worshipful Company of Fan Makers presented the Queen with a fine silk lace fan incorporating shamrock, rose, thistle and harp (no. 69). This was the first of many gifts of royal presentation fans made by the Company.

Queen Victoria also commissioned a number of fans. The documentation of her patronage of fan-makers has yet to be fully researched, and because most of her commissions were intended as presents (particularly for her five daughters), the resulting fans do not survive in the Royal Collection. However, the Queen's accounts indicate that she patronised a number of fan-makers in both London and

Paris.[87] A fan decorated with a view of Osborne House (no. 47), the royal holiday home on the Isle of Wight, was intended to be one of the Queen's presents to her second daughter Princess Alice at the time of her marriage to Prince Louis of Hesse, but was never presented. The marriage, originally set for 1861, was delayed by court mourning following the deaths of the Duchess of Kent and then of the Prince Consort. By the time that it finally took place, in July 1862, the happy memories intended to be conjured up by the decoration of the leaf and sticks were evidently considered inappropriate and the fan was retained by the Queen. Another notable fan, the leaf designed by Lady Alford in 1877 (no. 54), was commissioned by Queen Victoria to commemorate a speech made by the Prince Consort in Edinburgh in 1850, in which he encouraged Britain's pursuit of 'National Progress' through education and science. The verso of the fan is inscribed 'The picture of a most healthy national progress: education and science directing exertion; the arts which only adorn life, becoming longed-for by a prosperous and educated people.'

The Queen was in touch with the doyenne of fan collecting and fan studies at this time, Lady Charlotte Schreiber. On 29 June 1891 she noted in her Journal, 'After luncheon, saw Ly. Charlotte Schreiber, who brought me a book on fans, which she has compiled.'[88] By the time of Queen Victoria's death ten years later, there was clearly a realisation of the historic importance of the fans accumulated in the different royal residences. Shortly before her death, the Queen made a list of eighty-five fans in her possession, with details of those to whom they were to pass. Thirty of the finest were bequeathed to her son and heir, King Edward VII, including nos. 5, 6, 9, 21, 23, 25, 30, 40, 41, 42, 45; a single fan, one of those from Gotha (no. 10), passed to his consort, Queen Alexandra. Queen Victoria evidently perceived that these fans were of historical or associational interest in the context of the Royal Collection as a whole, rather than merely ornaments of fine female attire. The remaining fans went to the homes – in England and on the Continent – of the surviving sons and daughters, and the granddaughters, of the 'Grandmother of Europe'.[89] But some (including nos. 14 and 39) have since been returned to the collection, having been bequeathed (respectively) to the Duke of Connaught and to Princess Helena. Not mentioned on Queen Victoria's list are the items which were 'in use', including the black silk fan on ebony guards and sticks (no. 62), which is still accompanied by a scrap of mourning paper inscribed *Fan used at the last moments* – at the time of the Queen's death, at Osborne House on the Isle of Wight, in January 1901 (plate 62.1).

The fans owned by Queen Alexandra were in some ways similar to those owned by her mother-in-law, Queen

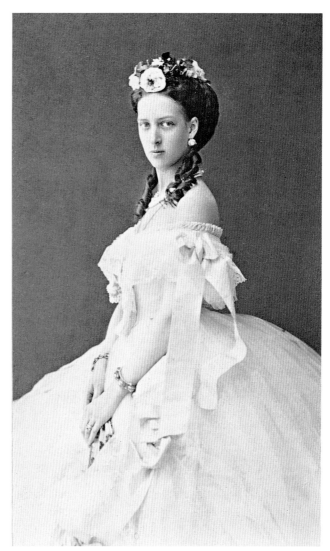

Fig. 19. *Alexandra, Princess of Wales*, 1864; photograph by Robert Bingham (RPC 01/0176)

Victoria – they had richly jewelled guards, they were decorated with commemorative scenes on the leaves and included a number of historic family heirlooms – but in other ways were quite different. Throughout her life Queen Alexandra (fig. 19) dressed with grace, elegance and flair, and her collection therefore included fine examples of fashionable late nineteenth-century designs. The large satin 'Christmas fan' (no. 58), with leaves painted by Alice Loch, is one of these; it was a Christmas present from Queen Victoria in 1881. Very few records relating to Queen Alexandra's purchases have survived, so the fanmakers that she patronised, and other details relating to acquisitions, are not known; however, in 1910 she is said to have owned between three and four hundred fans.[90]

Many of these fans will have been gifts from family and close friends. The eldest of three daughters of Christian IX of Denmark, the future Queen Alexandra received a number of fans and fan leaves on her marriage in 1863,

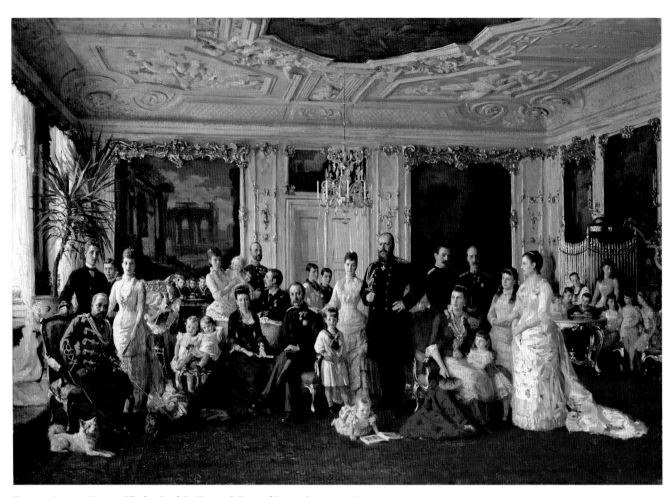

Fig. 20. Laurits Tuxen, *The family of the King and Queen of Denmark*, 1885; oil on canvas (RCIN 402341)

including one painted with a skating scene which was a gift from Queen Victoria's half-sister, Feodora (no. 48). Another wedding present, from a group of Danish ladies, was the magnificent carved ivory fan incorporating designs by Thorvaldsen (no. 49). Tuxen's group portrait of 1885 (fig. 20) shows how widespread was the use of fans, in Denmark as in England, at this time.[91] Occasionally the Princess and her sisters received almost identical gifts – presumably from a member of their immediate family. For instance, in the 1860s they each received a leather *brisé* fan, the guards of which were personalised with their first names (see no. 50). On other occasions the decoration on the fan was even more particular to the recipient. For the Princess of Wales's thirty-seventh birthday in 1871 she received a wooden *brisé* fan decorated with photographs of her children (no. 52); it was probably made by her sister-in-law, Princess Alice. One of the three Fabergé fans in the Collection (no. 74) was a Christmas present to Queen Alexandra from her sister, the Dowager Tsarina Marie Feodorovna, in 1904;[92] while another (no. 75) was given by the Queen to her daughter-in-law Queen Mary in 1912: the close family links between the Russian, Danish and British ruling families were largely responsible for the popu-

larity of Fabergé's works in Great Britain, and for the unsurpassed group of works by the imperial jeweller in the Royal Collection. Sandringham House in Norfolk, the country home of the Prince and Princess of Wales, was the location for much of the Fabergé collection, and also of the collection of other miniature objects, including fifteen miniature fans (see nos. 70 and 71). The house and surrounding estate is the subject of a fan from Queen Alexandra's collection (no. 55) decorated by the Swedish amateur fan-painter 'Count Nils', presumably specifically as a family gift to the future Queen. The Brazilian fan incorporating a humming-bird (no. 53), which formed a somewhat incongruous part of the Princess's costume (as Mary, Queen of Scots) at the Waverley ball in 1871, was probably a gift received shortly before the ball. Other fans in her collection had a more official origin, such as the fine painted fan presented by the Mayor and Corporation of Reading in July 1870, at the time of the laying of the foundation stone of Reading School by the Prince of Wales (no. 51). Queen Alexandra also inherited a number of fans following the death of her mother, Queen Louise of Denmark, in 1898. These included the fine eighteenth-century English fan painted with the Siege of Barcelona (no. 7).

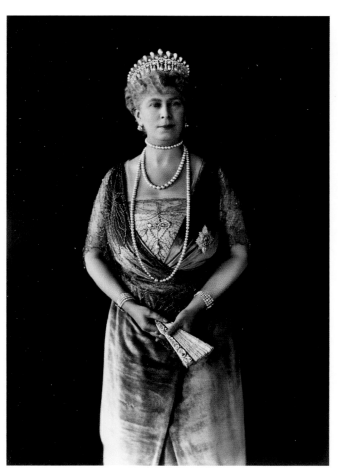

Fig. 21. *Queen Mary*, 1920; photograph by W. & D. Downey (RCIN 2912659)

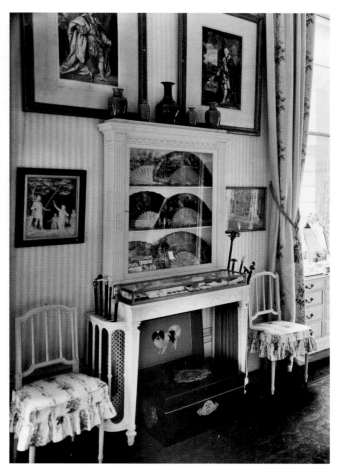

Fig. 22. The fan case (including no. 54) in an upstairs room used by Queen Alexandra at Marlborough House, 1912; photograph by Grove & Boulton (RCIN 2102004)

With Queen Mary (fig. 21) – a passionate 'curator-manqué', particularly of objects of historical interest – royal fans found their most enthusiastic collector, and their first cataloguer.[93] When the collection of her uncle, the 2nd Duke of Cambridge, was offered for sale at Christie's following his death in 1904, Queen Mary made valiant efforts to buy as much as possible for the Royal Collection.[94] Following Queen Alexandra's death at Sandringham in late 1925, Queen Mary helped Princess Victoria (the unmarried second daughter of King Edward VII and Queen Alexandra) to sort through the late Queen's personal belongings, many of which were kept at Marlborough House (her London residence following the King's death in 1910; see fig. 22[95]). In her diary for early 1926 Queen Mary records several visits: on 4 February 'Busy in the afternoon unpacking stuffs etc. here, also Grandmama [Queen Victoria]'s fans and lace – most interesting.' On 16 February King George V accompanied them, 'to choose more pictures & to go through some of Gdmama's and Mama [Queen Alexandra]'s things and with Toria. In the afternoon to MH again to sort out Mama's fans for Toria to choose from.'[96]

By this date Queen Mary was herself the owner of many hundreds of fans, nearly every one of which was listed and itemised by her. Queen Mary's fans had been assembled from her earliest years, as Princess Victoria Mary of Teck. In 1888 four fans were listed among her twenty-first birthday presents.[97] Two years later she inherited some fine examples from her grandmother, Augusta, Duchess of Cambridge (nos. 16, 32), while others passed by bequest on the death in 1897 of her mother, born Princess Mary Adelaide of Cambridge (nos. 24, 46).[98] But the largest single group of fans reached her in 1893, at the time of her marriage to the Duke of York (the future King George V), the only surviving son of the Prince and Princess of Wales (later King Edward VII and Queen Alexandra). The bride received over forty fans as wedding presents, nine of which are further discussed here. Some of these would already have been considered 'antiques' (nos. 13, 15, 20). However, the majority were evidently newly made – some in France (nos. 61, 63), others in the United Kingdom, including a magnificent fan with a Honiton lace leaf (no. 65), and another with a leaf of Youghal lace (no.

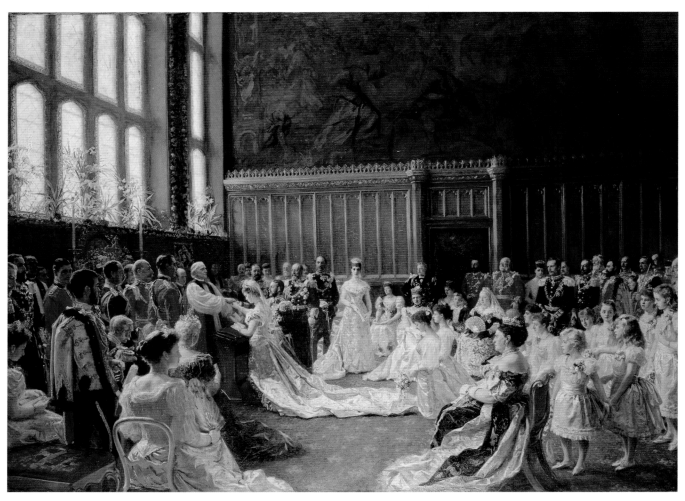

Fig. 23. Laurits Tuxen, *The marriage of George, Duke of York, and Princess Victoria Mary of Teck, 6 July 1893*; oil on canvas (RCIN 402437)

64). This was also the period when exotic materials were used to make fans: one of Queen Mary's wedding presents has a leaf made entirely of jay feathers (no. 66). Tuxen's painting of the marriage ceremony (fig. 23) shows many of the guests holding fans, some open, others closed. This was at a time of considerable fan-making activity in England, encouraged by many exhibitions, mostly under royal patronage. Four fans – doubtless including some of these splendid wedding gifts – were loaned by the bride, now Duchess of York, to the Fan Makers exhibition in 1897.

The coronation of King George V and Queen Mary in 1911 was marked by the Worshipful Company of Fan Makers with the gift of another Honiton lace fan (no. 78). In the following year, Queen Alexandra's Christmas present to Queen Mary was the Fabergé fan with a painted silk leaf (no. 75). One of the finest early fans in the Royal Collection (no. 2) was given by the widowed Queen Alexandra to Queen Mary on her forty-seventh birthday in 1914; another fan, dating from towards the end of the eighteenth century (no. 27), was given to Queen Mary by members of her family on her eighty-first birthday in 1948.

Queen Mary's known interest in fans and their historical associations led Queen Amélie of Portugal (*née* Orléans) to bequeath to her the splendid fan painted by Eugène Lami with a view of the Château d'Eu (no. 59), which had been a wedding present to Queen Amélie in 1886.

Queen Mary's continuously evolving collection of fans was divided between those that were 'in use' (and therefore kept by her dresser) and those placed on display in the royal residences. Her home as Princess of Wales (1901–10) was Marlborough House (later the home of her widowed mother-in-law), where a small number of fans were displayed in a cabinet which was transferred – with its contents – to Buckingham Palace in 1911, following the coronation.[99] Around thirty of the Queen's finest fans were placed on display in the Palace, on a double-sided screen installed in the 'Tapestry Drawing-Room' by 1914 (fig. 24).[100] Soon after Queen Alexandra's death, many of the finest fans (from the collections of Queen Victoria, Queen Alexandra and Queen Mary) were installed in two low glass-fronted ebony cabinets and in two tall gilt cabinets, purchased by the Queen from Mr Amor (and then fitted

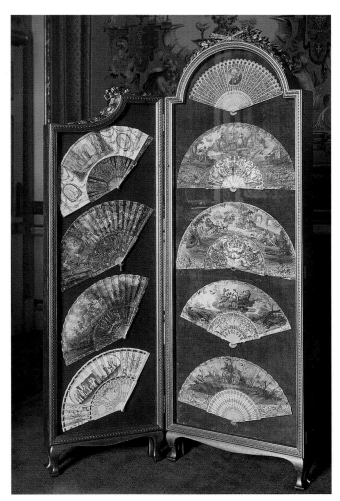

Fig. 24. Queen Mary's double-sided fan screen (including nos. 13, 24 and 32) photographed in the Tapestry Room (now the Queen's Audience Room) at Buckingham Palace, 1914

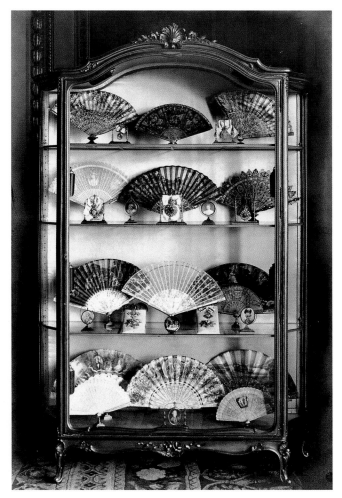

Fig. 25. One of Queen Mary's fan cabinets (including nos. 5, 6, 8, 9, 21, 33, 41, 42 and 43) at Windsor, as shown in her catalogue (WC Fans), 1927; photograph (RCIN 1126906, facing p. 1)

out with electric light) and placed in the Private Apartments at Windsor (fig. 25). The fans were arranged and listed by Queen Mary in 1927, her notes indicating that the best examples had been chosen for these displays.[101] After the death of King George V in 1936, Queen Mary moved back into Marlborough House with the possessions that she considered her personal property, including the fans on the fan screen from Buckingham Palace. She continued to live at Marlborough House until her death in 1953.

It is to Queen Mary that we owe much of the surviving documentation of the fan collection. Each example that came into her possession was meticulously recorded in a series of inventories: either the four-volume Catalogue of Bibelots covering acquisitions from 1893 to 1945 or the inventories of Queen Mary's Fans made in 1921 and of Windsor Castle Fans made in 1927.[102] It was also Queen Mary who made the list of Queen Alexandra's fans in 1927, and of the contents of the Stuart Room at Windsor (including no. 1) in 1916.[103] These and other manuscript sources

trace the steady growth of her own fan collection, several examples having earlier royal associations, particularly with the reign of George III (no. 31), while others were considered especially fine specimens of a particular type of fan: for instance, a ballooning fan or a cabriolet fan (nos. 28, 17). Both of these examples were purchased by the Queen.

Occasionally a documented fan is described by Queen Mary as being 'in personal use': this was the case in the 1890s with the Brussels lace fan received as a wedding present (no. 63), and in 1952 for the fine mid-eighteenth-century French 'Bacchus and Ariadne' fan (no. 16), inherited from the Duchess of Cambridge. The occasion at which a particular fan was used is also sometimes recorded. Another wedding present, painted with 'La Fontaine de Jouvence' (no. 61), was 'carried by Queen Mary at the wedding of Victoria Louise of Prussia and Prince Ernest Augustus of Cumberland, Berlin, 24 May 1913' (see plate 61.3): the bridegroom's parents had given the fan to Queen Mary twenty years before.

Queen Mary had a strong sense of the proper status of the different parts of the Royal Collection. The magnificent ivory *brisé* fan, made at the time of the marriage of Frederick, Duke of York, in 1791 (no. 33), was transferred by the Queen 'to the collection of fans' in 1927; in the same year, it was shown in one of the new fan cabinets at Windsor (fig. 25). Her determination to form and maintain a historical family collection led other members of the royal family to give or bequeath to her items of particular interest. Thus a fan that had belonged to Queen Adelaide and Queen Victoria, but had been bequeathed by the latter to a younger daughter (Princess Christian), was in 1948 presented to Queen Mary by Princess Christian's daughter (Princess Marie Louise), 'for the family collection of fans in Windsor Castle' (no. 39). Both these fans soon found a place in the display cases at Windsor. Queen Mary's collection probably numbered around five hundred fans in total, the majority of which remain in the Royal Collection. But the entries for several fans received as wedding gifts in 1893, and a number of others, are annotated with the words 'given away' in Queen Mary's fan notebook.[104] Towards the end of the Queen's life a number were presented to the Victoria and Albert Museum,[105] while others were bequeathed to the Princess Royal.[106]

The early twentieth century also saw the first published discussions of the fans in the Royal Collection, although 'Marie-Antoinette's fan' (no. 5), acquired by the young Queen Victoria in 1839, had already been reproduced as a colour print by the Arundel Society in 1871. In 1910 a number of royal fans were discussed and illustrated in Woolliscroft Rhead's *History of the Fan*, while the *Connoisseur* for 1927 included three articles by Eugénie Gibson entitled 'Some Fans from the Collection of Her Majesty The Queen'. Fans were also discussed in an article by Tancred Borenius entitled 'Treasures from Her Majesty's Collection' published in *The Queen* in 1935, and after the war G. Bernard Hughes contributed an article entitled 'Enamels and fans illustrated by examples from the collection of Her Majesty Queen Mary' to *Country Life*, where it was published in January 1947.[107]

Both Queen Mary and Queen Alexandra were closely involved in the discussions leading to the foundation of the London Museum (now the Museum of London), whose first home (from 1911) was the State Apartments at Kensington Palace, before moving to Lancaster House in 1913. A number of early fan loans were received by the Museum from Queen Alexandra from *c*.1912, including Queen Charlotte's lace fan (no. 21), one of Princess Augusta's fans (no. 25), both of the fans from Queen Victoria's visits to France (nos. 41, 42), and Queen Victoria's Diamond Jubilee lace fan (no. 69).[108] Following

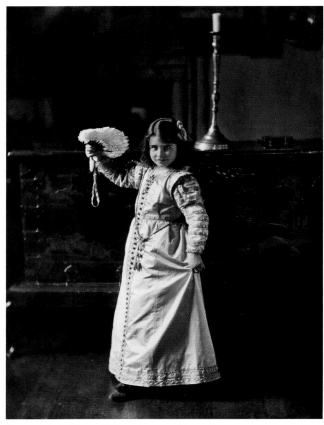

Fig. 26. *Lady Elizabeth Bowes Lyon at Glamis Castle*, 1909; photograph by Lafayette (RCIN 2999501)

Queen Alexandra's death all these were returned, to be placed on display at Windsor and incorporated in Queen Mary's catalogue of Windsor Castle Fans. From the mid-1920s Queen Mary placed a number of other fans on loan at the London Museum, including the printed fan commemorating the marriage of George III and Queen Charlotte (no. 19), and a group of fans from Queen Alexandra's collection (including nos. 50, 51, 53). Most of these remained on loan throughout the further moves of the Museum, back to Kensington Palace in 1951 and in 1976 to its present home at London Wall.[109]

One of the most striking fans in the Royal Collection is no. 72, made of exquisite curled white ostrich feathers, the diamond-encrusted tortoiseshell guards decorated with roses, shamrock and thistles. After Queen Alexandra's death the fan passed to Queen Mary, who in turn passed it on to her daughter-in-law, Queen Elizabeth. Typically, a note of the fan's provenance was supplied at the time of the gift: 'For darling Elizabeth in remembrance of Coronation Day, 12th May 1937, from her loving Mama Mary. This fan formerly belonged to Queen Alexandra' (see plate 72.1). It is likely that the fan was carried at ceremonial events by each of its owners. The fact that fans were included in the trousseaux of the magnificent dolls

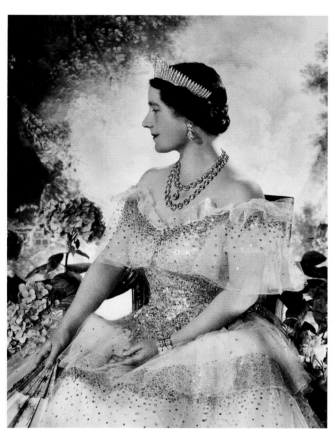

Fig. 27. *Queen Elizabeth*, c.1939; photograph by Cecil Beaton
(RCIN 2912660)

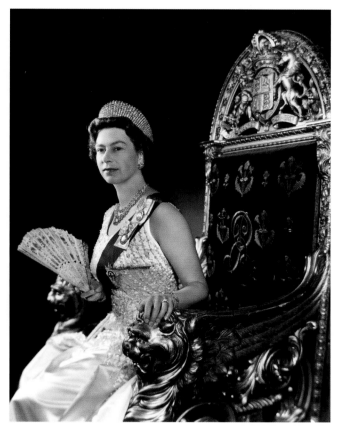

Fig. 28. *HM The Queen*, 1967; photograph by Yousuf Karsh
(RCIN 2912662)

France and Marianne, presented by the children of France to Princesses Elizabeth and Margaret in the course of the King and Queen's State Visit to Paris in the following year, is indicative of their perceived status in the wardrobe of a finely dressed young lady, in Paris if not in London. Each doll has two fans, all four supplied by the great Parisian fan-maker Duvelleroy: in each case one of the fans had a paper leaf – painted by Marie Laurençin – while the other had an ostrich-feather leaf (see plates 80/81.1 and 2).

The reality, however, was that by this date – with the gradual modernisation of court life and of female dress – fans no longer had a significant place in a royal lady's wardrobe. Although Queen Elizabeth The Queen Mother was shown as a child in fancy dress, holding a fan (fig. 26),[110] by the end of her long life fans were not part of normal royal attire. The decline in their use is suggested by the inclusion of only three fans (as opposed to Queen Mary's forty or so) in the list of Queen Elizabeth's wedding presents in 1923,[111] even if the enduring glamour associated

with fans is clear from Beaton's photograph (fig. 27).[112] There were around fifty fans in the royal wardrobe at Clarence House at the time of Queen Elizabeth's death in 2002. A large proportion of these, including the child's fan with which the 8-year-old Lady Elizabeth Bowes Lyon had been photographed over ninety years earlier (fig. 26) and the vast Coronation fan (no. 82), were made of ostrich feathers.[113]

In addition to inheriting all the fans which had belonged to her forebears, and to receiving France and Marianne's fans in 1938, HM The Queen received eighteen fans (including nos. 12, 18) on her marriage in 1947, and further examples at the time of the Coronation and Silver and Golden Jubilees. In line with historical tradition, a small group of these fans is still kept by The Queen's dresser as part of the royal wardrobe. And just as Queen Elizabeth I was often painted holding a fan in the sixteenth century, so – at the start of her reign (fig. 17) – Queen Elizabeth II was frequently photographed with fan in hand, four hundred years later.[114]

NOTES

1 RCIN 25307. The inscription was in Irish.

2 Parthey 611. 'Summer' is included in each of Hollar's other series of the seasons; she holds a folding fan in two others, with the inscription ending 'her fann doth coole the Ayre' (Parthey 607), and 'Her fann protects her from Sunburning ayre' (Parthey 615).

3 Parthey 608.

4 No precise translation is possible. The meaning is 'for social grace'; a translation could be 'to keep up appearances' or 'to create an effect' (Diderot 1751, p. 139). Already in 1625 Callot's series of etchings entitled 'The Ladies' had included a standing lady holding a folding fan (Meaume 683; RCIN 801392). A. Bosse's print of the French Queen Anne of Austria with the infant Louis XIV in 1638 (RCIN 616886) shows several ladies holding (open) folding fans.

5 Millar (O.) 1992, no. 555.

6 'Grandmama raises her fan over her face, she is delightfully, pleasurably scandalised, but she understands; leaning towards me, her fan still over her mouth, she whispers: "But, oh my dear child, I am afraid she's really not very nice!"' (Roumania 1934, I, p. 236).

7 For instance, at the court of Henri III of France (reg. 1574–89) folding fans were frequently used by men. Callot's engraving *Battaglia del Re Tesi e del Re Tinta*, issued in Florence in 1619, shows men holding rigid fans. This is paralleled by Thomas Coryat's *Crudities* (1608), which notes the use of fans by both men and women in Italy. Male use of fans in late seventeenth-century England is described by John Aubrey; and in the following century Lord Hervey's use of fans led to his nickname 'Lord Fanny'. In Oscar Wilde's *Lady Windermere's Fan* (1892), Lord Augustus Lorton is encouraged to carry the fan.

8 The usual descriptive term 'chickenskin' has not been used in this publication. Following microscopic examination at Windsor, a skin surface is described as either leather or vellum (see Glossary, p. 212).

9 Owing to the French guild systems, until the reorganisation of the guilds in the late eighteenth century all fan-painters in France had to be members of the Académie de St Luc, the professional painters' guild (see also n. 35 below). Very few fan leaves attributable to known eighteenth-century painters have survived. A single painted fan leaf (*Les oies de Frère Philippe*, in the museum at Besançon) has survived by the French artist François Boucher, who earned contemporary renown for his fan designs (see *Boucher* 1986, no. 7; and pp. 82, 91).

There was a revival of interest in fan-painting at the end of the nineteenth century, with the Impressionist movement: at the fourth Impressionist exhibition in 1879, Degas planned a room devoted entirely to fans. Meanwhile, in England – in 1747 – fan-painting was described as 'an ingenious trifling branch of the painting business' (quoted in Baker 1999, p. 21).

10 This problem was already present in 1870 when Samuel Redgrave was arranging the Loan Exhibition of Fans: 'The arrangement of the Exhibition was commenced with the intention to classify the Fans according to the country and date . . . however, a difficulty, and indeed uncertainty, was experienced in assigning to some Fans the country to which their manufacture might be most correctly attributed. The workmen of one country have been tempted to another, Chinese carvers even having been brought to Europe' (introduction to the catalogue for London 1870).

11 They include leaves painted by Hippolyte Ballue (no. 44), 'Count Nils' (Nils Barck; no. 55), Jenny Boucher (no. 48), Danys (no. 70), Jules Donzel (no. 61), Gimbel (no. 48), Paul Hervy (no. 44), Francis Houghton (no. 60), Eugène Lami (no. 59), Marie Laurençin (nos. 80, 81), Madeleine Lemaire (no. 68), Alice Loch (no. 58), Emma Roberts (no. 47), and Marcus Ward (no. 51); and guard sticks signed by Robert Gleeson (no. 69; see also no. 78), Jorel (no. 54), Adrian Rodien (nos. 59, 68), and by Carl Fabergé's work masters Michael Perchin (no. 73) and Henrik Wigström (nos. 74, 75).

12 Alexander 1995, p. 18. The order stipulated 'three quarters of them to be on white paper, a quarter on coloured, and all to be well painted with figures upon one side and flowers on the other, the side sticks to be lacquered black and inlaid with mother-of-pearl for 30 taels [£10] per mille'.

13 Fraser 2004, p. 141.

14 Three early eighteenth-century Italian fan leaves, in their original fan-shaped box (inscribed *A Sigri Baracchi* and *Mucotti, Livorno*), were sold at Christie's South Kensington, 21 October 1970, lots 298–300. Two of the leaves are now in the Victoria and Albert Museum (see Mayor 1980, p. 29, and Hart and Taylor 1998, fig. 3).

15 Harrison's account, quoted in Arnold 1988, p. 12. The massacre of French Protestants in 1572 was part of the Wars of Religion. It was followed by the flight from France of hundreds of Huguenots (French Protestants). Between the passing of the

Edict of Nantes in 1598 and its revocation in 1685, the Huguenots enjoyed apparent religious freedom.

16 Rhead 1910, p. 102.

17 Arnold 1988, p. 12.

18 Arnold 1988, figs. 26, 27, 31, etc.

19 Arnold 1988, figs. 13, 14.

20 For instance, in the full-length portrait by Marcus Gheeraerts the Younger of c. 1611–14, in which she holds a vast red-and-black feather fan (Hearn 1995, no. 130), and in the following portraits in the Royal Collection: Anonymous, dated 1614 (Millar (O.) 1963, no. 98); by Paul van Somer, datable 1617/18 (Millar (O.) 1963, no. 106); the engraved double portrait of the early 1610s by Renold Elstrack (Hind 1955, p. 181, no. 37); and the equestrian portrait by Simon de Passe of 1616 (Hind 1955, p. 248, no. 3).

21 Inventories of the collection of James I's son and heir, Charles I, include a few references to fans, including one (probably an old bejewelled one) in a leather case (MacGregor 1989, p. 278).

22 Arnold 1988, pp. 42, 44. Further work on such fans continued through the 1590s. This included 'new Tuftinge' a fan, 'the Tufts Carnacion Silke ingrayne' (Arnold 1988, p. 44), suggesting a fan with silk tufts ornamenting the guards such as that which the Queen is shown holding in the 'Ditchley portrait' of c. 1592 (see n. 24 below).

23 The posthumous inventories of her possessions made in 1589 include five leather fans 'fashioned in the Oriental style', which were presumably similar to the 'Indian' folding fans described in England at around the same time (Blondel 1875, p. 68).

24 The first portrait to show the Queen holding a folding fan is that dated 1590 at Jesus College, Oxford (Arnold 1988, pl. III; fig. 66). The 'Ditchley portrait' in the National Portrait Gallery, London, is probably a few years later (Arnold 1988, fig. 71; Hearn 1995, no. 45). For a surviving fan of similar design (at Ecouen), see Melville 1991, figs. 3, 4, and Trogan 1995. The precise status of the cockade fan in the National Museum of Scotland, Edinburgh (H.U1 2), with a traditional association with Mary, Queen of Scots (1542–87), is unclear. Although it is reputed to have formed part of the Penicuik jewels, it does not appear in the Fotheringay inventory of February 1587. The pleated leaf is of coloured silk decorated with silver lace; it retracts into a tortoiseshell handle and may be Italian, late sixteenth century.

of the Penicuik jewels, it does not appear in the Fotheringay inventory of February 1587. The pleated leaf is of coloured silk decorated with silver lace; it retracts into a tortoiseshell handle and may be Italian, late sixteenth century.

25 The sitter has been tentatively identified as Penelope, Lady Rich, the sister of Robert Devereux, Earl of Essex, and the muse of Sir Philip Sidney (Reynolds 1999, no. 30).

26 Hearn 1995, no. 126.

27 For two equestrian portraits of the Queen, each showing her holding a folding fan (closed), and each published in the 1630s, see RCIN 602055 (engraved by Jerome David; published by Jean I Le Blond), and RCIN 602051 (derived from the Mytens painting; published by Pierre Daret). See also the slightly later painting in the National Portrait Gallery attributed to Hendrick van Steenwyck (illus. MacGregor 1989, fig. 97): the fan in the latter portrait has a painted leaf. In the years around 1615 folding fans are included in a number of portraits by Marcus Gheeraerts the Younger (Strong 1969, nos. 309, 310) and by William Larkin (Strong 1969, nos. 331–4).

28 MacGregor 1989, p. 338.

29 See note 12.

30 Marschner 2000, p. 47. These fans may also be seen as part of Queen Mary's taste for Oriental goods, including fabrics and porcelain.

31 Marschner 1997, p. 32.

32 See the India Office Records in the British Library (IOR G/12/92). The fans are included in the sections headed 'Presents added on the Occasion of the Feast' (p. 327), 'Additional Presents' (p. 330), and 'Additional presents when the Ambassador was introduced to the Emperor' (p. 323). The lists on pages 327 and 330 appear to be repetitious (13 + 100 fans in each). Several carved ivory and lacquer fans were included in the posthumous sales of Queen Charlotte's possessions in 1819. 'Ventoli' are flag fans or handscreens.

33 Quoted in Willcocks 2000, p. 55.

34 Comment by Savary de Brouslons, quoted in Alexander 1995, p. 18.

35 The éventaillistes had to depend on sticks produced by a member of the guild of tabletiers (unless they used freelance stick-makers from near Beauvais) and leaves produced by professional painters.

36 Quoted in Baker 1999, p. 21. For Thomas Coke's purchase of 'a fan painted by Mr Winter a German' for 1.50 Roman Crowns, in Rome in 1714, see Hart and Taylor 1998, p. 57.

37 The account of the trousseau of George II's daughter Anne, the Princess Royal, before her marriage in March 1734 to William IV of Orange, included the assembling of a folding fan (Marschner 1997, p. 332). See also Wilton and Bignamini 1996, p. 301; Baker 1999, p. 21.

38 As described by Diderot (Diderot 1751, p. 139).

39 Although these examples appear on Italian fans, many Italian fan leaves were imported to England in the eighteenth century; for instance, the fan mount painted by Filippo Lauri in the 1690s, still preserved, in its contemporary Italian frame, at Christ Church, Oxford (see Baker 1999). Similar subjects occur on fans produced in England.

40 Quoted in Alexander 1995, p. 22. See also no. 21.

41 See Garden of Fans 2004, pp. 86–101.

42 For fig. 11 see Rococo 1984, no. F5. According to an advertisement in the Craftsman for 1 July 1732, Hogarth's series of prints entitled A Harlot's Progress were copied on fan-mounts, three designs on each side, 'printed in divers beautiful Colours, Price 2s. 6d.'.

43 For another example of the use of fans outside at this period, see Hogarth's Family of George II of c.1731–2 (Millar (O.) 1963, no. 559). Laroon's Musical Tea-Party dated 1740 (ibid., no. 521) shows fans in use indoors.

44 See under no. 30.

45 And see no. 28 for one of many ballooning fans produced both in France and in England in the late eighteenth century.

46 Quiet Conquest 1985, no. 458; ibid. no. 459 for a printed fan signed by Francis Chassereau. Two people of this name were members of the Worshipful Company of Fan Makers.

47 Marschner 2000, p. 47. See also Marschner 1997, p. 32.

48 Quiet Conquest 1985, no. 243.

49 In 1752 'A fan set with brilliants, which was given to the late Queen [Caroline] by the Empress Elizabeth' was returned to Hanover with other jewels (RA/VIC/C 58/57).

50 Quoted in Baker 1999, p. 21.

51 Quoted in Wheatley 1989, p. 6.

52 Bennett 1988, p. 12.

53 Schreiber 1888, 98/99 and 147/148; for the box, see Hart and Taylor 1998, fig. 6.

54 Wheatley 1989, p. 31.

55 In Oscar Wilde's play, Lady Windermere's Fan (1892), Lady Windermere remarked 'A useful thing a fan, isn't it?', and announced 'If that woman [Mrs Erlynne] crosses my threshold, I shall strike her across the face with it.'

56 Queen Victoria 'did not approve of long services, and would sometimes scandalise the minister by indicating, with uplifted fan, that the sermon was getting too lengthy ('The Character of Queen Victoria', Quarterly Review, April 1901, p. 320).

57 Private Life 1979, p. 89.

58 Duvelleroy 1995, p. 4 and no. 51.

59 The boxes for the following fans included in this publication bear the 167 Regent Street address: nos. 18, 42, 54, 58, 63, 69. Other boxes bear the addresses of Duvelleroy at 121 Bond Street (nos. 6, 27) and 20 Motcombe Street, Belgrave Square (no. 64).

60 Among Queen Mary's wedding presents was 'a lace fan and case' (now RCIN 25125) from M. Jules Duvelleroy (QMWP 1893, no. 329).

61 An invoice from Duvelleroy dated 13 February 1914 related to King George V's purchase of an 'ivory carved antique style fan' for £7 17s 6d, perhaps as a Valentine present for the Queen (RA PP/GV/MAIN/PRIV/ACC/BILLS/608).

62 With the address 17 Passage-Panoramas (no. 8), the 'boutique' used by Duvelleroy from the 1840s to the early 1900s; and 37 Boulevard Malesherbes (nos. 80, 81), the firm's base from the late 1930s.

63 The Duvelleroy firm continued in operation in Paris until 1981, reopening (for sales and repairs) at 25 rue de Lille in 1983–4. The London branch closed in 1962.

64 Fans with the same subject were given to both the Princess of Wales and the Empress Eugénie in the 1860s (see entry for no. 61).

65 London 1870, nos. 268, 269 and 271–85, including nos. 5, 6, 9, 10, 23, 39, 42 in the present publication. All these may later be traced in Queen Victoria's list of fan bequests (QVL). In addition, the Prince and Princess of Wales lent five fans (including no. 49) to the exhibition (London 1870, nos. 216 and 455–8). Both the 1870 and the 1878 exhibitions were organised by the Department of Science and Art.

66 At the same period, portraits of the bride and groom appear on Dutch marriage fans (see no. 20).

67 Other fans received as wedding gifts were decorated with sprigs of may blossom (see Royal Fans 2002, no. 6). However, the majority of the fans received as wedding presents bore the bride's initials VM (Victoria Mary): see nos. 63, 64, 67; or M (Mary): see no. 65. After the accession of King George V in 1910, Queen Mary's fan guards bear the initials MR (Maria Regina): see no. 78.

68 Alexander 1995, p. 16.

69 James Northcote, Reynolds's pupil and biographer (see Smart 1992, no. 81). For another early portrait (by G.D. Matthieu, 1762) of Queen Charlotte holding a fan, see *Mecklenburg* 1995, no. 6.27.

70 Millar (O.) 1969, no. 775.

71 As described in Northumberland 1926, p. 36.

72 Fraser 2004, p. 93.

73 Letter from Lady Mary Howe to Louisa, Lady Altamont, 2 January 1790, quoted in Fraser 2004, p. 129.

74 We have already seen how, in 1792, Queen Charlotte requested fan leather from Italy (and see no. 23).

75 Payments for fans appear in the accounts of the Mistress of the Robes and of the Treasurer to the Queen. There is a single payment for fans in the surviving accounts for the former office: to Nicolas Mesureur in 1787 (RA GEO/36912); this must relate to an item or items supplied for the use of the Queen. The accounts of the Queen's Treasurer (RA GEO/36842–948; and BL Add MS 17870–71) included items supplied for the Royal Nursery and for the use of the princesses. Within these accounts, payments for fans were made to the following: Anne Baylie (1782–3), William Bryan (1793–4), Joseph Clayton (1781), Mary Francis (1793), Henry Laurence (1792), William Warndley/Werndley/ Werndly (1774, 1778–93), Margaret Williams (1781, 1785) and Thomas Williams (1773, 1787, 1789, 1791–3). The largest invoices were submitted by Ann Ward (1786–93). Other information concerning fan-makers may be found on trade cards: that of William Werndly (1791) mentions his work for the Queen. A tube-like fan box in the Royal Collection bears the printed trade label of William Werndly, fan-painter, and a fragmentary inscription *Given by Miss Goldsworthy ... 17 Feb. 17[?94]*, doubtless referring to Martha Gouldsworthy, sub-governess to George III's daughters from 1774 to 1808. Both label and inscription are badly rubbed, but the fan box still contains a fan (RCIN 25331), apparently Italian or English c.1780–90, the leaf painted with Mount Vesuvius erupting.

76 As a small child in 1801, Princess Charlotte of Wales received the gift of a fan from her aunt, the Princess Royal (Fraser 2004, p. 196).

77 Fans were included in sales held at Christie's in London, commencing on the following dates: 7 May (Oriental Curiosities and Porcelain), 17 May (Jewels), 24 May ('Remains'), 26 August 'Miscellaneous'). Seven fans from Queen Charlotte's collection, lent by A.W.S. Gwyn, W.R. Harcourt Gwyn, Charles A. Jones and Princess Frederica of Hanover, were included in the *Exhibition of the Royal House of Guelph* (London 1891: nos. 481, 484, 505–7, 509, 1962).

78 Christie's, London, 26 August 1819, lot 37. 'Green fans' were large, simple, robust fans for use outside in the summer heat; one is held by George III's niece, Princess Louisa Augusta of Denmark, in the portrait by Jens Jules of 1787 (Frederiksborg Castle, Denmark). Garden fans are also mentioned in the sale catalogue of the collection of George III's mother, Princess Augusta of Wales (Christie's, London, February 1773; lot 31), but none has survived in the present Royal Collection. An early eighteenth-century fan (Christie's, South Kensington, 15 February 2000, lot 72) has a leaf painted with a scene in which a man uses a green fan to cool a lady seated in a garden.

79 Payment to William Bryan of £11 19s. 6d. in 1794 (PRO HO 73/17) and to William Cook of £21 on 12 April 1795 for '1 Rich Pierced and carved Ivory Fan ornamented with the Portrait of H.R.H.' (PRO HO 73/18). The large carved ivory cockade fan (no. 34) appears to have been made for presentation to the future George IV.

80 Millar (O.) 1992, nos. 532, 817, 6, 209. Photographers also showed the Queen with fan in hand, particularly at the time of the Diamond Jubilee (see pl. 21.1).

81 RCIN 25080, said to have belonged to Louis XVI's sister, Madame Clothilde.

82 These fans were both bequeathed away from the Collection in 1901 (QVL 28 and 29).

83 Queen Victoria's costume for the masked or 'powder' ball at Buckingham Palace on 6 June 1845, where the dress was to be from the period 1740–50, included a fine fan, as recorded in Landseer's painting of the Queen (Millar (O.) 1992, no. 400). The published account of the ball, issued in 1845 (by Charles Evans), described how, in the Yellow Drawing Room of Buckingham Palace, Queen Victoria welcomed her guests: 'It was in this room principally the old courtly manners of the reign of George the Second were attempted to be revived, and the gliding of hoops, the rustling of fans, the presentation of snuff-boxes, and the interchange of bouquets, called into temporary existence a page of poetical history' (p. 12).

84 The collection, formed at around the time of the accession of Duke Augustus in 1804, included a large group of fans that the Duke had acquired in England. His only child, Louise (1800–31), was Prince Albert's mother. An inventory of objects in the Chinese Cabinet in 1805–10 includes 234 fans. One hundred further fans came with the estates of Princesses Caroline and Augusta of Saxe-Coburg Saalfeld, who died in 1829 and 1833 respectively. But at one stage there were only seventy fans in the Chinese Cabinet. Three hundred fans remain in Schloss Friedenstein today. (Information from Dr and Mrs Uwe Wandel and Mrs Elisabeth Dobritzsch of Gotha.) Two fans were given to Queen Victoria by Duke Ernest I in 1836; others were presented at the time of the royal marriage in 1840; further fans may have been bequests received following the Duke's death in 1844 (see no. 9).

85 The Queen may be shown holding one of these in Francis Grant's portrait of 1843 (see Alexander 1995, p. 25). Two of Princess Augusta's *brisé* fans were included in the recent George III exhibition (London 2004–5, nos. 465, 466).

86 The use of this historic fan at the marriage of the future Queen Mary was particularly appropriate in view of the bride's keen interest in fans.

87 The Mistress of the Robes Letter Books include a payment to Madame Rebours (Alexandrine) in 1858, and payments to Duvelleroy, Faucon, Miss Lock (*sic* for Loch), Fulgence, and Marcot in the 1870s–90s (PRO LC 13/3–4; information from Kay Staniland); and the Queen's expenditure on presents (RA VIC/MAIN/ PERS/ACC/LED/2 and 4) included 'fancy articles' from Howell & James in 1886 (£50 19s.), and a fan from V. Marcot in 1899 (£7 10s.).

88 The passage continues: 'She is nearly blind, & her daughter, Mrs. Elliot, came with her' (RA VIC/QVJ/1891: 29 June). The book was presumably one of the volumes of *Fans and Fan-Leaves*, published in 1888 and 1890 respectively. In her correspondence with Queen Victoria in the 1880s and 1890s, the Princess Royal refers to a number of visits to Lady Charlotte in London; in March 1894 she found her 'quite blind' (RA VIC/Z 55/61; see also VIC/Z 35/34, VIC/Z 54/44). The principal part of Lady Charlotte's collection of printed fans was presented to the British Museum (see Cust 1893).

89 Three of the four fans which passed to her fourth daughter, Princess Louise, were illustrated in Rhead's major publication on fans, issued in 1910. These included one from the collection of the Queen's aunt, Princess Augusta, one from the Gotha

collection, and one other which had been given to the Queen by the Prince Consort (Rhead 1910, pl. 2, figs. 68, 97). Rhead also illustrated a fan painted by A. Soldé, given to Princess Louise by Queen Victoria (Rhead 1910, fig. 28). Five fans from Princess Louise's collection were presented by the Duchess of Gloucester to the Fan Makers Company in 1956, but were stolen seven years later (see Fowles 1977, p. 15). Royal loans to the Japan–British exhibition in 1910 included a French royal wedding fan presented by the Comte de Paris and the Duc de Chartres to Princess Helena for her wedding; Princess Henry of Battenberg (Princess Beatrice) lent a fan presented by Empress Eugénie.

90 *Liverpool Courier*, 22 March 1910 (account of preparations for the Japan–British exhibition). Some of Queen Alexandra's fans were lent to the London Museum in 1912 but these were returned after her death (see pp. 26, 28).

91 Millar (O.) 1992, no. 785. A fine group of fans (including the counterpart to no. 49) was lent by the Danish Royal Collections to the *Royal Fans* exhibition at Greenwich in 2002 (London 2002).

92 Another gift to Queen Alexandra from the Tsarina was the '*Fontaine de Jouvence*' fan (RCIN 25026); an almost identical example, signed by Alexandre, was owned by the Empress Eugénie, and is now in the H. Alexander Collection (*Royal Fans* 2002, no. 4; see under no. 61).

93 See Gere 2004. Among the numerous painted portraits showing Queen Mary holding a fan (but none easily identifiable) are those by A.T. Nowell (RCIN 407416) and R. Jack (RCIN 404548), both in 1927, and by O. Birley in 1934 (RCIN 407413). Many formal photographs of the Queen show her holding a fan from her collection. The fan shown in fig. 21 is RCIN 25222.

94 The sale of Porcelain and Miniatures (from 8 June 1904) included (on Day 5) thirty fans (lots 694–9). The most expensive lot was lot 696, purchased by Queen Mary for 14 guineas (now RCIN 25089); lot 695 (now RCIN 25078) was purchased by her later.

95 The fan case shown in fig. 22 is now located in the Saloon at Sandringham House.

96 RA GV/QMD/1926: 4 and 16 February. On Princess Victoria's death in 1935 her possessions were bequeathed to members of her immediate family.

97 RA GV/CC 43/25. The fans included a lace and mother-of-pearl example from the employees at Elise.

98 Other fans from the Duchess of Teck's collection passed to her daughter-in-law, Princess Alice, Countess of Athlone, and thence to the collection of the Worshipful Company of Fan Makers (see Fowles 1977 and Willcocks 2000, *passim*). See also *Royal Fans* 2002, no. 42. Other fans from the collection of Princess Mary Adelaide include RCIN 25122, 25123, 25140, 25178, 25179, 25247 and 25400. The fan held by Queen Mary in fig. 21 was also inherited from her mother (RCIN 25222).

99 See manuscript list of souvenirs in the Chippendale cabinet belonging to the Princess of Wales, Marlborough House, 1906 (RCIN 1114512).

100 The room is now called The Queen's Audience Room. The photograph belongs to the sequence used in Alexander Nelson Hood's three volumes on Buckingham Palace, privately issued in 1914. The screen was originally two-leafed (as shown in fig. 24 and in Hood 1914); it was later adapted by Queen Mary to have three leaves (see illustrations in Borenius 1935). By 1935 nearly thirty fans were accommodated on the screen; all but a few (given away by Queen Mary) are still identifiable in the Royal Collection. Photographs show that the display changed in the course of the reign. At various times thirteen of the fans included in this publication were displayed there. The screen itself is now used to display fans in the Private Apartments at Windsor.

101 See Condensed Report of Alterations carried out at Windsor Castle during the reign of His Majesty King George V under the direction of Her Majesty Queen Mary 1911–1936 (RCIN 1114883). Most of the fans included in Queen Victoria's bequest (QVL) were still on view in the display cases in Room 240 in the 1980s, together with other important family relics assembled by Queen Mary. At the same period some of Queen Victoria's fans, with others from the collections of Queen Alexandra and Queen Mary, were located in the cases in the Sovereign's Entrance. Queen Mary's cabinets are still used for the display of fans at Windsor.

102 See QMB, QMF and WC Fans. Further fans were placed by Queen Mary in the Lace Room at Windsor (see Levey 1995), where they were listed for the Queen in the 1930s. Many of the twenty or so fans in the Lace Room have historical associations (particularly with the daughters of Queen Victoria), but they were considered less important than those included in the

display cases in Windsor and London.

103 See QAF and Stuart Room Catalogue.

104 QMN.

105 A group of twenty-three fans from Queen Mary's collection was allocated to the Circulation Department of the Victoria and Albert Museum (Circ 233–1953 to 255–1954). A further twenty-four fans loaned to the Museum were returned to the Royal Collection in 1998.

106 Some of these remain at Harewood House, Yorkshire (see Harewood 1986), while a number were sold at Christie's, London, 28 June 1966. Other fans formerly in Queen Mary's collection were presented by Princess Alice, Countess of Athlone, to the Worshipful Company of Fan Makers.

107 See Gibson 1927, Borenius 1935 and Hughes 1947.

108 In the early years of the London Museum Queen Mary also sent fans on loan, annotating an early list (RCIN 1114512) 'Lent to Family Museum KP' (i.e. Kensington Palace).

109 However, Queen Mary's own lace coronation fan (no. 78) was loaned for only a brief period, from 1926 to (probably) 1933.

110 The fan, with ribbon still attached, remained in Queen Elizabeth's wardrobe (RCIN 25321).

111 RA ADY/MAIN/001: manuscript and typed lists of the Duke of York's wedding presents.

112 The fan is RCIN 25313.

113 The wardrobe also contained a number of single ostrich feathers in different colours, their quill tips encased in plastic. The quill tips will have been slipped – either singly, or in two or threes – into plastic handles; these were very fashionable in the 1920s and early 1930s, when feathers were also worn in headbands. One of the three Fabergé fans in the collection (no. 73) appears to have been a gift – doubtless presented more because it was made by Fabergé than because it was a fan. Princess Alexandra's Danish fan (no. 49), which had left the collection after being bequeathed to a younger daughter, was presented to Queen Elizabeth in 1949 and transferred to Sandringham soon after.

114 Fig. 28, taken by Karsh of Ottawa, shows Her Majesty holding a lace fan (RCIN 25222) from the collection of Princess Mary Adelaide, Duchess of Teck. That fan, with the one (RCIN 25215) held by The Queen in fig. 17, is still cared for by The Queen's dresser.

Overleaf: no. 28 (detail)

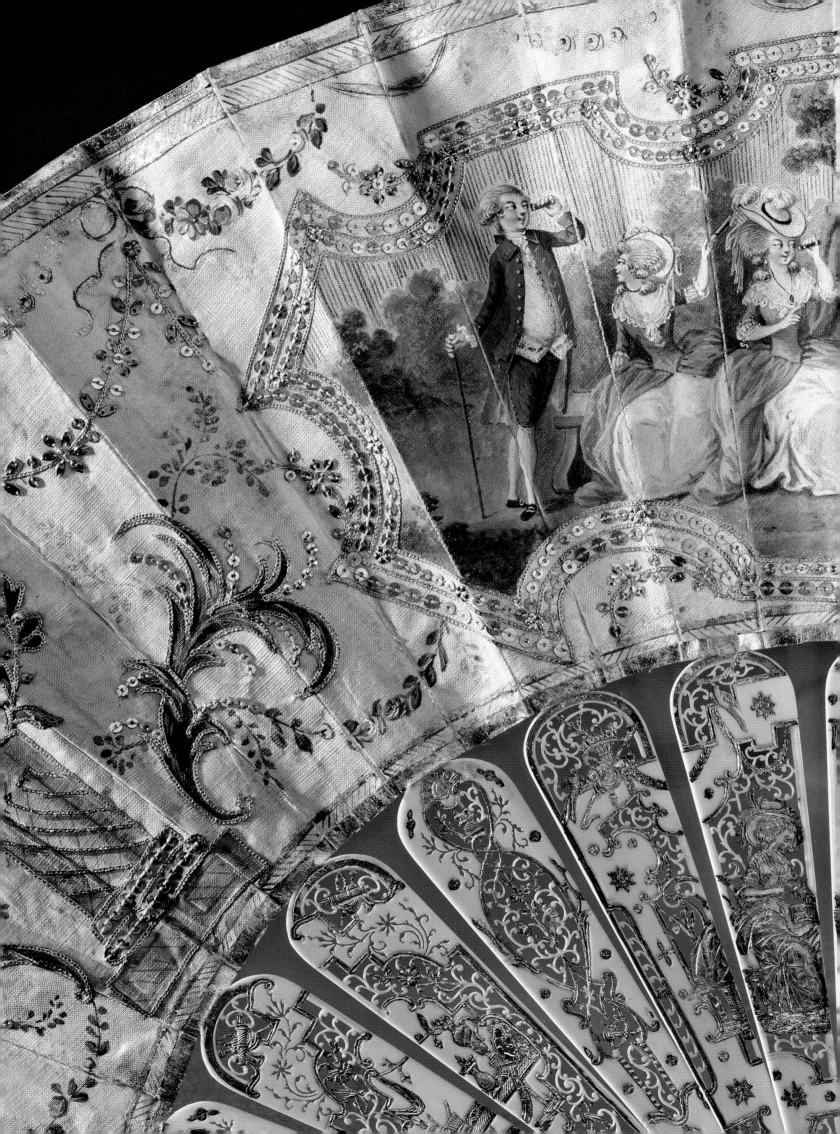

CATALOGUE

INTRODUCTORY NOTE

The following entries are presented in approximately chronological order.
Detailed information concerning materials, measurements, inscriptions,
inventory numbers, provenance, previous published citations and
exhibition history is given in the 'Illustrated descriptions' section,
on pp. 196–211. Catalogue notes appear on pp. 191–5.

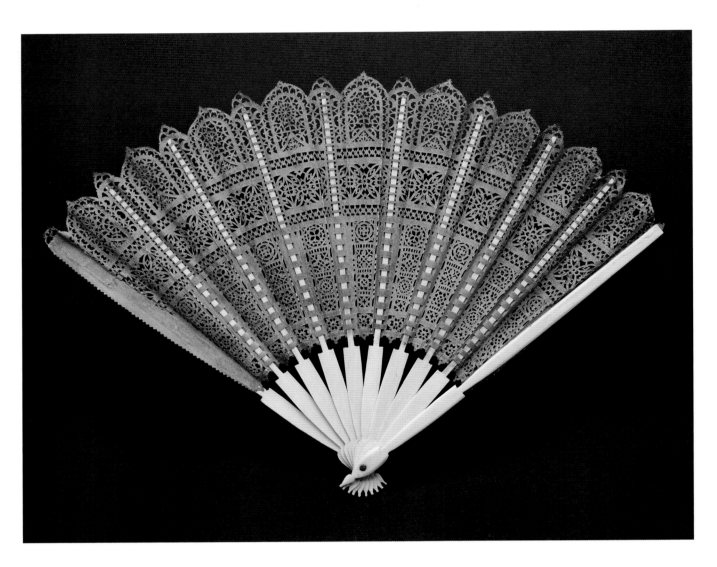

1. FAN FROM THE STUART COLLECTION
ENGLISH, *c*.1600

This fan is a rare survival of an early folding fan and belongs to a small group that includes single examples at the Château d'Ecouen[1] and in Boston.[2] In each case the geometric decoration has been cut out of the leaf using a small knife. The decoration was copied or adapted from the printed plates of one of the many pattern books that were published in Italy from the mid-sixteenth century.[3] The design would have been laid over the leaf and the outlines pricked onto the leaf with pins. The holes made by the pins in the course of the transfer process can still be seen on this fan under magnification. The leaf, formed from the skin of an animal (possibly a dog in the case of this fan), was mounted by threading the pointed ends of the sticks through slots cut into the leaf. The upper portions of the sticks have traces of green and red pigment and remains of copper strips covered with a white metal (possibly tin). Fans such as this appear in a number of painted portraits, which provide the principal dating evidence. One example is the (uncoloured) fan held by Diana Cecil, Countess of Oxford, in the portrait of *c*.1614–18 attributed to William Larkin.[4] Appropriately, that fan is shown in the context of Lady Oxford's rich apparel, which includes ruff, cuffs and handkerchief adorned with deep borders of reticella lace of a similar type to that which forms the basis of the pattern in no. 1. In the late sixteenth century folding fans are normally depicted with richly decorated sticks (see fig. 9). See also the fan with pierced and coloured leaf held by Agatha Bas in Rembrandt's portrait of 1641 (plate 1.1).

The fan is one of the twenty-four Stuart relics from the Hamey collection purchased for the Royal Collection for £350 in 1910. Dr Baldwin Hamey (1600–1676) was a successful physician in London throughout much of the seventeenth century. In his later years he assembled quantities of relics relating to Charles I. This was one of two fans included in the 1910 purchase.[5] The specific association of these fans with Charles I is not recorded and the second fan (plate 1.2) would appear to post-date his execution. However, both fans are listed in the inventory of 1829 acquired with the relics in 1910. In August 1892 the collection had been offered by the then owner, Mrs Still of Seaton, Devon, to Queen Victoria's last librarian, Richard Holmes. Negotiations for a royal purchase continued through the reign of King Edward VII and were not finalised until the first months of the following reign, of King George V.[6] By 1916 these items had been arranged by Queen Mary as part of the display in the newly designated Stuart Room in Windsor Castle.

Plate 1.1. Rembrandt, *Agatha Bas*, 1641; oil on canvas (RCIN 405352; detail)

Plate 1.2. Recto of late seventeenth-century English fan acquired in 1910 with no. 1; painted silk leaf and tortoiseshell sticks (RCIN 25351 recto)

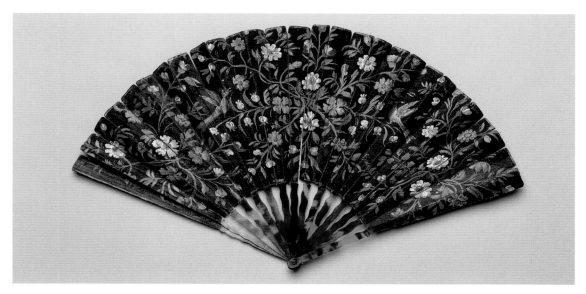

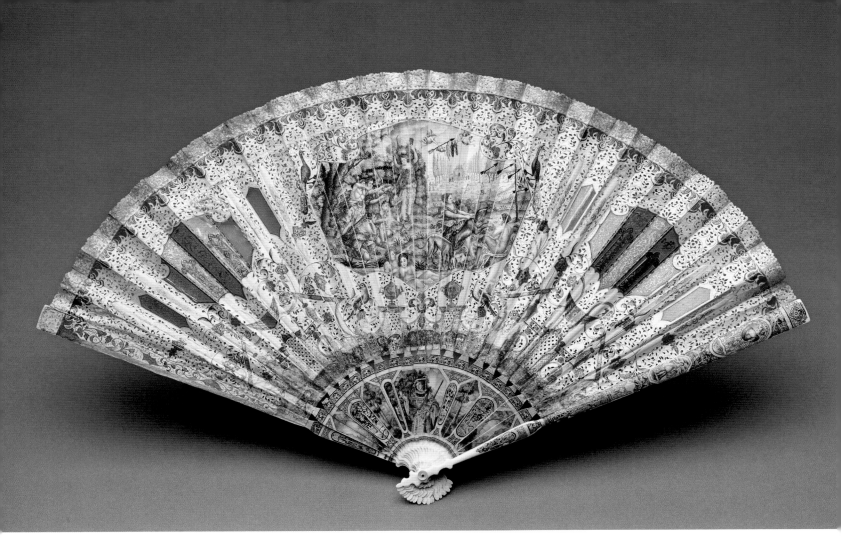

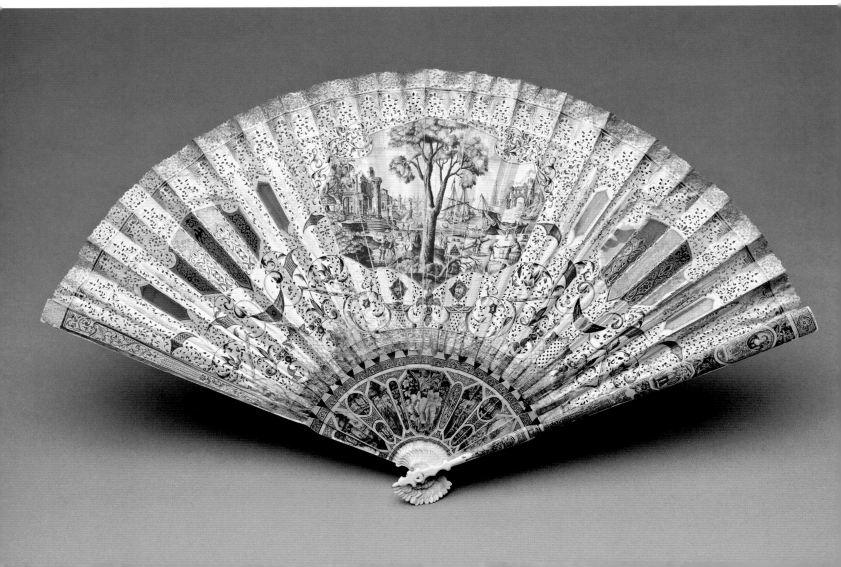

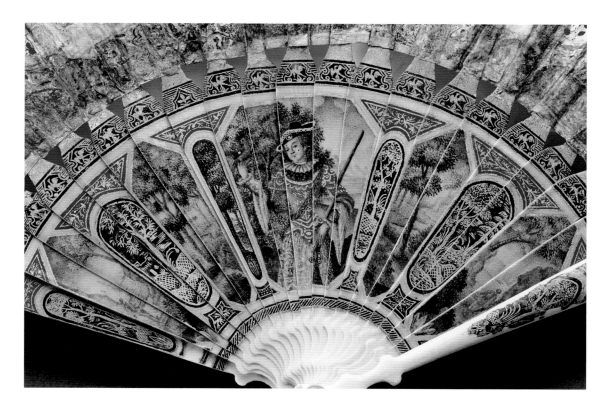

2. 'DIANA WITH NYMPHS AT PLAY'

ITALIAN, *c.*1700

This is the finest of a small group of similarly highly decorated fans with mica insertions. In addition to no. 2, there are comparable examples in Munich, Cambridge and elsewhere.[7] The recto of the Munich fan was probably painted by the same hand as no. 2, while another artist painted the versos of the three other fans. Although the decoration on these fans has traditionally been associated with the Preissler family, no similarities have yet been established between the painted decoration and that found in glass painted by the best-known member of that family, the Bratislava glass-painter Ignaz Preissler (1676–1741). The group of fans may in fact be Italian in origin.

The central scene on the recto is derived from the painting by Domenichino (1581–1641) of *Diana with Nymphs at Play*,[8] dated to the end of the second decade of the seventeenth century. The painting 'has a large progeny':[9] in the seventeenth century a number of painted copies were made, in addition to engravings by P. Scalberge, G.F. Venturini and others. Both the subject-matter and the arrangement of the figures made Domenichino's painting popular with fan-painters: it reappears on both painted and printed leaves produced in eighteenth-century London.[10]

The verso is painted with scenes showing ships being loaded with bales of wool. Cannon and cannon balls are shown in the foreground while in the reserves at either side are two groups of three cannon balls. Similar subjects are frequently found on Meissen porcelain of the early eighteenth century. The sticks are lacquered with a falconer, a hunting scene and woodland scenes. The delicate decoration on the mica panels is composed of cut-out leather (kidskin) covered with gold on the recto and silver on the verso. The main body of the leaf was punched or cut from the front, but the top border appears to have been punched and cut through two thicknesses of kidskin.

The fan was a birthday present to Queen Mary in 1914 and was later mounted onto the double-sided fan screen (see pp. 26–7). In her article on Queen Mary's fans, Eugénie Gibson described this 'as one of the most remarkable in the collection. Generally it is in wonderful preservation; eloquent testimony to the care which has been taken of it from the time of its creation.'[11]

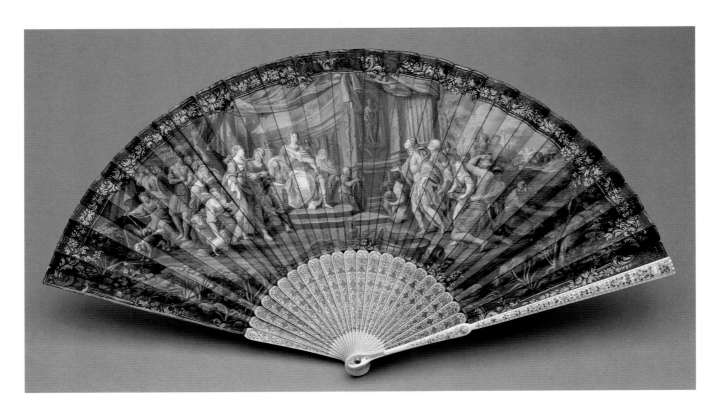

3. 'THE CONTINENCE OF SCIPIO'

ITALIAN, c.1700

The story of the Continence of Scipio was first told by Livy. After the capture of Carthage by the Roman forces led by Publius Cornelius Scipio in 209 BC, Scipio's soldiers brought him a beautiful female prisoner as a prize of war. When Scipio learnt that the prisoner was already betrothed to Prince Allucius, he summoned her parents and fiancé and insisted she be returned to the Prince. Furthermore, Scipio refused to accept the gift of gold offered to him by the parents and gave it instead to the young Prince. Scipio is here shown seated to left of centre, his gaze directed at the young Prince who approaches from the right, with other figures bearing precious gifts. The girl who had been offered to Scipio is shown at left with a group of Scipio's soldiers. The dogs accompanying the group may allude to fidelity. The subject was popular throughout the seventeenth and eighteenth centuries. The allusions to the moral stand and self-restraint that could be found in a brave and successful military leader meant that it was well suited for fan leaves: the holder of the fan might look for such qualities from her suitor.

The fan was purchased by Queen Mary in 1925 from the collection of Major H.C. Dent, a renowned authority on *piqué*. The Queen probably acquired the fan as much for the fine silver *piqué* guards and sticks as for the high quality of the painting on the leaf.[12] The name of the artist may be indicated by the initials N.F., inscribed below the column in the centre. The figure painting in the *Rape of Europa* fan leaf at Christ Church, Oxford, signed by Filippo Lauri (1623–94) and datable to the early 1690s, has elements in common with the present leaf.[13] A fan with an almost identical mount was recently on the London art market.[14]

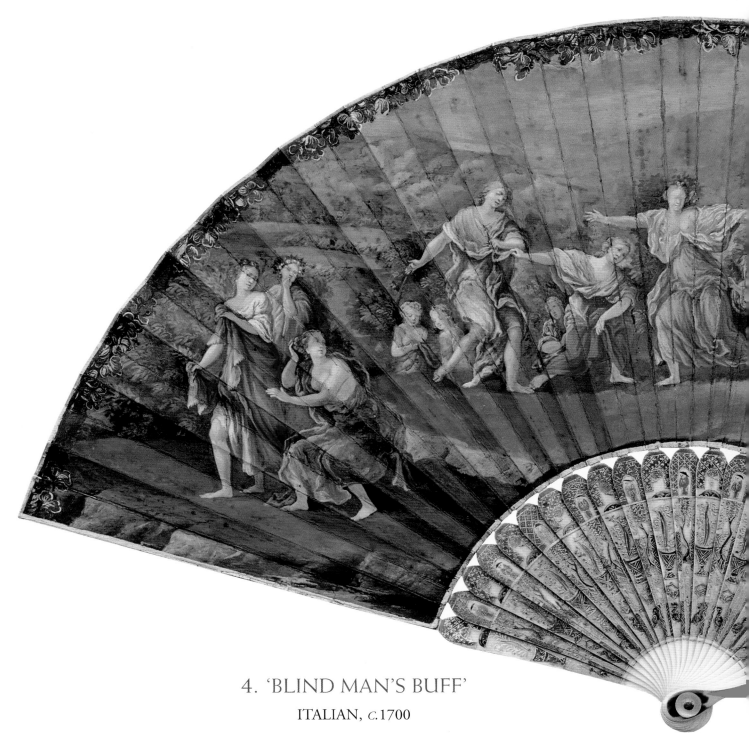

4. 'BLIND MAN'S BUFF'

ITALIAN, *c.*1700

The subject of the fan leaf is the game of Blind Man's Buff, enacted in Grecian costume. The game has been played by both children and adults from time immemorial. In written accounts it is naturally interpreted as a parable of the folly of love and marriage. In early eighteenth-century France the subject ('*Le Colin-maillard*') had a particular popularity for painters such as Watteau, Lancret and Pater.[15]

As the players in the scene shown on this fan leaf are in classical dress, it is likely that the specific subject is a scene from Giovanni Guarini's *Il Pastor Fido* (The Faithful Shepherd), first performed in 1596. The nymph Amaryllis has organised a competition to see which of her maidens is the best kisser. The shepherd Mirtillo (shown here approaching the blindfold Amaryllis from the left) insinuates himself into the party dressed as a woman, and wins the contest. A series of canvases painted with scenes from Guarini's play were painted by various artists for the hunting lodge of Frederick Hendrick of Orange and Amalia von Solms at Honselaarsdijk in the 1630s. The Blind Man's Buff scene, which has a completely different composition to this fan, was painted by Dirck van der Lisse and is now at the Jagdschloss Grunewald, Berlin.[16]

The style of painting on the fan leaf is similar to that in a series of unmounted leaves that have been extended at the corners to form rectangles and have later been framed.[17] The ivory sticks are painted with chinoiserie designs with Oriental figures at the tops of each alternate stick in the gorge. The verso has a plainly decorated leaf with gold-painted pagodas and birds in the gorge below.

According to Queen Mary, this fan was 'Used by Queen Charlotte at Worcester, 1788' during the royal family's visit in August of that year. At the time they were staying in Lord Fauconberg's house at Cheltenham, where it was hoped that the King would benefit from the spa waters. The royal party travelled to Worcester to attend the Music Meeting (subsequently known as the Three Choirs Festival), and to visit the Bishop, Richard Hurd, a close friend of the King. Fanny Burney, who was in attendance on the Queen (as second Keeper of the Robes) at the time, recorded that the arrival of the royal party in Worcester was greeted with 'a huzza that seemed to vibrate through the whole town'.[18] Although the Cheltenham waters appeared to have worked a cure, in November 1788 the King suffered a recurrence of the illness from which he recovered only early in the following year (see no. 30).

Lady Ward, who gave this fan to Queen Mary in 1927, was born Jean Templeton Reid, the only daughter of Whitelaw Reid, formerly American Ambassador to London.[19]

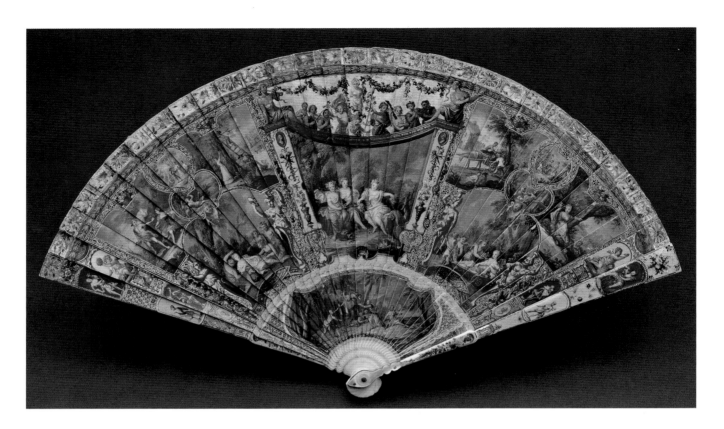

5. 'MARIE-ANTOINETTE'S FAN'

FRENCH, c.1720–30

This fan was acquired for Queen Victoria in Paris by her aunt, Queen Louise of the Belgians (1812–50). The purchase was made in late December 1839, between Queen Victoria's proposal of marriage to Prince Albert in October 1839 and the royal wedding in February 1840. Queen Louise (plate 5.1) was the elder daughter of Louis-Philippe, King of the French, and his wife Marie-Amélie. In 1832 she had married Queen Victoria's favourite uncle, Leopold I, King of the Belgians. From the time of their first meeting in 1835 the future Queen Victoria and Queen Louise became close friends. During the next few years their correspondence includes frequent mentions of Parisian style and fashion. Queen Louise sent elegant

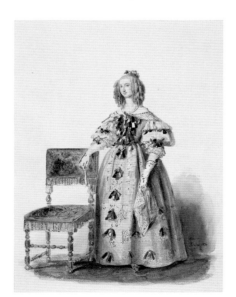

Parisian dresses, cravats, ribbons and bonnets to England, where they were received with raptures by her young niece.[20] Queen Louise's younger sister, Clémentine, was also involved in Queen Victoria's commissions.

The first mention of the purchase of this fan occurs in a letter from Queen Louise to Queen Victoria of 25 November 1839:

> I send you with this letter 3 fans which Clémentine choose [*sic*] for you and I enclose the <u>bill</u> which she was obliged to pay in the shop – as she would not [declare] her name and could not venture to give yours . . . I send herewith a <u>magnificent fan</u> which belonged formerly to Marie Antoinette. She says it is remarkably fine but it is dear it costs 500 f. about £20.[21]

Plate 5.1. Jean-Baptiste Madou, *Louise, Queen of the Belgians, dressed as Mademoiselle de Montpensier for the Belgian 'bal costumé'*, 1836 (RL 13187)

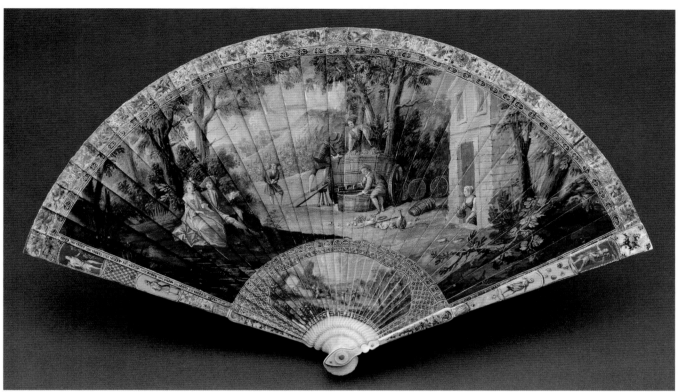

The fans were dispatched on 23 December, under cover of another letter from Queen Louise: 'the fans which you ordered are going with this letter. I hope you will like them. The small one which belonged to Marie Antoinette is I think very curious.' Queen Victoria recorded in her Journal for 26 December that after dinner at Windsor Castle she had showed her Prime Minister, Lord Melbourne, 'a very curious fan (not a very large one, but beautifully painted)' which had just arrived from Paris 'and which belonged to Marie Antoinette. Lord M. admired it very much, and said, it was "very pretty". He the other day admired several fans of mine.'[22] Four days later Queen Louise wrote to Queen Victoria: 'I am very glad to hear that you approved of my modest offering [a dress] and that you were pleased with the fans. That of Marie Antoinette is really curious and I am glad that you purchased it. It would have been a pity if it had fallen into bad hands.'[23]

This is a rare example of a painted and lacquered *brisé* fan from the early eighteenth century. Although such fans are normally described as *vernis Martin*, the lacquering technique used is much simpler than the layers of varnish required on japanned furniture. Parts of the fan[24] were probably largely over-painted in the 1820s, but in other areas the decoration is of the highest quality. It is unlikely that the reputed association with Queen Marie-Antoinette (1755–93) can be proved; the fan was certainly not made for her, as *brisé* fans had gone out of fashion by c.1730. In the 1860s and 1870s, when objects associated with Marie-Antoinette were particularly popular,[25] this fan enjoyed considerable fame. It was reproduced by the Arundel Society in 1871 and four years later was described by Blondel as 'Le richissime éventail Louis XIV', a 'chef-d'oeuvre'.[26]

Although Queen Victoria's invoice for the fan does not appear to have survived, the original leather-covered box – with the trade label of Vanier, Parfumeur – remains in the Royal Collection. Vanier had supplied the eighteenth-century fans to the Duchesse de Berry for use at her fancy-dress ball at the Tuileries in 1829,[27] and a group of so-called *vernis Martin* fans was lent by M. Chardin of Maison Vanier to the 1870 loan exhibition.[28]

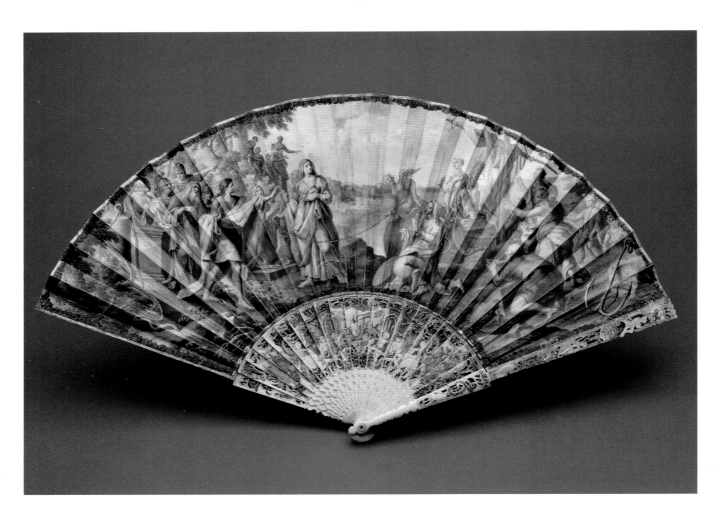

6. 'CLAUDIA PROVING HER INNOCENCE'
ITALIAN, *c*.1740

According to Roman legend, Claudia Quinta was a Vestal Virgin. She and her companions tended the sacred fire brought by Aeneas from Troy to Rome and kept in a sanctuary in the Forum. Claudia was wrongly accused of adultery but proved her innocence with the help of the goddess Cybele. In this fan she is shown standing to left of centre, holding one end of her girdle in her right hand. The other end of the girdle is tied around the gilded prow of a ship bearing the sacred stone image of Cybele, the 'Great Mother'. The ship had become grounded at the mouth of the Tiber on its journey from Pergamum to Rome, but Claudia had managed to pull it free. After this miraculous outcome the elders (shown here at left and right) were convinced of Claudia's chastity. To right of centre another Vestal Virgin, Tuccia, kneels while gazing at Claudia in wonderment. Tuccia had proved her own chastity by carrying water in a sieve, shown here propped up behind her knee.

This finely painted fan belonged to George IV's only child, Princess Charlotte, who died in childbirth at Claremont House, Surrey, in 1817. It was among the Princess's belongings which passed to her dresser, Mrs Louisa Louis (1771–1838), who continued to live at Claremont after the Princess's death and was close to a number of members of the royal family. On Queen Victoria's accession in 1837 Mrs Louis moved to Buckingham Palace, where she died, on Easter Sunday, in April of the following year. The Queen recorded the decline and ultimate death of Mrs Louis in her Journal, later noting that a 'Nobler more disinterested or more high minded person never breathed'.[29] Queen Victoria's Journal also records her receipt of a small number of mementoes of Princess Charlotte (including a chain and a pincushion) in the

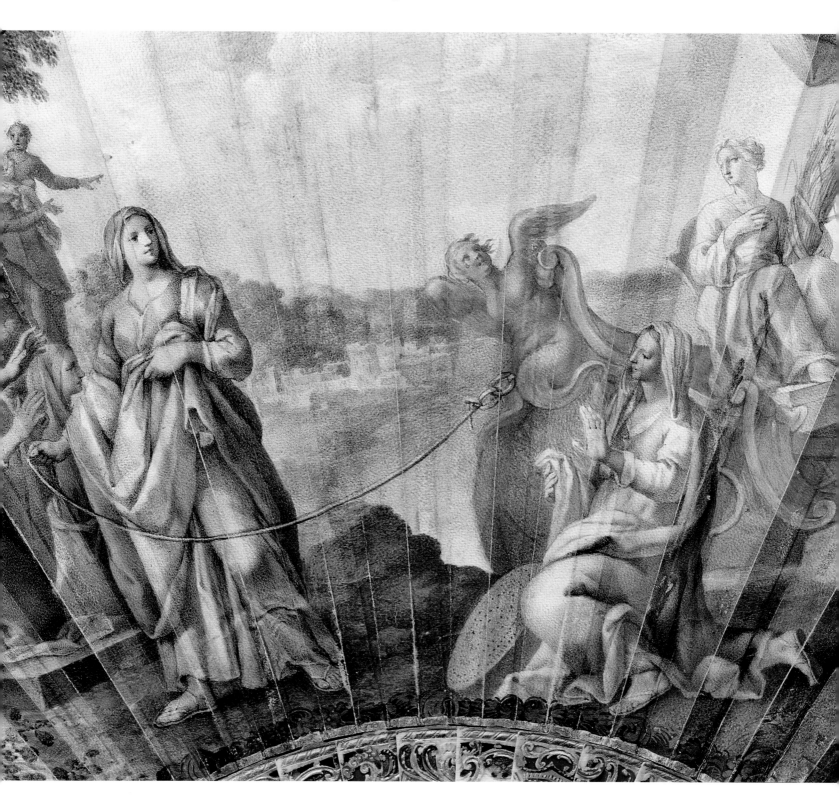

period immediately following Mrs Louis's death. In the 1870s the fan was lent by Queen Victoria to two exhibitions, with the information that it had been 'Given to the Queen by Mrs Louis'. Other items of clothing which had belonged to Princess Charlotte were bequeathed by Mrs Louis to Lady Gardiner (1784–1876), Woman of the Bedchamber to Queen Victoria, who discreetly sold them in order to benefit Mrs Louis's German relatives. The purchasers included Queen Victoria, the Duchess of Kent, the Duchess of Gloucester and the Queen of the Belgians, in addition to a small circle of other royal ladies.[30]

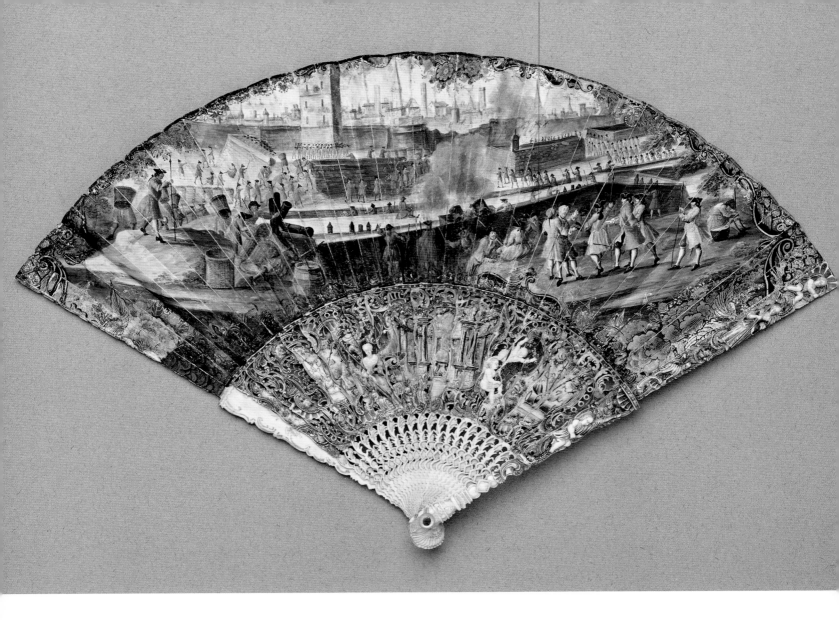

7. 'THE SIEGE OF BARCELONA, 1714'

ENGLISH, c.1740

The painting on the fan leaf shows Barcelona from the north, closely besieged; the bastion of Santa Ciara on the left has been breached and the Bourbon forces are now entering it. The siege took place in the final stages of the War of the Spanish Succession (1701–14). On the death of the childless Charles II of Spain, the chief claimants to the Spanish throne were the Bourbon Philip, Duke of Anjou (grandson of Louis XIV), and the Habsburg Archduke Charles (younger son of the Emperor Leopold); the former succeeded as Philip V of Spain in 1700. In 1705 an Anglo-Catalan force secured Barcelona for the Archduke Charles. The city was returned to Bourbon rule in 1714 after it was besieged, stormed and looted on behalf of Philip V. That siege is the subject of the present fan leaf.

The depiction of the siege is ultimately based on the engraving by Jacques Rigaud (1684–1745) issued in 1732. Rigaud's print (plate 7.1), which was part of a series of six, was copied in London by a number of print-makers, including Remi Parr in the mid-eighteenth century, again as part of a series of six. It is possible that one of these English copies rather than Rigaud's original was the model for this fan leaf. Parr's series remained popular throughout the remainder of the century, with the title *The Manner of Besieging a Town*. The plate relating to no. 7 was entitled *The Attack on the Bastion*.

The red-coated soldier on the verso of this fan, marching with his musket at the slope, was possibly copied from a design by Bernard Lens II (1682–1740), a drawing master who provided exemplars of military subjects. The European wars of the period c.1670–1740 inspired a large number of fans,

No.7 verso (detail)

Plate 7.1. Jacques Rigaud, *Attaque et logement du chemin couvert*, 1732; engraving (British Museum)

both painted (as here)[31] and printed (as advertised in the political journal entitled *The Craftsman* throughout the 1730s).[32] In 1745 the painter Joseph Goupy (1689–1769) submitted an invoice to Frederick, Prince of Wales (the elder son of George II), for materials and work related to fans, including 10 guineas 'For Painting the leather of the passage of the Rhine'.[33] Printed depictions of military operations mounted on a rigid fan or handscreen were also produced in the mid-seventeenth century.[34]

The fan is associated with a leather fan box (possibly the original one), with a note indicating that it had belonged to Queen Alexandra's mother, Queen Louise of Denmark. The leaf may have been cropped on the left-hand side; the sticks on the left side have a different width and seem to be in the wrong order. The crowned head formed by the ends of the sticks when the fan is closed is very similar to that found on a fan recently on the London art market.[35]

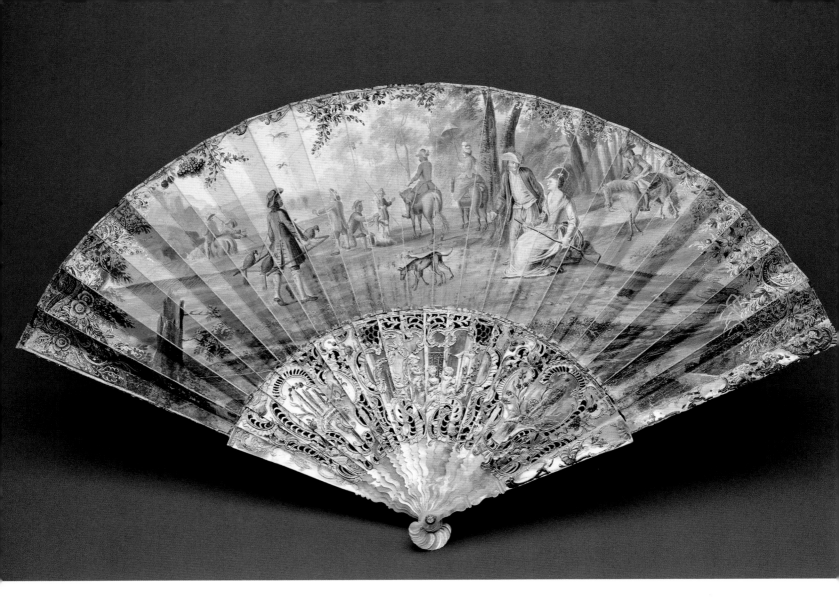

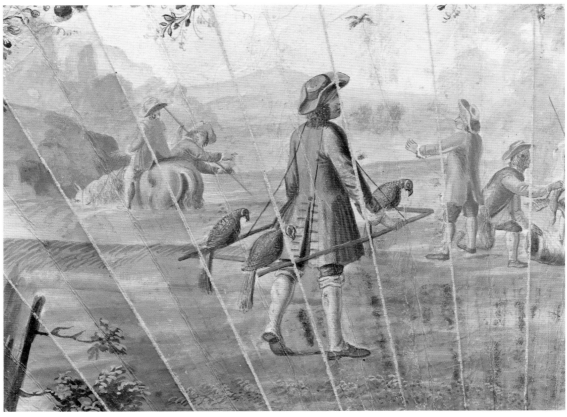

8. 'A HAWKING PARTY'

FLEMISH LEAF; FRENCH GUARDS AND STICKS, c.1740/50

The finely painted leaf shows different aspects of the sport of hawking, which was popular throughout Europe from the Middle Ages to the early nineteenth century. Professional hawkers would release trained hawks to pursue birds for the amusement of the followers of the sport. In this fan the figure seen from behind to left of centre is a cadger: suspended from his shoulders is the wooden frame or cadge on which the hawks are carried. The hawks are kept hooded (and therefore sightless) until they are required for sport. In the background a hawk is released to catch another flying bird. A kneeling figure presents the dead prey to a mounted horseman. In the right foreground a seated lady holds a long-barrelled gun and her male companion has two hunting dogs on a leash.

The subject of hawking is seldom encountered on fans. The dark tonality of the painting suggests that it may be the work of a Flemish artist working in Paris in the mid-eighteenth century. An early eighteenth-century red chalk design for a fan, attributed variously to Watteau or to Pierre-Antoine Quillard (1701/4–33), shows a similar scene.[36] However, the cadge in the drawing is circular rather than rectangular as shown here. The carved mother-of-pearl guards and sticks are typical French work of the mid-eighteenth century.

Queen Mary was given this fan by Mr Thomas Williams (1875–1944), who worked at the Victoria and Albert Museum from 1893 to 1924,[37] before transferring to the Royal Household as Superintendent (or Inspector) at Buckingham Palace. He occupied that post from October 1924 to December 1942, occasionally serving as a conduit for the transfer of items from Queen Mary to the Museum.[38] While Queen Mary was at Badminton during the Second World War, he kept her informed of developments at the Palace, particularly during the worst of the bombing in London.[39]

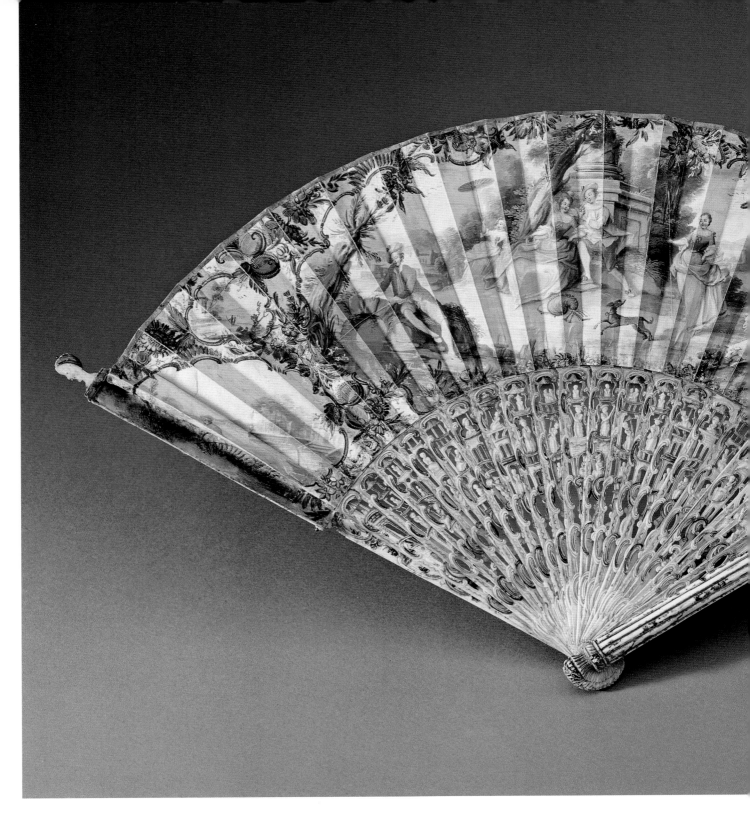

9. BATON FAN WITH BLACKAMOOR FINIALS
FRENCH LEAF; GERMAN GUARDS AND STICKS, *c.*1750

This fan and the one following are baton fans, so-called because their shape when they are closed resembles that of a field marshal's baton.[40] The leaf (which has been trimmed to left and right) is painted with a pastoral scene in which a gentleman presents a lady with a bunch of flowers; on the left a lady holds a parasol and a gentleman fishes. The upper part of the guards is carved with a lady and gentleman in bergère costume, with bagpipes and a sheep. When closed, the knop (lower end of the sticks) forms a basket of flowers. The blackamoor finials both have metal ear-rings, the backs of the finials are painted with fair-skinned faces. The sticks are intricately carved with Oriental figures.

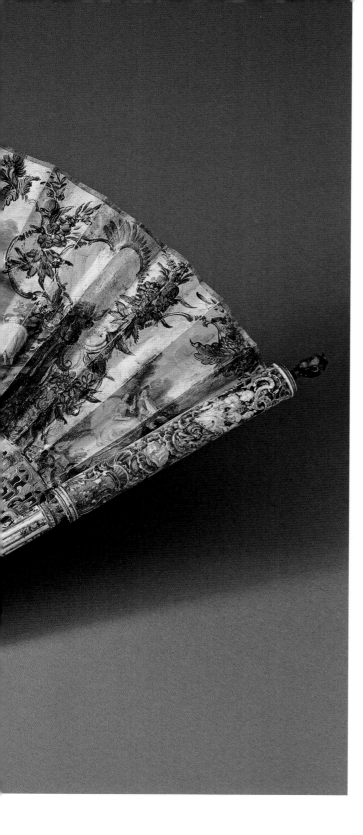

Following its inclusion in the Loan Exhibition of Fans in 1870 and in Blondel's publication five years later, this fan became widely known. The protective role played by the upper part of the guards provided the inspiration for Georges Duvelleroy's *Eventail Autoprotecteur*, the patent of which was registered on 25 September 1893.[41] Two wooden examples of Duvelleroy's fan are known.[42] Although the design principle is followed in Duvelleroy's patented models, the appearance of these fans is quite different.

This is one of four fans presented to Queen Victoria by Prince Albert at the time of their marriage, on 10 February 1840. On the day before the wedding, the Queen noted in her Journal: 'Albert and Ernest came in to see me, after my breakfast, dear Albert looking so well. He brought me 4 beautiful old fans.'[43] The precise identity of these four fans is clarified with reference to the list made by Queen Victoria at the end of her life, in which six fans presented to the Queen by the Prince from the collection at Gotha (including no. 9 and one other specifically stated to have been presented 'at the marriage') are noted.[44] The other eight ex-Gotha fans in that list are all stated to have been presented to the Queen by 'the late Duke of Saxe Coburg & Gotha' (Prince Albert's brother, Duke Ernest II).[45] Of the fourteen ex-Gotha fans which passed through Queen Victoria's collection, six remain in the present Royal Collection.

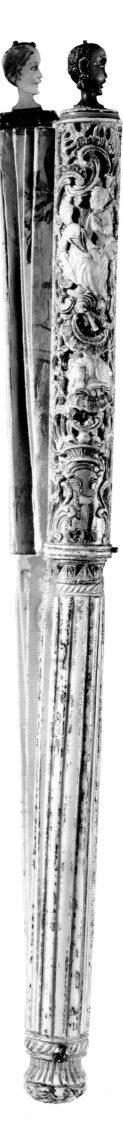

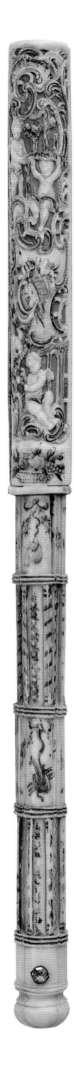

10. BATON FAN

FRENCH LEAF; GERMAN GUARDS AND STICKS, *c.*1750

Although this fan is rather smaller and slightly less ornate than no. 9, it is equally decorative. The two fans may have been produced by the same workshop, probably in Germany. They share the use of polychrome and carved and gilded pierced baton guards. Originally they would probably both have had the same number of sticks, and the same angle of opening. The decoration on both sides of the present fan demonstrates clearly that it has been reduced — presumably following damage to the sticks.

The leaves of both these fans include depictions of bagpipe players. The bagpipe — properly *musette de cour* — was increasingly popular in France from the late seventeenth century. It was above all the instrument of

> lovers of *fêtes champêtres* and other pastoral amusements, because it recalls the idyllic times when shepherds courted their sweethearts by joining their voices to the soft, flattering tones of the bagpipe. The musette was made for the solitude of the forests and to express the sighs of a lover . . . [46]

According to a note on the fan box (plate 10.1), this fan was given by the Duke of Coburg to the Princess of Leiningen. The latter was Queen Victoria's mother, born Princess Victoria of Saxe-Coburg-Saalfeld, who in 1803 married the Prince of Leiningen. After his death (in 1814) she married (in 1818) Edward, Duke of Kent. The donor of the fan could have been either her father (Duke Franz Friedrich Anton), who died in 1806, or her elder brother, Duke Ernest I (1784–1844). The dukedom of Coburg and Gotha was created after the death of Duke Augustus of Saxe-Gotha in 1822; his only child, Louise, was Ernest I's first wife and the mother of Princes Ernest and Albert of Saxe-Coburg-Gotha. As the Saxe-Coburg merger followed the Princess of Leiningen's remarriage, this fan provides evidence of a fan collection at Coburg (as well as at Gotha: see no. 9) by the early years of the nineteenth century. This was the only one of Queen Victoria's fans to be bequeathed specifically to Queen Alexandra rather than to King Edward VII.[47]

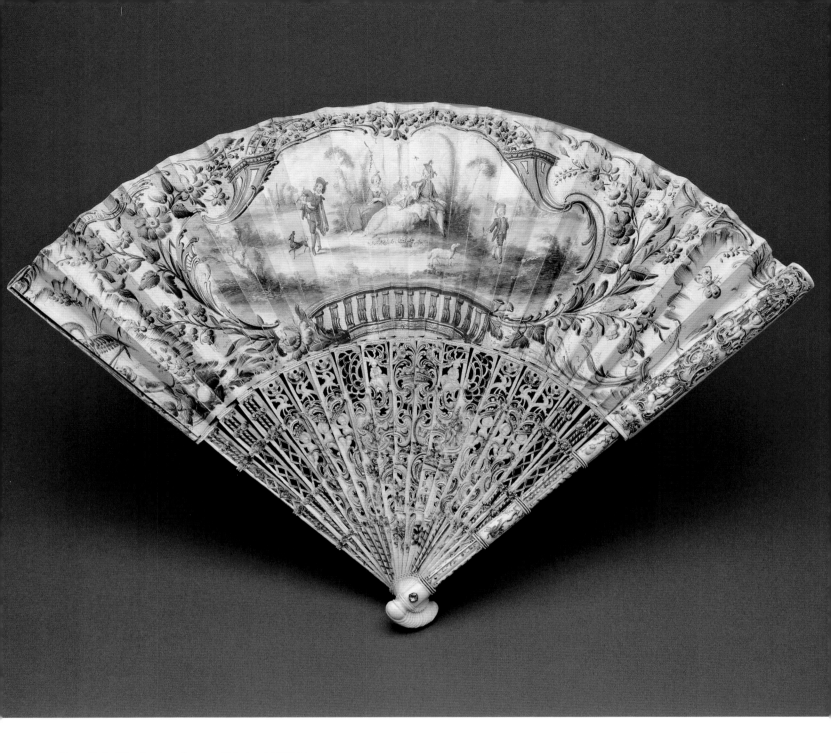

Plate 10.1. The fan box for no. 10 (RCIN 25093.b)

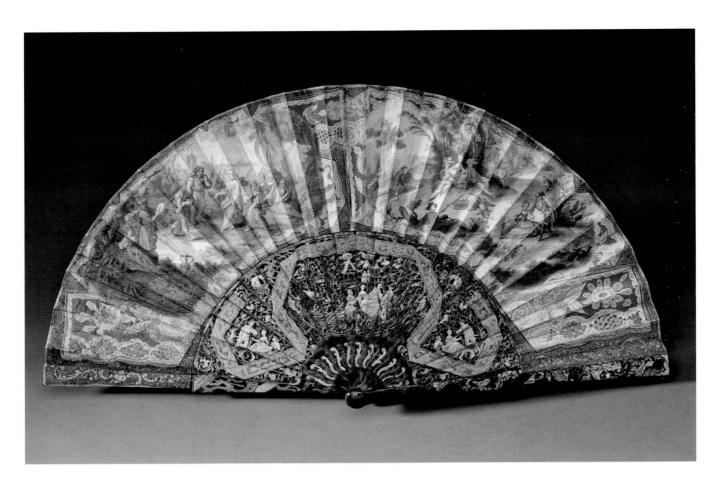

11. *TROMPE-L'OEIL* LACE FAN

FRENCH, *c.*1750

This is an early example of a fan with a *trompe-l'oeil* painted leaf. The two scenes or vignettes are shown as if torn from two sheets of paper and laid onto pieces of lace arranged in the shape of the fan. A narrow strip of lace is painted onto the lower part (the gorge) of the tortoiseshell sticks to provide unity to the design. In the later eighteenth and early nineteenth centuries such fans would show vignettes arranged in a less formal manner, with a random assortment of playing cards, letters, prints and other objects.

The subjects of the two scenes are unclear, but may relate to the story of Dido and Aeneas: according to Virgil's *Aeneid*, Dido, Queen of Carthage, fell in love with Aeneas, who was driven by a storm to her shores; she committed suicide through grief at his departure. On the left the figures are partly in classical and partly in eighteenth-century dress; the dress on the right is of the eighteenth century. A traveller with an elderly companion (possibly Anchises) on the left is welcomed on the shore by a group of elegant ladies; on the right a group of figures rests in a woodland setting, possibly during a hunt.

This is the first entirely French fan with a painted leaf in the present publication. French guild regulations insisted that fans had double leaves, rather than a single leaf being mounted onto the sticks *à l'anglaise* (compare nos. 7 and 8). The plates issued to accompany Diderot's *Encyclopédie* demonstrate how, after the leaves had been painted and decorated, they were partly stuck together before being pleated; the sticks were then inserted between the leaves and were glued in place (fig. 6).[48]

Queen Mary was presented with this fan in 1939 by the Hon. Claude Yorke (1872–1940), the third son of the 7th Earl of Hardwicke.[49] According to inscriptions on the box, the fan had belonged to Queen Charlotte. This association would have ensured that it was a particularly welcome gift.

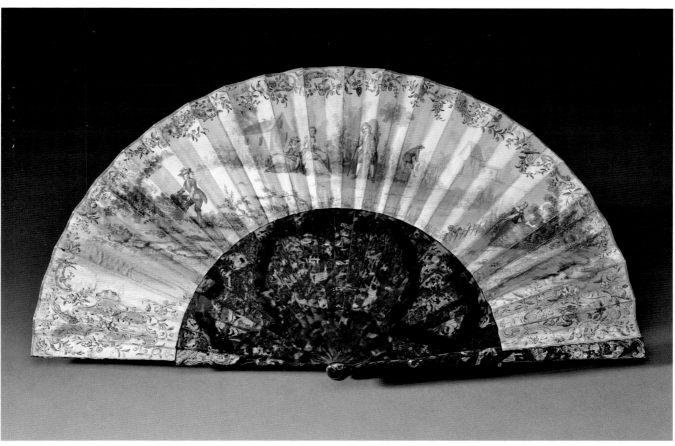

No. 11 verso

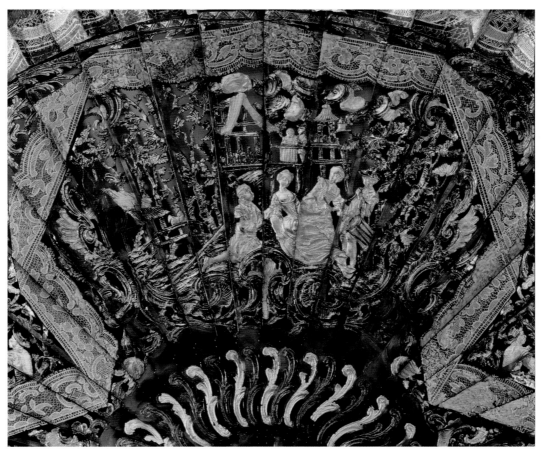

Detail of the gorge of no. 11 recto

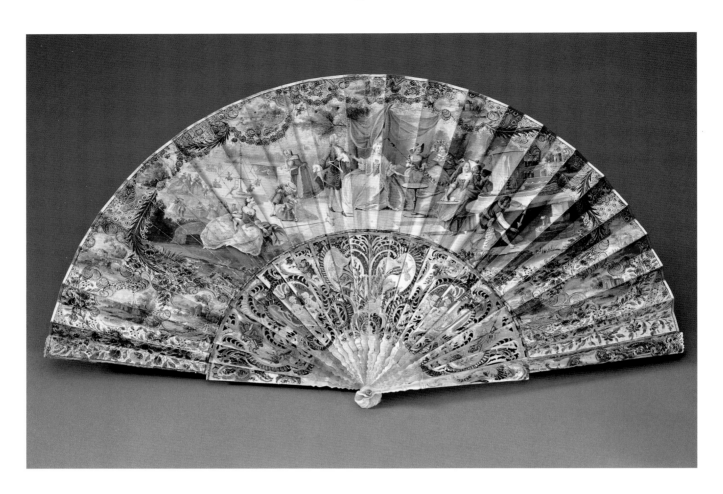

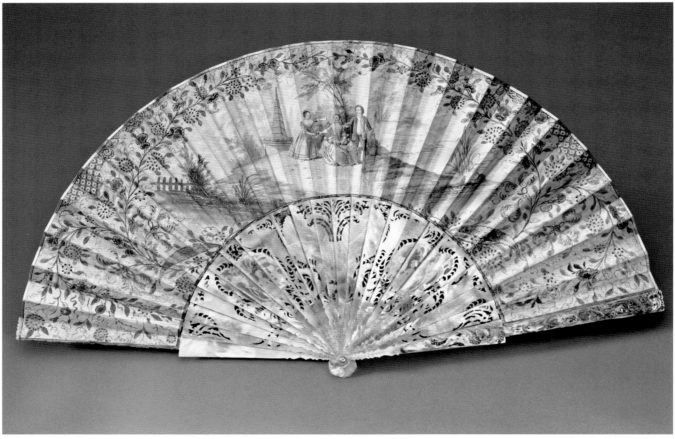

No. 12 verso

12. MARRIAGE FAN WITH A WEDDING FEAST

FRENCH, c.1750

This was one of eighteen fans presented to HM The Queen (then Princess Elizabeth) at the time of her marriage in 1947 (see also no. 18). Appropriately, as with no. 18, it is a marriage fan. In common with a number of similar fans, the painting of the main scene is reminiscent of the work of the French court painter François Boucher (1703–70).

Wedding feasts were popular subjects for painters and decorators in mid-eighteenth-century France. In this case, the left background included scenes of more general merry-making, as found in depictions of *foires de villages* (village fairs).[50] Different aspects of the fair shown here include a merry-go-round with four seats (occupied by children) suspended from a central pole, and a lake with a small boat.

The fan was a gift from the Worshipful Company of Fan Makers and was sent under cover of a letter from the Master (Mr Norman Latchford), expressing the Company's good wishes and hopes that Princess Elizabeth would accept the fan as 'an example of the Art or Mistery of Ffanmaking[*sic*]'.[51]

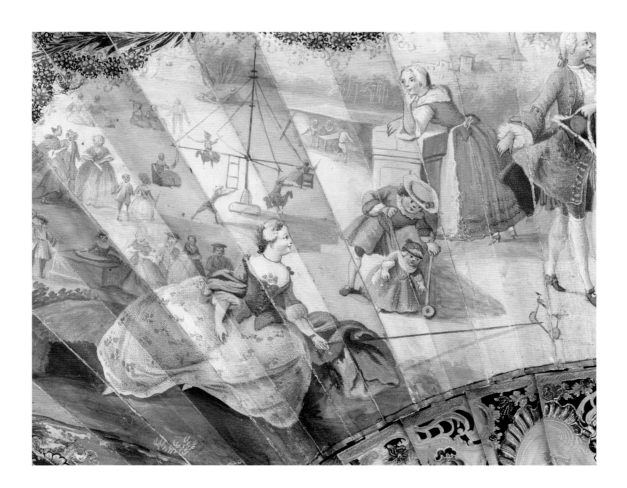

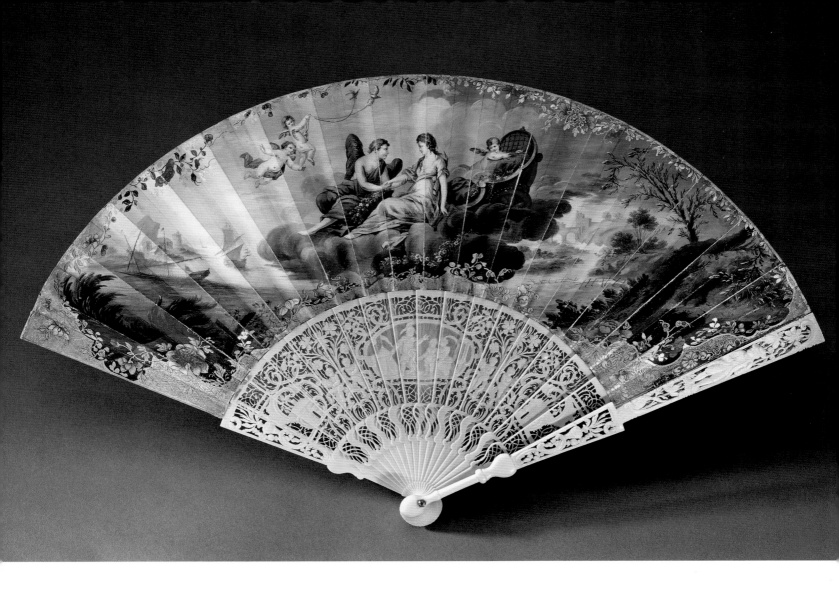

13. 'CUPID AND PSYCHE'

ENGLISH, c.1750

The fan leaf shows winged Cupid at left, holding the hand of Psyche, who emerges from her chariot supported on clouds. The subject is an episode from the story of Cupid and Psyche, a late Antique fairy tale recounted in Apuleius's *Golden Ass*: Psyche was a beautiful maiden who aroused the jealousy of Venus, the goddess of love. Cupid, the god of love, was sent by Venus to arrange for Psyche to fall in love with some worthless being, but instead fell in love with her himself. After a number of adventures, Jupiter took pity on Psyche and she was carried up to heaven, there to be reunited with Cupid.

With such a subject, the fan was well suited to serve as a marriage gift. It was one of over forty fans presented to the future Queen Mary at the time of her wedding in 1893. The donor was Charles Brinsley Marlay (1831–1912), who is chiefly known today as one of the greatest benefactors of the Fitzwilliam Museum, Cambridge. His bequest to the Museum consisted of a large capital sum in addition to a fine collection of paintings, drawings, books, manuscripts, and decorative arts, which included fourteen fans.[52] Marlay's London home was St Katharine's Lodge in Regent's Park, London, the lease of which he took on following his mother's death in 1882. His gift of this fan to the future Queen Mary in 1893 may have been partly inspired by his gratitude to the Queen regnant for allowing him to remain in occupation.[53]

This fan is typically English, in the fine floral border and reserves, and in the working of the ivory in both the guards and the sticks. The guards are carved with an elegantly dressed man holding a crook, a goose at his feet. The silhouetted figures on the gorge depict, in the centre, Hector taking leave of his wife Andromache and his son Astyanax.

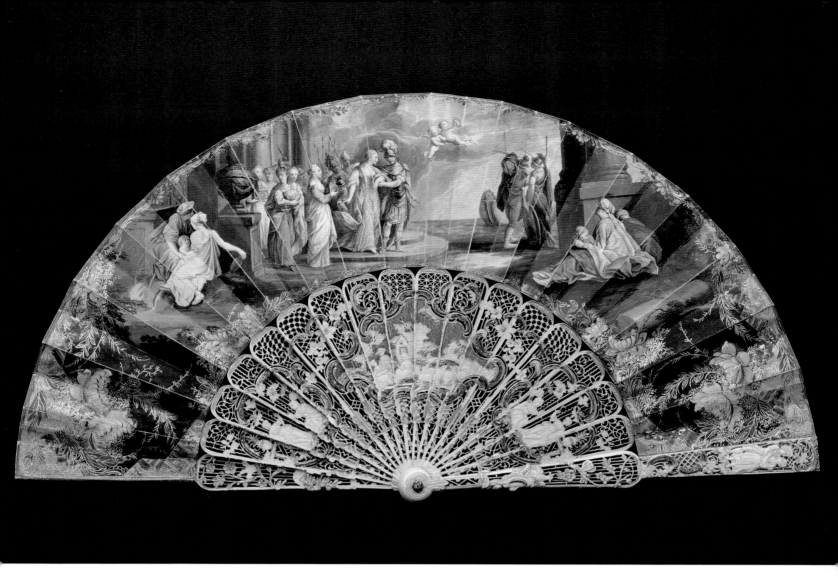

14. 'THE ABDUCTION OF HELEN'
ENGLISH, c.1750

This fan leaf was probably painted by an Italian artist working in London. It is designed to open *à grand vol*, that is, to 180°, a fashion which was at its height in the 1750s. In the reserves at either side of the finely painted main scene are lengths of blue silk ribbon, depicted in *trompe-l'oeil*, with large and elaborately painted flowers.[54] The sticks are elaborately carved and profusely gilt; the spectacular overall effect is heightened by the use of crushed mother-of-pearl. The guards and the edges of the sticks are carved to produce a unified decorative scheme of putti, birds, flowering trees, a butterfly and a dolphin when the fan is shut; the upper parts of the guards are decorated with delicately carved pairs of figures.

The scene painted on the leaf is the Abduction of Helen. According to Homer, the seduction by Paris of the beautiful Helen, wife of the King of Sparta, was the cause of the Trojan Wars. A very similar fan, also originating in mid-eighteenth-century England, has a leaf painted with the Continence of Scipio (compare no. 3) on the recto and Chinese domestic scenes on the verso, as here.[55]

Although this fan certainly belonged to Queen Victoria, it is not known when she acquired it. It was one of two fans bequeathed by the Queen to her third son, Prince Arthur, Duke of Connaught. Princess Louise, Duchess of Connaught, also inherited two of the Queen's fans, and their daughters Margaret and Patricia received one each. Christie's house sales at Clarence House and Bagshot Park in 1942, following the Duke's death, included around eighty fans. This was the only lot at the Bagshot sale to be acquired direct by Queen Mary, although another fan in the collection is also noted as having come from that sale.[56]

Overleaf: detail of the gorge of no. 14 and the closed fan

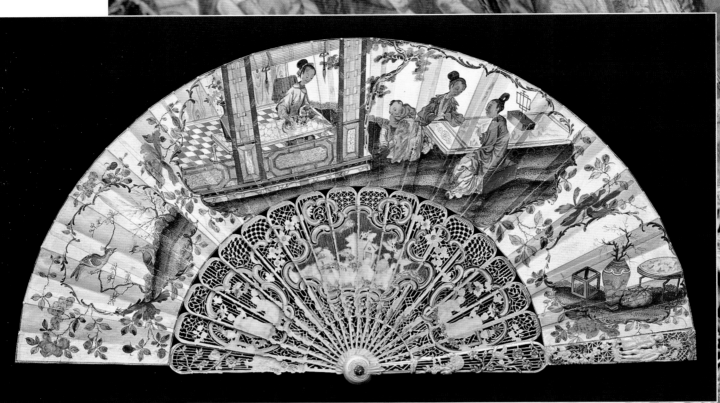

No. 14 verso

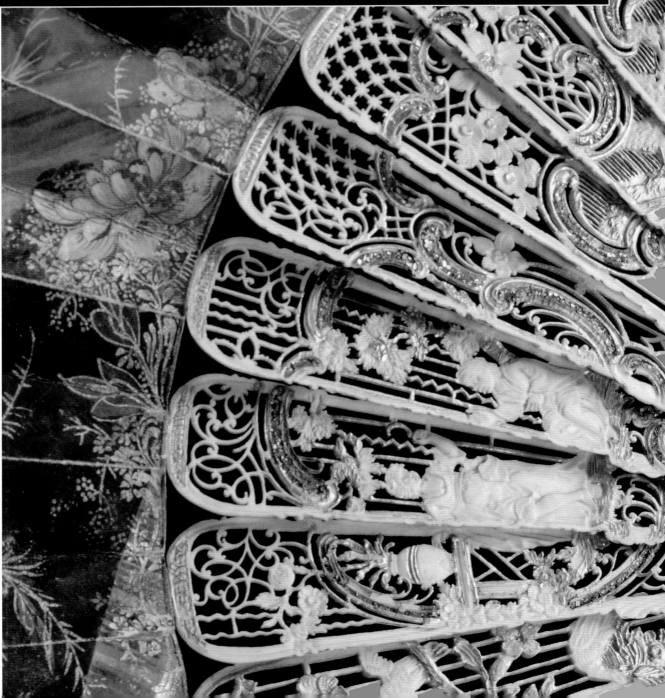

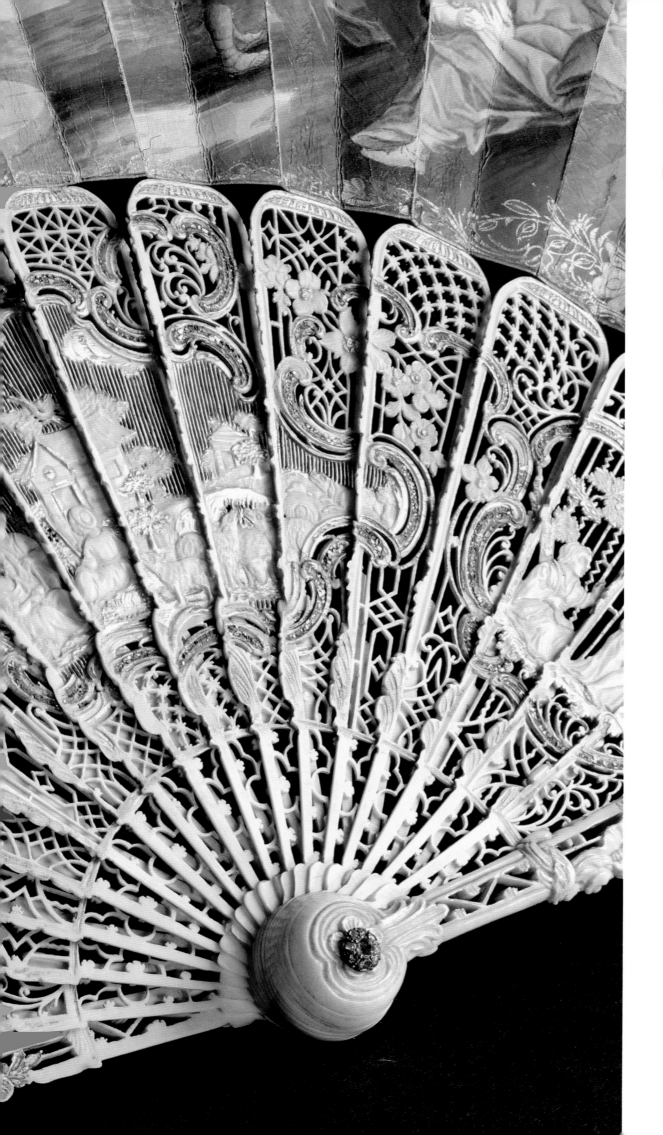
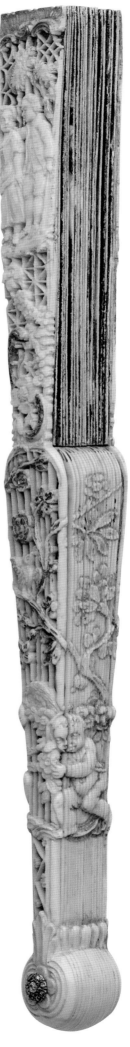

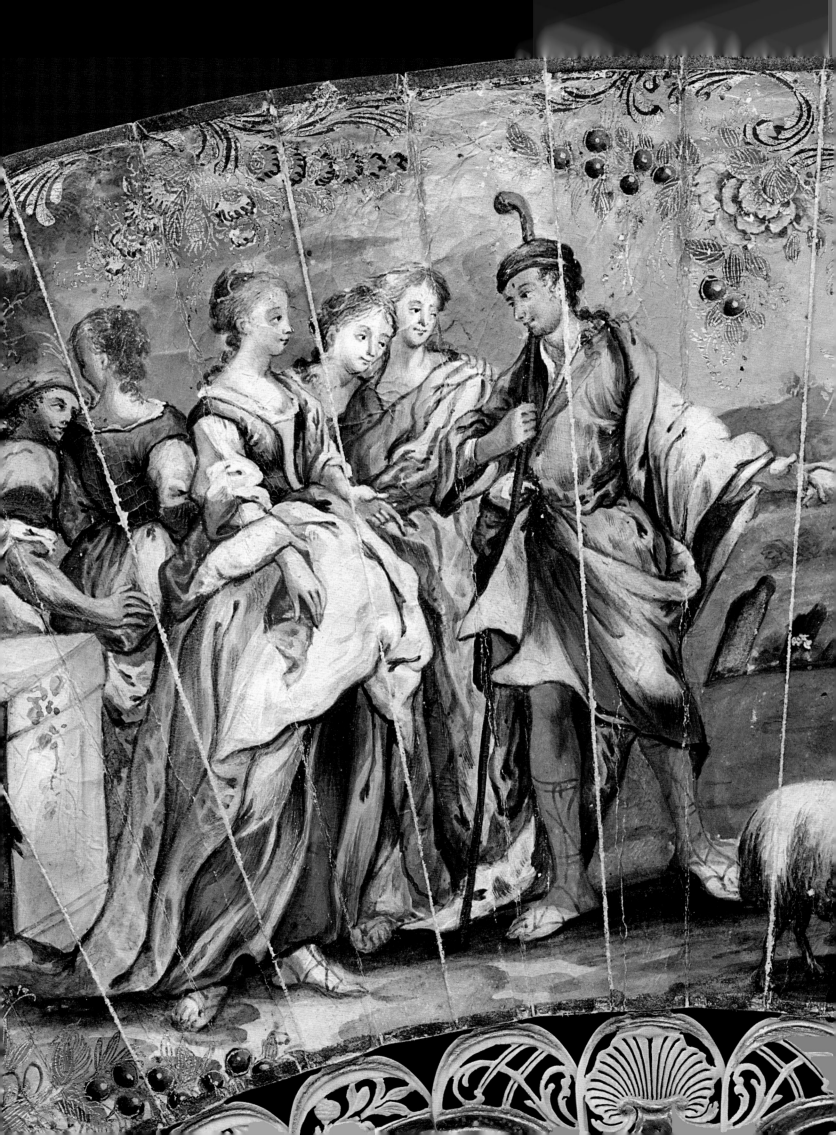

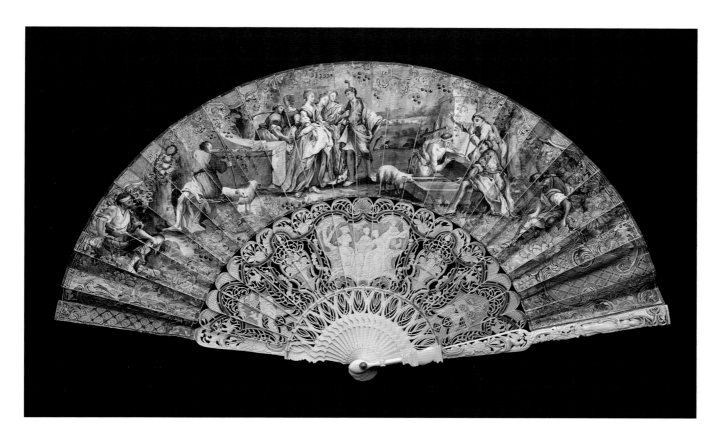

15. 'JACOB MEETING RACHEL AT THE WELL'
?ITALIAN LEAF; ENGLISH GUARDS AND STICKS, *c.*1750

The biblical account of the meeting of Rachel and Jacob at the well is told in Genesis 29: 9–12. Jacob was the son of Isaac and Rebecca. After stealing the blessing destined for his brother Esau, Jacob took refuge with his mother's brother, Laban. He encountered Laban's second daughter, Rachel, while she was watering her father's sheep at a well. Jacob (shown in the centre, with a plumed cap) was instantly struck by Rachel's beauty and assisted her by moving the stone from the mouth of the well (shown at right on this fan leaf). After working for Laban for seven years in order to win the hand of Rachel in marriage, Jacob was duped into marrying her elder sister, Leah. When he protested, Laban gave him Rachel as his second wife, but required Jacob to work for a further seven years.

The finely painted main scene is probably the work of an Italian artist, working either in Italy or in England. The floral decoration on the reserves and upper and lower edges appears to have been added by an English artist. The painting on the verso is also occasionally of unusually high quality. In addition, the carving of the ivory guards and sticks (illustrated overleaf) is very fine, something which would have appealed to Queen Mary, who received the fan as a wedding present in 1893.

No. 15 verso (detail)

Overleaf: detail of the gorge of no. 15 recto

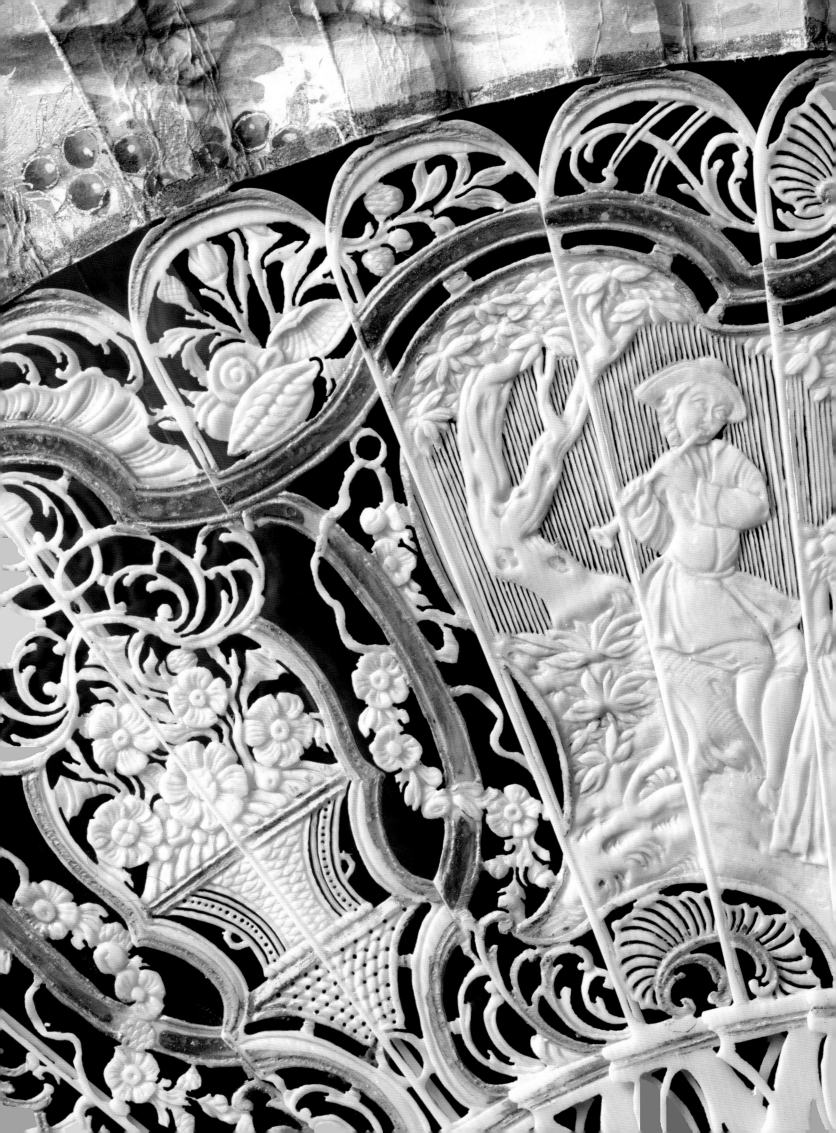

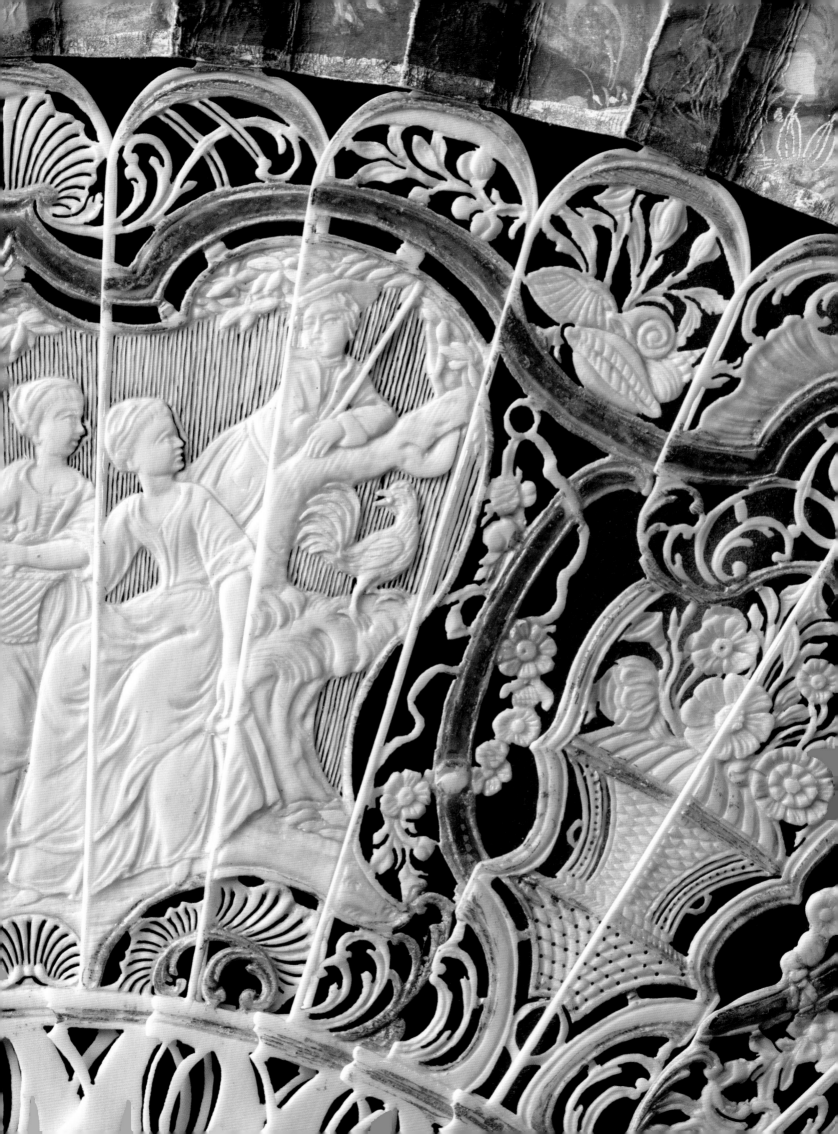

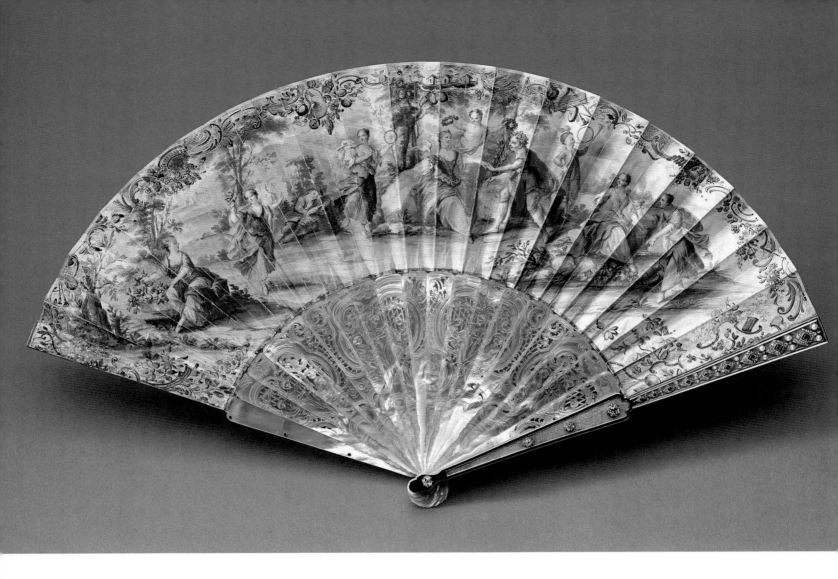

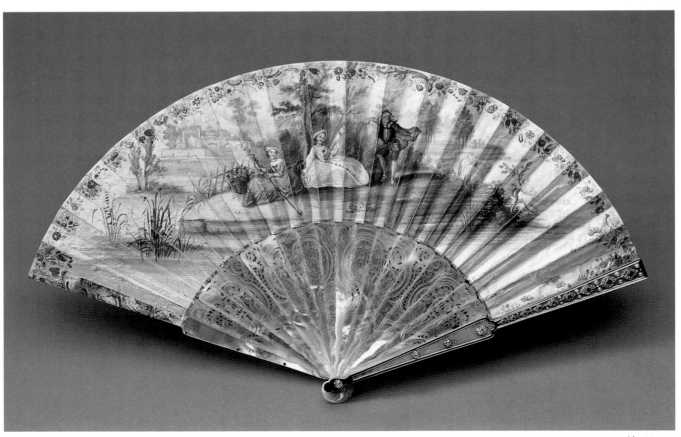

No. 16 verso

16. 'BACCHUS AND ARIADNE'

FRENCH LEAF, c.1750;

ENGLISH GUARDS, MID-NINETEENTH CENTURY

Although the figures on the leaf were traditionally identified as the Christian warrior Rinaldo and the sorceress Armida (from Torquinato Tasso's *Gerusalemme Liberata*), they are more likely to represent the mythological lovers Bacchus and Ariadne. According to Greek legend, Ariadne, the daughter of Minos, King of Crete, had helped Theseus (with whom she had fallen in love) to escape from the labyrinth, the maze where Minos kept the bull-headed monster the Minotaur. On his return journey to Athens, Theseus abandoned Ariadne on the island of Naxos. Bacchus (Dionysius), the god of wine, soon found her there and proposed marriage. Bacchus's discovery of Ariadne is shown (in classical dress) on no. 22. His marriage proposal is depicted in a combination of eighteenth-century and classical dress on the present fan. The romantic subject-matter suggests that this may have been made as a marriage fan. The leaf appears to have been cut down on the left-hand side.

The fan was formerly in the collection of Queen Mary's maternal grandmother, the Duchess of Cambridge, who died in 1889. Some time in the mid-nineteenth century the present guards were added by the jeweller Hancock of Bruton Street, London.[57] In 1910, the year of the accession of her husband as King George V, Queen Mary gave permission for the fan to be reproduced in colour on satin-finished cotton. The resulting printed fan leaves were included as a supplement to the Christmas number of *The Gentlewoman* (see plate 16.1), and mounted fans (using the same printed leaves) were given to the diners at the Savoy Hotel, London, who attended the ball on New Year's Eve 1910/11, which was also the twenty-first anniversary of the opening of the hotel. According to the archives of the Savoy Hotel, 1,500 fans were made but only 1,000 were distributed to the public.[58] The brocaded-silk fan boxes were labelled: *The fan presented is a facsimile of the famous 'Rinaldo' fan on which is depicted a scene in the story of Rinaldo in the garden of Armida. The original is in the collection of Her Majesty The Queen, who has very graciously granted special permission for its reproduction. With compliments of the Savoy, New Year's Eve, 1910–1911.*[59]

Plate 16.1. Colour reproduction of no. 16, printed on satin-finished cotton, distributed with the 1910 Christmas issue of *The Gentlewoman* (RCIN 25342)

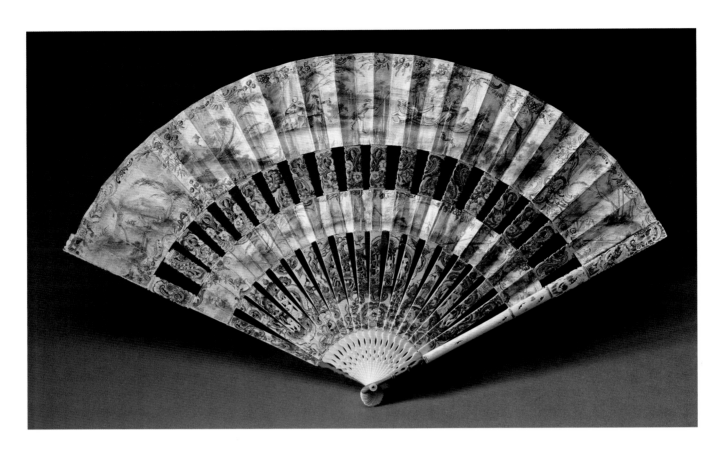

17. CABRIOLET FAN

FRENCH, *c.*1755

In the mid-1750s a new type of light horse-drawn carriage – a cabriolet – came into use in France and, in simplified form, in England. In June 1755 Horace Walpole informed his friend Horace Mann:

> All we hear from France is, that a new madness reigns there . . . This is *la fureur des cabriolets;*
> *anglice,* one-horse-chairs, a mode introduced by Mr Child: they not only universally go in
> them, but wear them; that is everything is to be, *en cabriolet;* the men paint them on their
> waistcoats, and have them embroidered for clocks to their stockings; and the women who
> have gone all the winter without anything on their heads, are now muffled up in great caps,
> with round sides, in the form of, and scarce less than the wheels of chaises.[60]

Cabriolet fans, which are generally of French production, were part of the *fureur* described by Walpole. They consist of two (or occasionally three) concentric fan leaves mounted onto the same sticks. The mount 'usually consists of Parisian scenes – persons driving in cabriolets, or promenading'.[61] In this fan cabriolets are shown on the main fan leaf, on the gorge and on the guard sticks. Most surviving cabriolet fans have similarly muted (or faded) colours to those here.[62] The Schreiber collection includes two mounted cabriolet fans with printed leaves.[63] Such fans are datable to the period *c.*1755–65.

In her later years Queen Mary hung this fan – which was housed in a gilt display case – in her boudoir at Marlborough House.[64] The fan was formerly in the collection of Ida, wife of the 4th Earl of Bradford (who died in 1915). Lady Bradford was one of Queen Mary's closest friends, serving her as Extra Lady of the Bedchamber until her resignation in 1928. In the same year she gave Queen Mary a sequinned silk fan, until recently on loan to the Victoria and Albert Museum.[65]

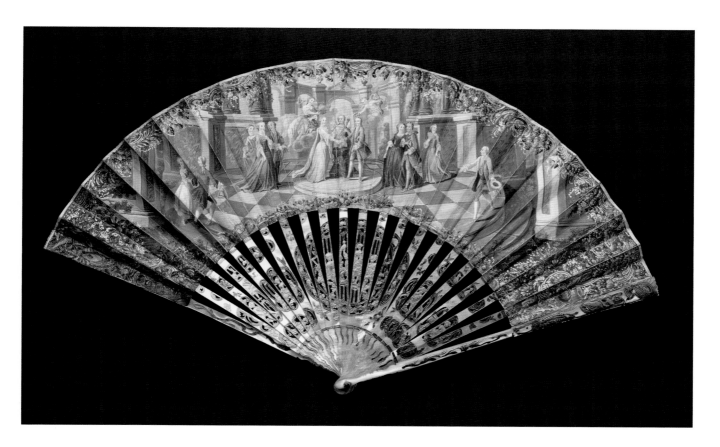

18. MARRIAGE FAN

FRENCH, C.1760

Marriage fans such as this would traditionally have been carried by a bride and occasionally also by her attendants on the wedding day (see no. 12). The fan was a gift to HM The Queen at the time of her marriage in 1947, when it was said to have been 'made for the wedding of Louis XV and Marie Leczinska'. This is clearly incorrect because the fan post-dates the wedding (1725) by around thirty-five years; in addition, the level of finery worn by the bridal couple and the guests suggests that the fan was made for a bourgeois or minor aristocratic – rather than a royal – wedding.

The painted fan leaf shows the wedding guests wearing red favours (ribbons); the ladies, including the bride, all carry fans. However, as well as these contemporary features, there are a number of allegorical references including the putto hovering over the bridal pair, and Cupid holding a flaming torch, both of which are symbolic of love. The guards are carved with rabbits, symbols of fecundity. Later in the eighteenth century (see no. 27) marriage fans would often show the couple making a sacrifice at the altar of Hymen, adorned with hearts and surmounted by a flame. A small number of such fans have portraits – presumably depicting the couple – painted on the reserves, or small miniatures set into the guard sticks.

In the printed list of wedding presents, the donor's name is given as 'Mr J. Duvelleroy'.[66] However, it is more likely that the fan was presented by the London branch of the Parisian firm of fan-makers of this name (see pp. 17–18).

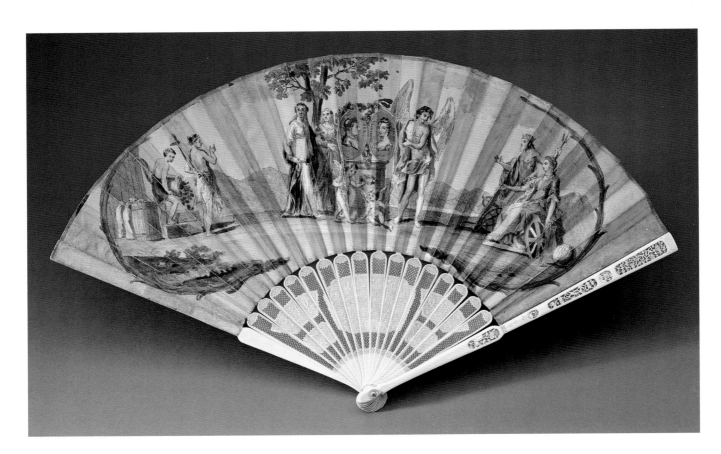

19. 'THE MARRIAGE OF KING GEORGE III AND PRINCESS CHARLOTTE OF MECKLENBURG-STRELITZ, 1761'

ENGLISH, 1761; ORIENTAL GUARDS AND STICKS

The marriage of George III and Queen Charlotte took place at St James's Palace, London, on 8 September 1761, a short time after the bride's arrival in this country. Their coronation in Westminster Abbey followed two weeks later. The royal union is here supported by allegorical figures probably representing Fame and the Arts in the centre, with personifications of Commerce and Liberty (at left) and Britannia and Neptune (at right).

From the 1720s the increased sophistication of the print-publishing industry, combined with the widespread use of fans throughout Europe, meant that numerous printed fan leaves were produced, particularly in London. Fans of a royal or commemorative nature were particularly popular, and would have been available with hand-painted coloured additions (as here) at an extra cost. Three other examples of fans with this printed leaf are known: one in the Schreiber collection,[67] and two in private collections.[68]

The carved ivory guards and sticks were imported from China. Miscellaneous decorative items from the East were quite widely available in Europe by this date.

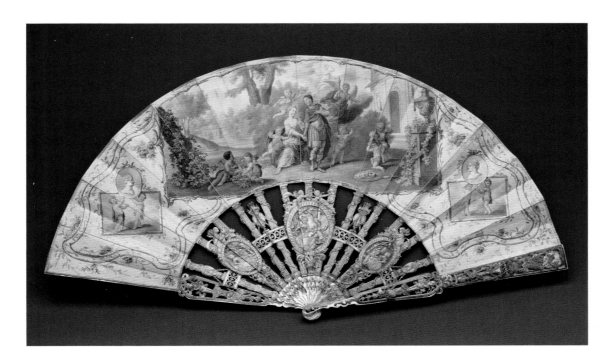

20. DUTCH MARRIAGE FAN

DUTCH LEAF; FRENCH OR DUTCH GUARDS AND STICKS, *c.*1770

The centre of the leaf is occupied by figures probably intended to represent Venus and Mars, with the amorini who have disarmed Mars. According to ancient mythology, Venus, goddess of love, fell in love with the brutal and aggressive Mars, god of war. The story was symbolic of the union of beauty and valour, a suitable subject for use on marriage fans. To left and right are profile heads; although one might assume that they are likenesses of the bride and groom, the laurel crown worn on the mature head on the left might suggest otherwise. The guards and sticks are decorated with further romantic motifs (including amorini and flaming hearts) and a pair of doves is depicted on the verso.

The golden colouring and design of the leaf are typical features of fan leaves produced in Holland.[69] The sticks are particularly fine examples of the *battoire* form – incorporating oval panels similar in shape to a racquet (*battoir* in French) – popular in France at this time. Luxury goods produced in France were frequently imported into the Netherlands. A Dutch guidebook for merchants visiting Paris in 1751 (the *Journal du Citoyen*) quotes wholesale prices for fans: these must apply to unmounted sticks, as leaves are never mentioned. Alternatively, the sticks may have been produced in Holland, for the Amsterdam fan industry was dominated by Huguenots.

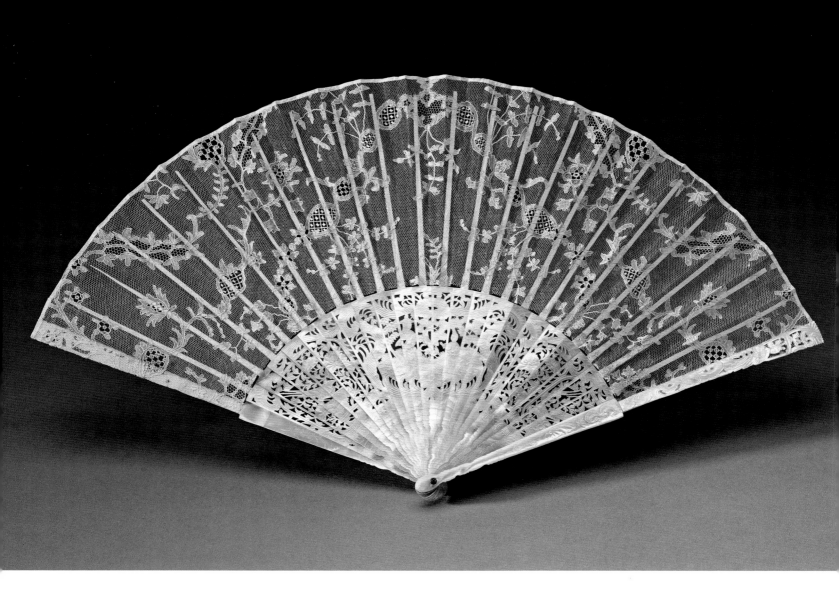

21. BRUSSELS LACE FAN

BELGIAN LACE, *c.*1770–80; ENGLISH GUARDS AND STICKS, *c.*1780

According to a note on the fan box, Queen Charlotte 'had always used [this fan] at the Christenings of her children'. Although there would appear to be no means of substantiating this statement, the fact that the fan was once in the possession of her sixth son, Prince Augustus, Duke of Sussex, may support the claim. The fan appears to have been made a few years after the Prince's own christening in 1773. Therefore it could not have been used at the christenings of the Queen's older children, but could have been available for the christenings of Prince Octavius (born 1779) and Princess Amelia (born 1783). The fan is not identifiable in any of Queen Charlotte's 1819 sale catalogues; it may therefore have been among the personal effects that were distributed among the Queen's children immediately after her death. Prince Augustus was an executor of the estate of his elder sister, Princess Augusta, who died in 1840, and may have acted as the conduit for the family possessions (including fans) which passed from Princess Augusta to their niece, Queen Victoria.[70]

The leaf is cut from a large piece of Brussels lace, rather than being made of a shaped piece of lace (compare nos. 63–65, for instance). The pattern pieces are of needle lace; they are grounded with fine bobbin-made *drochel* net, made up from a number of invisibly joined narrow strips. Although the pattern is not complete, the ratio of design to plain ground suggests a date in the late 1770s or 1780s.

Large sums of money were spent on fine Brussels lace for Queen Charlotte's use. The Great Wardrobe Accounts record that in 1762, before the impending birth of her first child, a 'Sitting up State Bed' was

supplied for the Queen's use during her reception of important visitors after the birth. The suite of 'Superfine Flanders point Lace to Cover all over', charged at £2,699, cost considerably more than the woodwork and hangings. The supplier was 'Priscilla MacEune Lacewoman'. In the same account, and from the same source, was a 'suit of the Like Lace to Cover a Toilet Table Compleat', costing £1,079 14s. It seems very likely that the lace mentioned in the latter account is that shown in Zoffany's painting of the Queen and her two eldest sons of c.1765 (plate 21.1).[71] A flounce of Brussels lace from Queen Charlotte's collection was given by Queen Victoria to the future Queen Mary on her marriage in 1893.[72] Queen Charlotte's marriage fan was described by a contemporary as 'ivory sticks, finely carved, the Mount Brussels lace, price forty guineas'.[73]

This may be the fan held by Queen Victoria in Leslie's painting of *The christening of the Princess Royal* in 1841 (fig. 18). In 1893 the fan was shown open in the Queen's hand, both in Tuxen's painting (fig. 23) and in the photographic portrait taken by W. & D. Downey (plate 21.2) at the time of the marriage of Princess Victoria Mary of Teck (later Queen Mary) to the Duke of York (the future King George V); the photograph was later used as an official portrait for the Queen's Diamond Jubilee in 1897.[74]

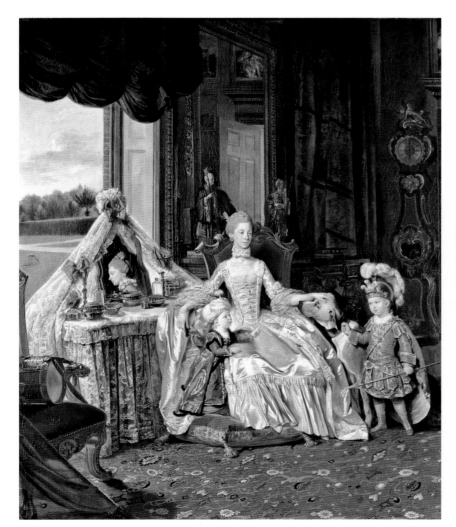

Plate 21.1. Johan Zoffany, *Queen Charlotte and her two eldest sons*, c.1765; oil on canvas (RCIN 400146, detail)

Plate 21.2. *Queen Victoria*, 1893; photograph by W. & D. Downey, re-issued for the Diamond Jubilee (RCIN 2912658)

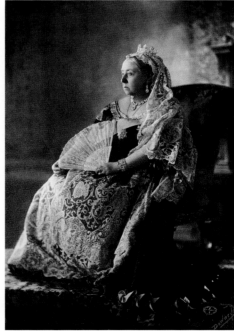

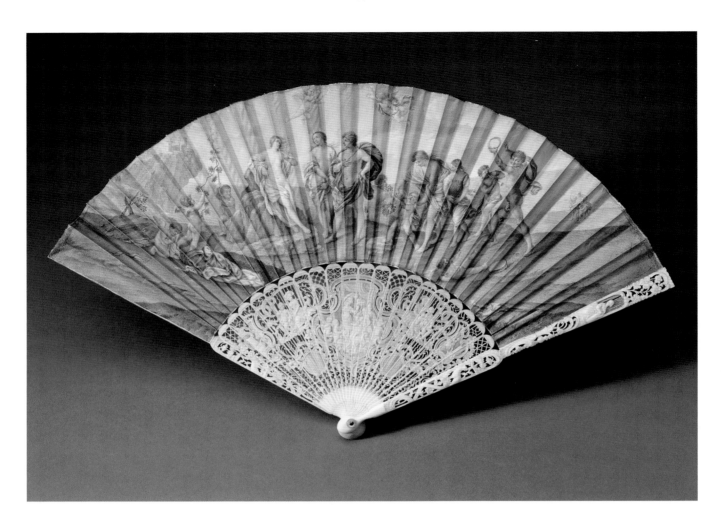

22. 'BACCHUS AND ARIADNE ON THE ISLAND OF NAXOS'

ITALIAN LEAF; ENGLISH GUARDS AND STICKS, c.1780

This fan leaf is based on the painting by Guido Reni (1575–1642) of *Bacchus and Ariadne*, completed in 1640 as a result of a commission from Cardinal Barberini as a gift to Queen Henrietta Maria. After the dispersal of Charles I's collection, by the late 1640s the picture had passed into the possession of Particelli d'Hémery, an Italian financier, after whose death in 1650 it was cut up on orders from d'Hémery's widow, who considered it lascivious. Before its destruction, Reni's painting was engraved by his pupil Giovanni Bolognini. A large fragment of the original canvas, representing the seated figure of Ariadne (to left of centre on the leaf), has recently been identified in a private collection.[75]

The scene depicted is the moment when Bacchus (in the centre, with blue drapery) discovers the distraught figure of Ariadne on the island of Naxos. He soon falls in love with her and proposes marriage (see no. 16). The painting on the verso depicts Ganymede transported to Mount Olympus by Jupiter, who had transformed himself into an eagle. It is based on the ceiling panel of Ganymede in the gallery of the Palazzo Farnese, Rome, painted by Annibale Carracci.[76] A fine mid-eighteenth-century Italian kidskin leaf, painted on both sides but unmounted, is very close to this fan leaf.[77]

Although this fan is known to have belonged to Queen Alexandra, its early history is undocumented. It does not appear to have been owned by Queen Victoria.

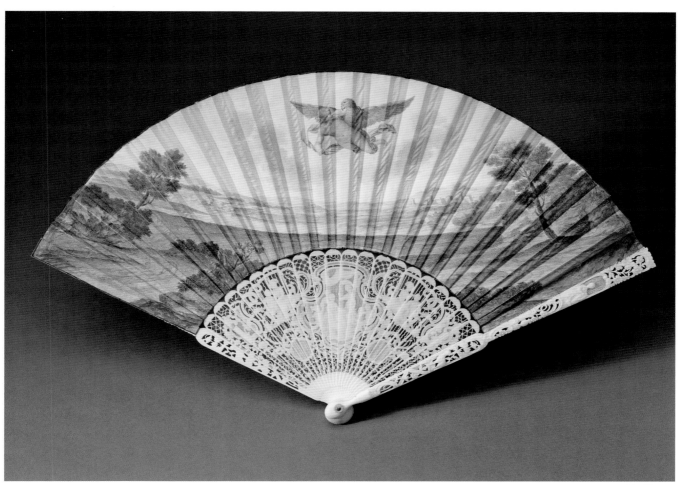

No. 22 verso

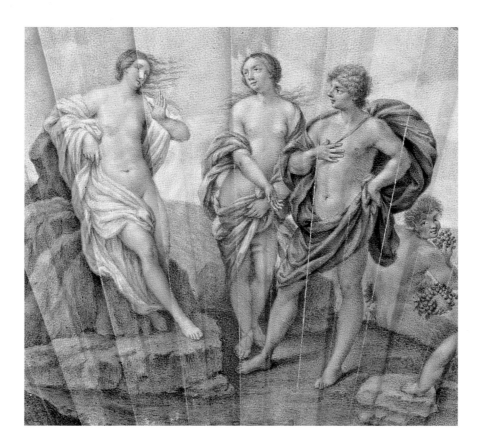

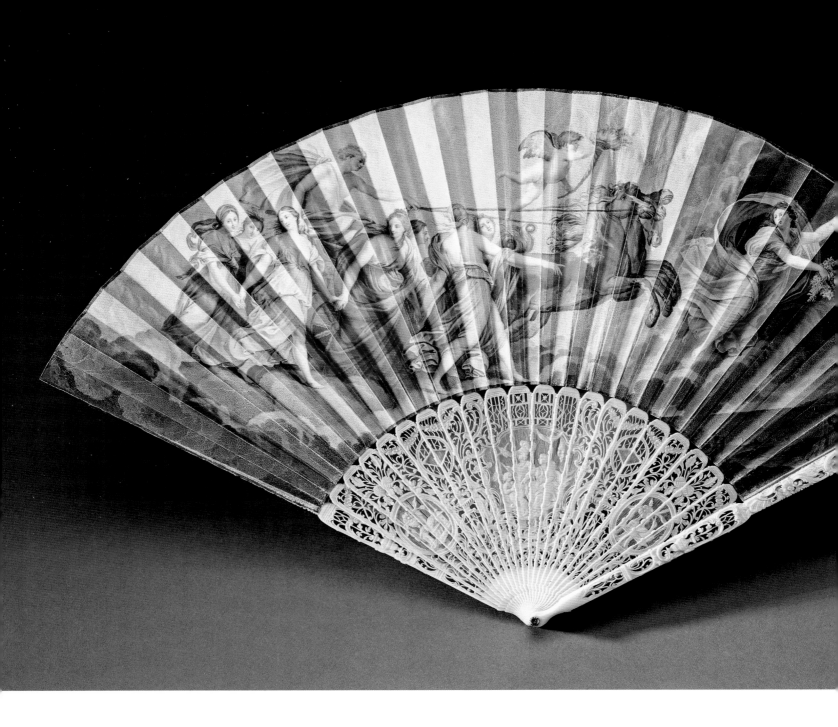

23. 'AURORA AND APOLLO'
ITALIAN LEAF; ENGLISH OR ITALIAN GUARDS AND STICKS, c.1780

Aurora was the rosy-fingered goddess of the dawn. Each morning she would leave her aged husband in bed to lead her brother Helios, the sun-god, to the heavens. Aurora appears at right, her hands full of flowers that she will scatter over the earth. In the sky above the chariot of Helios is the amoretto Phosphorus, the morning star, who holds a lighted torch. The imagery is more overtly romantic in the ivory carving in the gorge, where Mars and Venus are shown. The foredge carving revealed when the fan is closed includes further romantic symbols.

The composition is based on Guido Reni's original (also known as the *Triumph of Aurora*), painted in 1615 in the Casino Rospigliosi, Rome, and subsequently widely publicised through painted and engraved copies. The *Triumph of Aurora* was considered to be Reni's masterpiece. The romantic subject-matter combined with the high standing occupied by the artist throughout the eighteenth century, and the ease of access (via engraved copies) to the composition, ensured that it was a very popular subject

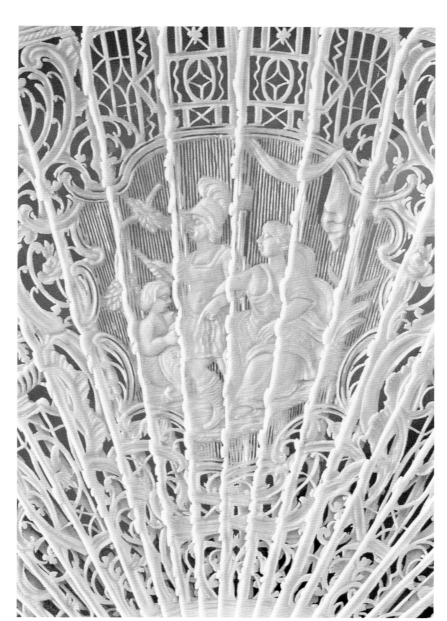

with fan-makers. Numerous other fan leaves decorated with this composition are known,[78] but this is the only one that is signed: by Giuseppe Trono (1739–1810) who was the son of Alessandro Trono, a Piedmontese artist. He specialised in making miniature copies of paintings by Old Masters, particularly in Naples and Rome. In 1781 he was appointed painter and miniaturist to the royal court in Turin. Four years later he travelled to Lisbon, where he produced portraits and some religious works.

The fan was a gift to the young Queen Victoria from her Lady of the Bedchamber, the Duchess of Bedford. Queen Victoria believed that it had belonged to Queen Charlotte, and Queen Mary subsequently identified it as 'A fan with highly finished painting on ivory, from the Aurora of Guido, with pearl rivet', included in Queen Charlotte's 1819 sale catalogue. As the Duchess's gift was made only twenty years after that sale, the identification is likely to be correct, in spite of the curious description. The fan may possibly have been acquired in Italy by Queen Charlotte's sixth son, Augustus, later Duke of Sussex, who was in Rome in the early 1790s. The Queen's correspondence with Prince Augustus at this time includes a request for some Italian fan leather 'quite white for to paint on, and if besides you will send us some Naples fan mounts I shall be much obliged to you'.[79] On their arrival in England, the fan mounts (i.e. leaves) would have been made up as fans, for the use of the royal ladies.

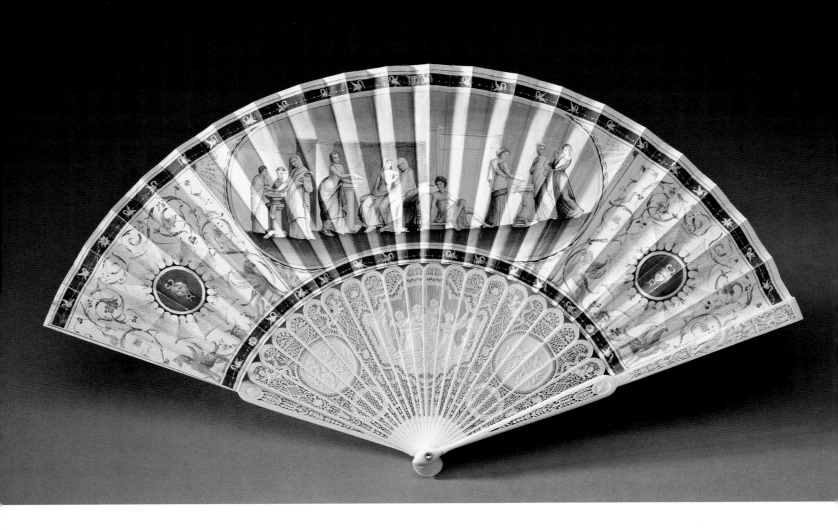

24. 'THE ALDOBRANDINI WEDDING'
ITALIAN LEAF; ENGLISH GUARDS AND STICKS, c.1780

This fan depicts the ancient Roman wall painting uncovered in 1605–6 on the Esquiline Hill, Rome. The main subject, showing wedding preparations, was soon detached and removed to the garden of the villa of Cardinal Pietro Aldobrandini; in 1818 it was acquired for the Vatican Museums where it remains to this day. From the time of its discovery the so-called Aldobrandini Wedding attracted great interest. It was copied and engraved on numerous occasions during the seventeenth and eighteenth centuries, in both Italy and elsewhere.[80]

Like nos. 23 and 25, this fan leaf was produced in Italy (probably in Rome), specifically for the Grand Tour market. But unlike the following fan (no. 25), it appears to have been exported – unmounted – to England, where it was mounted on sticks and made up as a fan. Typically for fan leaves of this type and date, it has a fine decorative border. The latter incorporates swans with eels in their beaks, the reserves are decorated in Etruscan style with the heads of Gorgons at either side.

The fan formerly belonged to Princess Mary Adelaide of Cambridge, Duchess of Teck, from whom it passed to Queen Mary, her daughter.

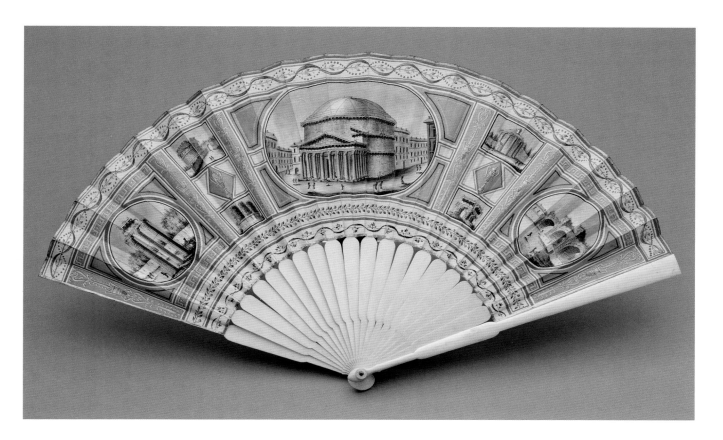

25. GRAND TOUR FAN

ITALIAN, *c.*1780

The fan leaf contains three principal and four subsidiary views of buildings which would have been visited by Englishmen travelling to Rome in the late eighteenth century. In the central oval is the Pantheon, in the left oval are the three columns of the Temple of the Dioscuri (Castor and Pollux) in the Forum, and in the right oval the Basilica of Maxentius or Constantine. The smaller fields show (at left) the Tombs of Cecilia Metella and of the Horatii and the Curiatii (both on the Via Appia Antica), and (at right) the Temple of Vesta in the Forum and a corner fragment of a Corinthian cornice.

Many thousands of fan leaves of this type must have been made in Italy for the tourist trade. Some would have been sent home unmounted, for attachment to sticks in England; others, like no. 25, may have been mounted on plain sticks in Italy. A fan-shaped box containing a finished fan leaf and a design for a fan, signed in Rome by the otherwise unknown Neopolitan artist Domenico Spinetti, provides a rare insight into the export process; the box is marked with the name of the forwarding agent in Livorno and of the consignee in London.[81] In most cases the names of artist and agents are unknown.[82] The majority of the surviving fans with Roman views date from the late eighteenth century.[83]

This is one of four fans in the Royal Collection with a traditional association with Princess Augusta (1768–1840), the second daughter of George III and Queen Charlotte.[84] The Princess never married. Following her mother's death in 1818 she resided chiefly at Frogmore House, Windsor, until her death in 1840. It was probably through her brother, Prince Augustus, Duke of Sussex, that some of her personal effects were transferred to their niece, Queen Victoria: Princess Augusta died intestate and Prince Augustus acted as her executor.[85] A further six fans, described at the end of Queen Victoria's reign as having belonged to 'one of the Queen's aunts', may also have come from Princess Augusta's collection. Two of these fans are still in the Collection; the remainder were bequeathed elsewhere by Queen Victoria.[86]

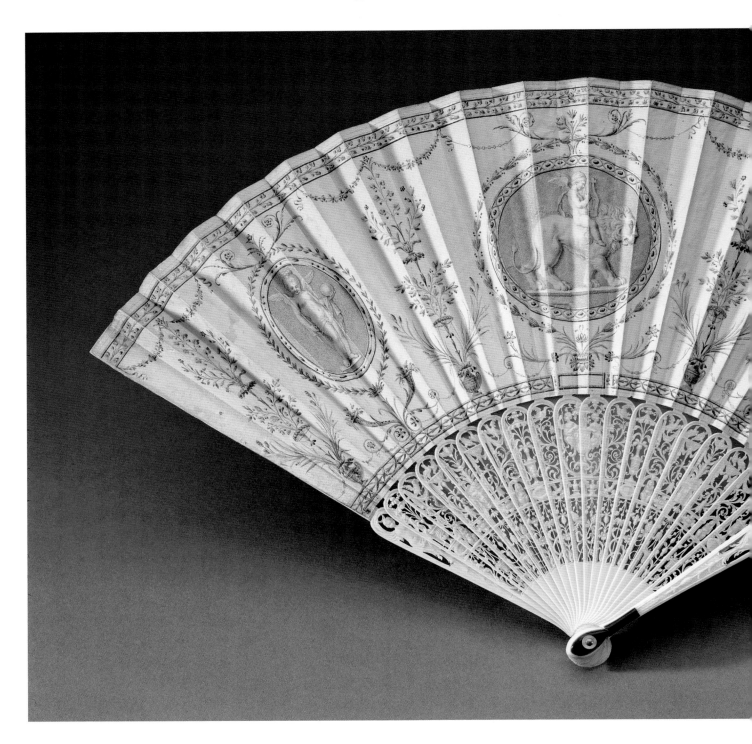

26. 'THE POWER OF LOVE'

ENGLISH, 1780

In the central medallion winged Cupid (holding a kithara, similar to a lyre), symbolising Love, rides a lion. On the left is Cupid with stick and ball; on the right is the infant Hercules. All these figures may be taken as symbols of the power of love; they all derive from Antique gems. The central figure is copied from the gem engraved (i.e. carved) by Protarchos, which was illustrated several times in the seventeenth and eighteenth centuries.[87] The guards feature a decorative winged interpretation of the moon goddess Diana.

A line of printed text, with the name of the fan-maker and publisher Antonio Poggi (*fl. c.*1769 – after 1803), is just visible at the foot of the leaf, above the gorge.[88] Mr Poggi, of St George's Row, Hyde Park, was highly regarded both as a maker of fans and as a painter. He is said to have arrived in London in the train of Pasquale Paoli, the Corsican patriot, and exhibited pictures at the Royal Academy in both 1776 (when he was still based in Rome) and in 1781. After Fanny Burney visited his shop with Sir Joshua Reynolds in March of the same year, she recorded seeing

> some beautiful fans, painted by Poggi, from
> designs of Sir Joshua [Reynolds], Angelica
> [Kauffmann], West, and Cipriani, on leather;
> they are, indeed, more delightful than can well
> be imagined: one was bespoke by the Duchess
> of Devonshire, for a present to some woman of
> rank in France, that was to cost £30 . . .[89]

The Power of Love was the earliest dated fan to be published by Poggi. It was followed by *Victory* in 1782, with *Children playing Battledore* and *Children with Tops* in 1788, *Shakespeare's Tomb* (after Angelica Kauffmann) in 1790 and *Cupid and Psyche* in 1797. An auction of Poggi's stock held in London by Messrs Christie and Ansell on 11 April 1783 included fans made by Poggi himself (and by Bartolozzi, Kauffmann and West), while lots 99–116 were described as 'Drawings of Fans'; these included *The Universal Power of Love* which presumably relates to the design shown on the present fan.

Poggi frequently published the work of the engraver Francesco Bartolozzi (1725–1815), and Lionel Cust believed that Bartolozzi rather than Poggi engraved this fan leaf. A total of eighteen engraved fan leaves, including the present one, were included in the catalogue raisonné of Bartolozzi's work.[90] The artists responsible for the designs that Bartolozzi engraved included Giovanni Cipriani, Angelica Kauffmann, Joshua Reynolds and Benjamin West.

Later in his career Poggi set up as a dealer in Old Master drawings, and in 1793 he helped to disperse Sir Joshua Reynolds's collection. By 1801 he was supplying drawings to the Prince of Wales (the future George IV). In February 1803 he wrote to request payment of his invoice: he was on the point of 'quiting [*sic*] this Country' after 'various disappointments'.[91] It is unlikely that this fan has an early royal provenance; it was purchased by Queen Mary from the Red Cross Gift House in July 1916.

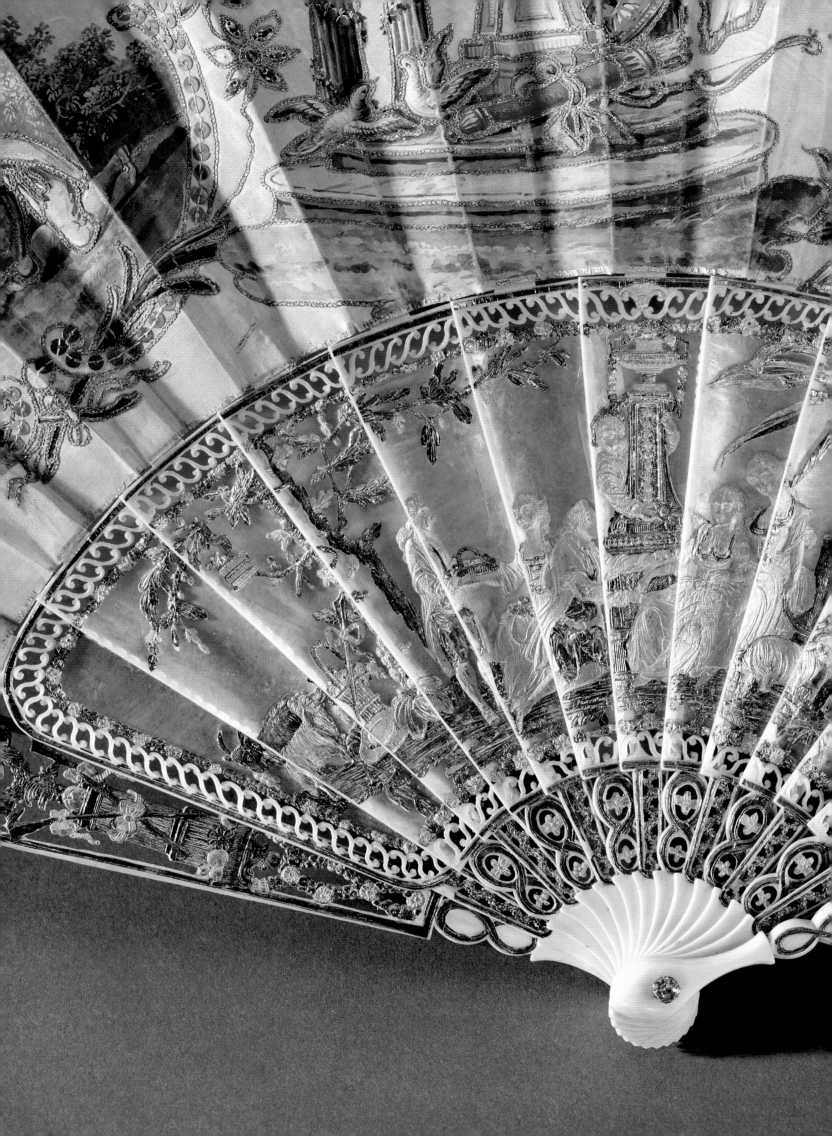

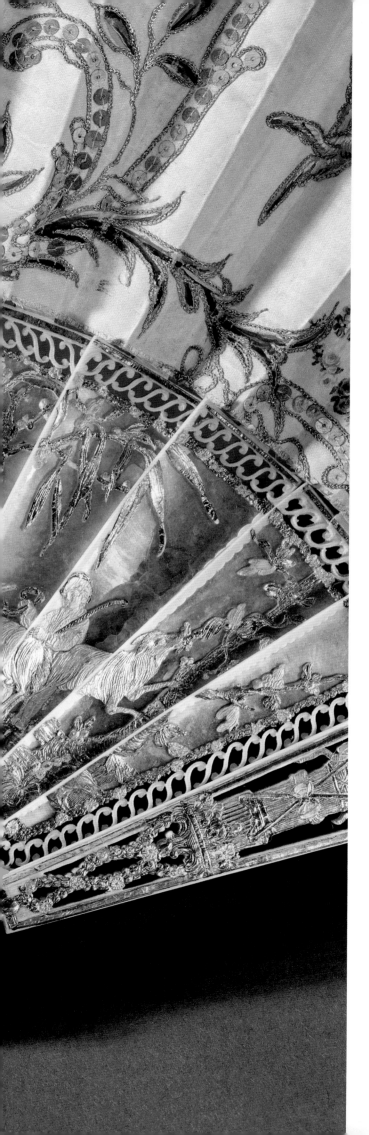

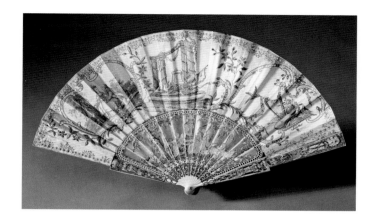

27. MARRIAGE FAN
FRENCH, c.1780

This richly decorated sequinned silk fan is a typical product of a Parisian workshop in the final decade of Louis XVI's reign. The diversification of ornamental techniques may have resulted from the rigid guild system: until the reforms of 1782 responsibility for painting fan leaves lay exclusively with members of the painter's guild, the company of St Luke. In order to decorate his fans, an *éventailliste* or fan-mounter was therefore obliged either to employ a member of the painter's guild, or to apply ornamentation using a medium other than paint – for instance embroidery or sequins. The introduction of the tambour frame from the East c.1760 greatly assisted the fan decorator: with the help of the frame and a tiny crochet hook, minute stitches, using fine – often metallic – thread, could be applied to the fan leaf which, from c.1770, would frequently be made of silk rather than paper or kidskin (see also no. 28.)

The imagery on the fan leaf is entirely related to love and marriage. In the centre is the flaming altar of Hymen; on the left is an amorous couple, and on the right love birds arrange flower garlands around musical instruments. Similar motifs are included in the carving on the guards and sticks.

This fan was a gift to Queen Mary in May 1948, on her eighty-first birthday.

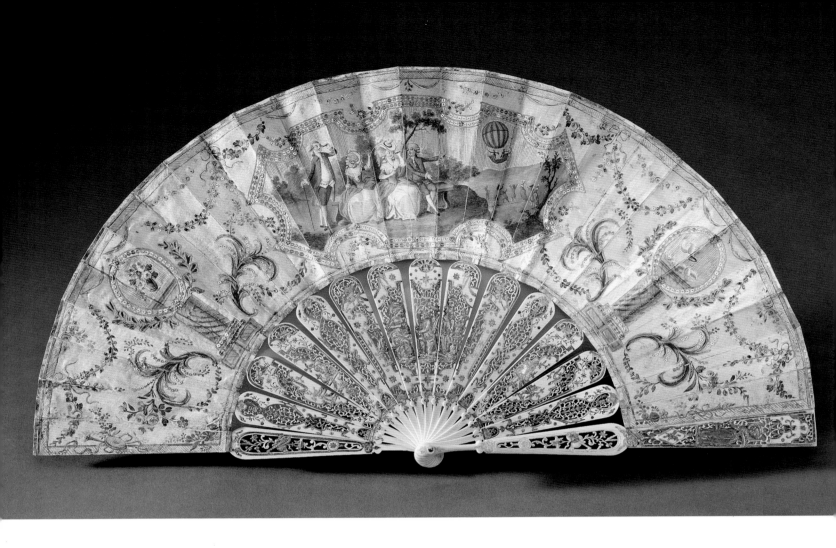

28. 'THE ASCENT OF M. CHARLES'S AND M. ROBERT'S BALLOON, 1783'

FRENCH, 1783

The central vignette contains a depiction of the balloon flight on 1 December 1783 of Jacques Charles (1746–1823) and Nicolas Robert, with the distinctive hanging gondola in which they are known to have travelled. This was the second successful manned balloon flight. The first had been made by M. de Rozier (using Montgolfier's balloon) on 21 November 1783. Less than two weeks later the physicist M. Charles with his assistant M. Robert made a successful ascent in a balloon (inflated by hydrogen) from the gardens of the Tuileries in Paris – to the amusement and delight of crowds of onlookers, represented in this fan by two elegantly dressed couples. The flight ended at Nestle, 43 kilometres away.

These manned balloon flights were made possible by the earlier work of the Montgolfier brothers, Joseph and Etienne, who had used heated air to raise a balloon. Jacques Charles, a professor at the Académie des Sciences, developed the concept with the use of hydrogen gas, which he first demonstrated on 27 August 1783. A public demonstration in the forecourt of the Château de Versailles, in the presence of Louis XVI, Marie-Antoinette and their family, followed on 19 September.

The success of these balloon ascents was followed by the production of quantities of souvenirs – in prints or painted on pottery, boxes or other trifles. In their haste to produce more expensive examples, *éventaillistes* adapted fan leaves already painted with central vignettes of *scènes galantes* or *fêtes champêtres*, adding ballooning decoration at either side, or sticks incorporating a ballooning theme – sometimes even a hastily painted balloon inserted in the sky. The success of the balloon ascent of M. Charles and M. Robert in 1783 was recorded in a number of fan leaves, most of which were made in Paris between 1783 and 1785.[92] (See also illustration detail, pp. 34–35.)

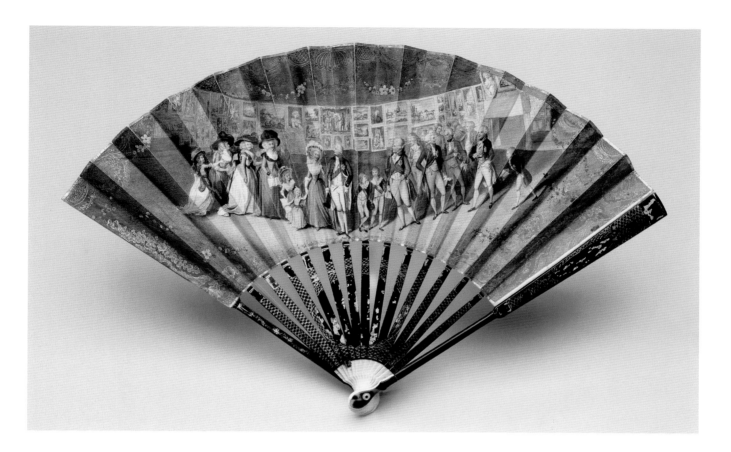

29. 'KING GEORGE III AND HIS FAMILY VISITING THE ROYAL ACADEMY, 1788'

ENGLISH, 1789

This fan records the occasion, in the summer of 1788 – shortly before his first serious illness – when George III and his family visited the summer exhibition at the Royal Academy of Arts. The Academy had been founded by George III in 1768 and in the 1780s moved to new premises – provided by the King – at Somerset House. The royal family were recorded in the Great Room there by J.H. Ramberg, whose design was engraved by P. Martini as *Portraits of their Majesty's [sic] and the Royal Family viewing the Exhibition of the Royal Academy, 1788* and published by A. Poggi on 6 March 1789, following the King's recovery.[93] On the basis of the key published at the same time as the Ramberg/Martini print, the members of the royal family can be identified as follows (left to right): Princesses Mary, Elizabeth, Augusta, Charlotte (Princess Royal), Sophia, Amelia; Queen Charlotte; George III; Princes Adolphus (Duke of Cambridge), Augustus (Duke of Sussex), the Prince of Wales (later George IV), Frederick (Duke of York), William (Duke of Clarence, later William IV), Edward (Duke of Kent, father of Queen Victoria) and Ernest (Duke of Cumberland).

The engraving of the royal visit to the exhibition at Somerset House was very popular and is known in a number of variant forms. This printed fan leaf appears to be the second state of the Ramberg/Martini plate published in March 1789.[94] The engraved plate was adapted so that the printed area was reduced to the size of a fan leaf; the upper range of paintings was removed, and the figures were adjusted to include the two youngest children. A third state of the Ramberg/Martini print, published by Poggi (for whom see no. 26) on 11 January 1790, retains the fan-leaf shape and incorporates further alterations to both figures and background (including a view of Windsor Castle).[95] Several mounted fans with the later leaf are known. These include examples in the Victoria and Albert Museum, on carved bone sticks,[96] and in the collection of the Worshipful Company of Fan Makers.[97]

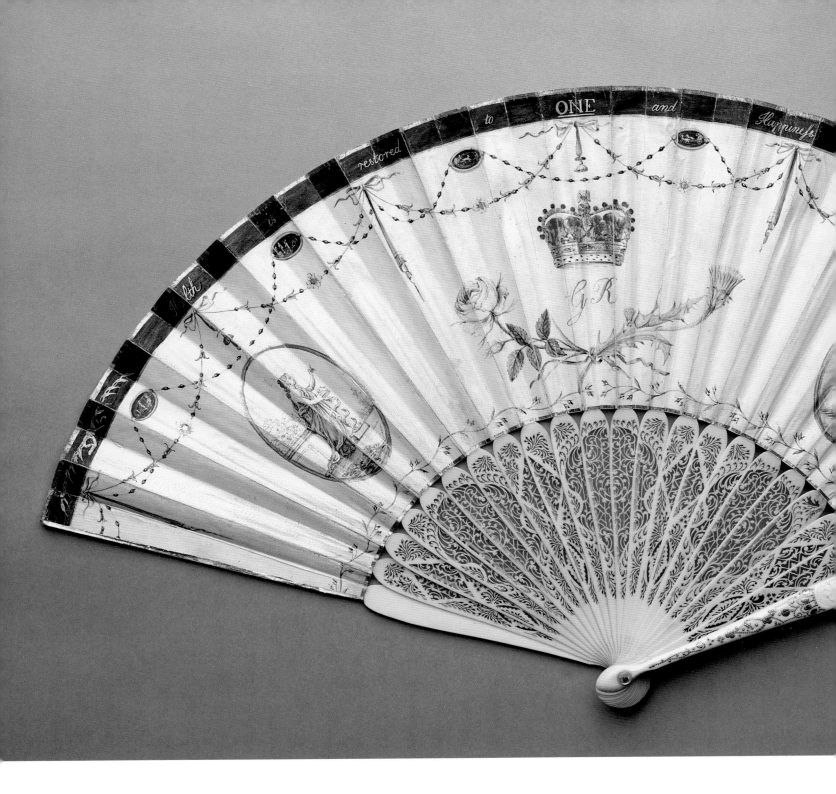

30. PRINCESS ELIZABETH'S FAN

ENGLISH, 1789

The recovery of George III from his first serious bout of illness (from November 1788) in February 1789 was the occasion for widespread jubilation and festivities. In her record of one of these celebrations, in April or May 1789, the novelist Fanny Burney noted, 'The Queen graciously presented me with an extremely pretty medal of green and gold, and a motto, *Vive le Roi*, upon the Thanksgiving occasion, as well as a fan, ornamented with the words – *Health is restored to ONE and Happiness to Millions.*'[98]

A small group of fans associated with George III's recovery are known, including a number of almost identical examples, all of which are variants of the present fan. The best known of these is now in the Victoria and Albert Museum, having formerly also belonged to Queen Mary.[99] Although the inscribed

border and the central crowned *GR* with rose and thistle in that fan are the same as in the current example, the ovals at either side are there replaced by long blue scarf-like bands inscribed *On the King's* and *Happy Recovery*; the fan is dated 1789 at the foot of the leaf. Several fans close in appearance to the London example are known in public collections.[100] Further 'recovery fans' close to the London example have also survived in private collections. One of these descended through the family of Thomas Weld (of Lulworth, Dorset), with whom the King stayed in August 1789.[101]

It seems likely that these fans, which have a number of variations in the sticks and decoration, may have been produced in some quantities for distribution at one of the many festivities organised to give thanks for the merciful release of the King from his illness. The overall dark blue and white colouring of the group suggests that they may be associated with the evening 'Gala' at Windsor Castle on 1 May 1789, organised by the King's eldest daughter, the Princess Royal. According to the *Annual Register* for 1789, the 228 guests were invited by both the Princess and the Queen. 'The dresses were the Windsor uniform . . . The gown was white tiffany, with a garter blue body . . . All the ladies wore bandeaus round the front of their head dresses, with the words "God save the King;" and many of them had beautiful medallions of his majesty.'[102] The King was present for part of the evening, in the company of the Queen and their sons and daughters.

The person responsible for decorating these charming but far from sophisticated objects is not identified on the fan itself. According to a scrap of paper inscribed during the lifetime of Queen Victoria (who received this fan as a Golden Jubilee gift), it was George III's third daughter, Princess Elizabeth (1770–1840). The Princess's artistic activities from the 1790s onwards are relatively well documented,[103] and it is intrinsically possible that she was involved in the decoration of the 'recovery fans', including no. 30. From the Queen's letters of 1792, requesting both leather and sticks from Italy (see no. 23), it seems that fan production may have been one of the royal family's favoured leisure activities. However, it would appear unlikely that Princess Elizabeth painted hundreds of similar fans unaided.

George III's recovery was also the subject of numerous engraved fans, including one in the Royal Collection and another published by T. Balster in March 1789.[104] This incorporates many of the same elements as are present in the painted fans: for instance, the initials GR (for Georgius Rex, King George) and the rose and thistle (symbolising the union of the crowns of England and Scotland). In addition it includes the French inscription *Vive Le Roy* (Long Live the King), a particularly poignant reminder of contemporary events in France where, on 17 June 1789, the Third Estate declared its autonomy from the King and constituted itself as a National Assembly; just under a month later the Bastille was stormed.

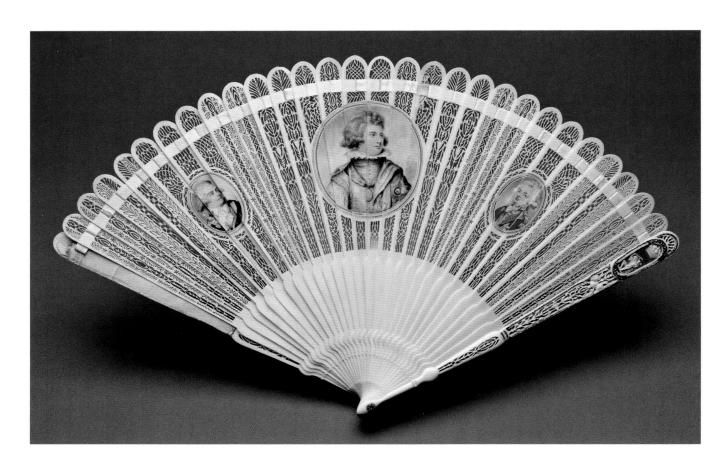

31. 'THE THREE ELDEST SONS OF KING GEORGE III'

ENGLISH, *c.*1787

The portraits painted onto this ivory *brisé* fan represent, from left to right, Prince William, Duke of Clarence, later King William IV (1765–1837); George, Prince of Wales, later King George IV (1762–1830); and Prince Frederick, Duke of York (1763–1827). The portraits are based on engravings after paintings by Thomas Lawrence and Richard Cosway. Cosway's miniature portrait of the Prince of Wales[105] was first engraved by Thomas Burke and published in December 1787. The high quality of the painting suggests that the fan may have been made for a member of the royal family, possibly one of the princesses.

The guards of this fan are particularly unusual. They incorporate small jasper-ware plaques made in the Wedgwood factory. The jasper process was perfected in 1777 and plaques gradually became available for use in decorative pieces, although no records have survived to indicate that fan-makers purchased the plaques direct from Wedgwood. The design of the plaque applied to the front guard in no. 31 was taken from an intaglio in the collection of Louis XV depicting Hercules overcome by Love; engraved copies were available in numerous publications. The plaque on the back guard shows a sacrifice to Ceres or Diana. As with no. 33, the decoration of the guards includes strung cut-steel beads, produced in the Soho works of Matthew Boulton (1728–1809) from the 1760s. The Royal Collection contains two other fans with Wedgwood plaques: another ivory *brisé* fan, and a silk fan with steel guards.[106]

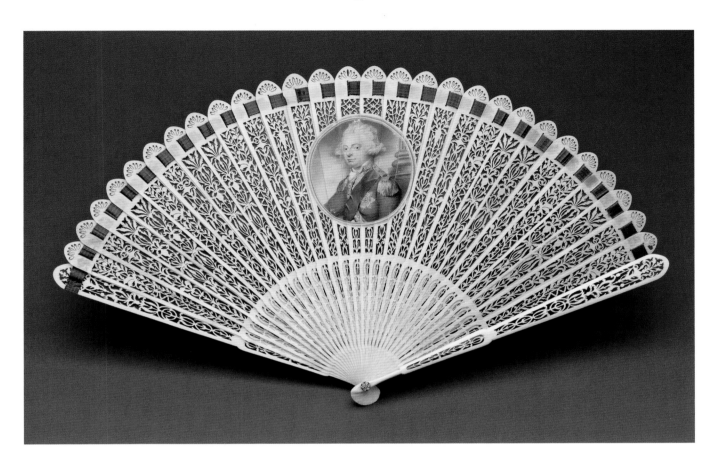

32. 'FREDERICK, DUKE OF YORK'

ENGLISH, *c.*1790

Prince Frederick (1763–1827), Duke of York, was the second son of George III and Queen Charlotte. He was brought up with the Prince of Wales (later George IV) and the two remained close throughout their lives. In November 1780 Prince Frederick was gazetted colonel and left London for Hanover in order to complete his military education. The Prince's marriage on 29 September 1791 to Princess Frederica, eldest daughter of Frederick William II, King of Prussia, is commemorated in no. 33. He commanded the British army in Flanders in 1793–5, was appointed Field Marshal in 1795, and was Commander-in-Chief of the British forces in 1798–1809.

The portrait in the present fan is ultimately based on a bust by J. Lochee exhibited at the Royal Academy in 1787, following sittings given by the Duke in Germany. The portrait type proved very popular (see, for instance, the Wedgwood medallions also issued in 1787). Two years later the portrait was copied in a drawing by Sir Thomas Lawrence. The engraving by Edmund Scott after Lawrence's drawing, published in 1789, was presumably the basis for the portrait in the present fan and for no. 31.

The Prince's portrait is painted onto the flat area of ivory in the shape of a medallion, spreading over six separate sticks. The medallion appears in the centre of the fan when it is opened. The remainder of the ivory sticks have been cut with a number of different patterns. The design of this fan is typical of the late eighteenth century.[107]

Both of these ivory *brisé* fans with painted royal portraits belonged to Queen Mary. Whereas no. 31 was purchased, no. 32 was inherited from the Queen's grandmother, the Duchess of Cambridge.

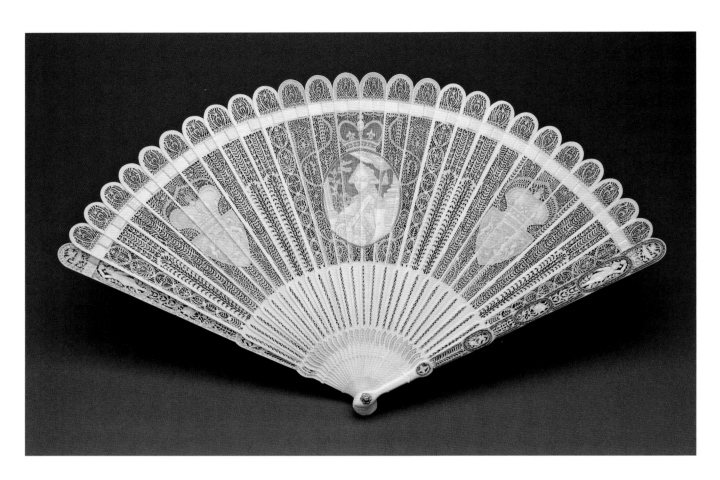

33. 'THE MARRIAGE OF FREDERICK, DUKE OF YORK, AND PRINCESS FREDERICA OF PRUSSIA, 1791'

ENGLISH, 1791

The marriage between Prince Frederick, Duke of York, and Princess Frederica (1767–1820; see plate 33.1), eldest daughter of King Frederick William II of Prussia, took place in Berlin on 29 September 1791 and was followed by an English ceremony, in the Saloon at Buckingham House (now Buckingham Palace), on 24 November of the same year.[108] What appears to be the present fan, but with the original diamond-set gold guards replaced, was included in a description, published in the *Public Advertiser* for 19 January 1792, of the 'costly decorations worn by her Royal Highness [the Duchess of York] at the Drawing Room yesterday'.

> The Fan – we give precedence to this article, it being contestedly the most tasteful, elegant and brilliant thing of the kind that ever was manufactured in this and we need not add, any other country in Europe. The whole is of pierced ivory held together with coquelicot ribbon, the carving of which speaks a knowledge of sculpture equal to what the best Academical products of marble exhibit. The outside sticks, in exception to the ivory, are of gold, in the form of a chain, closely set with diamonds with which they are also bordered; . . . in the interstices of the chain are roses of diamonds, fixed with a kind of mosaic work, transparent also. The inner sticks of ivory, when open, exhibit an oval medallion of His Royal Highness the Duke of York in relief a correct likeness and of masterly execution; over which is an imperial crown – one each side in the same style appear the arms of their Royal Highnesses, quartered, on an antique shield over which is a crown also. The value of this elegant ornament is estimated at eighteen hundred guineas.[109]

As the present guards appear to be contemporary with the fan, they may have been made as replacements for the original diamond-set guards at an early date.[110] In place of diamonds, the present guards are decorated with cut-steel beads, as produced for use in jewellery and other accessories at Matthew Boulton's works in Soho, Birmingham, from the early 1760s. Steel beads are also used, with tiny Wedgwood plaques, on no. 31.

The quality and intricacy of the ivory carving in this fan is indeed extraordinary, particularly when compared with a fan such as no. 32, which may have been produced a year or two earlier. An entry among the accounts of the creditors of the Prince of Wales (later George IV) in 1795 for '1 Rich Pierced and carved Ivory fan ornamented with the Portrait of H.R.H.' at £21 may refer to a companion fan, with the portrait of the Prince of Wales, the elder brother of the Duke of York; the fan was supplied by William Cock of 42 Pall Mall on 12 April 1795.[111] This description, together with the January 1792 account quoted above, is one of the few relatively detailed descriptions of fans acquired by members of the royal family at this period. The subsequent history of the present fan is unknown until it was transferred by Queen Mary to the historical collection of fans at Windsor in 1927 (see p. 26).

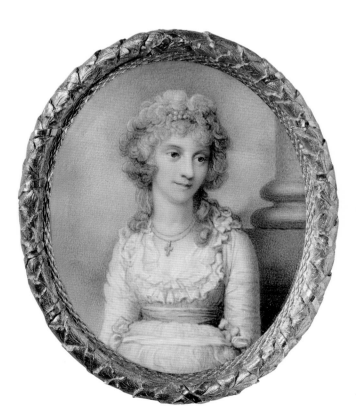

Plate 33.1. Richard Cosway, *Frederica, Duchess of York*; watercolour on ivory (RCIN 420927)

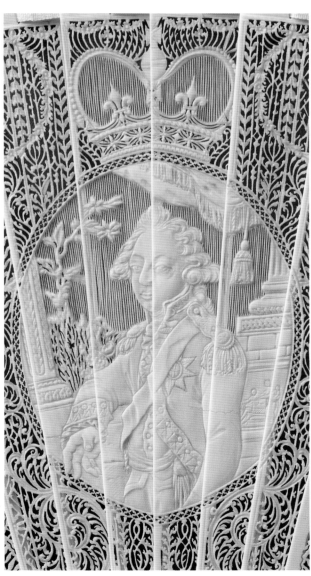

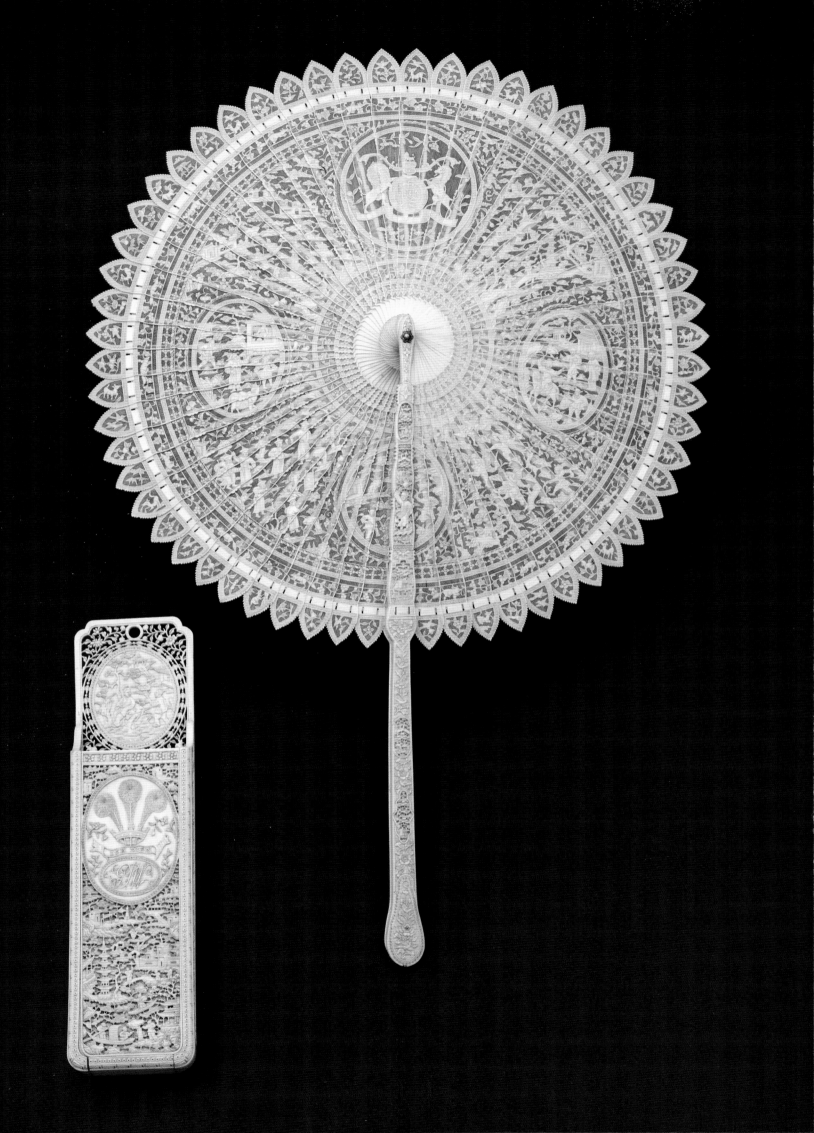

34. IVORY COCKADE FAN

CANTONESE, c.1790

This fan (one of a pair) is a high-quality product made in China for the Western market. Oriental craftsmen were extraordinarily skilled both at carving ivory to paper-like thinness and at imitating Western ornamental vocabulary. The craftsmen would have been supplied with patterns to copy: thus the arms and feathers of the Prince of Wales are convincingly depicted – but with some misrepresentation. Close examination reveals that the Welsh harp which should occupy the lower left quadrant of the arms is here replaced by an Oriental zither, while the crests of the feathers on the box are similar to chrysanthemums. The decoration elsewhere is more obviously Oriental: at the right is a tiger hunt, while at the left is a scene involving Oriental archery practice. Both the decorative content and the broad grip of the handle indicate that this fan was intended for male use. However, although eighteenth-century Chinese paintings show men with folding paper fans, none shows cockade fans such as these; nor would the accompanying fan holder have been used in China.

Cockade fans – which open to a full 360° circle – are first recorded in early medieval times and may have been invented in China. St Theodolinda's fan in the basilica of St John the Baptist, Monza, may date from the sixth century; while an ivory cockade fan from Sri Lanka, incorporating the figure of a peacock, is datable to 1500–1550.[112]

The George IV provenance is indicated by the coat of arms and motto of the Prince of Wales on the fan, and by the medallion bearing the three feathers, motto and cipher which form the badge of the heir apparent, prominently carved on the box. This fan and its pair[113] were presumably made for presentation to the Prince. These and two other ivory cockade fans in the Royal Collection,[114] together with a further fan once in the Collection,[115] would have been ordered in China for export to England. It is possible that the order was placed by someone involved in Earl Macartney's embassy to the Emperor Qianlong in 1792–4.[116]

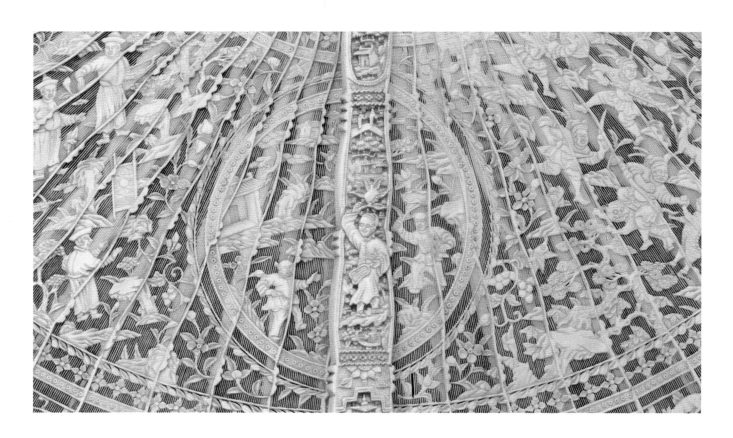

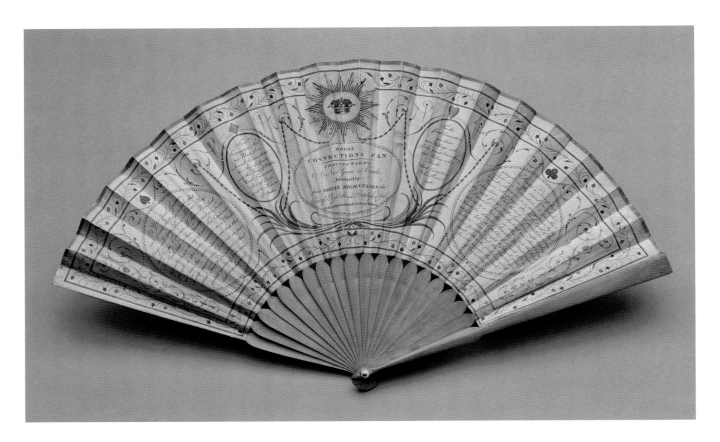

35. 'ROYAL CONNECTIONS'

ENGLISH, 1794

The printed text on this fan leaf describes the aims and rules of 'Connections. A new game at cards invented by their Royal Highnesses the Princess Elizabeth and Duchess of York which is played in the first circles of fashion'. The border features a foliate design with symbols of all four card suits. In the centre a conventionalised ducal coronet is set within an aureole. In the previous year (1793) the 'Royal Casino Fan' had been issued, also including the rules of a card game, and with a dedication to the Duchess of York.[117] Both fan leaves were published by Stokes, Scott & Croskey, of Friday Street, London, by whom a number of other printed fans are known.[118] However, Stokes, Scott & Croskey were neither fan-makers nor print publishers – nor were they even stationers or milliners; they were an established firm of silk weavers off Cheapside in the City of London. The firm was founded by Henry Stokes before 1783 at 18 Friday Street. By 1792 Messrs Stokes & Scott were located at 19 Friday Street. By 1793 Croskey had joined the partnership, but it had reverted to Stokes & Scott in 1800. The firm continued to be recorded as weavers and occasionally as warehousemen at 19 Friday Street until 1803. Their brief excursion into fan publishing, between 1793 and 1798, cannot be easily explained.

The design of this fan leaf, with a predominance of words, is typical of English printed leaves of this period. The inventors of the card game to which it relates are named as Princess Elizabeth (1770–1840), the talented third daughter of George III, and the Duchess of York (1767–1820), the Prussian wife of Frederick, Duke of York. Card-playing was a popular pastime for the royal ladies.[119] For another fan associated with Princess Elizabeth, see no. 30. The marriage of the Duke and Duchess of York in 1791 was celebrated in the fine ivory *brisé* fan, no. 33.

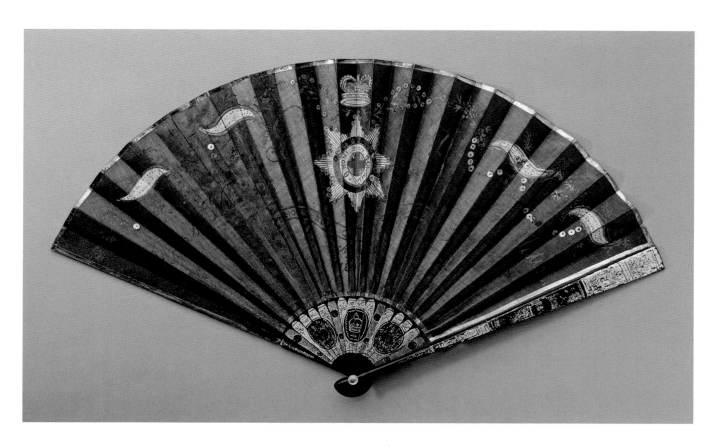

36. GARTER FAN

ENGLISH, 1805

Like no. 30, this fan may have been painted by one of the daughters of George III. The rather naïve paint-ing includes a crown, the Garter Star and motto, with the words *Windsor Installation* and the date 23 April 1805, clearly associating it with the Garter Installation held at Windsor on that day. The fan may have been held by one of the royal ladies as they processed from the royal apartments in the Upper Ward to the service in St George's Chapel in the Lower Ward of Windsor Castle. The 1805 Garter Instal-lation was a particularly impressive occasion, the solemnity of the service only slightly marred by much pushing and shoving by those hoping to be seated.[120] After the service a splendid banquet took place in St George's Hall, but the royal ladies dined elsewhere.

Although in many ways a remarkable survival, this small silk fan is a typical product of the early years of the nineteenth century. At this period the size of fans reduced considerably, to harmonise with the narrower dresses and shorter sleeves of the 'Empire' period. The (now fragmentary) decoration of sequins, fixed with silk thread, would have glittered decoratively in both natural and artificial light.

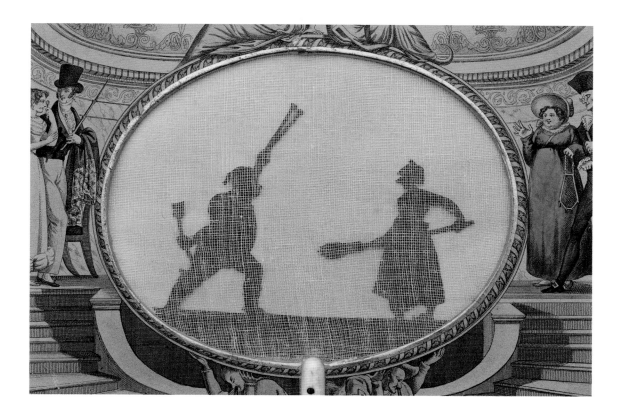

37. SILHOUETTE HANDSCREEN: LADY WITH A BROOM

ENGLISH OR FRENCH, *c*.1820

38. SILHOUETTE HANDSCREEN: THIN MAN AND FAT MAN

ENGLISH OR FRENCH, *c*.1820

Rigid handscreens as distinct from folding fans have been part of the history of the Western fan since the earliest times. Until *c*.1630 the majority of fans consisted of a feather – or group of feathers – mounted in an ornate (frequently jewelled) handle (see fig. 8). In the second half of the eighteenth century handscreens again became popular, particularly to protect the faces of women seated in front of a fire; at this period facial cosmetics were largely wax-based.

Handscreens were often produced as pairs; when not in use they served as decoration at either end of the chimneypiece. In one of these screens, a lady with a broom attacks a stout man holding fire tongs and shovel; in the other, a naval gentleman fights a duel with a stout man wearing a military hat. Movement is introduced by means of a lever on the verso which activates the figures. Other early nineteenth-century handscreens include panoramas which move at the turn of a handle, or illustrations of the seven ages of man.[121]

It has not been possible to trace the early history of these screens, which are first recorded at Frogmore House around thirty years ago. The printed surrounds include figures at the top who are 'female spirits': on the left Joy, holding a jester's stick; and on the right Luck, holding an umbrella or parasol, come rain or shine. The silhouettes may be associated with Augustin Edouart (1789–1861), a fashionable silhouettist who worked in many of the English spa towns and in 1835 published a *Treatise on Silhouette Likenesse by Monsieur Edouart*.[122] One of Edouart's patrons was William, Duke of Gloucester (1776–1834), who in 1816 married his first cousin, Princess Mary, fourth daughter of George III.

39. QUEEN ADELAIDE'S FAN
FRENCH LEAF AND STICKS; ENGLISH GUARDS, *c.*1830

According to Queen Victoria, this fan belonged to her aunt, Queen Adelaide (1792–1849), whose crowned cipher *AR* appears on both guards. The style and finish of the gold work on these guards is close to that produced in England at the time, particularly by firms such as Rundell, Bridge & Rundell, who undertook numerous commissions for the royal family. However, the fan leaf, with appliqué decoration, is of a type that was already produced in Paris before the Revolution, with the more spectacular examples dating from the 1830s. A very similar fan, but without jewelled gold guards, bears the label of Alphonse Giroux et Cie.[123] Giroux, who was a painter as well as a purveyor of luxury goods (from furniture to photographs), may have supplied the richly decorated leaf of no. 39 before it was exported to England for mounting.[124] The tiny painted ivory heads – a feature of Cantonese fans such as no. 40 – were produced in China for export to Western (particularly French) fan-makers. However, the features of the faces painted onto the ivory here are Western, not Oriental.

Queen Adelaide, born Princess of Saxe-Meiningen, had married George III's third son, William, Duke of Clarence, in 1818. On the death of George IV in June 1830, the Duke of Clarence succeeded to the throne as William IV. There were no surviving children of the marriage, and on the King's death in June 1837 his niece, Victoria, succeeded. Both Queen Victoria and Prince Albert were fond of the Dowager Queen, who appears to left of centre as the chief sponsor at the Princess Royal's christening in Leslie's painting (fig. 18). On Queen Adelaide's death in December 1849, many of her jewels and personal possessions – probably including this fan – passed to Queen Victoria.[125]

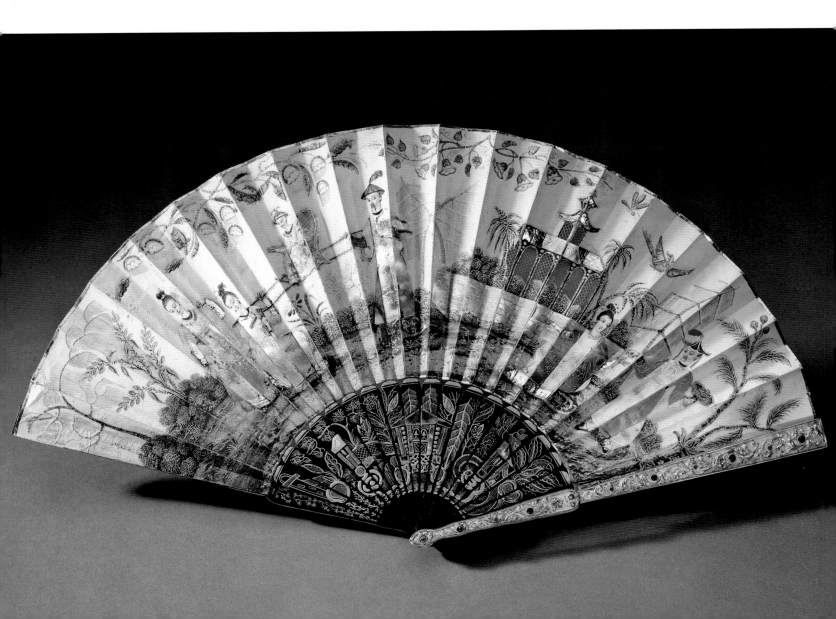

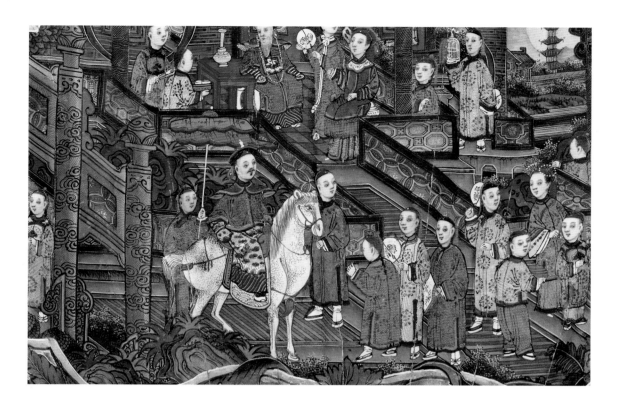

40. 'MACAO'

CANTONESE, *c.*1840

This fan is a high-quality example of Cantonese fan production in the 1830s or 1840s: large numbers of figures were shown, in which the faces are painted on tiny pieces of ivory (see also no. 39) and the clothes are made of real silk, pasted onto the paper ground. Gradually (as on the verso of this fan) whole leaves were decorated with crowded figure groups. However, the older traditions of fan decoration, where flowers and (later) topographical views dominated, also continued. At either side of the central figure scene, in which a magistrate greets his son who returns home on a white horse, are views of Macao: at the right the Praya Grande; on the left the Penha Hill with two ships bearing the red ensign, as flown by the British merchant navy. Macao, on the south-west shore of the Yellow River delta, was a popular winter residence for Europeans based in China. Although Macao had its own fan industry, fans produced there are normally identifiable by their use of vivid yellows and pinks. The Cantonese origin of this fan is confirmed through the survival of the original coloured lacquer box, finely decorated with Oriental figures, flowers and buildings. On the base of the inside of the box (see plate 40.1) is the trade label of the shop (Volong) in Canton which supplied the fan.

Such fans are not uncommon.[126] Another highly ornate version bears the crowned cipher *FC* on the gorge, and includes ships flying the French tricolour, the Union Jack and the flag of Denmark.[127] It may have been presented to Frederick VII, King of Denmark (*reg.*1848–63). The brightly coloured decorative surrounds include – on the recto – three-toed and three-legged frogs and – on the verso – borders containing bats, creatures symbolic of happiness and good fortune in Chinese culture.

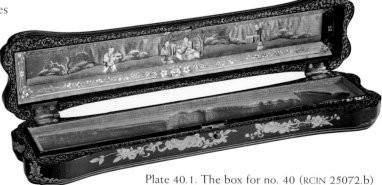

Plate 40.1. The box for no. 40 (RCIN 25072.b)

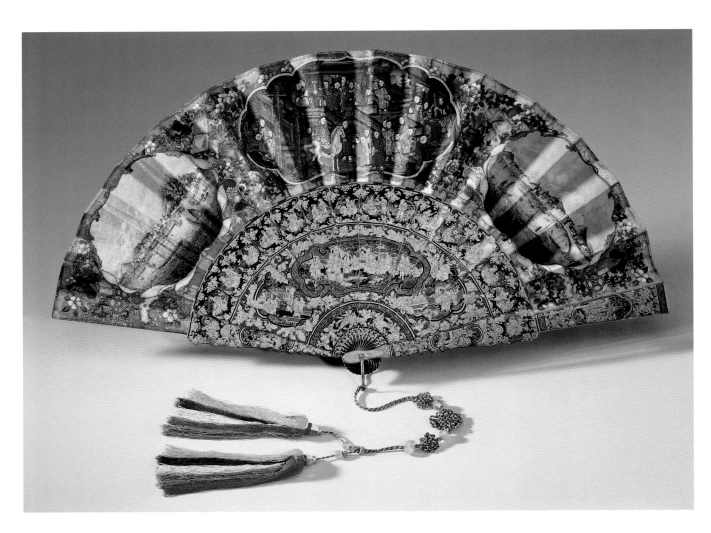

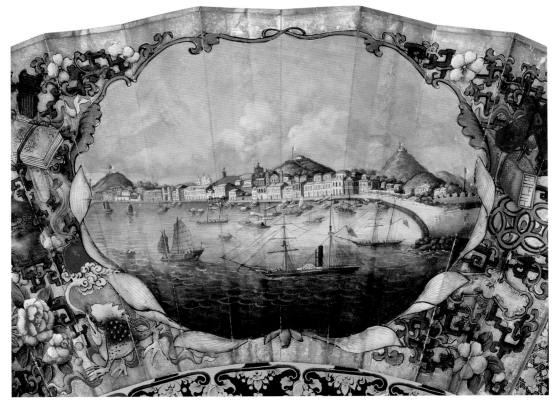

No. 40 recto: detail
with view of the
Penha Hill, Macao

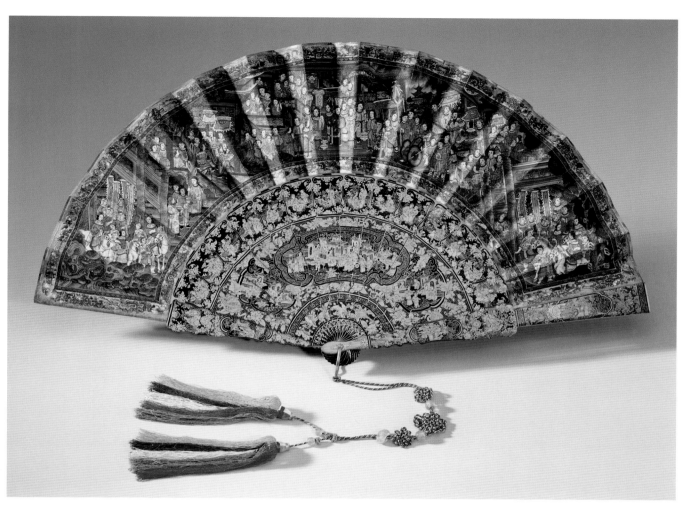

No. 40 verso

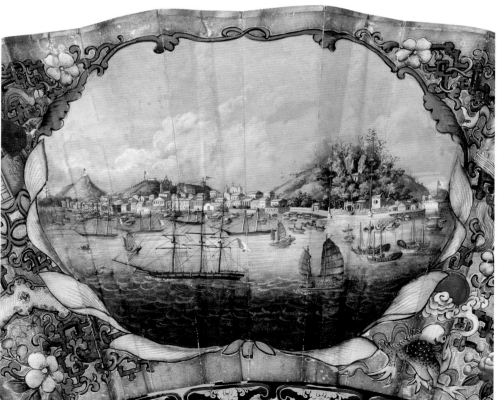

No. 40 recto: detail
with view of the
Praya Grande

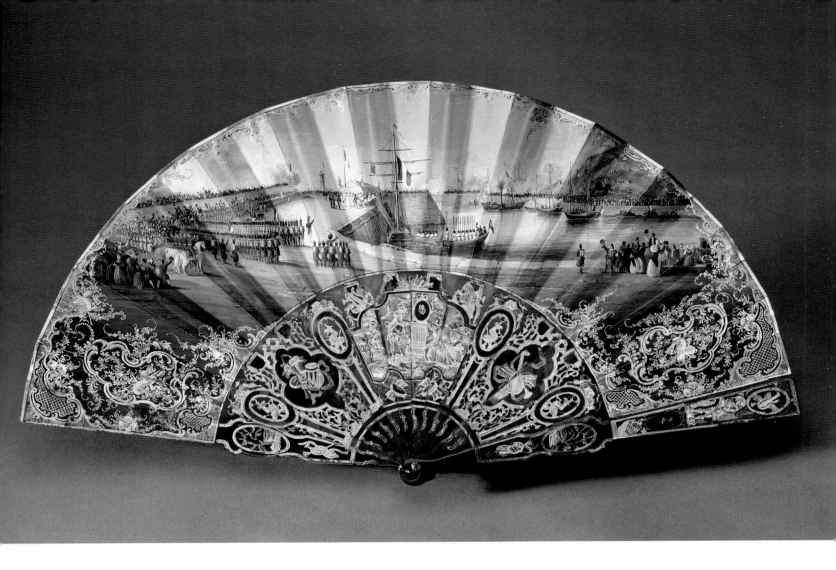

41. 'QUEEN VICTORIA'S ARRIVAL AT TRÉPORT, 1843'
FRENCH, 1843

This fan was created as a memento of the start of Queen Victoria's first overseas visit, in 1843. From 2 to 7 September the Queen and Prince Albert were the guests of Louis-Philippe, King of the French, and his wife Marie-Amélie, at the Château d'Eu, their country residence close to Tréport. The British royal party arrived in the late afternoon of 2 September on board the newly completed royal yacht *Victoria and Albert* (seen here, with its central steam funnel, to right of centre). Queen Victoria described how Louis-Philippe came to collect them from the yacht in the French royal barge:

> [accompanied by] Aumale, Montpensier, Augustus, M. Guizot, Lord Cowley, and various officers and ministers. The good kind King was standing on the boat, and so impatient to get out that it was very difficult to prevent him, and to get him to wait till the boat was close enough. He got out and came up as quickly as possible, and embraced me warmly. It was a fine and really affecting sight, and the emotion which it caused I shall never forget . . . The King expressed again and again how delighted he was to see me. His barge is a very fine one, with many oars, and the men in white, with red sashes, and red ribbons round their hats . . . The landing was a fine sight, which the beauty of the evening, with the setting sun, enhanced. Crowds of people, (all so different from ours), numbers of troops (also so different from our troops), the whole Court, and all the authorities, were assembled on the shore. The King led me up a somewhat steepish staircase, where the Queen received me with the kindest welcome, accompanied by dearest Louise [Queen of the Belgians], Hélène [the recently widowed Duchesse d'Orléans], in deep mourning, Françoise [Princesse de Joinville], and Madame

Adélaïde. All this — the cheering of the people, and of the troops, crying 'Vive la Reine! Vive le Roi!' — well nigh overcame me . . . The King repeated again and again to me how happy he was at the visit, and how attached he was to my father and to England.[128]

Queen Victoria's fond association with the French royal family was greatly strengthened by the marriages of three of Louis-Philippe's children to members of the Saxe-Coburg-Gotha line. In 1832 the eldest daughter, Louise, had married Leopold I, King of the Belgians, who was uncle of both Queen Victoria and Prince Albert (see no. 5). Members of Louis-Philippe's extended family gathered at Eu for the visit of Queen Victoria and Prince Albert and were shown there in Winterhalter's painting (plate 41.1).

The fan leaf records the moment on 2 September when Queen Victoria and Prince Albert were formally greeted by their French hosts on the quay at Tréport. The same event — but from different viewpoints — was recorded in two watercolours by Eugène Lami in the Royal Collection (see plate 59.1).[129] These belong to the series of thirty-two watercolours recording the 1843 visit, presented by Louis-Philippe to Queen Victoria at the time of his return visit, to Windsor, in October 1844. All these watercolours, by artists such as Eugène Isabey, Antoine Morel-Fatio and Siméon Fort — as well as Lami — remain in the Royal Collection.[130] It is likely that this fan was presented to Queen Victoria at the same time, in October 1844. Its original box, bearing the trade label of Vanier of Paris, has also survived.[131]

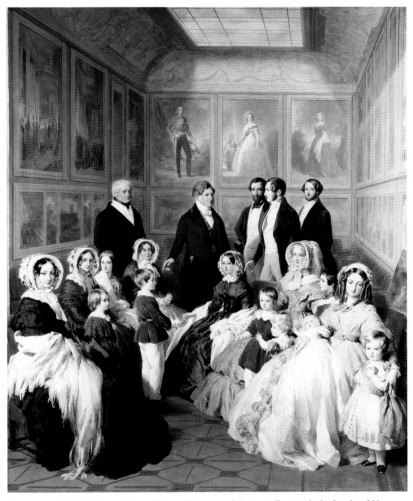

Plate 41.1. F.X. Winterhalter, *Queen Victoria and Prince Albert with the family of King Louis-Philippe at the Château d'Eu*, 1845, oil on canvas (RCIN 409251). Louis-Philippe stands in the centre, with Prince Albert in profile to the right; Queen Victoria is seated below King Louis-Philippe, with Queen Marie-Amélie to her left

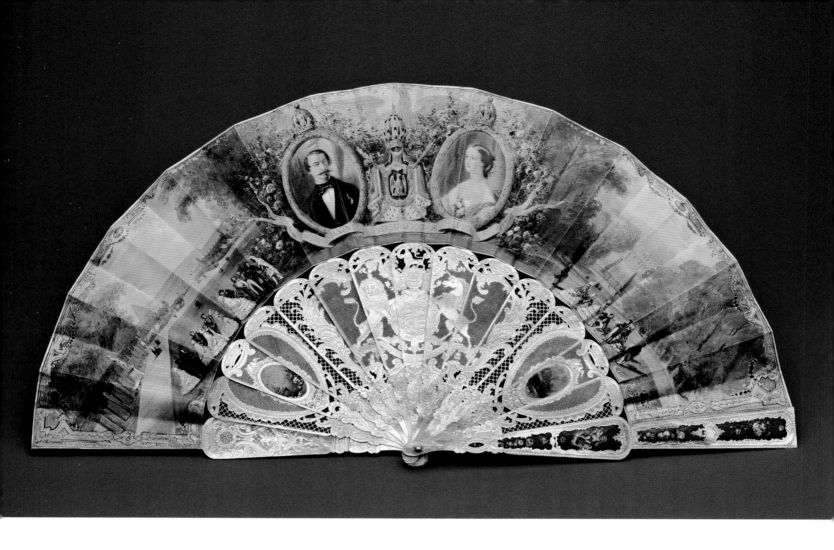

42. 'EMPEROR NAPOLEON III AND EMPRESS EUGÉNIE'
FRENCH, 1855

Just as no. 41 is a memento of Queen Victoria and Prince Albert's visit to King Louis-Philippe in 1843, so no. 42 is a souvenir of the royal couple's stay with the King's vanquisher and successor, Emperor Napoleon III, in 1855. After the Emperor and Empress had been the guests of Queen Victoria at Windsor and Buckingham Palace in April 1855, the Queen and Prince – with their two eldest children – were the guests of the imperial couple from 18 to 27 August at the Château de Saint Cloud (plate 42.1), just to the west of Paris. (The palace was destroyed during the Franco-Prussian War.) Several visits were paid to Paris and to Versailles. As with the 1843 visit, the main events were recorded in a number of watercolours which were presented to Queen Victoria by her host at the end of the year. Further painted records of the visit were commissioned by the Queen; all twenty-six of these watercolours remain in the Royal Collection.[132] However, the artist responsible for the views painted on this leaf is not known.

 The front of the fan shows bust-length portraits of Emperor Napoleon III and his wife, the Empress Eugénie, with scenes in the gardens of their chief residences – Versailles and Saint Cloud – to left and right. The portraits of the Emperor and Empress were based on recent paintings by Winterhalter.[133] The figures in the scenes at either side are doubtless intended to represent the royal and imperial families. The large British coat of arms on the gorge (see opposite) and the decoration on the fan leaf verso clearly indicate that the fan was made for Queen Victoria. It is likely that it is the fan presented to Queen Victoria by the Empress on 27 August, the last day of the visit. The Queen's entry in her Journal for that day records that the Empress 'gave me a beautiful fan, and a rose and a heliotrope from the garden'.[134] Old records state that the fan was bought by Queen Victoria at the Exposition Universelle of 1855. During the course of her three visits to the exhibition, which was one of the principal reasons for the royal visit to France, Queen Victoria is known to have purchased a fan, a bronze, and some Lyons silk.[135]

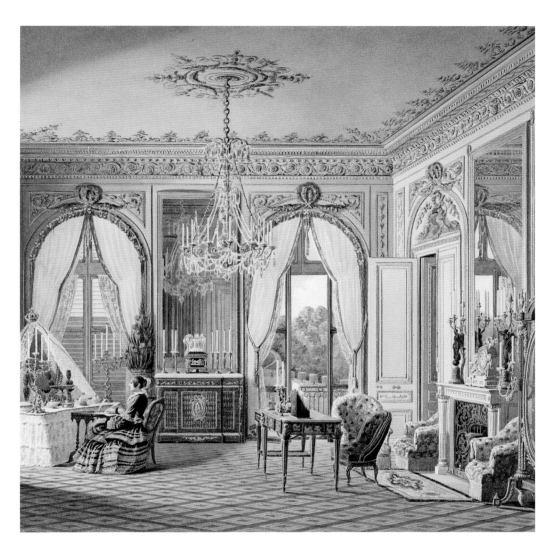

Plate 42.1. Jean-Baptiste Fortuné de Fournier, *Queen Victoria's dressing room at St Cloud*, 1855; watercolour (RL 20063)

No. 42 recto (detail)

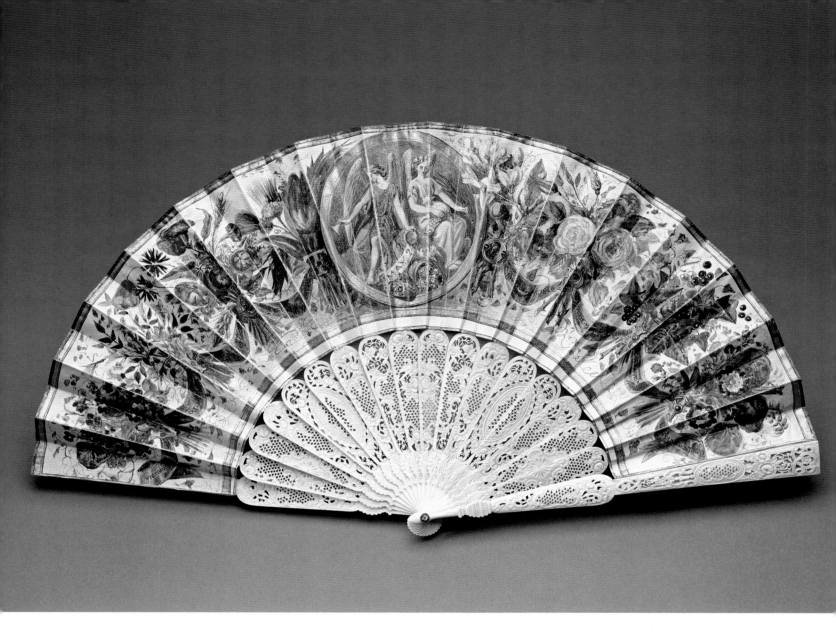

43. THE PRINCESS ROYAL'S FAN

ENGLISH, 1856

This fan was a thirty-seventh birthday present to Queen Victoria from her eldest child, the 15-year-old Princess Royal (1840–1901), on 24 May 1856. The painted fan leaf is one of the most charming examples of the artistic work of the Princess, who was active in a variety of media – watercolour, oil and marble – throughout her life. Her principal teacher was Edward Henry Corbould (1815–1905), the illustrator and watercolour artist who was appointed drawing master to the princes and princesses in April 1852. The Princess had become unofficially engaged to Prince Frederick William (later Emperor Frederick III) of Prussia in October 1855; the engagement was announced in April 1856 but the marriage was delayed until January 1858, by which time the Princess Royal was 17 years old. After 1858 she lived chiefly in Berlin and Potsdam.

The front leaf contains a central roundel with allegorical figures symbolic of Fame and Peace, and a scroll bearing the date of the Queen's birthday. At each side there are four bouquets of flowers, linked by a purple stole. The stole is inscribed with the names of the Queen's eight children; her last child, Princess Beatrice, was born in April 1857, a year after the delivery of this fan. In front of each bouquet are capital letters spelling the Queen's name, *VICTORIA*. The flowers in each bouquet are chosen to correspond with the relevant letter. Thus the first bouquet (V) contains violets; the third (C) includes columbines, cornflowers and corn ears, and so on.

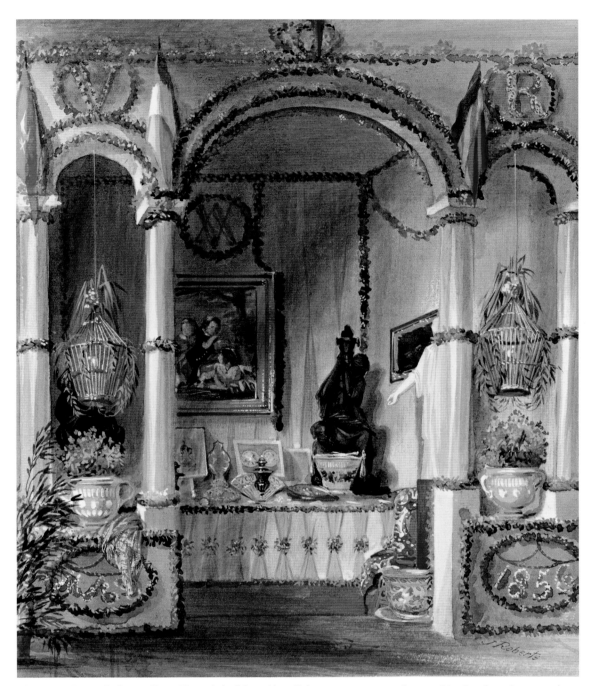

Plate 43.1. James Roberts, *Queen Victoria's birthday table at Osborne*, 1856; watercolour and bodycolour (RL 26522).
No. 43 is shown behind a vase in the centre of the table

In 1856 Queen Victoria spent her birthday at Osborne. Her presents were laid out, as in previous years, and a painted record of the Birthday Table – including this fan – was made for the Queen (see plate 43.1).[136] In her diary entry for that day, the Queen noted: 'I got charming things also from dear Mama & the Children, Vicky having given me a lovely fan, which she had painted herself, emblematical of my name and of those of all the Children.'[137]

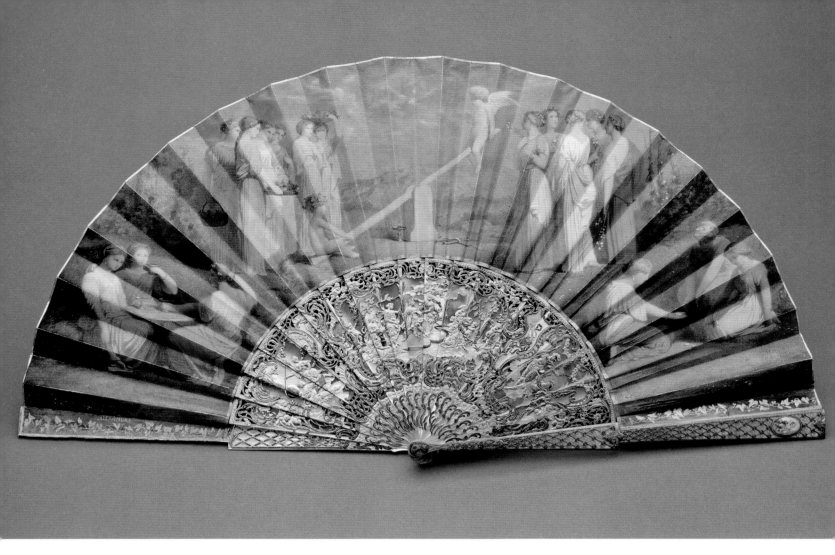

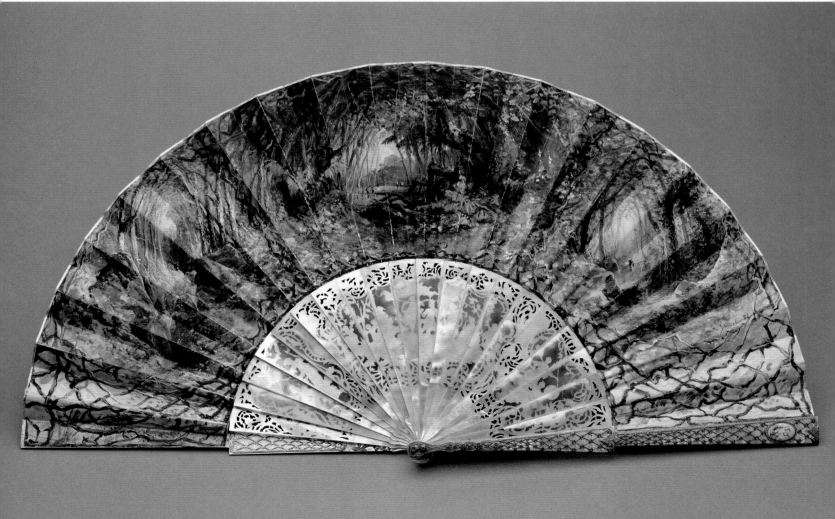

44. 'LA BALANÇOIRE'

FRENCH, 1857–8

The romantic subject-matter of the principal of the two fan leaves was explained in the obituary of the designer (Hamon) published in 1875: 'the figures at either end of the see-saw are Amor (Love), with open wings, at the top, and Hymen (goddess of marriage, her head crowned with flowers), with closed wings, at the bottom. The female onlookers are divided into four groups, becoming less carefree with increasing years and experience (of love).'[138] Inscriptions on the front leaf indicate that the fan was produced by the fan-maker Félix Alexandre of Paris. The front leaf is dated 1857 while the back leaf is dated 1858. Alexandre made many of the finest fans between 1855 and 1875 (when he sold his business), winning prizes in the major competitions where his chief competitor was Duvelleroy. By 1856 he appears to have occupied the position of *éventailliste* to the Empress of France, to Queen Victoria, and to the Russian Tsarina.[139] Loans from the Empress and the Tsarina, and from the Queen of Spain, were among Alexandre's exhibits at the Paris Exposition Universelle in 1867, and at the South Kensington Loan Exhibition of Fans in 1870. As well as decorating some of the fan leaves himself, Alexandre employed a number of fine professional painters for particular fans, in this case Paul Hervy (*fl.*1850s) and Hippolyte Omer Ballue (1820–67).

The front leaf was copied by Hervy from a design by Jules Louis Hamon (1821–74), fan-painter to the Empress Eugénie. As well as being closely associated with the Sèvres porcelain works, Hamon produced a number of fan leaves, most of which were associated with the subject of love or marriage.[140] There is another fan painted by P. Hervy in the Royal Collection. Inscribed *Alexandre à Paris* and dated 1854, it shows a village wedding scene. Unlike the present fan, which was a gift to Queen Alexandra, the 1854 fan belonged to Queen Victoria.[141] The verso leaf of no. 44 was painted by Hippolyte Omer Ballue, a professional painter whose oeuvre included landscapes, allegories, pastels and theatrical designs.[142]

Overleaf: detail of the gorge of no. 44 recto

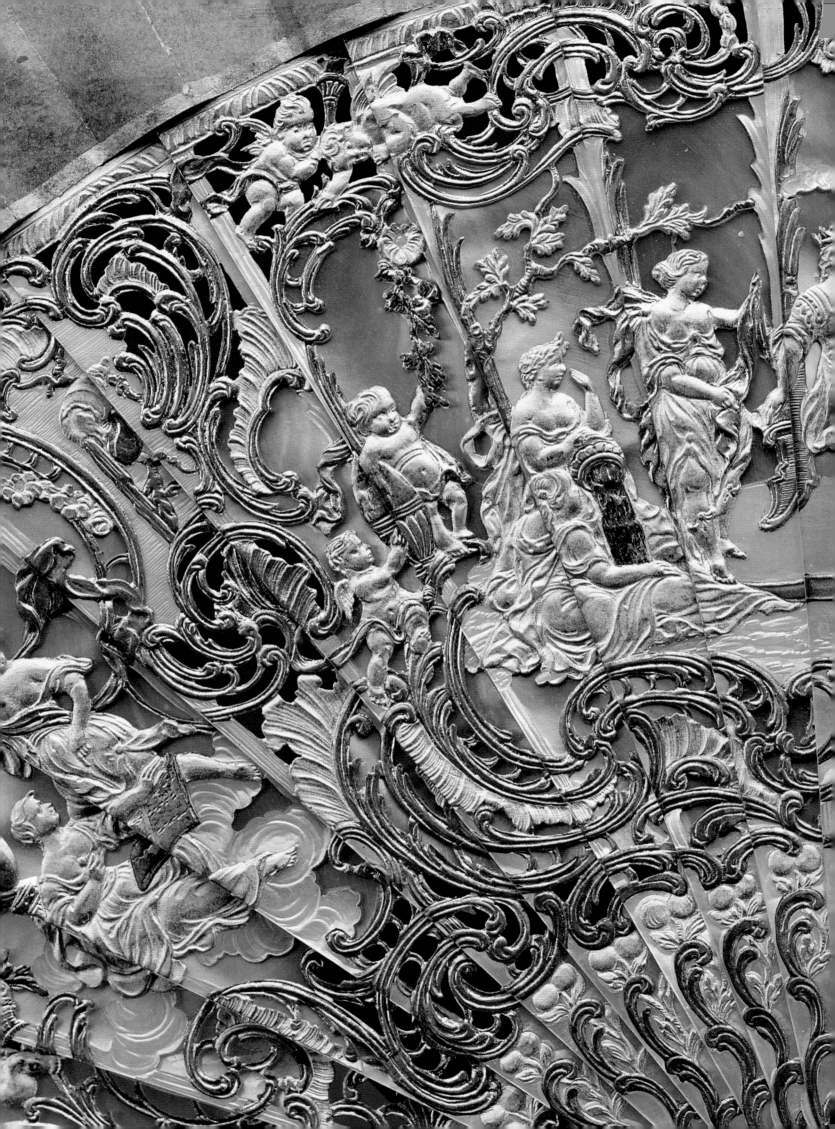

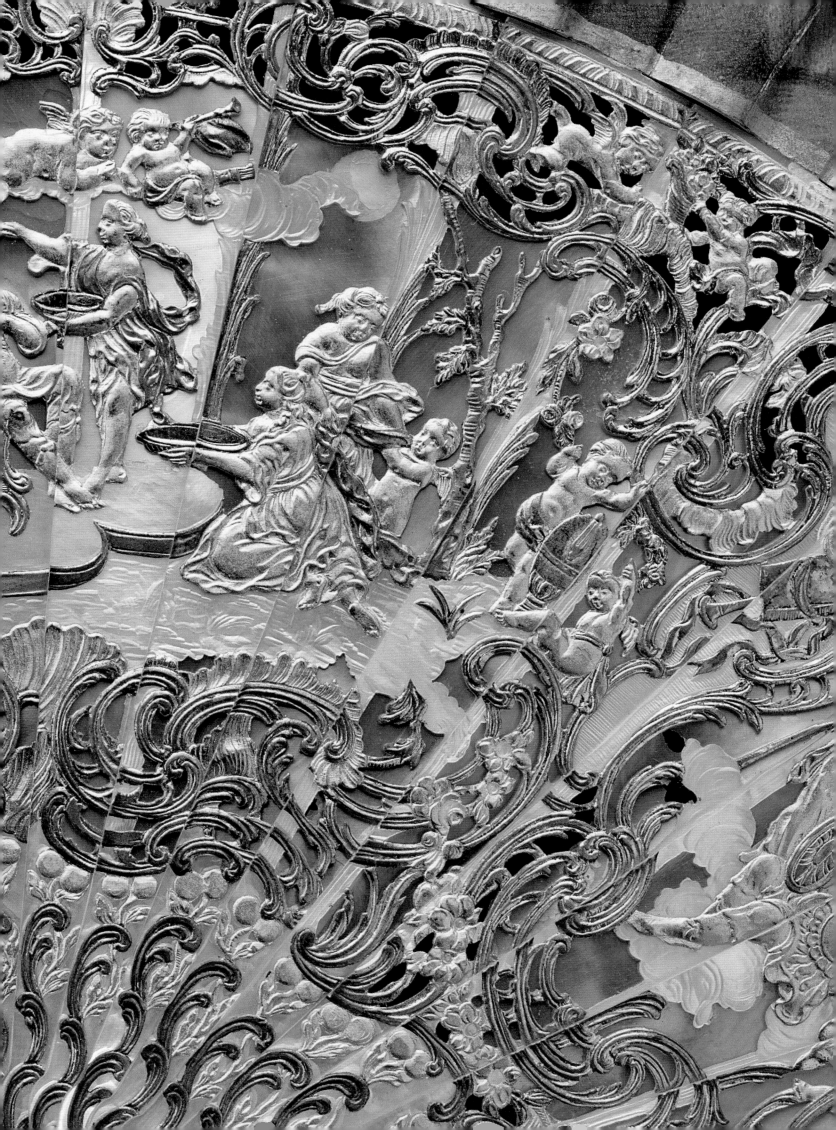

45. QUEEN VICTORIA'S BIRTHDAY FAN

FRENCH, 1858

Fans of this form were popular in Europe from the mid-nineteenth century.[143] In these fans, which may derive from Chinese painted feather fans, the decoration continues from leaf to leaf. In the present case the decoration includes the emblems of the British Isles — rose, shamrock and thistle — with swags of lilies-of-the-valley and ribbons. In the centre of the leaf is Queen Victoria's monogram *VR* surmounted by a crown, while in the centre of the gorge is the Queen's cipher, employing the letters *VR* and *A* (for her first name, Alexandrina),[144] with her crown and the date 24 May 1858, her thirty-ninth birthday. Flower symbolism was very popular during the Victorian period and lily-of-the-valley was the 'birth flower' of the month of May. Queen Victoria's thirty-ninth birthday was spent quietly at Osborne, with the remaining members of her family. She is shown holding the fan in a photograph taken in 1860 (plate 45.1).

This fan survives with its original box — similarly decorated with flowers, monogram and crown — bearing the trade label of Mme Rebours of 17 Rue Rousselet, Faubourg Saint-Germain, Paris. A very similar fan, also dated 1858 but with a different flower decoration and a crowned *V* (rather than *VR* as here), was made for the Princess Royal at the same time.[145] 'Madame Rebours (Alexandrine)' received a royal warrant on 20 December 1858, which may be associated with the production of these fans.[146]

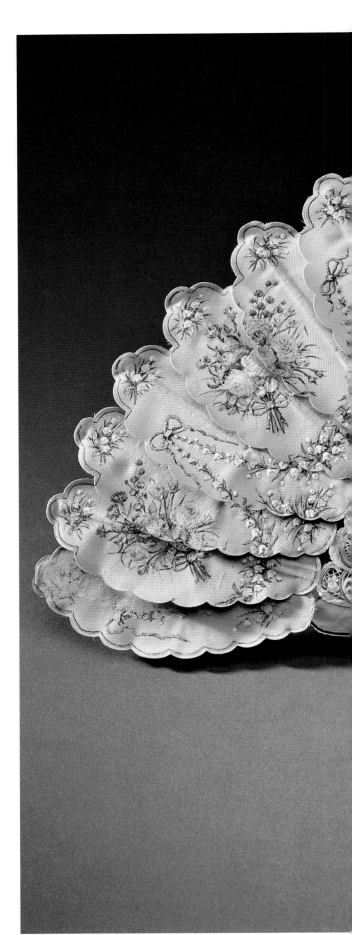

Plate 45.1.
Queen Victoria,
1860; photograph
by unknown
photographer
(RCIN 2912657)

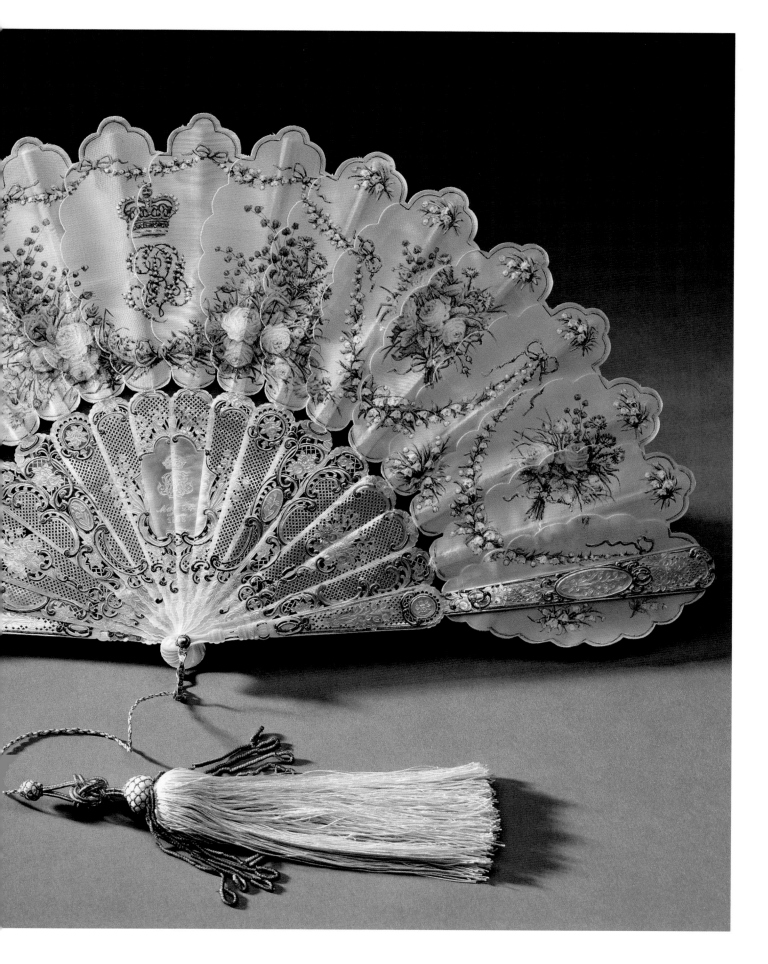

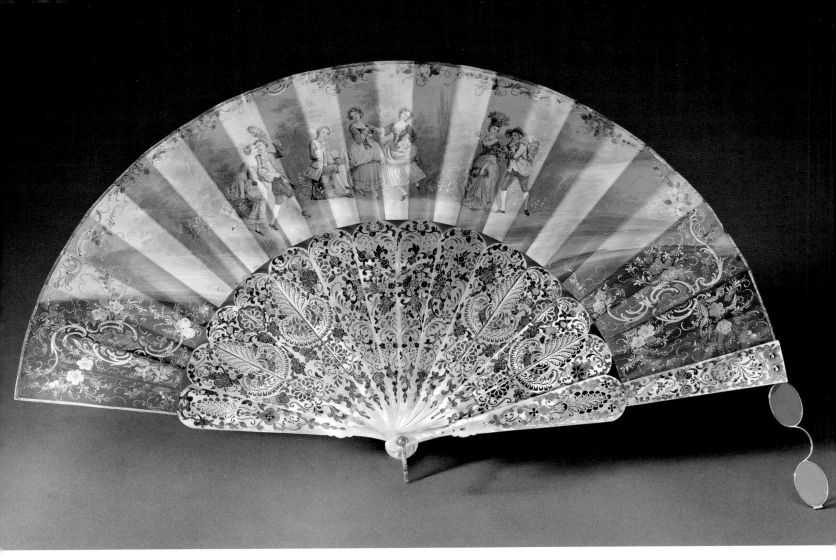

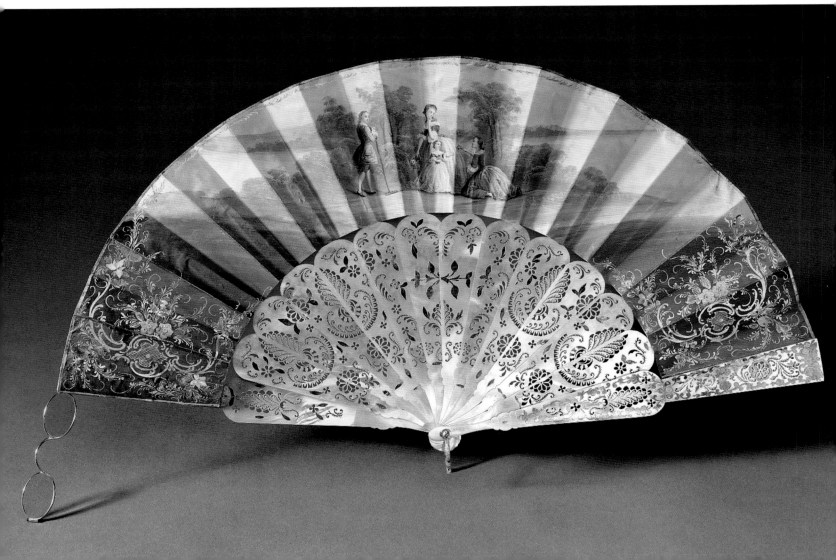

46. 'APRÈS LES VENDANGES'

FRENCH, c.1860

An article on Queen Mary's fans included the following comment on the present fan: 'A useful and unusual detail in this fan, which can be clearly seen in the illustration, is the lorgnon, which, working on a spring, can be hidden under the *panache* when not wanted.'[147] In the course of the nineteenth century, numerous patents were taken out in Paris for fans of ever more ingenious construction and variety of attachments.[148] Patents for fans with lorgnettes attached to guard sticks were issued in 1838, 1855, 1867, 1888 and 1899. Of these the penultimate, the 'Eventail-lorgnon' registered by Hermine Baeder in 1888, is closest in design to the present fan.[149]

The fan leaf is a hand-coloured lithograph printed on paper, a popular medium for fan leaves throughout Europe by the mid-nineteenth century. There was still a burgeoning market for fans with the construction and appearance little changed from the eighteenth century, hence the desire to introduce novelties such as patent mechanisms. Fans such as this are generally described as having been made for the Spanish market. No. 46 had belonged to Queen Mary's mother, Princess Mary Adelaide, the second daughter of Prince Adolphus, Duke of Cambridge (seventh son of George III); in 1866 Princess Mary Adelaide married Francis, Prince and Duke of Teck. The couple were based chiefly in England, but also travelled frequently to Germany and spent a prolonged period in Florence where it was possible to live well at less expense than in London. Queen Mary was Princess Mary Adelaide's only daughter and inherited a number of her fans, including no. 24.[150]

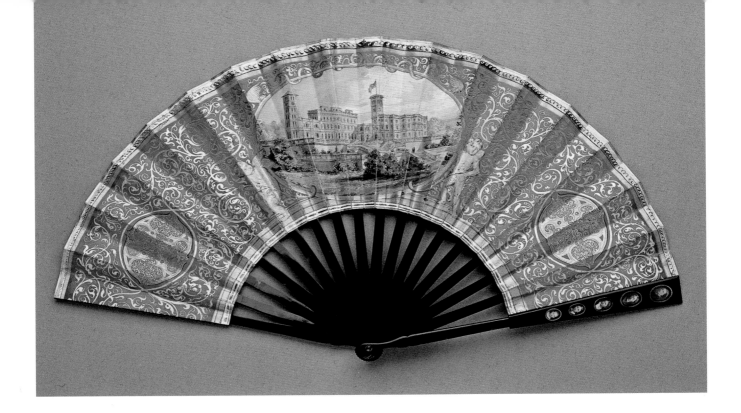

47. 'OSBORNE HOUSE'

ENGLISH, 1861

Both fan leaf and guard sticks indicate a very close association with Queen Victoria. Osborne House, Queen Victoria's marine villa on the Isle of Wight, is shown in the central oval, supported by two putti. The new house at Osborne was built between 1845 and 1851 to the designs of Prince Albert and Thomas Cubitt, as a summer retreat from court life. It was a favourite residence of the royal family from the time of its completion. Queen Victoria died at Osborne in 1901.

The guards are set with ten hand-coloured photographic portraits of members of Queen Victoria's family. On the front guard are the five daughters: the Princess Royal (later the Empress Frederick of Germany) and Princesses Alice, Helena, Louise and Beatrice. On the back guard are the Prince Consort and the four sons: Albert Edward, Prince of Wales (later King Edward VII), and Princes Alfred, Arthur and Leopold. There is no portrait of Queen Victoria. All the photographs come from full-length images, eight of which were taken by J.J.E. Mayall, at dates between March 1860 and July 1861; the photograph of the Prince of Wales taken in 1859 is probably also from an original by Mayall. The portrait of Princess Alice was taken by Camille Silvy in 1861. The upper portrait on each guard is signed by Heath & Beam, a London firm employed by the royal family between 1861 and 1863. The firm was probably also responsible for the reductions and hand-colouring of the remaining portraits.

Both leaves are signed by Emma Roberts, whose father James Roberts (c.1800–1867) was much employed by Queen Victoria between 1848 and 1861 to paint watercolour views of the interiors of her homes (pl. 43.1). Until the Revolution of 1848, father and daughter lived in Paris, where they both gave drawing lessons. In the Royal Archives are records of payments to Emma Roberts for small illuminated drawings, and for a fan intended for Princess Alice's marriage, which may be identified with the present fan.[151]

Princess Alice (1843–78) was Queen Victoria's second daughter. She became engaged to Prince Louis (later Grand Duke) of Hesse in November 1860. Although there were discussions about the forthcoming marriage throughout 1861, the ceremony was delayed until July 1862 owing to the deaths of the Duchess of Kent and of Prince Albert, respectively the Princess's grandmother and father, in March and December 1861. Emma Roberts was paid for Princess Alice's fan in August 1861;[152] after Prince Albert's death the joyful memories (or 'souvenirs') conjured up by the view of Osborne House may no longer have been considered appropriate. This could explain why the fan was retained by Queen Victoria rather than being presented to Princess Alice, for whom it had been intended.

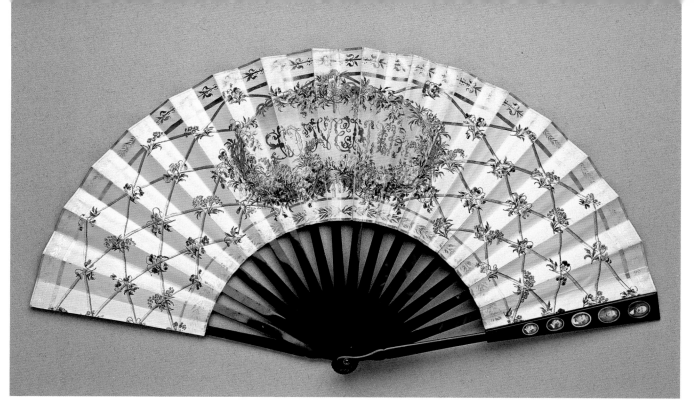

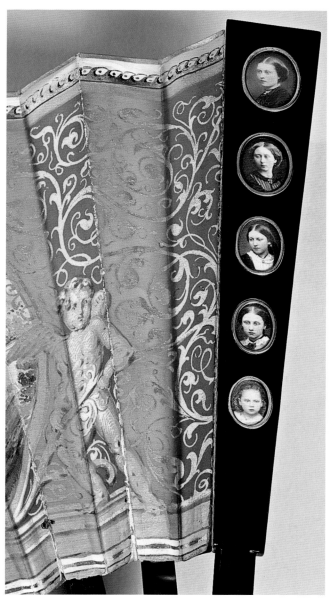

Detail of the front guard of no. 47

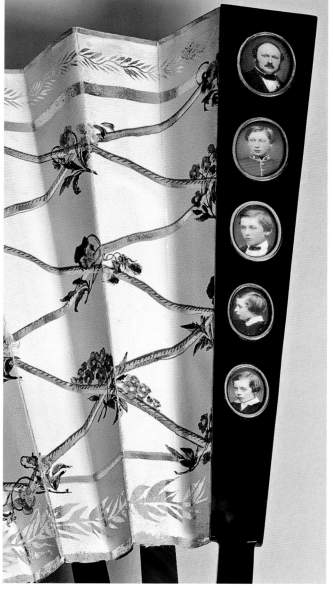

Detail of the back guard of no. 47

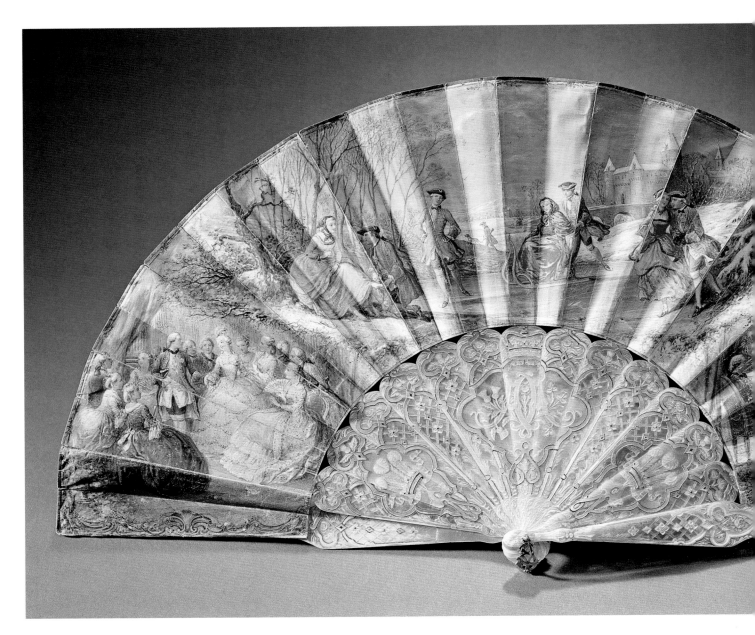

48. 'A SKATING SCENE'

FRENCH LEAF; FRENCH OR ENGLISH GUARDS AND STICKS, 1863

Like no. 49, this fan was a wedding gift to the future Queen Alexandra in 1863. The donor was Queen Victoria's half-sister Feodora (1807–72), who had married Ernest, Prince of Hohenlohe-Langenburg (1794–1860), in 1828. Following the death of her husband, the Princess settled in Baden, but kept in close touch with Queen Victoria and her English relations. According to a contemporary list of Princess Alexandra's wedding presents, this was one of two fan mounts 'painted with various figure subjects, in the style of the time of Louis Quinze'. The second fan is probably identifiable with another, also signed *Gimbel f.*, in the Royal Collection.[153] The original box for the latter fan has survived, with the trade label of Howell James & Co., 5, 7 and 9 Regent Street, Jewellers to Her Majesty. It is likely that the two 'mounts' (i.e. leaves) presented to Princess Alexandra by Feodora were mounted by this London firm. Howell & James supplied a large number of items to the court as mercers to both the Queen and the Prince of Wales. In addition to fabrics and textiles, they sold small goods, jewels and perfume, and were evidently closely involved in the production of fans such as no. 51.[154] The guards and sticks of these fans, which

may also have been made in France, are appropriately decorated with royal arms, Prince of Wales's feathers, and the initials of the bride and groom – two *A*s and one *E*, for Alexandra and Albert Edward. The initials *A* and *E* form the gold loop of the present fan (see detail below).

The leaf is decorated with three scenes of eighteenth-century courtly life: dancing, skating and music-making.[155] Princess Alexandra was renowned for her skill in each of these activities. She was ice-skating on the frozen lake in the gardens of Frogmore House, Windsor, shortly before the premature birth of her eldest child, the Duke of Clarence, in January 1864. The Gimbel brothers (George and Charles) of Strasbourg were prolific copyists of early fans in the 1840s but later painted fan leaves to their own designs. George Gimbel was still exhibiting at the Paris Salon in 1880.[156] Nothing is known of the artist Jenny Boucher who signed the verso.

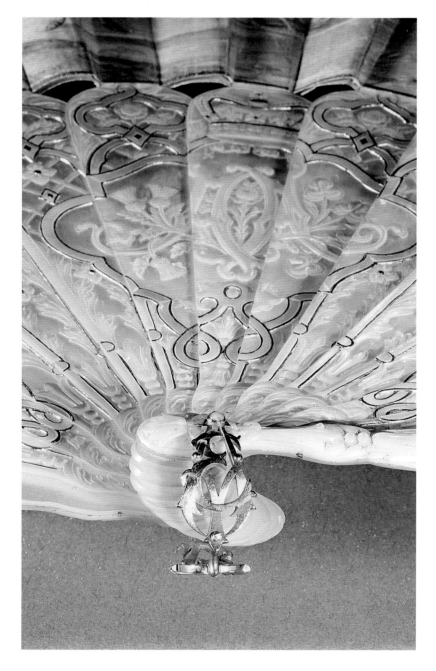

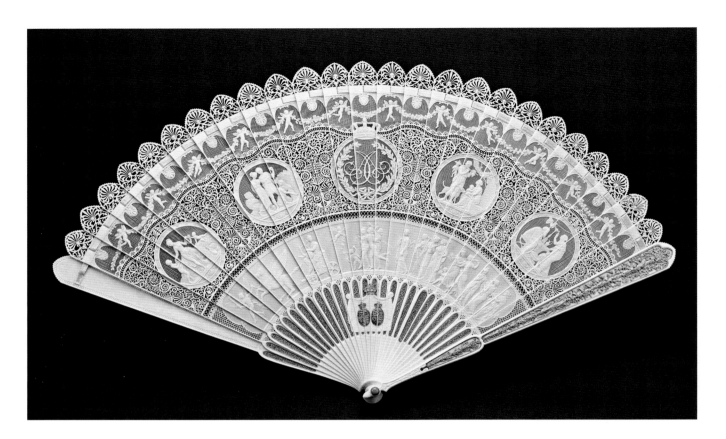

49. PRINCESS ALEXANDRA'S DANISH FAN

DANISH, 1863

This fan, made in Denmark in 1863 as a wedding present for Princess Alexandra of Denmark (the future Queen Alexandra) from a group of Danish ladies, combines astonishing skill in ivory-carving with carefully contrived decoration incorporating symbolism that was particularly appropriate to the circumstances of the commission. Thus the gold decoration of the guards incorporates plants symbolic of the British Isles (roses, shamrock, thistles), bound with a chain of ivy and with oak leaves, ears of corn and cornflowers; there is a bouquet of forget-me-nots below. The central element of the fan itself is a roundel – below the Danish crown – containing two conjoined *A*s, the initial letters of the first names of both the Princess and the Prince of Wales. The gold decoration in the centre of the gorge includes the royal arms of Denmark and the arms of the Prince of Wales. Appropriately, a turquoise is applied to the head of the pin: it is the birthstone for December, the month of the Princess's birth.

With the exception of the central medallion, the extraordinarily delicate carving on the sticks consists of four circular medallions above a frieze, in each case derived from models by the Danish Neoclassical sculptor Bertel Thorvaldsen (1770–1844), whose work was greatly admired by the future Queen Alexandra. The four medallions at either side contain copies of reliefs of the Four Seasons combined with the Ages of Man, executed in Rome in 1836; from left to right, Spring–Childhood, Summer–Youth, Autumn–Manhood, Winter – Old Age. The plaster models and the marble carvings are in the Thorvaldsen Museum, presented by the sculptor to his home town of Copenhagen.[157] Below the medallions is a frieze with figures of Apollo in his chariot, the Graces and the Muses, alluding to wedding festivities. Above is a border of Cupids holding wreaths of flowers. The carving was executed by the sculptor Christian Carl Peters (1822–99), who trained in the Copenhagen Academy before studying in Italy (1850–55); he was professor of the Copenhagen Academy from 1868 to 1889. The gold decoration on the sticks was the work of V. Christesen.

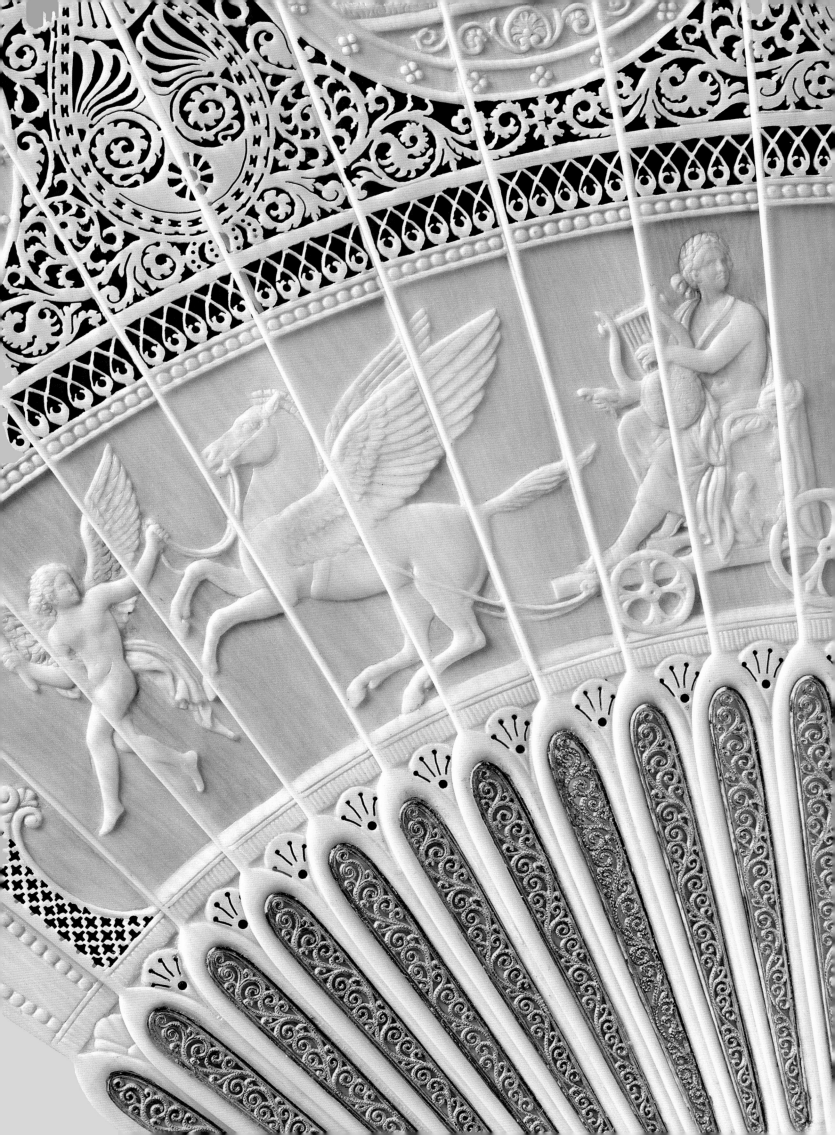

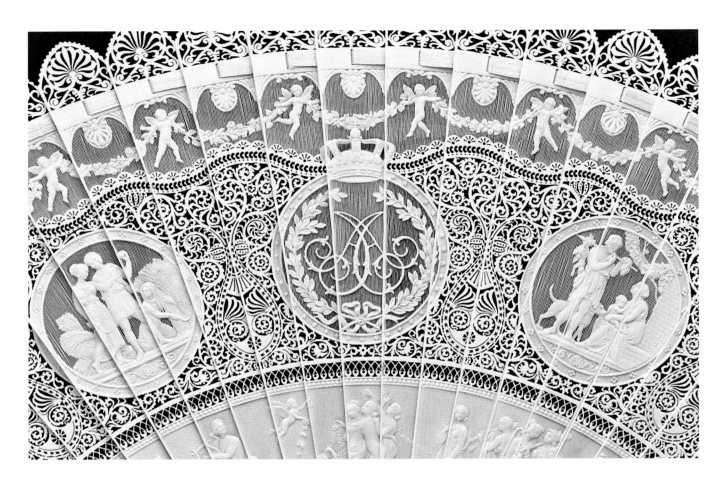

The fan was produced by the Copenhagen firm of I.G. Schwartz & Son, established in 1801 by the carver and turner Johan Adam Schwartz, who had emigrated from Büdingen, near Hanau. Four years later he was joined by his nephew, Johan Georg Schwartz, who took over the running of the business and at the age of 23 became purveyor to the Danish Royal Household. Their wares were widely exhibited in the nineteenth century and the firm continues in operation in Copenhagen to this day. At the time, great pride was taken in the display of Danish workmanship in this fan: 'Danish industry can with satisfaction let the capital of the world [London] view such a piece of craftmanship, by which Messrs Schwartz & Son, the sculptor C. Peters and the skilful worker, who in the short period of four months has completed it, have highly distinguished themselves.'[158] Louis Griesing, who signed and dated the reverse of one of the sticks, may be identifiable with the unnamed 'skilful worker'.

The fan is not mentioned among the list of wedding presents published in the official souvenir of the royal wedding and may not have been ready at the time (10 March 1863). The fan passed from the Queen's daughter Victoria to the Queen's goddaughter Alexandra, Lady Worsley, who presented it to Queen Elizabeth in 1949.[159] In 1869 Schwartz produced a similar fan for the wedding of Princess Louisa of Sweden and Norway to Princess Alexandra's brother, Frederick (later Frederick VIII of Denmark). That fan was a gift to the bride from the Danish ladies born in Norway and Sweden.[160]

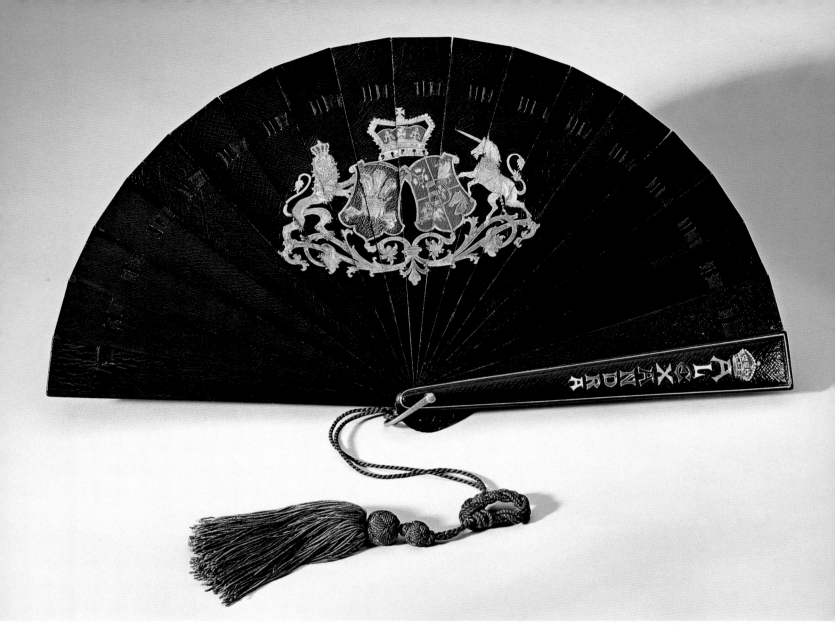

50. *BRISÉ* LEATHER FAN
AUSTRIAN, *c.*1866

This fan is one of three of very similar design, each bearing the names of their original owners on the front guard. These were the three daughters of King Christian IX of Denmark (*reg.*1863–1906): Alexandra (no. 50), Minny (christened Dagmar)[161] and Thyra.[162] As the first two fans include the coats of arms of both Denmark and the countries into which the two princesses married (Great Britain and Russia), they must post-date their weddings, respectively in March 1863 and November 1866. The third sister, Thyra, was born in 1853, and married in 1878;[163] her fan includes only the Danish royal arms.

The fans are typical products of the Viennese fan industry of the period. Superb fans were already produced in Vienna in the eighteenth century. However, early in the nineteenth century new types of *brisé* fans began to overwhelm the previously traditional output. These fans were initially made of wood, then leather-covered wood, then (as here) leather-covered board. The feather fans which enjoyed such a vogue at the end of the century (see nos. 66 and 67) emerged from this earlier fashion. The Viennese fan-makers were second only to their Parisian counterparts in the quality and quantity of their goods. Viennese fans were widely available, both throughout the Austro-Hungarian Empire and elsewhere. There were five agents for Viennese fans in Paris in 1900.

The surviving box of Princess Thyra's fan bears the trade label of Gebrüder Rodeck of Vienna, who were almost certainly also the suppliers of the fans for Princesses Alexandra and Minny.[164]

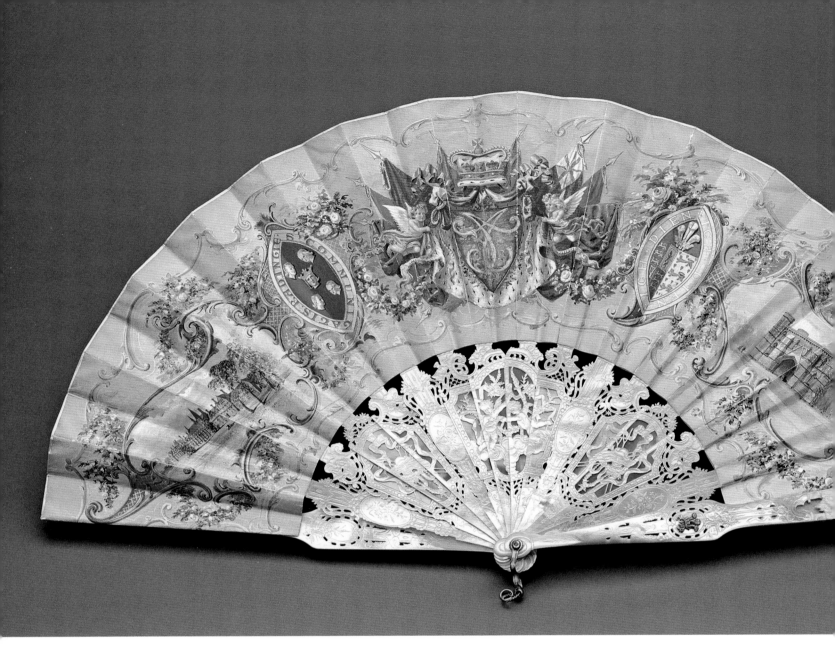

51. THE READING FAN

ENGLISH LEAF; ?FRENCH STICKS, 1870

This fan was presented to the Princess of Wales on the occasion of the laying of the foundation stone of Reading School by the Prince of Wales on 1 July 1870 (the date inscribed on the verso). The new school, built to the designs of Alfred Waterhouse (1830–1905), replaced that founded by Henry VII and was erected under the terms of the Reading School Act passed in 1867. The foundation ceremony was described in full in the Court Circular. After the delivery of the Mayor's address to the Prince of Wales, and the Prince's response,

> An address, happily not read, was then handed to the Princess in a very novel form. It was reduced by photography, and appended to a fan mounted in mother of pearl, delicately carved, and mounted with gold. Attached to the fan was a solid gold vinaigrette, having on one side the coronet and monogram of the Princess, and an inscription setting forth the occasion of its presentation.

In the centre of the fan leaf are two intertwined *A*s surmounted by the Prince of Wales's coronet. At either side are views of Reading School and Reading Abbey, with the arms of Reading and of the Princess of Wales.

The Minutes of the Reading Borough Council for 1 July 1870 record that 'The Town Clerk also submitted to the Council the illuminated Fan mounted in Pearl, with Gold Vinaigrette attached which under the direction of the same Committee had been executed by Messrs Howell James & Co for presentation by the Mayor and Corporation to Her Royal Highness the Princess of Wales.'[165] Further details of the commission are not known; Howell & James[166] appear to have used French sticks, and to have sub-contracted the decoration of the fan leaf to Marcus Ward, whose signature it bears. Ward had started a company producing greetings cards at the Royal Ulster Works, Belfast, during the 1860s. The firm became noted for the high artistic quality of their cards and a branch was opened in London in 1867. Marcus Ward also produced a number of illuminated addresses, many of which included vignetted views of buildings in the borders. In *The Royal Illuminated Book of Legends*, published in Edinburgh *c.*1885, Marcus Ward – who provided the illustrations – is described as Illuminator to the Queen. As he is not known to have worked as an artist himself, the fan leaf was probably painted by one of the firm's professional decorative artists.

From the indentations in the fitted fan box (plate 51.1), it is clear that the fan was originally associated with both a circular vinaigrette and a miniature fan, the leaf of which presumably bore the photographic transcript of the Mayor's address mentioned in the Court Circular. Early descriptions indicate that these were attached to the main fan (no. 51) via a blue enamel A and a crown, which was suspended from the loop. Unfortunately these have become divorced from the fan and their present whereabouts are not known.

Plate 51.1. The fan box for no. 51 (RCIN 25409.b)

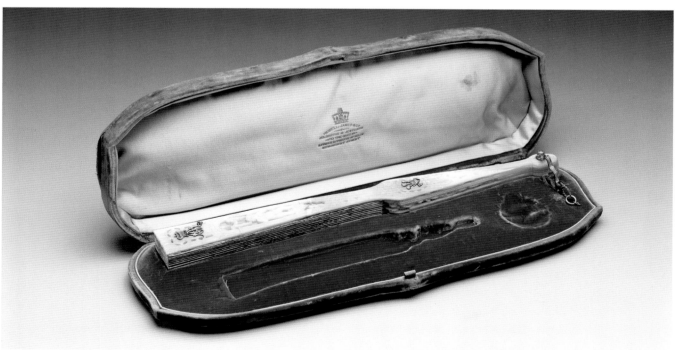

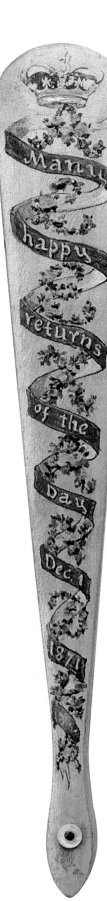

52. PHOTOGRAPHIC FAN

AUSTRIAN; DECORATED IN ENGLAND, 1871

Numerous plain *brisé* fans with wooden sticks were exported from Vienna in the second half of the nineteenth century, to be decorated either by professional artists or by amateur artists working at home. In this case the sticks bear small photographic portraits of the children of the Prince and Princess of Wales, thus ensuring that the fan would be a particularly fitting birthday present for the Princess in December 1871. The children are (from left to right) Princess Victoria (photographed ?by W. & D. Downey, 1870), Prince Albert Victor (later Duke of Clarence; photographed ?by Hills & Saunders, 1868), Princess Louise (later Duchess of Fife; photographed by Hills & Saunders, May 1869), Prince George (later King George V; photographed by Hills & Saunders, c.1868) and Princess Maud (later Queen Maud of Norway; photographed ?by W. & D. Downey, 1870).

Neither the donor nor the creator of this charming fan is recorded. However, they must have been closely associated with the royal family, for the photographs of the royal children which it incorporates

Plate 52.1. *The Princess of Wales and Princess Louise of Wales*, September 1868; photograph by W. & D. Downey (RPC 01/0238/21)

would not have been accessible to others. This fan would have been a particularly poignant gift following the death of the Princess's sixth child, Prince John, on 7 April 1871, twenty-four hours after his premature birth. Then in late November the Prince of Wales fell seriously ill; typhoid was diagnosed and by the day of the Princess's birthday the Prince was unconscious and thought to be in a terminal condition. The Prince and Princess and their family were at their new home at Sandringham at the time, and the Princess's birthday was not celebrated. As Princess Alice, Grand Duchess of Hesse, was at Sandringham supporting the Princess of Wales at the time of her birthday, it is possible that she created this rather hastily assembled but very personal gift for her sister-in-law.[167] The speed of creation is suggested by the fact that all of the photographs were outdated by over a year. The quality of decoration is not of the high level that one would expect from Princess Alice, who was an accomplished artist. She was also adept at producing decorative borders, and a number of pages in her *Hauschronik* – both written and illuminated by the Princess – include lettered ribbons as on this fan.[168]

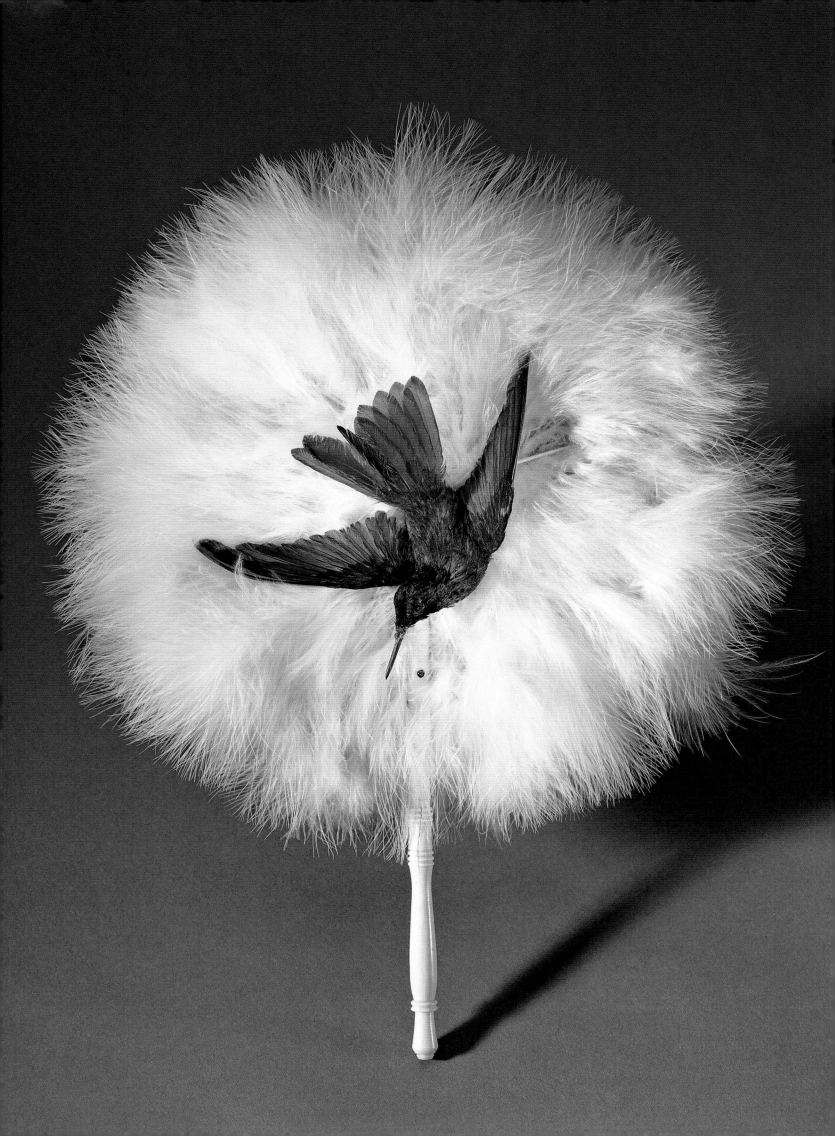

53. HUMMING-BIRD FAN

BRAZILIAN, c.1870

This 'novelty' fan is of a type produced in large numbers in Brazil in the 1870s.[169] Although no. 53 has a traditional association with Canada (and specifically with Niagara), it must have been manufactured in Brazil, where humming-birds are indigenous.

The Princess of Wales was photographed holding this fan in 1871 (plate 53.1),[170] when dressed for the Waverley Ball held at Willis's Rooms in King Street, St James's (London), to commemorate the centenary of the birth of Sir Walter Scott and to raise funds for the completion of the Scott Memorial in Edinburgh. The guests at the ball dressed as different characters in Scott's novels. The Princess of Wales was dressed as Mary, Queen of Scots, and the Prince of Wales as the Lord of the Isles. A number of the other guests (including Mrs Charles Forbes and the Countess of Shrewsbury) were also photographed holding these somewhat incongruous feather fans.

An explanation may be found in the presence of Pedro II, Emperor of Brazil, in England at the time of the Waverley Ball, and the Emperor's fondness for Scott's works. After the Emperor's visit to Windsor on 5 July 1871, Queen Victoria noted in her diary: 'He means to visit Scotland on account of Walter Scott whom he so much admires.'[171] Links between the British royal family and Brazil were also maintained through the sister of Pedro II, who was married to the Prince de Joinville, third son of King Louis-Philippe (see no. 41).

Plate 53.1. *The Princess of Wales (later Queen Alexandra) in her costume as Mary, Queen of Scots for the Waverley Ball*, 1871; lithograph, published by Beckmann Bros. after a photograph by A.J. Melhuish (RCIN 606297)

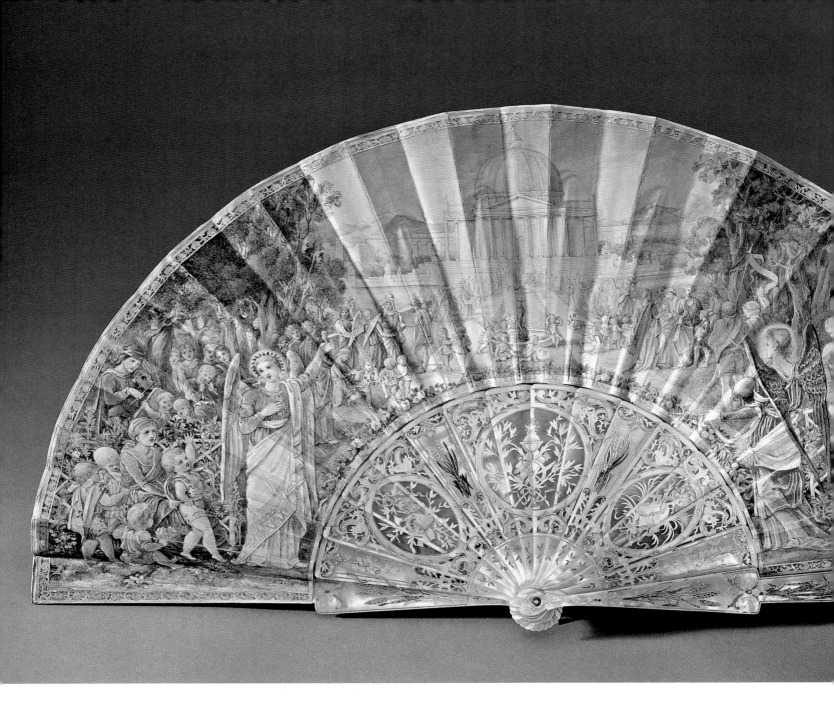

54. 'NATIONAL PROGRESS'

ENGLISH, 1877

This fan was commissioned by Queen Victoria, for her own use. The leaf is painted with emblematic scenes based on the text of Prince Albert's speech in Edinburgh, at the laying of the foundation stone of the National Gallery of Scotland in 1850.[172] Key passages from the speech, on the subject of 'National Progress', are transcribed on the verso: 'The picture of a most healthy national progress . . . Education and science directing exertion . . . The arts which only adorn life, becoming longed-for by a prosperous and educated people.' Other forward-looking subjects and tenets close to the Prince's heart are inscribed on the recto: 'Geology and Mechanics; Knowledge is Power; Education of Women'. The design of the leaf was the responsibility of Marianne, Viscountess Alford (1817–88), who explained the symbolism to Queen Victoria's Lady of the Bedchamber, Lady Ely, on 14 January 1877: 'The figure of the Genius at [the] left hand is that of Art, & on the right, the other Genius is that of Science. Both are sending their votaries up to a Temple of Instruction.'[173] At either side of the Temple are the diminutive seated figures of Queen Victoria and Prince Albert.

The design was first submitted to Queen Victoria as an unmounted fan leaf, painted on kidskin and signed by Lady Alford (plate 54.1). The Queen was evidently delighted with Lady Alford's work and had the leaf framed before hanging it at Osborne.[174] On 17 January Lady Alford wrote again to Lady Ely, to convey her thanks for 'The precious letter from the Queen in Her own beautiful handwriting full of the most kind and gracious approval of the fan.' She hoped that the Queen would allow her to add the finishing touches to the fan leaf which was to be made (by an unnamed person) using her design, 'that I may claim some share in that which will sometime be held in Her own Hand'.[175] The monogram *VRI* on both guard sticks (and on the box lid) was used by Queen Victoria following her proclamation as Empress of India on 1 January 1877, at the start of the month in which the fan design was presented by Lady Alford.

Marianne Alford was the daughter of the 2nd Marquess of Northampton. In 1841 she had married John, Viscount Alford, the son and heir of the 1st Earl Brownlow, but he died ten years later. Lady Alford spent much of her childhood in Italy and became an accomplished artist, painting fans, miniatures and illuminations and designing book illustrations, stained-glass windows and needlework. Her London home – Alford House, Princes Gate – was decorated and built by Sir Matthew Digby Wyatt in the early 1870s, to Lady Alford's designs. In 1872 she was among the founders of the Royal Society of Art Needlework in Kensington, publishing *Needlework as Art* in 1886.[176] Queen Victoria was evidently well acquainted with Lady Alford: three of her drawings were pasted by the Queen into an album used from 1833 to 1856.[177] After a meeting in April 1873, the Queen wrote of Lady Alford in her journal: 'as always, most agreeable'.[178]

The fitted fan box indicates that the fan was supplied through Duvelleroy's London branch. The back of the front guard is signed by Alfred Jorel, whose work for Duvelleroy can be traced from 1869.[179] By 1912 the fan had been placed by Queen Alexandra in a fan display case at Marlborough House (see fig. 22).

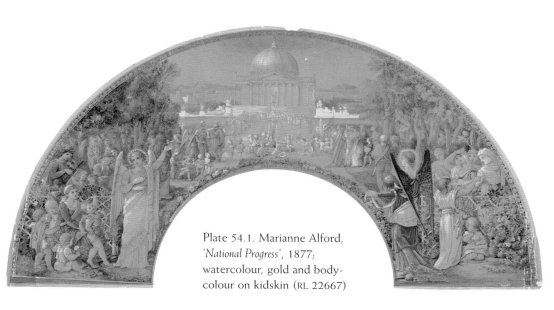

Plate 54.1. Marianne Alford, 'National Progress', 1877; watercolour, gold and body-colour on kidskin (RL 22667)

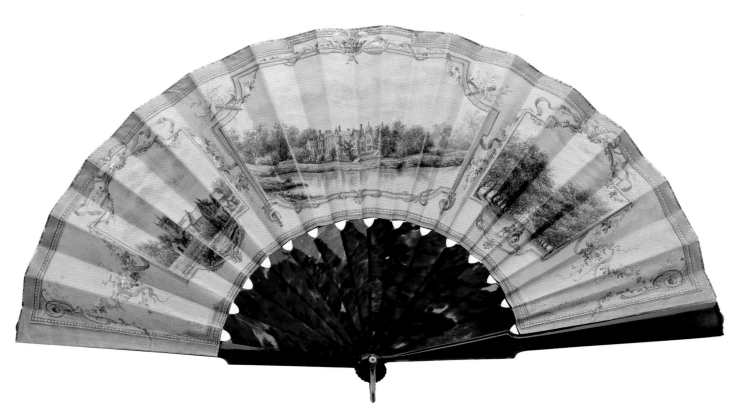

55. 'SANDRINGHAM'

ENGLISH, c.1880

Just as the previous fan is closely associated with Queen Victoria, so this fan clearly belonged to her daughter-in-law, Alexandra, Princess of Wales, whose crowned initial *A* is inscribed in the centre of the upper border. Following the Princess's marriage to the Prince of Wales in 1863, the newly acquired Sandringham estate (near King's Lynn, Norfolk) became her country residence. In the centre of the leaf is a view of the west front of Sandringham House, completed in 1870 following rebuilding. The vignette at the left contains a view of Sandringham Church and that to the right shows the Norwich Gates, to the north of the house, a wedding present to the Prince and Princess from the people of Norfolk.[180]

The fan leaf is signed C^{te} *Nils*, from whom it was presumably commissioned as a gift for the Princess of Wales. A small number of fans with the same signature are known, including two others in the Royal Collection: the first, with a view of Windsor Castle, was a birthday present from the Prince of Wales to Queen Victoria in 1877;[181] the second, with a view of the Bois de Boulogne dated 16 May 1878,[182] was presumably a gift from the Prince of Wales to the Princess, following his visit to Paris that month as President of the British Section of the International Exhibition. In the same year, 'Comte Nils of Paris' was awarded an Honourable Mention in Class II (Modern European Fans) of the first Competitive Exhibition organised by the Fan Makers Company in London. The award was made on the basis of a fan loaned by the Duchess of Bedford and presumably identifiable with the fan painted with views of the Bedford estate (including Woburn) still at Woburn.[183] Other fans signed by Nils have associations with the royal families of the Netherlands, Norway and Sweden.[184]

This prolific fan-painter would appear to be identifiable with Count Nils Barck (1820–96), a well-known collector of drawings. Although of Swedish origin, Barck lived chiefly in Paris from 1840 but made prolonged visits to both Spain and England. When the Marquis de Chennevières saw him in 1876, he commented '*il semblait n'avoir plus d'autre passe-temps que de peindre les éventails*' (he seems to have no other pastime than painting fans).[185]

56. SILK COCKADE FAN

FRENCH, c.1880

Cockade fans were made in a number of different forms: folding (no. 34), retracting (in the present case) or rigid (similar to a handscreen). Although London fan-makers took out patents for cockade fans during the nineteenth century, most of the surviving fans of that date are Parisian products. A very wide variety of these fans were made in Paris, where they were generally described as 'Chinois'.[186] Seven different designs for such fans were registered in Paris within a single year, 1868. Of these, the design of no. 56 is closest to one registered by Fritz Meyer *jeune*.[187] The fashion for cockade fans continued until the end of the century. Occasionally they were presented to ladies at dinner, when the gentlemen

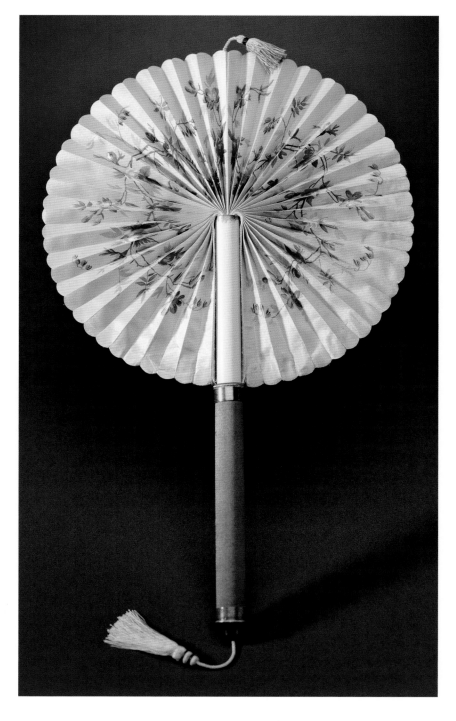

were given cigars in similar tubes. When the first Grand Magasin opened in Paris c.1890, canes with similar fans at the top were presented as souvenirs.[188]

This fan belonged to Princess Louise (1848–1939), the fourth daughter of Queen Victoria and Prince Albert. In 1871 she married the Marquess of Lorne (later 9th Duke of Argyll). Both the Princess and her husband were closely involved in the artistic life of England, Scotland and Canada, where they lived during the Marquess's appointment as Governor-General. Princess Louise was an accomplished artist, among whose surviving works is a fan leaf painted in February 1871, the subject of which is a skating scene.[189] The first Competitive Exhibition organised by the Fan Makers Company was held in 1878 under the patronage of the Princess, who lent seven fans to the fourth Competitive Exhibition in 1897. In addition to this fan and its pair, the Royal Collection contains two further fans from Princess Louise's collection.[190]

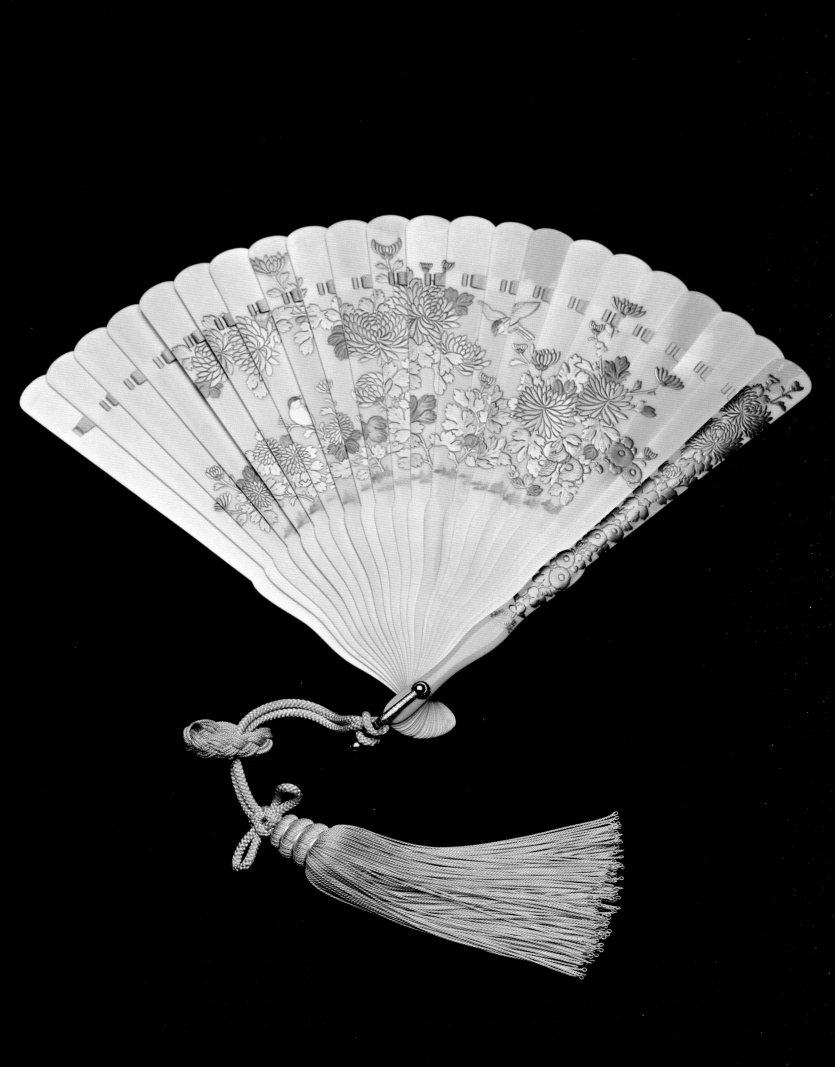

57. JAPANESE IVORY AND LACQUER FAN

JAPANESE, c.1880

This fan was a gift from Princess Chichibu (1909–95) to either Queen Mary or Queen Elizabeth in 1937. The donor, born Setsuko Matsudaira, was the daughter of Tsuneo Matsudaira, a former Japanese ambassador to Washington and London. In 1928 she married Prince Yasuhito Chichibu, the younger brother of Emperor Hirohito. Both Prince and Princess Chichibu were noted anglophiles and attended the coronation of King George VI in May 1937. In the course of Prince Chichibu's visit to England he presented the King and Queen with Japanese insignia.[191] Visits were paid to both Queen Mary at Marlborough House (on 30 April) and to the King and Queen at Buckingham Palace (on 19 May), but there appear to be no records of the presentation of this fan on either occasion.

The design – repeated in reverse on front and back – incorporates chrysanthemums (the Japanese imperial emblem) and birds. This is applied to the ivory sticks with raised gold lacquer work (*takamaki-e*). As befits a gift from a member of the Japanese imperial family, the quality of the lacquer work is extremely high. The present fan is particularly notable for the amount of gold lacquer work on both the recto and verso, and for the overall decoration with chrysanthemums. Repeated layers of lac (from tree sap) mixed with ground gold would have been involved in its creation, each layer being carefully rubbed down before the next was applied. After the lifting of the trade barrier with Japan in 1853, Japanese goods became very sought after in the West and Japanese manufacturers soon learnt to adjust their output specifically to accommodate Western taste. Fans of similar appearance to this were produced in Japan in the late nineteenth century, often for presentation to high-ranking European recipients.[192] The original lacquer box (illustrated below) is typical of a Japanese export product.

Plate 57.1. The fan box for no. 57 (RCIN 25182.b)

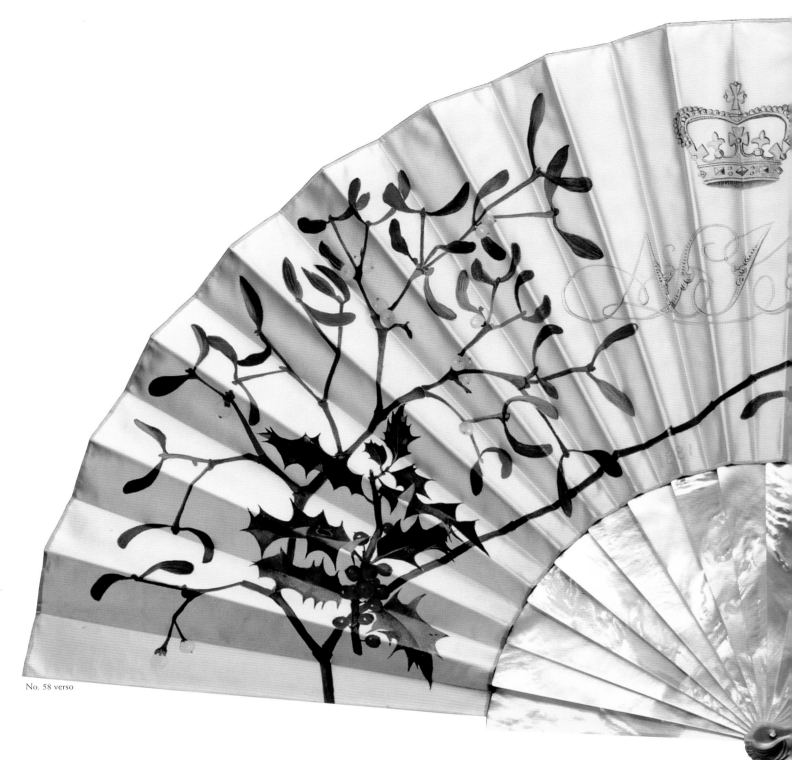

No. 58 verso

58. CHRISTMAS FAN

ENGLISH, 1881

The name *ALIX*, together with the decoration of holly, mistletoe and Christmas roses and the date *1881*, indicates that this was a Christmas present to the future Queen Alexandra in 1881. The donor was Queen Victoria, who is known to have commissioned fans from Alice Loch (who signed the recto) at this period.[193] As the fan box bears the trade label of Duvelleroy's London branch (fig. 13), it seems clear that this firm was employed to mount Miss Loch's painted leaves onto their mother-of-pearl guards and sticks.

Alice Loch (1840–1932) lived at The Cottage, Bishopsgate, close to the south-eastern boundary of Windsor Great Park. The eldest of the five daughters of George Loch, QC, MP, she studied painting in Paris in the 1860s and won an Honourable Mention for an unmounted fan at the Fan Makers Exhibition in 1878. Between 1883 and 1923 Alice's sister, Emily (1848–1931), was Lady-in-Waiting to Queen

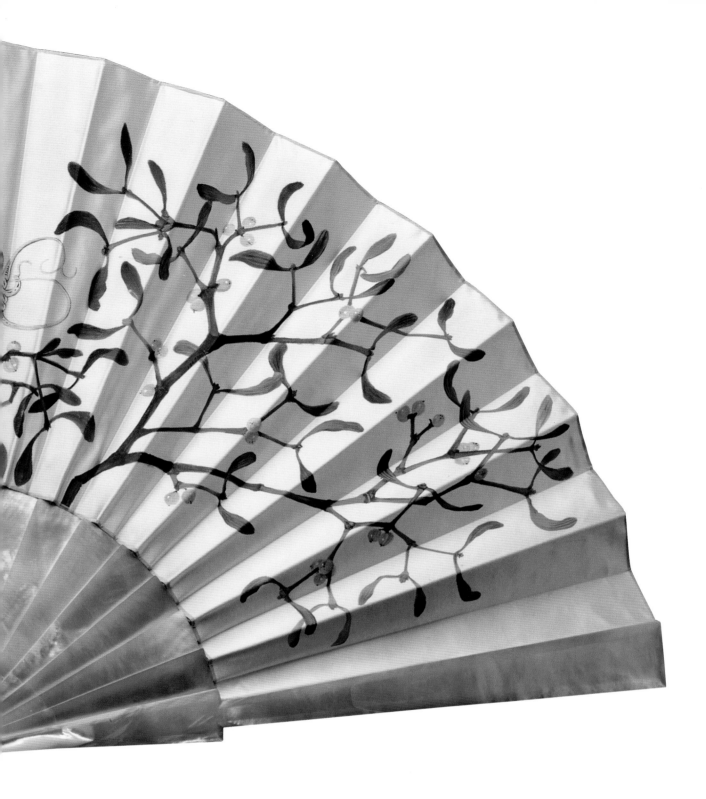

Victoria's third daughter, Princess Christian, whose chief residence was Cumberland Lodge, Windsor Great Park, close to Bishopsgate. According to Princess Marie Louise (Princess Christian's daughter), during the troubled period of her marriage in the 1890s it was suggested that she should travel overseas. 'My mother suggested that I should be accompanied by Alice Loch, the elder sister of her own lady-in-waiting. Alice was the greatest fun imaginable; brilliantly clever, she painted beautifully, was absolutely devoted to me, and we were the closest friends.'[194]

A preliminary sketch for this fan is in the collection of Duncan and Judith Poore, members of the Loch family. Another Alice Loch fan with royal provenance is painted with orange blossom. It appears to have been produced as a wedding gift – probably also from Queen Victoria – to Princess Louise of Prussia, who married (in March 1879) Queen Victoria's third son, Prince Arthur, Duke of Connaught.[195] A small number of other Loch fans are known.[196]

Overleaf: no. 58 recto

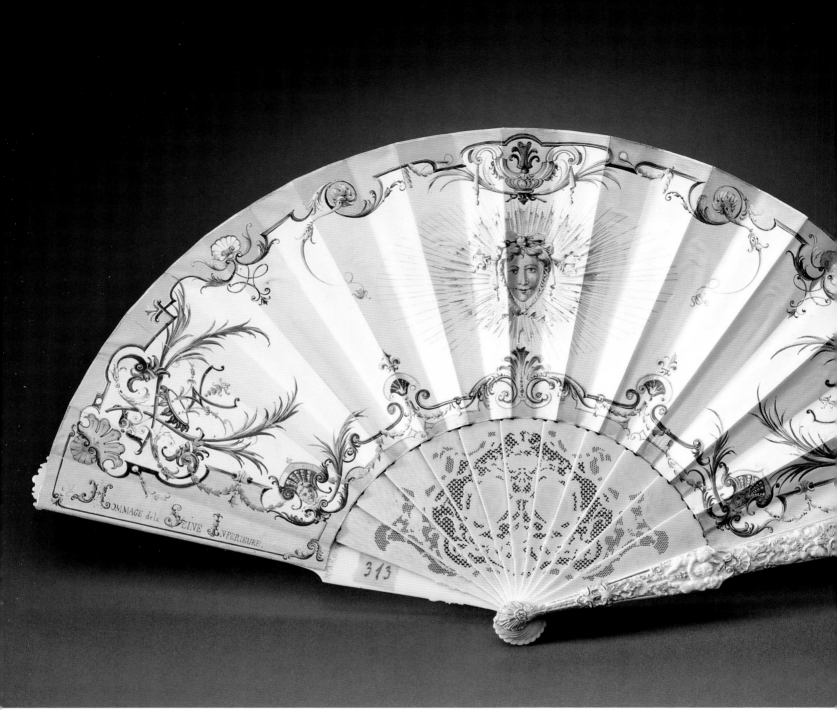

59. EU FAN

FRENCH, 1886

This fan (recto illustrated on pp. 144–5) was made as a wedding gift for a member of the Orléans family in France, and was bequeathed by the recipient to Queen Mary. It is the only fan in the Royal Collection painted by the nineteenth-century French artist Eugène Lami (1800–1890), who was employed extensively by King Louis-Philippe, by Emperor Napoleon III, and by members of the Rothschild family. He provided designs for costumes for a number of magnificent balls – including the Londonderry Ball of 1828 and the fancy-dress ball at the Tuileries in 1829 – and designed fan leaves for both Alexandre and Duvelleroy.[197] In addition to receiving examples of Lami's work from these patrons, Queen Victoria also patronised the artist directly (see pp. 6–7), particularly in the years around 1850 when he was resident in London. Lami designed the costumes for the Stuart Ball at Buckingham Palace in 1851,[198] of which he also painted a fine watercolour record.

The fan leaf is an extraordinarily accomplished work by the octogenarian Lami. It shows the Château d'Eu, the country residence of the Orléans family, which he had recorded on numerous occasions in the past.[199] On this occasion Lami's patron was the Departement (or area) of Seine Inférieur, the region around Eu. The fan, with its guard sticks and gorge appropriately decorated,[200] was presented to Princess Amélie (1865–1951), the eldest daughter of the Comte de Paris, who was himself the grandson of King Louis-Philippe (Queen Victoria's host at Eu in 1843; see no. 41 and plate 59.1). She was born at Twickenham, Middlesex, where her family lived in exile, but from the 1870s returned with her family to live in France, where her residences included the Château d'Eu. The occasion for the presentation of this fan was her marriage in May 1886 to the future Carlos I, King of Portugal from 1889 until his assassination in 1908. The fan was bequeathed by Queen Amélie to Queen Mary, but had not been transferred by the time of Queen Mary's death in 1953. It was therefore delivered in 1954 to HM The Queen, by the senior member of the Orléans family, the Comte de Paris.

Lami has depicted the Château d'Eu approximately as it would have appeared in the seventeenth century. Major refurbishment work took place there in the 1870s, under the direction of the architect Viollet-le-Duc. The sticks are signed by Adrian J. Rodien, a fan-maker of 48 Rue Cambon, Paris. In 1889 he had been awarded a silver medal at the Exposition Universelle in Paris, and in 1900 was awarded a gold medal.[201]

Plate 59.1. Eugène Lami, *The Arrival of Queen Victoria at the Château d'Eu, 2 September 1843*; watercolour (RL 19998)

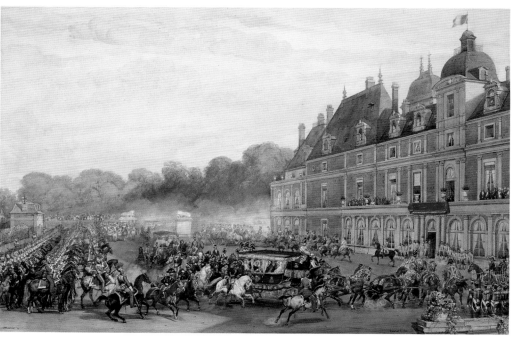

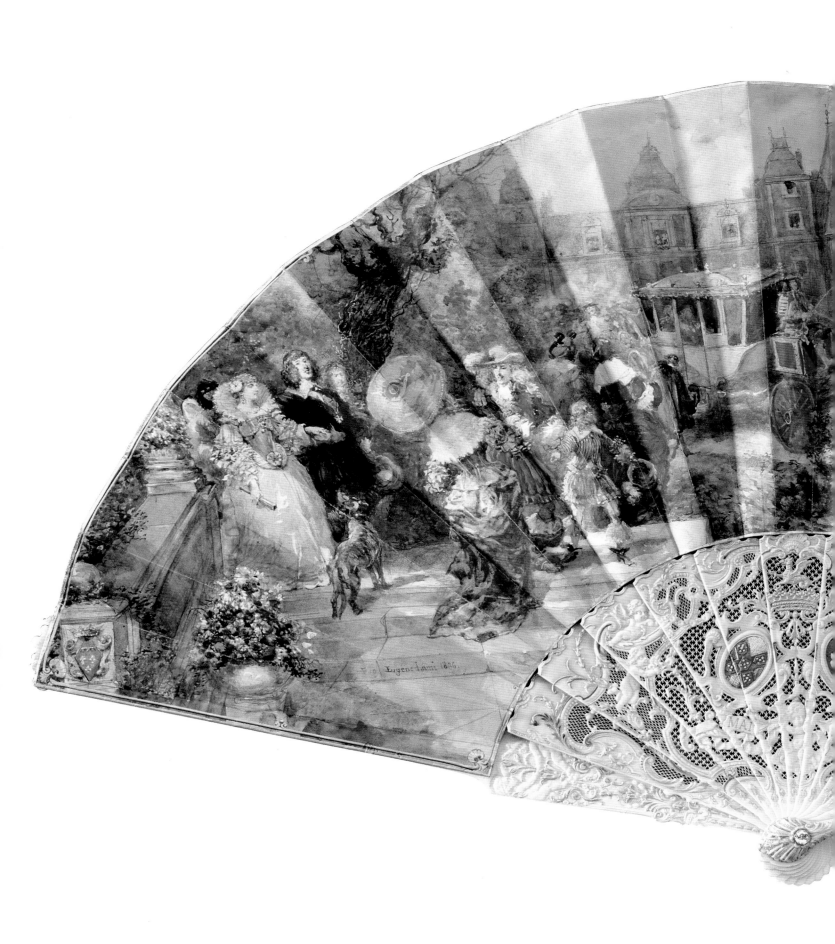

Eugène Lami 1886

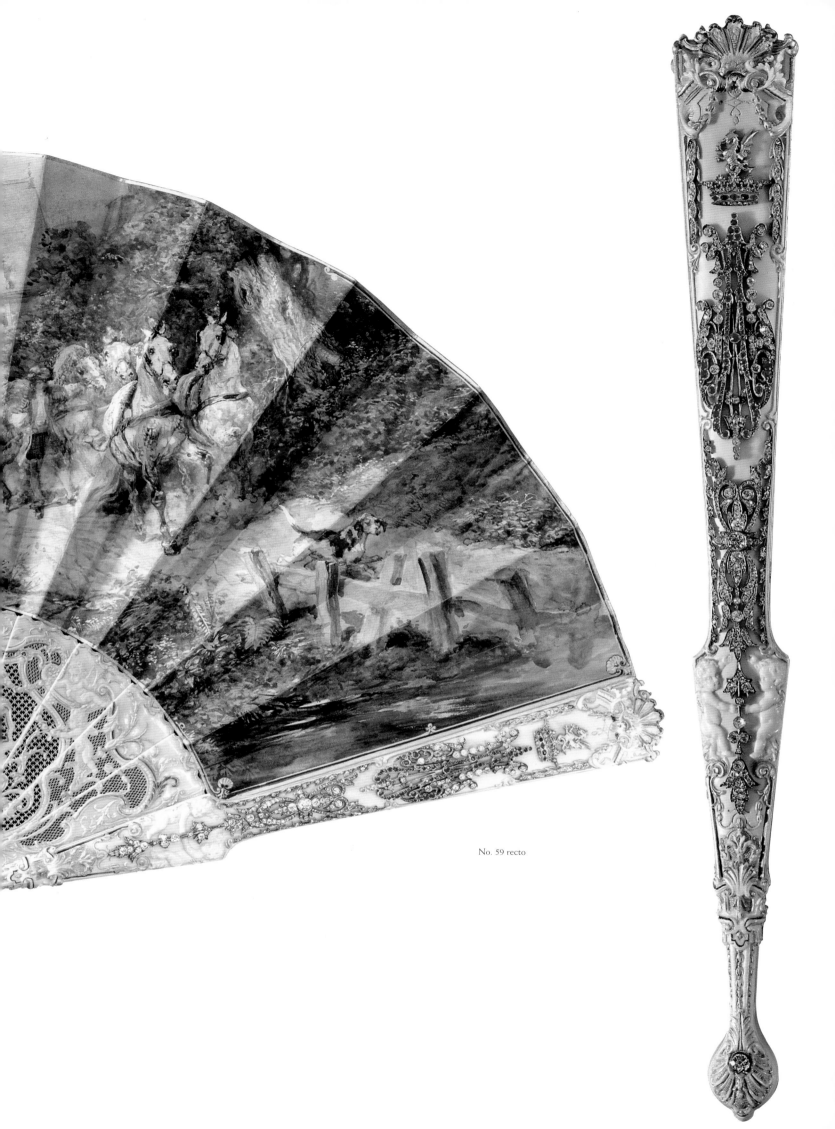

No. 59 recto

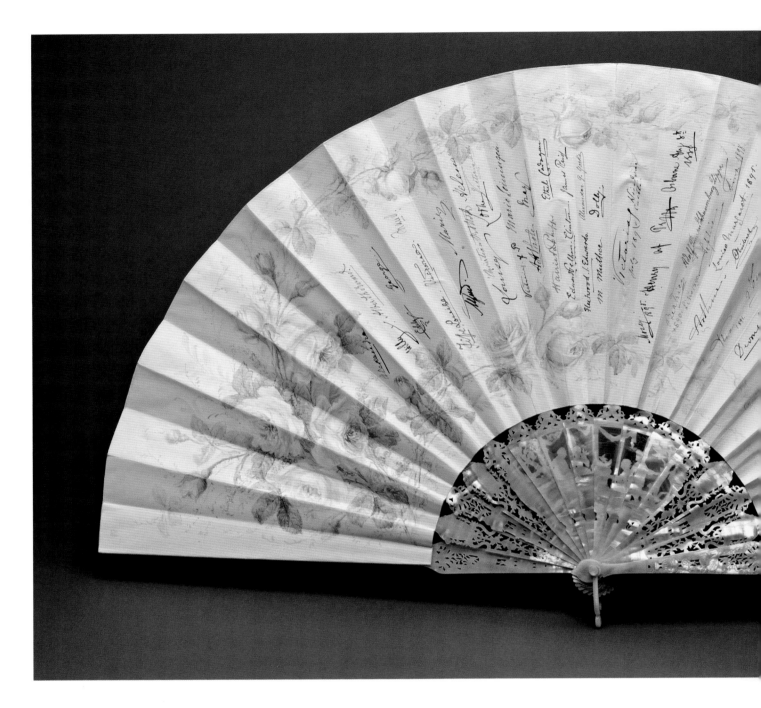

60. AUTOGRAPH FAN

ENGLISH, c.1887

As explained by Queen Alexandra in a note which remains in the original fan box, the fan was given to Queen Victoria by the Prince and Princess of Wales in the year of the Queen's Golden Jubilee. It was clearly intended to be written on. Between 1891 and 1900 numerous relations and friends signed their names on the fan leaf, presumably at the Queen's specific request. These commence at the left with the signatures of the donors; between the signatures of 'Alexandra' and 'Albert Edward' is that of 'Willy', Queen Alexandra's brother Prince William of Denmark, who had become King George I of Greece in 1863. The signatures continue with the children of the Prince and Princess of Wales: Eddie (the Duke of Clarence), George (later King George V), Louise and her husband (the Duchess and Duke of

Fife), Victoria, and Maud; then Queen Victoria's eldest child, Vicky (the Empress Frederick), and her children Victoria, Mossy (Margaret) and Henry with his wife Irene. Also there are Prince Alfred, Duke of Edinburgh and his wife Marie; Princess Helena and her husband (Prince Christian of Schleswig-Holstein) and their daughter Helena Victoria; Prince Arthur and his wife Louise Margaret (the Duke and Duchess of Connaught); and Princess Louise and her husband (the Marquess of Lorne). Other family signatures include those of Queen Victoria's granddaughter Alix (of Hesse, later Tsarina of Russia) and Alix's husband Nicky (later Tsar Nicholas II of Russia); also 'Dolly' (Adolphus) of Teck and his sister May (later Queen Mary), before her marriage in 1893 to the Duke of York. Members of the Royal Household who signed included the Queen's ladies-in-waiting, and her doctor James Reid. The fan was also signed by the Marquess of Salisbury (Prime Minister 1886–92 and 1895–1902) and by the statesman and Colonial Secretary (1895–1902) Joseph Chamberlain.

The practice of adding autographs to fan leaves originated in China. In September 1870 a wooden *brisé* fan was signed by members of the family of the infant Princess Alexandra of Greece, born in the previous month. The signatures were gathered by the baby's aunt, the Tsarina Marie Feodorovna.[202] In England the fashion was encouraged when, in the late 1870s, Lady Alma-Tadema (wife of the artist, Sir Lawrence Alma-Tadema) invited famous artists and musicians to sign and decorate the plain wooden sticks of a *brisé* fan.[203] It was also popular in France, where signature fans were known as *Livres d'Or*, and in Germany. Three continental examples of autograph fans were exhibited at the Karlsruhe exhibition in 1891. The Royal Collection also contains the autograph fan given to the future Queen Alexandra in the 1890s by her sister, the Tsarina Marie Feodorovna.[204]

Both the recto and verso leaves are signed by Francis Houghton, who was responsible for adding the decoration of roses on one side, and roses and forget-me-nots on the other. The latter join centrally to form the letter *V* surmounted by a crown. Houghton was the best-known English fan-painter of the last decades of the nineteenth century and was also active as a miniaturist. He received an Honorary Mention for an unmounted leaf at the Fan Makers first Competitive Exhibition, in 1878; at their third Competitive Exhibition, in 1890, where prizes were awarded for 'the exclusive work of British subjects', he was awarded first prize and a gold medal for a fan painted with *Les Forges de Vulcan* after Boucher. A number of other fans with his signature (or initials) are known, the majority of which include leaves combining paper, leather or silk edged with Brussels needle lace. A second Houghton fan in the Royal Collection, probably from the collection of Queen Alexandra, is painted on lace-edged silk gauze.[205] Fans painted by Houghton were available in North America at an early date.[206]

61. 'LA FONTAINE DE JOUVENCE'

FRENCH, c.1890

This was one of many fans given to the future Queen Mary on the occasion of her marriage to the Duke of York (later King George V) in 1893. The subject of the principal fan leaf was the promise of eternal youth: according to Roman myth, Jupiter changed the nymph Juventas into a fountain or spring that had the property of rejuvenating all who bathed in it. On this fan a group of people in eighteenth-century dress arrive at the opening to the spring, attended by amorini; they emerge restored as youthful participants engaged in happy pursuits. The subject was popular for fan leaves. In the 1860s a fan leaf design of *La Fontaine* was used not only on a fan given to the future Queen Alexandra by her sister and brother-in-law, the Tsarina and Tsar of Russia,[207] but also on one produced by Alexandre for the Empress Eugénie.[208]

Both recto and verso leaves are signed *DONZEL*. They are the work of Jules Donzel, the best known of the three members of the Donzel family who specialised in fan-painting. Some of his designs in the Duvelleroy archive bear a stamp lettered 'Donzel, 11 Bd. St. Martin, Cours de peinture pour Dames et Demoiselles'. The Donzels worked for all the top Paris fan-makers, including Duvelleroy and Kees.[209] The present fan leaf closely follows the artist's preparatory sketch (plate 61.1). The fan was evidently supplied by the London branch of Duvelleroy (at 167 Regent Street), whose description still accompanies the fan (plate 61.2). The following annotation was added to the description: *Carried by Queen Mary at The Wedding of Princess Victoria Louise of Prussia and Prince Ernest Augustus of Cumberland Berlin 24 May 1913*. A photograph of Queen Mary at this wedding shows her holding the fan (plate 61.3). The bridegroom (later Prince of Hanover and Duke of Brunswick) was the eldest surviving son of the donors; the bride was the only daughter of Kaiser William II. The Duchess of Cumberland, mother of the bridegroom, was born Princess Thyra of Denmark; she was the youngest sister of the future Queen Alexandra (see no. 50).

Plate 61.1. Jules Donzel, *La Fontaine de Jouvence*, c.1890; watercolour (Hélène Alexander collection)

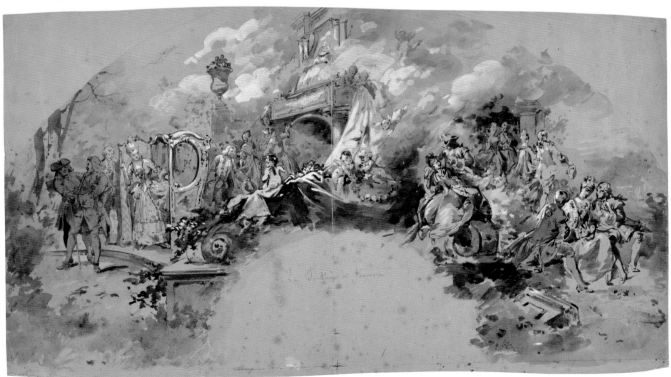

garden also figures, & this leaf is also painted by Donzel. Period about 1890.

This fan was Carried by Queen Mary at The Wedding of Princess Victoria Louise of Prussia and Prince Ernest Augustus of Cumberland Berlin 24 May 1913

Duke & Duchess of Cumberland 1893

J. DUVELLEROY,
Fan Maker, by Appointment,
LONDON: 167, REGENT STREET, W.

TELEPHONE
4175 GERRARD.

Mount made of Pearl carved & gilt Louis XV style, centre medallion with figures carved in relief on (fond burgauté) Leaf painted on skin with many figures in Louis XV Style, & cupids, Subject Fontaine de Jouvence by Donzel & decorated in Louis XV style. Back of Fan, is a Statue of Cupid in

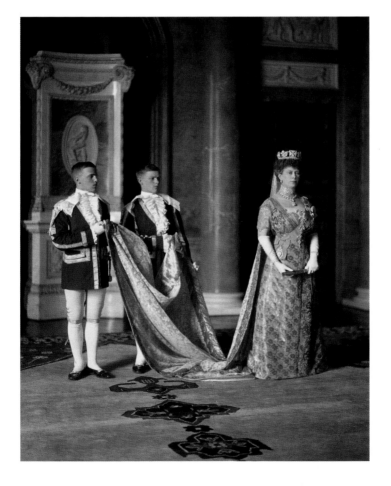

Plate 61.2. Description of no. 61 supplied with the fan by Duvelleroy, and later annotated for Queen Mary (RCIN 25138.c)

Plate 61.3. Queen Mary (holding no. 61) at the wedding of Princess Victoria Louise of Prussia and Prince Ernest Augustus of Cumberland, Berlin, 24 May 1913; photograph by Ernst Sandau (RPC no. 190/2001)

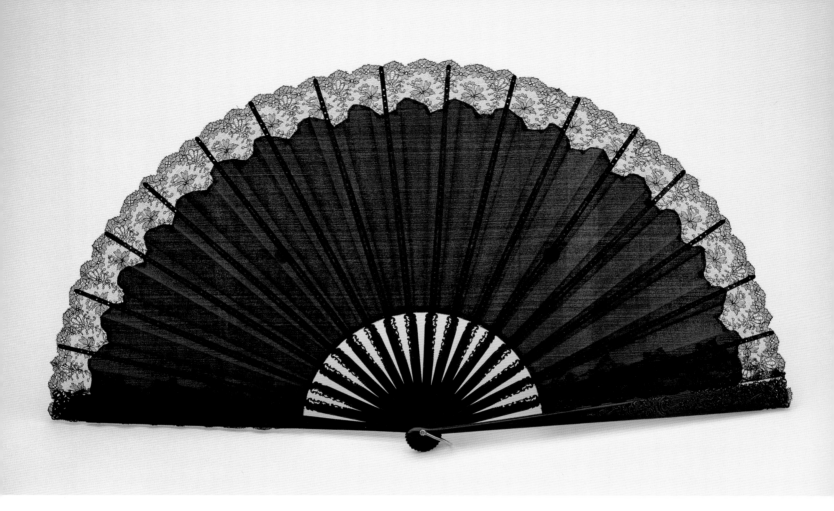

62. QUEEN VICTORIA'S FAN

FRENCH, c.1890

According to a note on a scrap of mourning paper (plate 62.1) kept with this fan, it was held by Queen Victoria in the final moments of her life. The Queen died at Osborne House on the Isle of Wight on 22 January 1901, at the age of 81. Since the death of Prince Albert in 1861 she had worn black exclusively,[210] allowing embellishments in white, gold or silver only in her later years. Her accessories were likewise either black or white, although many coloured fans – including the autograph fan, no. 60 – continued to be given to her. The lace edging indicates that this is not a mourning fan but an unexceptional dress accessory used by the widowed Queen, probably acquired from one of her outfitters. Neither the guards nor the sticks (both of which are made of ebony) are adorned or personalised in any way. A date towards the end of the century is suggested by the size of the leaf and the length of the sticks, and by the lace trim.

Lace was the most popular material for the manufacture of fan leaves by the 1890s. This fashion had been encouraged by advances in the production of machine-made lace, which was now widely available. However, at the Paris exhibition in 1878 lace fans already outnumbered all other types of fan displayed. In this fan the large black crape leaf is edged with machine lace made in imitation of hand-made Chantilly bobbin lace, incorporating a repeating daffodil motif.

Plate 62.1. Inscribed paper scrap kept with no. 62 (RCIN 25181.b)

Overleaf: no. 63

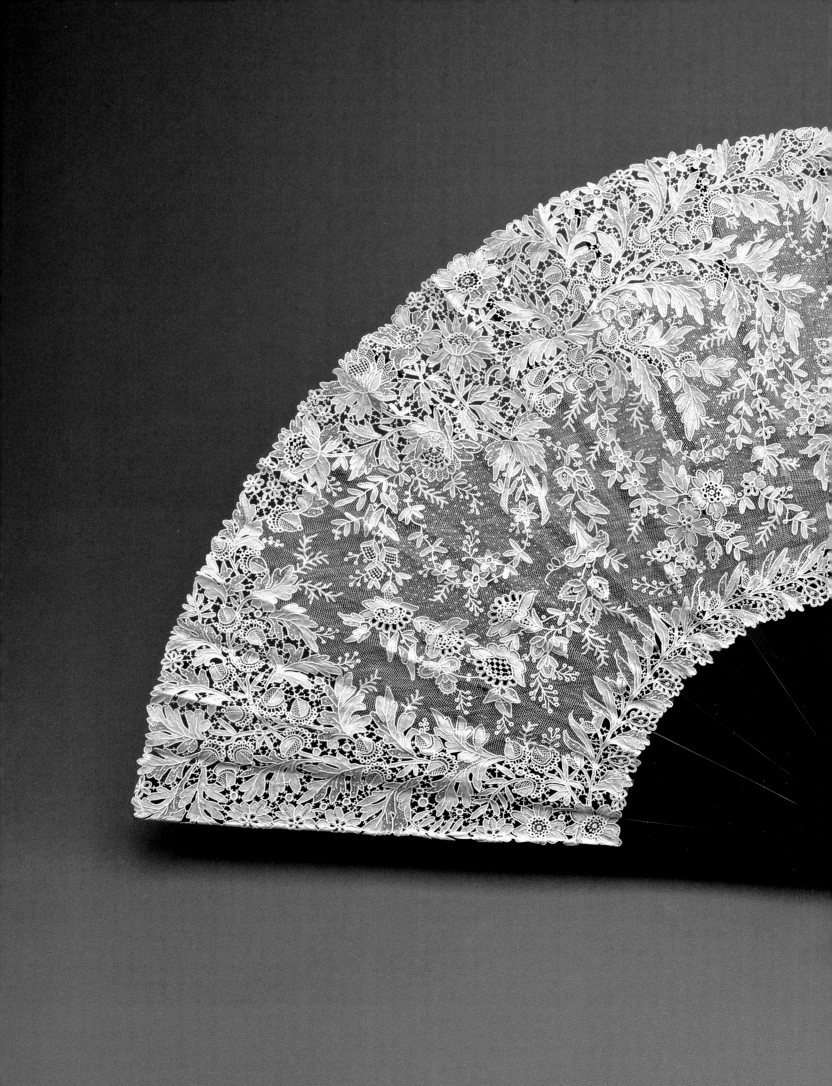

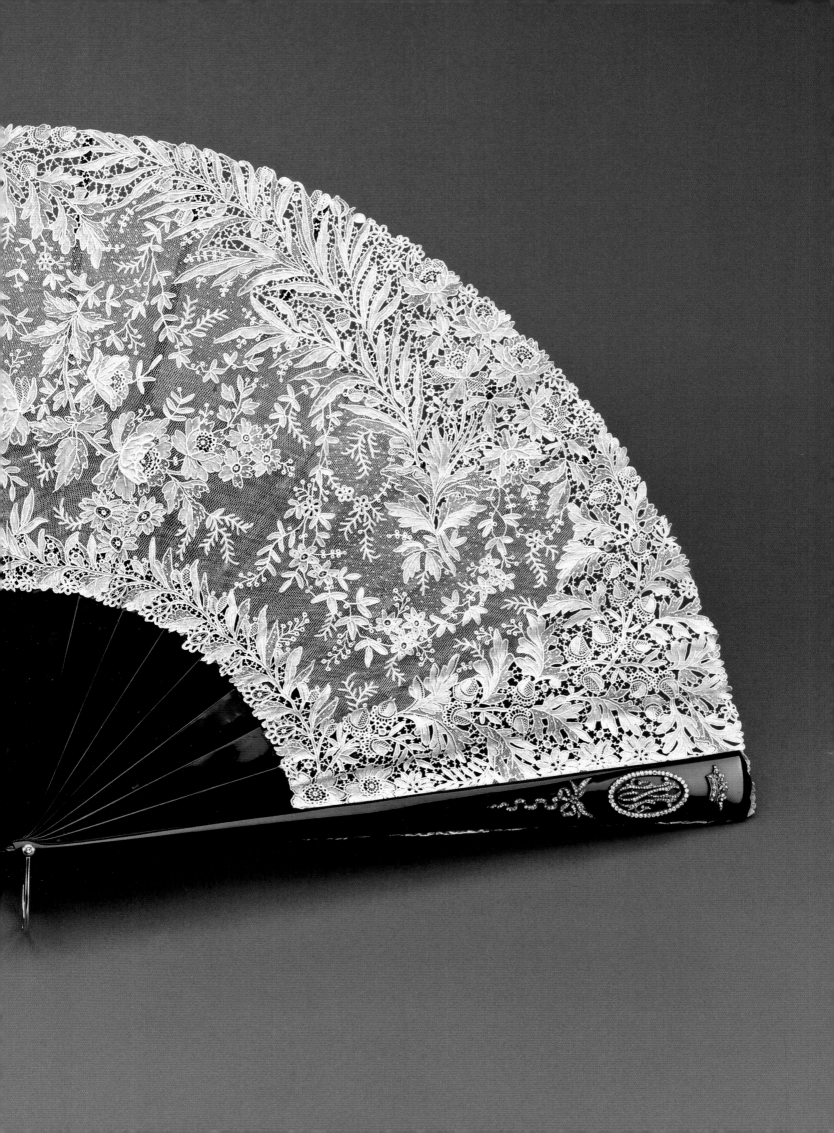

63. *POINT DE GAZE* LACE FAN
BELGIAN LACE; MOUNTED IN FRANCE, *c.*1893

By the end of the nineteenth century lace fans were an essential part of a bride's trousseau. At the time of the marriage of the Duke and Duchess of York in 1893 the bride received large numbers of lace fans, including this one (reproduced on the two preceding pages) and the two following. The present fan was the gift of the Earl and Countess of Yarborough.[211] The leaf is a fine example of Brussels *point de gaze* lace, a needle-lace technique revived in the 1840s. This was one of the most fashionable laces in the second half of the nineteenth century. It incorporated a fine mesh (*gaze*) ground and naturalistic floral patterns. Typical features are the use of tiny rings to ornament the centres of flowers and to serve as buds at the end of tendrils, and the tiny three-dimensional petals. The lace in this fan, which is of a very high quality, is beautifully designed to match the shape of the leaf.

Although it was possible to acquire fans from a number of the lace dealers in Brussels, the majority of Brussels lace fan leaves appear to have been exported and mounted in Paris, London or elsewhere. The original box supplied with the present fan, with the label of Duvelleroy's London operation in the lid, has survived. This fan is unusual in combining dark tortoiseshell guards and sticks with a white lace fan; tortoiseshell was normally used with black Chantilly lace while mother-of-pearl was used for Brussels lace. With the diamond cipher on the front guard, it was evidently very popular with its recipient and was soon described as being in her 'personal use'.

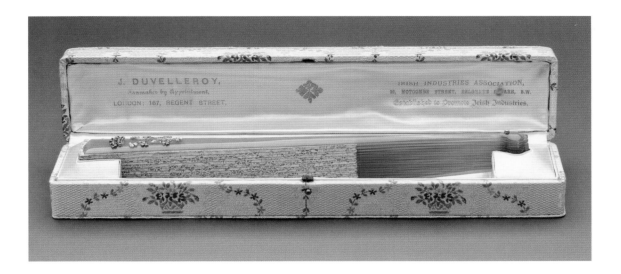

64. IRISH LACE FAN

IRISH LACE; MOUNTED IN FRANCE, *c.*1893

This Irish lace fan was another wedding gift to the future Queen Mary. The donor was Lord Houghton, Viceroy of Ireland from 1892 until 1895, when he was created Earl (later Marquess) of Crewe. The lace leaf was made by the Youghal Co-operative Lace Society at the Presentation Convent, County Cork, for the Irish Industries Association. The original fan box has survived, indicating that the fan was made up by Duvelleroy.

After the Irish potato famine of 1846 a number of small industries were set up in Ireland, almost all by the wives of Protestant clergymen or by Roman Catholic communities, in an attempt to establish new sources of income. The manufacture of lace was considered an appropriate way for the female labour force to be employed. One of the first lace manufactories to be set up was that at the Presentation Convent, Youghal, County Cork, 'where in 1846 Mother Mary Ann Smith unpicked some Italian needle lace in order to learn the technique. She began to teach the craft to the local children, and in 1852 the Convent established a lace school'.[212] By the early 1880s there was some need for improvement in standards, and it was at this time that the distinctive needle lace now associated with Youghal was developed. The designs worked in lace were devised by the nuns themselves, who had received training from the Board of Education; they also had close ties with the Cork School of Art.

A large number of fan leaves was produced at the Presentation Convent.[213] Of those intended for royal recipients, the present fan has been considered 'one of the most successful in point of design and richness of effect'.[214] Three years later another Youghal leaf was produced – with a crowned *M* in the centre – as a wedding gift to Queen Mary's sister-in-law Princess Maud, third daughter of the Prince of Wales. The Youghal lace fan presented to Queen Alexandra in 1903, on the occasion of her first visit to Ireland following the coronation, includes an Irish harp in the centre and a ribbon inscribed (in Irish) 'I cool, I refresh, and I can keep secrets'.[215] In 1905 the King's niece, Princess Margaret of Connaught, received a wedding gift of a Youghal lace fan which had won a prize at the Dublin exhibition in 1897.[216] Youghal lace was also used for other articles for royal use. In the year of her Diamond Jubilee, 1897, Queen Victoria received the gift of a shawl of Youghal lace. And Youghal lace-makers made a lace train for Queen Mary to wear at the time of the Delhi Durbar in 1911.

Overleaf: no. 64

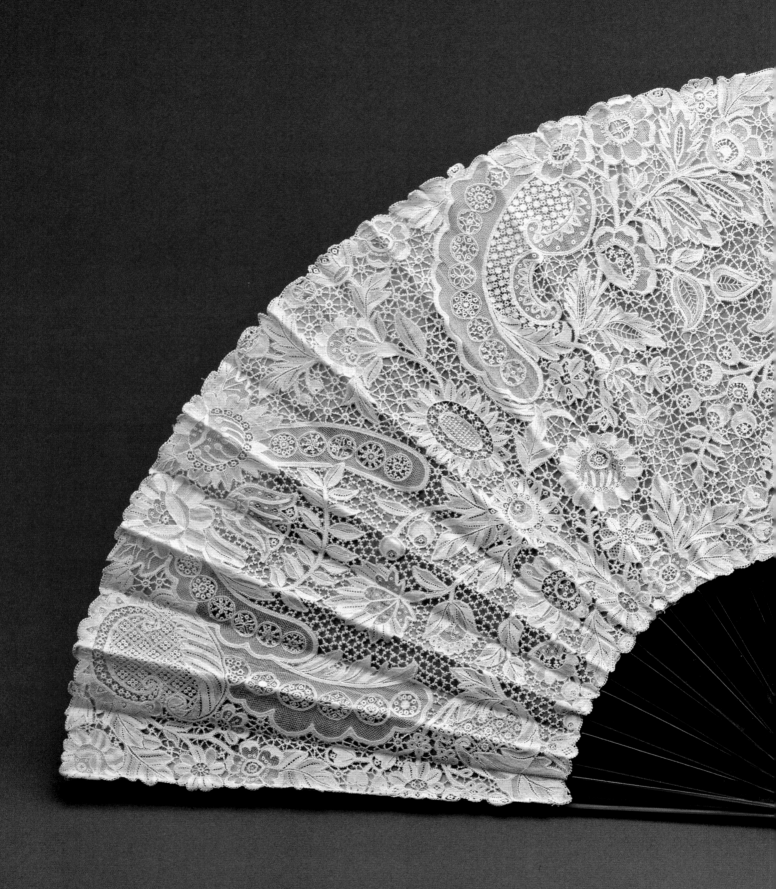

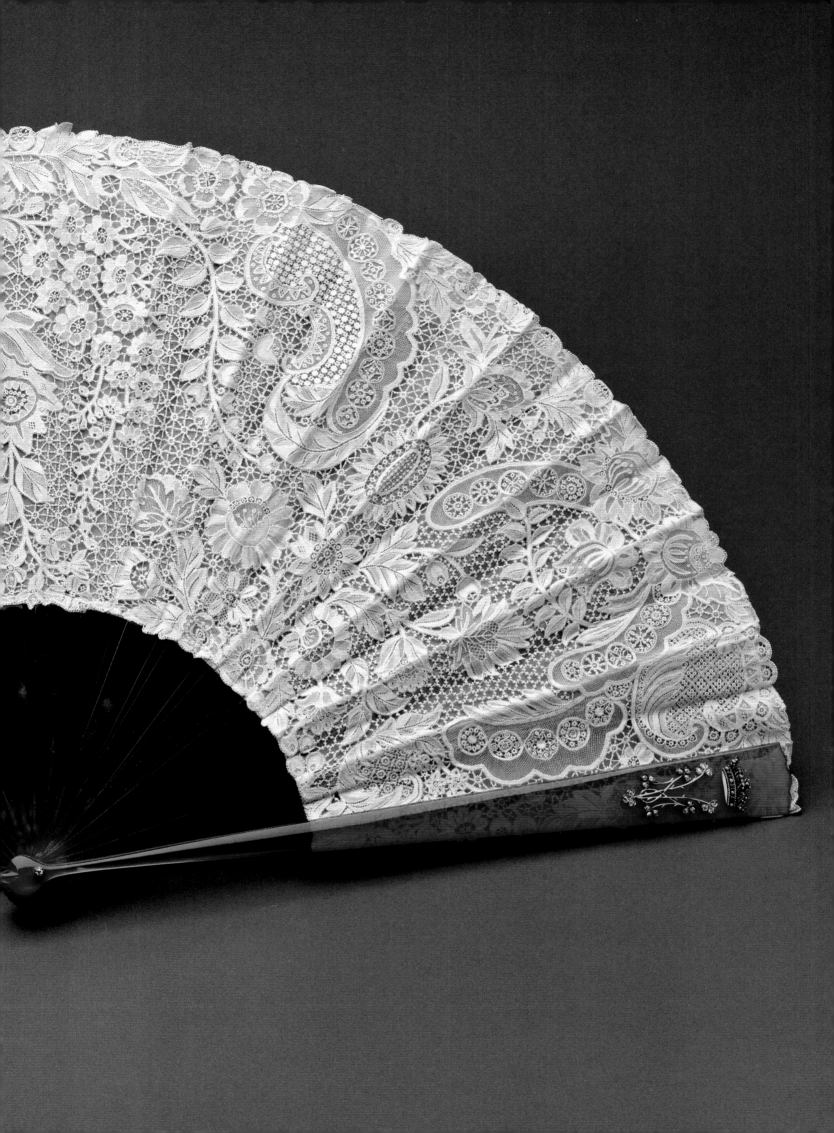

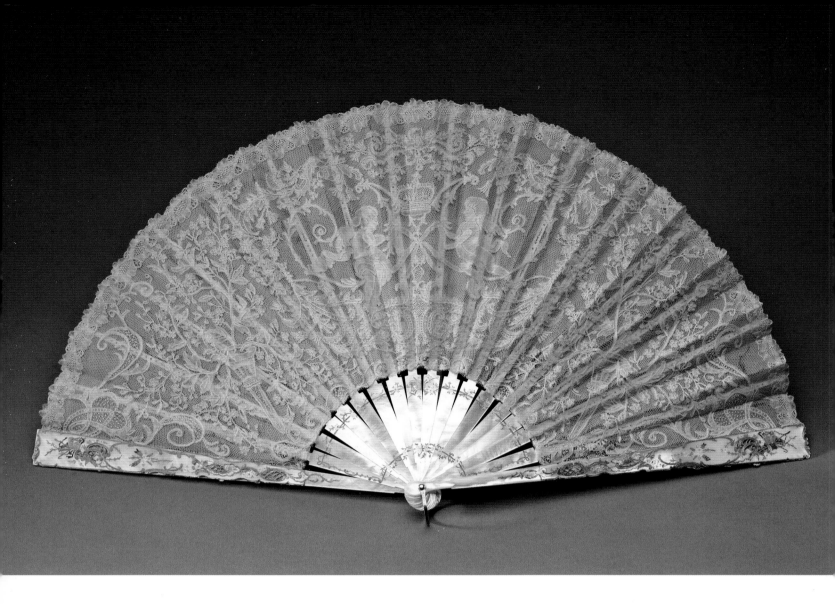

65. HONITON LACE FAN

ENGLISH, 1893

This fan was a wedding gift to the future Queen Mary 'from the Lacemakers and Ladies of Honiton and Neighbourhood'.[217] As a fine example of lace produced in Honiton (Devon), the main centre of native lace production at the time, it was clearly a most appropriate gift. (See also no. 78.)

Lace has been made in the Honiton area since the late sixteenth century. In 1830 a Royal Warrant for supplying lace was granted by Queen Adelaide to Amy Lathy, a Honiton lace-maker. Nineteenth-century Honiton lace has many similarities with Brussels lace, although at Honiton the individual pieces of bobbin lace were applied to a machine-made net ground, rather than one made of *drochel* net. Queen Victoria's wedding veil and dress flounce were made in Honiton,[218] as were those of the future Queen Alexandra.[219] However, lace fans were not in fashion in either 1840 or 1863. Queen Mary was the first royal bride to receive a Honiton lace fan on her wedding.

The decoration on the leaf includes in the centre a crowned *M*, and at either side cornucopia containing branches of may blossom. The bride – Princess Victoria Mary of Teck, born on 26 May 1867 – was known as May within her family.

66. JAY FEATHER FAN

AUSTRIAN, c.1893

By the end of the nineteenth century feathers had been used to make both rigid and folding fans for many centuries. However, a wide range of different feathers were now used, to create both colouristic and textural variety. Vienna was the centre of the production of feather fans at the time. This fan was a wedding present to the future Queen Mary from Count and Countess Henry Larisch;[220] it retains its original box (plate 66.1) with the fragmentary trade stamp of the Viennese firm Gebrüder Rodeck.[221] The bride's familiar name, *MAY*, set in diamonds, adorns the front guard. Overlapping pairs of large feathers, attached to each stick, form the supports for numerous tiny jay feathers, pasted onto the backing feathers.

The technique of making folding feather fans was soon mastered in London. In 1901 the future Queen Mary received from her husband a fan made of the pin feathers from woodcocks shot by the Duke of York. Each of the 6,520 feathers was fixed by a lady 'with two stitches of thread and worked upon a linen base'. Work for that fan commenced on 18 August 1900 and was completed on 28 October 1901; manufacture was entrusted to Mr Alfred Clark, goldsmith, of 33 New Bond Street, London.[222]

Plate 66.1. The fan box for no. 66 (RCIN 25134.b)

Overleaf: no. 66

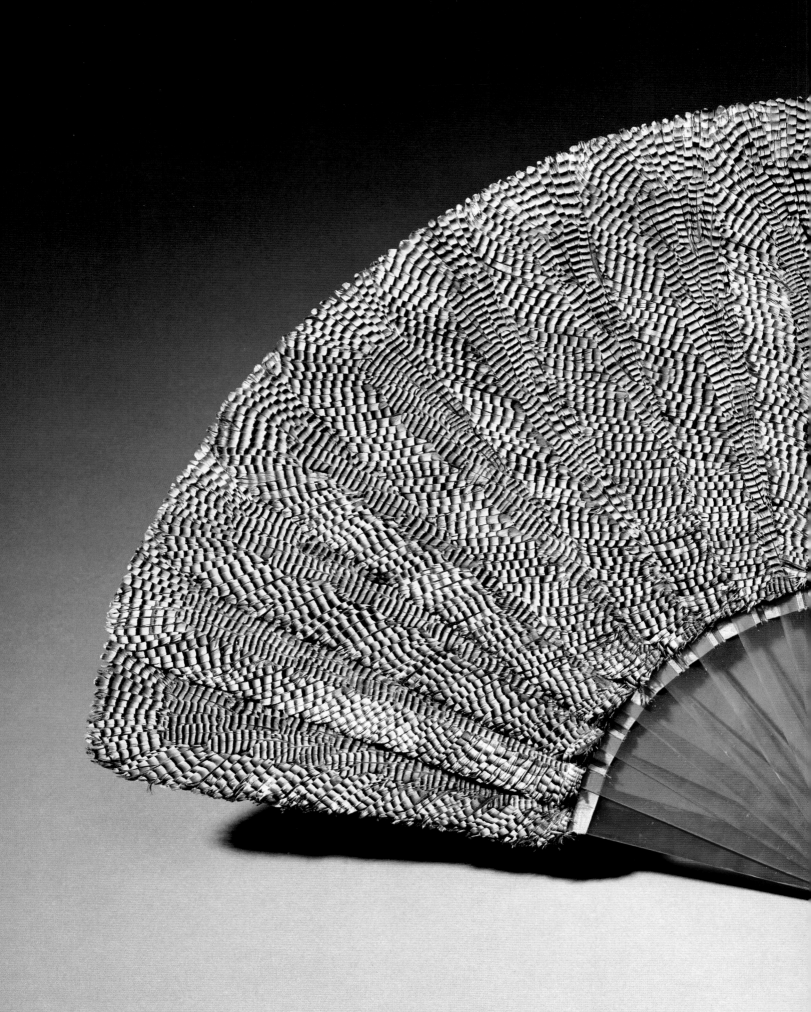

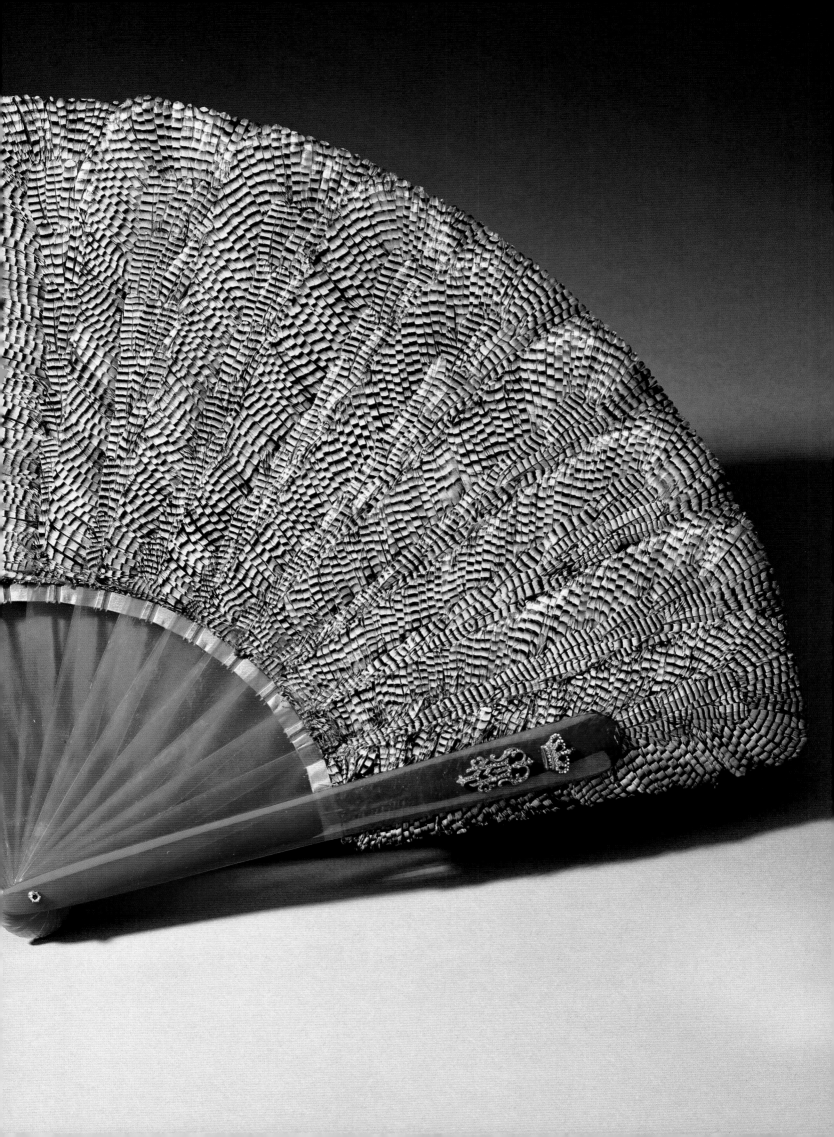

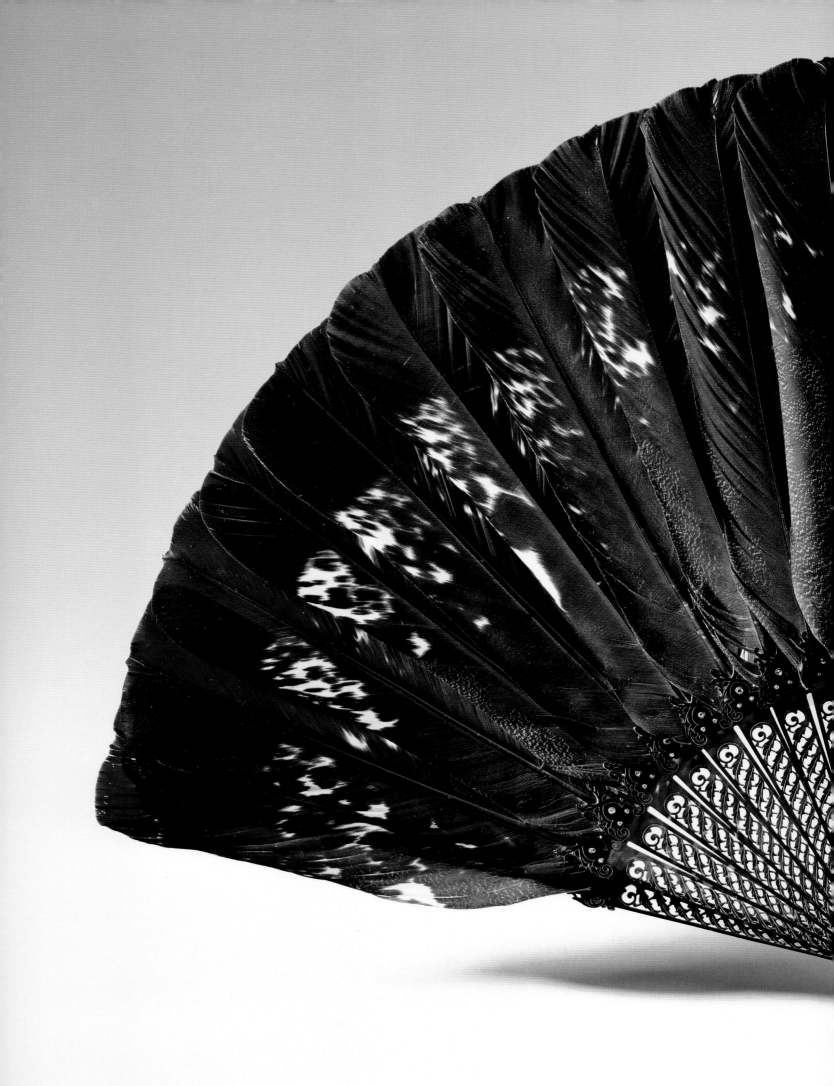

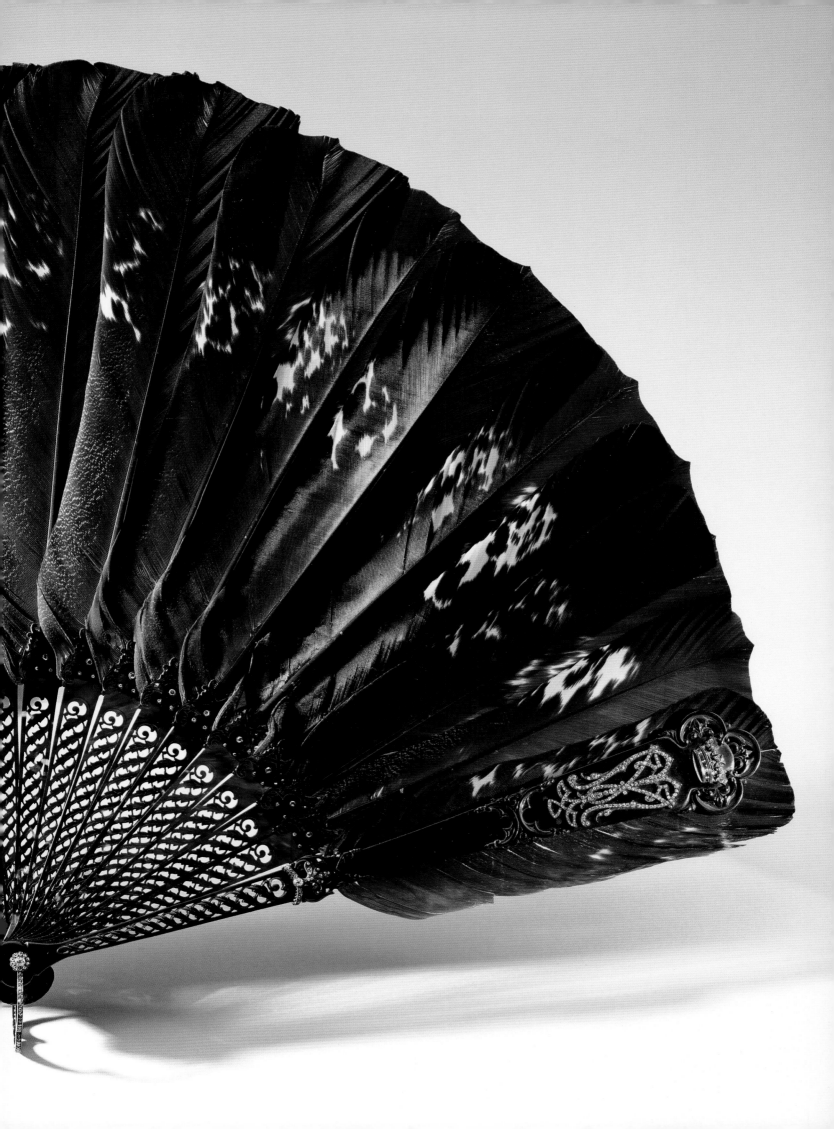

67. CAPERCAILLIE FEATHER FAN

AUSTRIAN, c.1893

Occasionally – but presumably not in the present instance – the exchange of feather fans in the late nineteenth century had distinct romantic overtones. In the case of this Viennese fan the feathers are those of a capercaillie (a large grouse). According to an article in the *New York Commercial* for 23 November 1890:

> The latest craze of Viennese society is a passion for fans of mountain-cock feathers. The last
> question the young Austrian belle asks her admirer before he goes on a hunt is, 'Won't you try,
> please, to bag me a fine fan?' An ideal fan of this kind must contain only feathers from birds
> brought down by the most expert shots, and every feather must be the lone representative of
> the giver's skill; consequently, such a fan may record the admiration and skill of sixty or
> seventy hunters. It is not unusual to have cut in the ribs of the fans a brief account of the
> circumstances under which the birds were shot. The German Empress is said to have
> expressed a wish last summer for such a fan, and ever since that time the young bloods of the
> Austrian Court, who have already bagged fans for their own women, have been shooting right
> and left for the Empress's sake. The handle of the fan, now being completed in Vienna, will be
> set with jewels in the Prussian colours.[223]

This fan (illustrated on pp. 162–3) was a wedding present to the future Queen Mary from Count Szapáry,[224] and was described in the printed list of presents as a 'mourning fan'. The front guard bears the bride's initials (VM) set in diamonds, below an enamelled diamond-set coronet. Unusually, the silver loop is also set with diamonds.

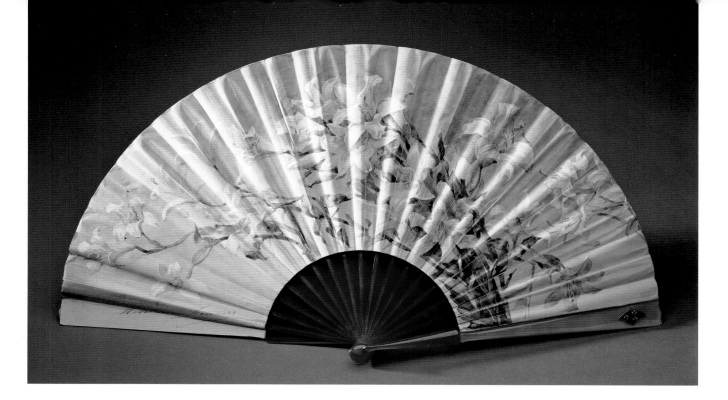

68. 'LILIES'
FRENCH, c.1895

This fan was a gift to Queen Mary from Princess Hélène (1871–1951), the second daughter of the Comte de Paris and the younger sister of Princess Amélie, for whose marriage in 1886 Lami painted the Eu fan (no. 59). In August 1890 the Roman Catholic Princess Hélène had become engaged to Prince Albert Victor, Duke of Clarence, the eldest son of the Prince of Wales, after a whirlwind romance. The engagement was broken off on instructions from Princess Hélène's father, and in December 1891 the Duke became engaged to Princess Victoria Mary of Teck (later Queen Mary). After his death in the following month both of his fiancées seemed doomed to spinsterhood, but Princess Victoria Mary soon married the Duke's younger brother, the Duke of York, and in June 1895 Princess Hélène married Prince Emanuele of Savoy (1869–1931), 2nd Duke of Aosta, in the Roman Catholic church of St Raphael, Kingston-on-Thames. The arms of France and Savoy, set in diamonds, appear on the front and back of the guards. According to Queen Mary's biographer,

> On the grandiose tomb erected to the Duke of Clarence's memory [at Windsor] there hung until quite recently a wreath of *immortelles* inscribed simply, 'Hélène'. And Princess Hélène it is who deserves to have the last word on the subject of the Duke. In November 1892 Queen Victoria had a conversation with this charming girl who had so faithfully loved her not very lovable grandson. *Je l'aimais tant*, said Princess Hélène, adding, somewhat surprisingly, *Il était si bon*.[225]

The occasion for the gift of this fan is not recorded, but the presence of the conjoined arms indicates that it followed Princess Hélène's marriage in 1895.

Madeleine Jeanne Lemaire (*née* Colle; 1845–1928), who signed the fan leaf, was a leading French fan-painter and book illustrator and was much employed by Duvelleroy.[226] She was trained by her aunt Madame Herbelin – a miniaturist – and later by the fashionable painter Charles Chaplin. One of her water-colours was listed in the Osborne catalogue of 1876 as a gift from the Prince de Joinville to Queen Victoria. Although that watercolour is no longer in the Royal Collection, Lemaire's decorated concert programme for June 1898 is in one of the Duchess of Connaught's photograph albums.[227] In October 1902 she published an article in *Fémina* in which she gave detailed instructions concerning the types of paper and vellum currently available for the manufacture of fans; in the same article she also lamented the recent fall in standards of fan-making. For Adrian Rodien, who signed the guards, see no. 59.

69. QUEEN VICTORIA'S DIAMOND JUBILEE FAN
ENGLISH, 1897

Queen Victoria's Diamond Jubilee in 1897 provided the opportunity for British lace-makers to prepare fans for presentation to their Sovereign, rather than to the younger members of her family. This fan was the gift of the Worshipful Company of Fan Makers. Its presentation followed the fourth Competitive Exhibition, held by the Fan Makers under the patronage of Queen Victoria, who had lent four fans to the exhibition from her own collection.[228] It was the first gift of a 'Royal Presentation' fan by the Fan Makers Company.[229] Both the lace leaf and the ivory guards and sticks had been awarded prizes at the exhibition: Miss Lizzie Oldroyd, who made the lace leaf, won Mr Duvelleroy's 'special prize', while Robert Gleeson, who signed the front guard, was awarded the prize for fan-mounts. When the proposed gift was first raised with Sir Arthur Bigge (Keeper of the Privy Purse) on 11 June 1897, Mr H.H. Crawford (Chairman of the Fan Makers exhibition committee) was at pains to point out that the fan was entirely the work of British subjects. On 19 June, the day following the delivery of the fan, Sir Arthur wrote on behalf of Queen Victoria to thank the Company for the gift, and to pass on 'her congratulations upon the artistic talent which in it [Miss Oldroyd and Mr Gleeson] have respectively displayed'.[230]

Miss Lizzie Oldroyd, of Denne Manor, Chilham, Kent, was a lady amateur member of the Fan Makers Company.[231] For this leaf she used the Maltese lace-making technique, combining cream silk with simulated gold thread (consisting of silk thread dyed yellow, wrapped around with yellow-coloured metal strips), and further ornamentation by tiny gold beads and spangles. Maltese lace is a straight bobbin lace made in one continuous process, pattern and ground together. The emblems incorporated into the leaf include the national emblems of the United Kingdom together with a crescent moon and a Maltese cross; the latter would normally suggest that the lace was actually made in Malta, but contemporary records clearly state that Miss Oldroyd produced it in Kent. Lace-making was reintroduced to Malta and Gozo in the 1830s and continues to this day.[232]

Robert Gleeson was also a member of the Fan Makers Company and an employee of Messrs Duvelleroy, whose trade stamp appears inside the fan box (plate 69.1). He also carved the sticks for Queen Mary's coronation fan (no. 78). According to the contemporary description in the *Daily Graphic*, the fan was 'rivetted with diamonds, and enclosed in a handsome case with crown and Royal initials in 18-carat gold'. Although the box has survived, the diamond-studded rivets have not.

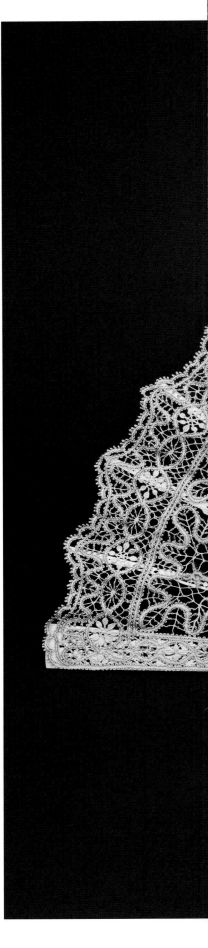

Plate 69.1. The fan box for no. 69
(RCIN 25065.b)

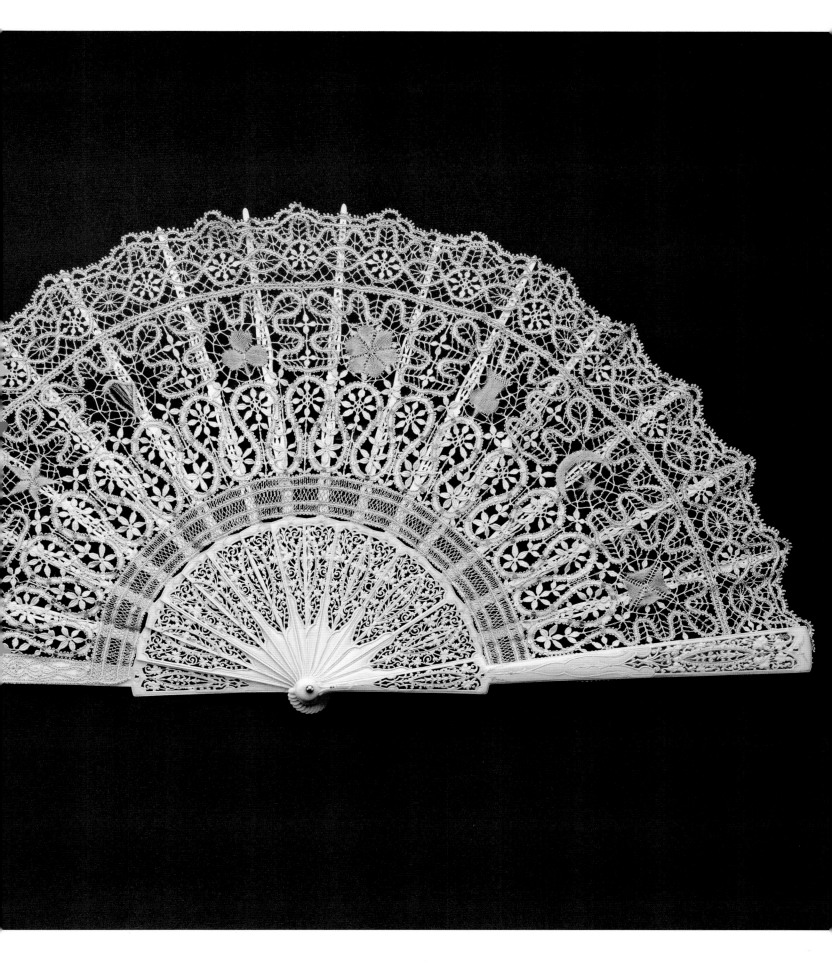

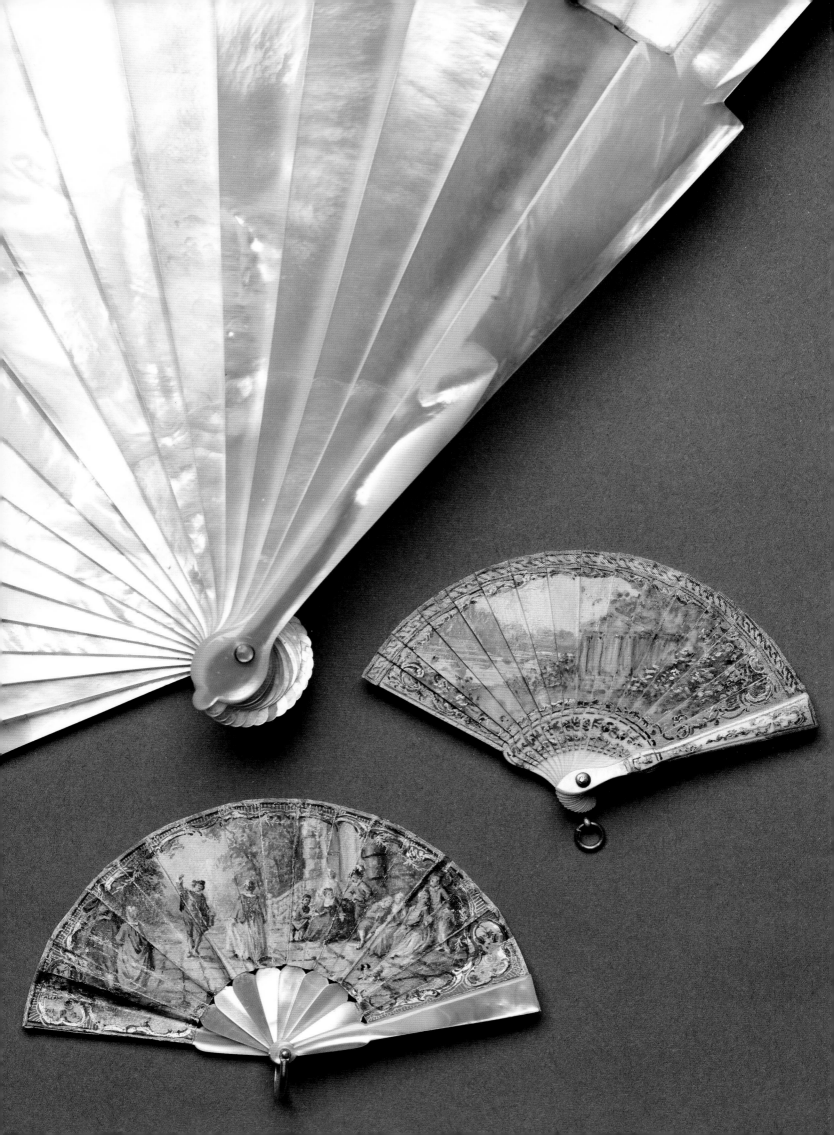

70. MINIATURE *BRISÉ* FAN
FRENCH, *c.*1900

71. MINIATURE FAN
FRENCH, *c.*1900

These miniature fans, shown here (slightly enlarged) beside the gorge of no. 58, belong to a collection of around twenty tiny fans at Sandringham House, Norfolk, the country residence of King Edward VII and Queen Alexandra (see no. 55). It was almost certainly Queen Alexandra who acquired them. Such fans were made as presents given by fashion houses or fan-makers (such as Duvelleroy) to favoured customers as gifts for their children.[233] In the case of no. 70, the ring attached to the pin might suggest that it was made to hang on a chatelaine. It is unlikely that these fans were made for dolls, although the firm of Aubin in Paris advertised '*Petits éventails pour poupées et oeufs de Pâques*' in the years before 1914.[234]

The tiny *brisé* fan is signed by the fan-painter M. Danys, who worked for the Parisian firm of Ernest Kees.[235] In both these fans the decoration precisely imitates, in miniature, fans of a much earlier period. No. 71 is decorated with a scene from Watteau's painting *Les Plaisirs du Bal* of *c.*1715 (Dulwich Picture Gallery).

Opposite: nos. 70 (above) and 71 (below)

72. QUEEN ALEXANDRA'S OSTRICH FEATHER FAN

ENGLISH, c.1901

This magnificent fan appears to have been made for Queen Alexandra at the time of the coronation in 1902. It later passed to Queen Mary, who presented the fan to Queen Elizabeth at a family lunch at Buckingham Palace in May 1937, two days before the coronation of King George VI.[236] Queen Mary's note (plate 72.1), tucked into the lid of the fan box, is typically informative about the fan's provenance.

Fans incorporating ostrich feathers are recorded from the sixteenth century (fig. 8), at which time the principal European emporium of ostrich feathers was Venice. The fashion for folding fans incorporating ostrich feathers evolved in the second half of the nineteenth century. By 1900, when ostriches were extensively farmed – particularly in South Africa – England had become 'the mart of the world for feathers'.[237] Each of the four ostrich feather fans listed among Queen Mary's wedding presents was the gift of a British individual or institution; appropriately, one of these fans was the gift of 'South Africans in England'.[238] In the present example the feathers have been artificially curled. The shaft of each feather, softened in a steamy atmosphere, is painstakingly scraped from base to tip until it curls – like curled ribbon.

Plate 72.1. Note in Queen Mary's hand kept in the fan box of no. 72
(RCIN 25279.c)

Opposite: no. 72 (front guard)

Overleaf: no. 72 recto (open)

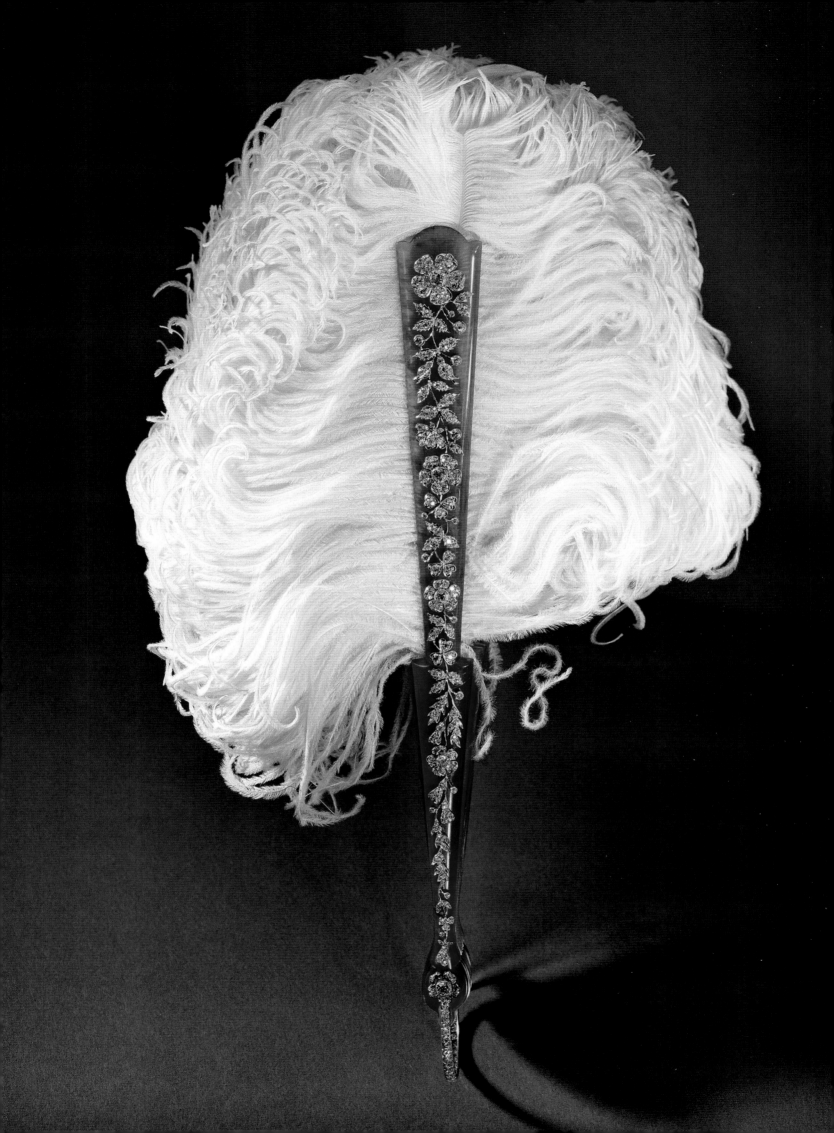

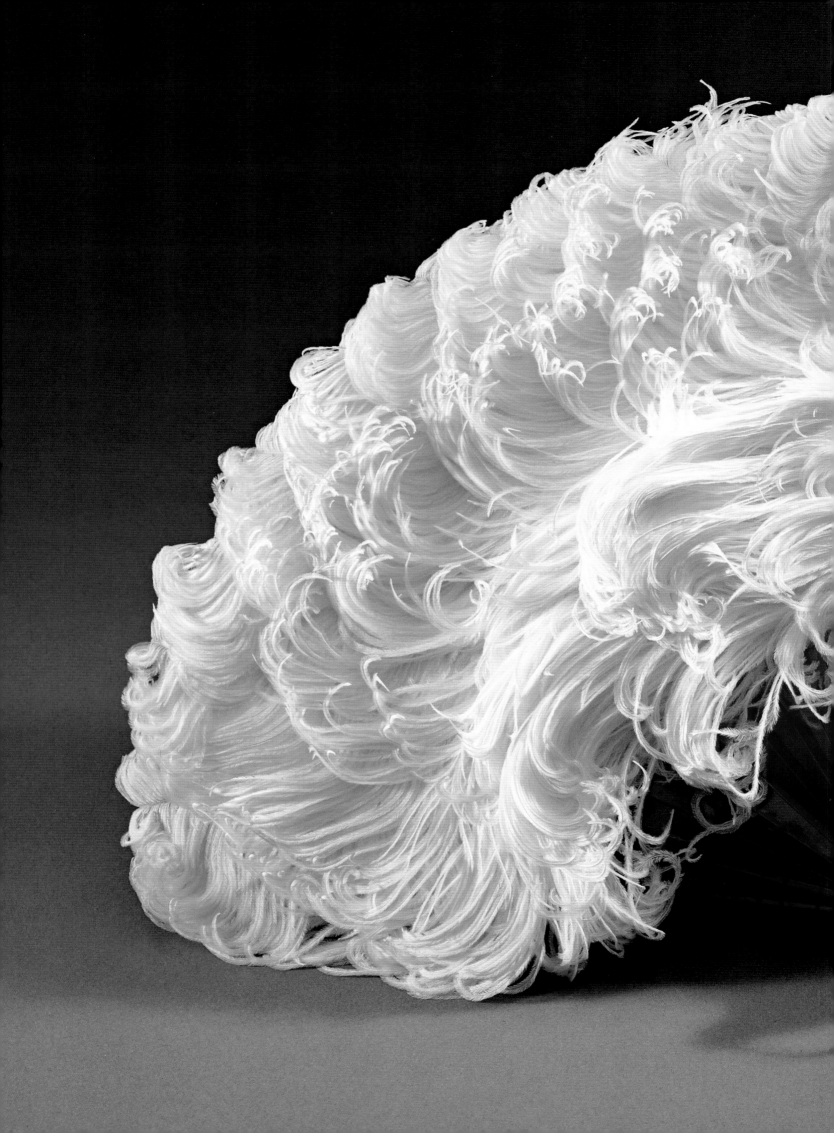

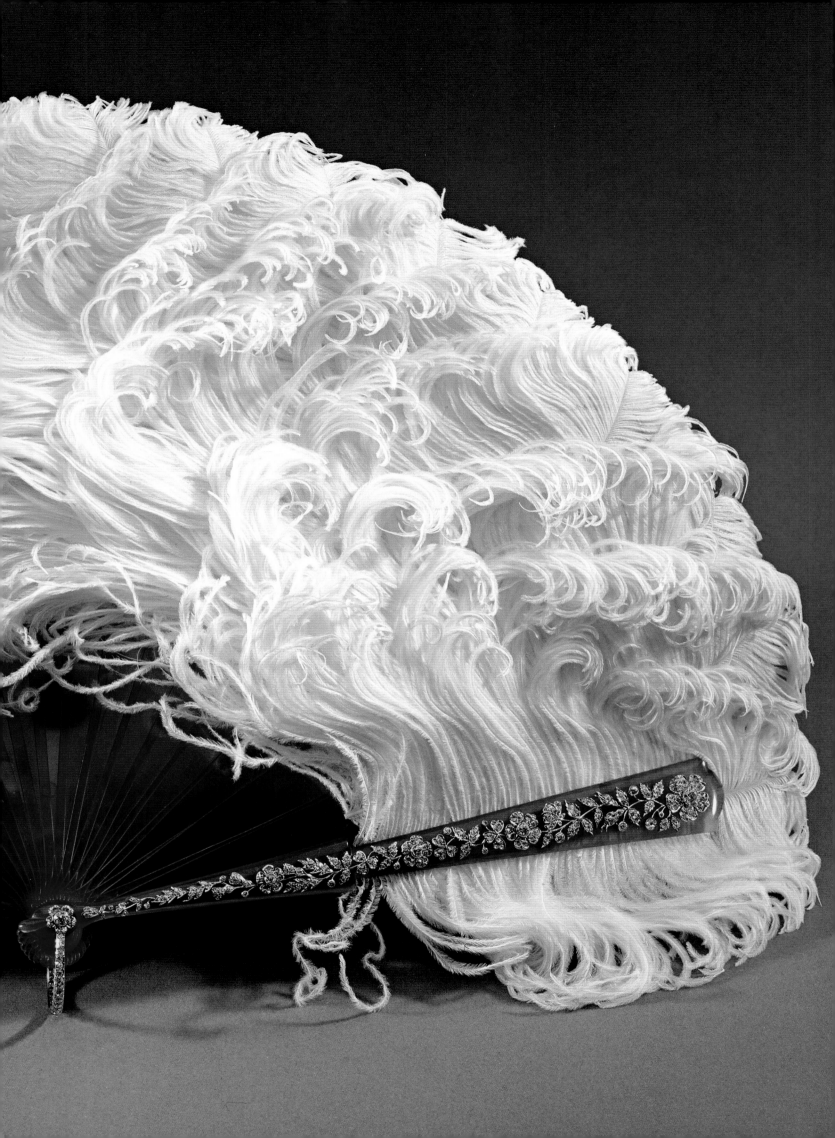

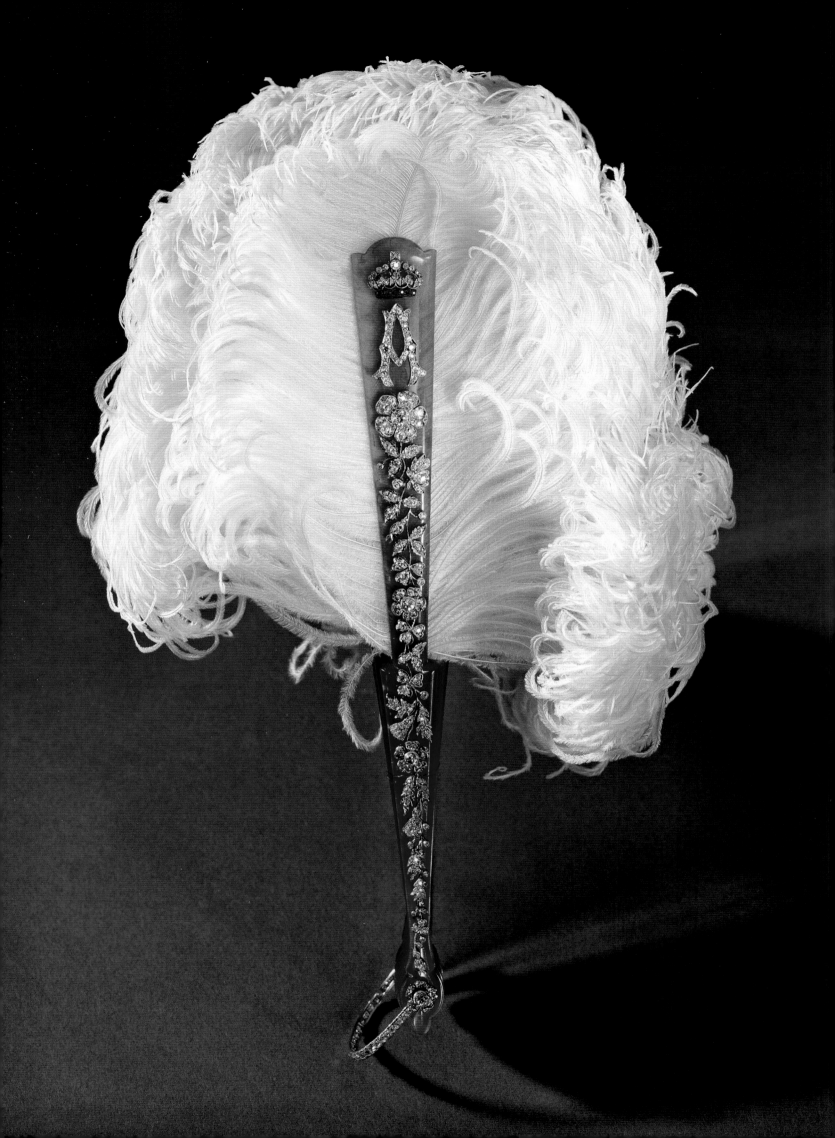

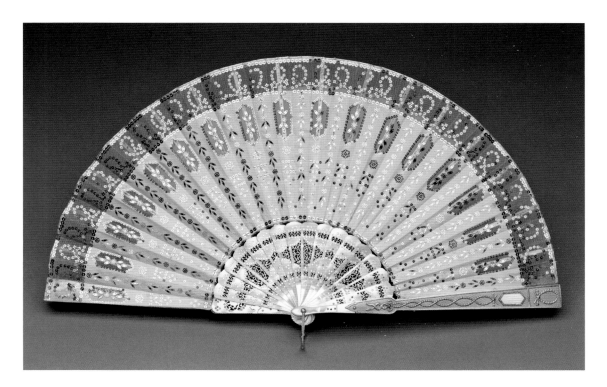

73. QUEEN ELIZABETH'S FABERGÉ FAN

RUSSIAN, c.1900

The firm of Fabergé was first established in St Petersburg in the 1840s, but its serious evolution dates from 1872, when Peter Carl Fabergé (1846–1920) took over the family business. From 1885 the firm was an official supplier to the Imperial Court and by 1910 Fabergé was the leading provider of jewellery, objects and silver to the Tsar and his family. To match the huge demand for his products, Fabergé introduced a highly organised system of workshops, each under its own workmaster, the most skilled of whom were elevated to the position of head workmaster.

The Royal Collection contains the largest group of works by Fabergé in existence, including three fans (nos. 73–5). The different marks which Fabergé's head workmasters applied to their works enable them to be quite precisely dated and attributed to a particular workmaster. In this case, we can be sure that the fan was made between 1896 and 1903 by Michael Perchin (1860–1903), Fabergé's head workmaster from 1886 until his death in 1903. Unfortunately, it has not yet proved possible to discover the original purchaser of the fan, which is first recorded in the possession of Queen Elizabeth The Queen Mother.

The period when Perchin was in charge of Fabergé's works is acknowledged as being particularly innovative, with the firm's output covering a great range of different object types and styles. In this case the silk leaf, decorated with sequins and spangles, imitates early nineteenth-century fans. The intricately decorated sticks – here combining two-coloured gold over pink and white guilloché enamel – are a particular feature of Fabergé's fans. A number of other fans produced by Perchin are known, several of which also have pink enamelled guards.[239] A Perchin fan with lilac enamelled guards and sequinned silk gauze leaf was made for Queen Alexandra's second daughter, Princess Victoria, at around the same date as the present fan.[240] However, fans were never more than a small proportion of Fabergé's output. By the late nineteenth century fans were supplied by other firms, in both Moscow and St Petersburg;[241] as in England, high-quality fans available in Russia were often made in Paris.

Opposite: no.72 (back guard)

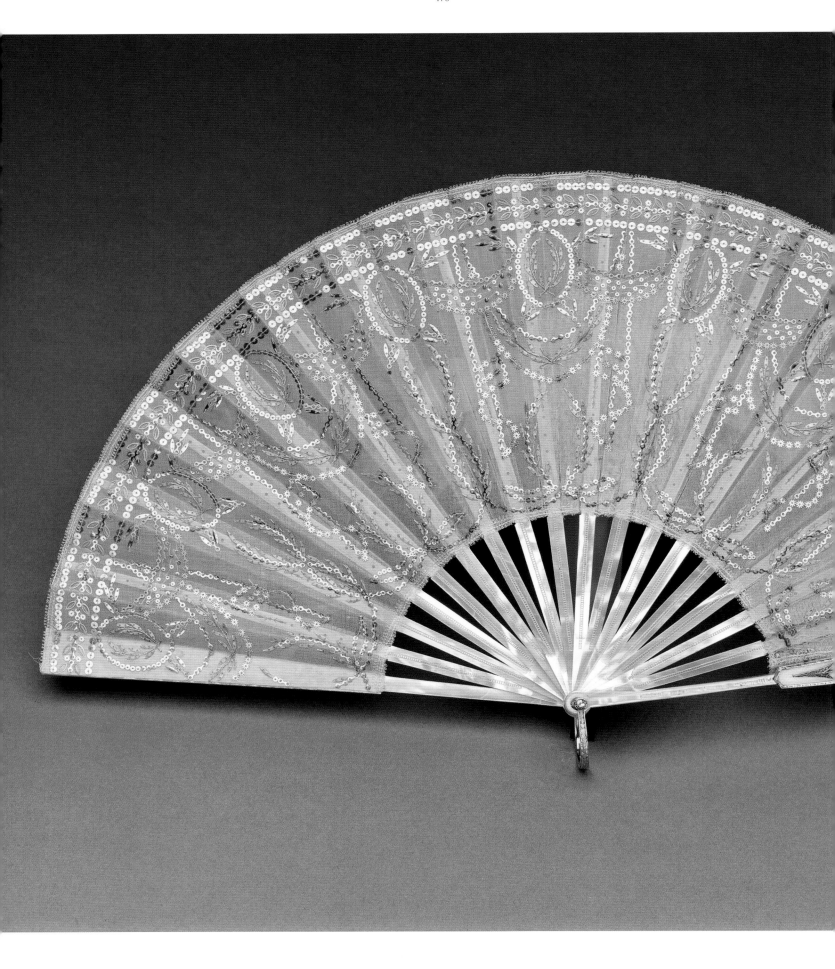

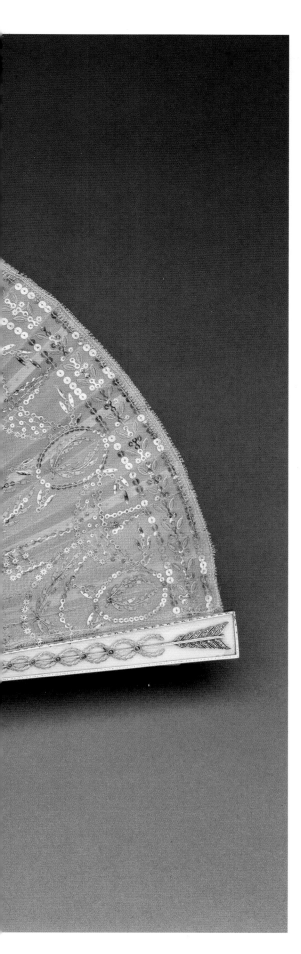

74. QUEEN ALEXANDRA'S FABERGÉ FAN

RUSSIAN, *c*.1904

The strong links between the British royal family and the products of Carl Fabergé's workshops were largely due to the family ties between the royal and imperial families. In 1866 Princess Dagmar of Denmark, sister of the Princess of Wales (later Queen Alexandra), had married the future Tsar Alexander III of Russia, and was to become Tsarina Marie Feodorovna. Their son succeeded as Tsar Nicholas II on his father's death in November 1894; later in the same month he married Princess Alix of Hesse, whose mother was Queen Victoria's second daughter, Princess Alice. Ten years earlier, Princess Alix's sister, Elizabeth, had married Grand Duke Sergei, Alexander III's younger brother.

This fan was a Christmas present from the widowed Tsarina Marie Feodorovna to her sister Queen Alexandra in 1904. It was purchased by the Tsarina direct from Fabergé's St Petersburg branch. After Queen Alexandra's death in 1925 the fan passed to Queen Mary (see plate 74.1), who gave it to the 6-year-old Princess Elizabeth (HM The Queen) in 1932.

The fan was made by Henrik Wigström (1862–1923), who took over as Fabergé's head workmaster on Perchin's death in 1903 and was responsible for some of Fabergé's finest pieces. In many respects – including the sequinned silk gauze mount and Neoclassical decoration of the enamelled guards – it follows the style of the fans created by Perchin (including no. 73). As with the earlier fan, the combination of sequinned leaf and mother-of-pearl sticks would have glinted decoratively in the evening light. A number of other fans produced by Wigström have painted leaves (see no. 75).

Plate 74.1. The fan box for no. 74, with Queen Mary's provenance note (RCIN 25219.b and .c) The note reads *Fan made by Fabergé. S^t Petersburgh. / belonged to Queen Alexandra – / given to Princess Elizabeth of York / by her grandmother Queen Mary / . 1932 .*

75. QUEEN MARY'S FABERGÉ FAN
RUSSIAN, *c.*1912

This fan was purchased by Queen Alexandra from Fabergé's London branch in December 1912 as a Christmas present for her daughter-in-law Queen Mary. Like the previous fan, it retains its original birchwood box, with Fabergé's Imperial Warrant stamped inside the lid (see plate 75.1). The London branch of Fabergé opened in 1903, largely because of the popularity of the firm's output with King Edward VII and Queen Alexandra. By the time of the purchase of this fan the branch was based at 173 New Bond Street, where it remained until the closure of the London operation in 1915. Between 1902 and 1914 disbursements of over £3,000 were made by Queen Alexandra to Fabergé; of this, over £2,500 was paid from the Queen's presents account, for gifts. King Edward VII also made numerous purchases from Fabergé, and in 1907 placed a major commission with the firm – for miniature animal sculptures of the domestic and farm animals at Sandringham. A strong interest in Fabergé was inherited by King George V and was shared by Queen Mary and by their daughter-in-law Queen Elizabeth The Queen Mother.[242]

Unlike the two other Fabergé fans in the Royal Collection (nos. 73 and 74), both of which are slightly larger, the silk leaf of this fan is painted rather than embroidered and sequinned. It is stamped by the workmaster Henrik Wigström, by whom a number of other painted fans are known.[243] The stock book containing watercolour records of the objects produced in Wigström's workshop between 1909 and 1915 includes a number of sketches of fans, but none of these relates to surviving fans in the Royal Collection.[244] In the present fan, a Rococo-inspired leaf is combined with guards decorated in a Neoclassical style.

Plate 75.1. The fan box for no. 75 (RCIN 25136.b)

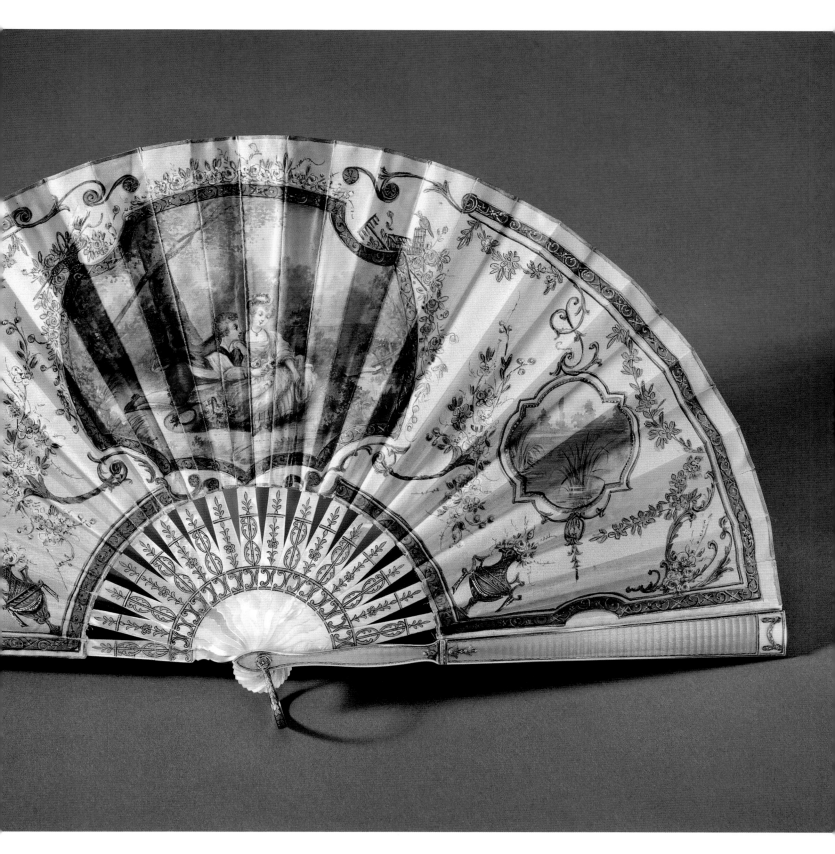

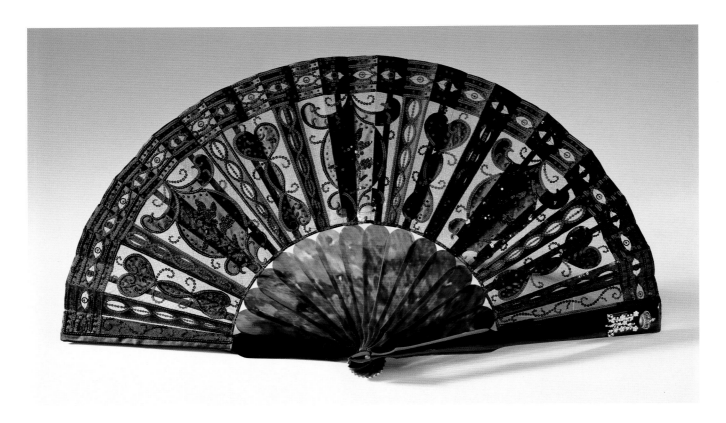

76. BLACK EVENING FAN

GERMAN, c.1910

The crowned initial *M* on the front guard indicates that this fan was made for Queen Mary after the accession in 1910. The decoration of sequins and spangles suggests that this was an evening fan (which would twinkle in the candlelight) rather than a mourning fan. Its traditional format, and its absence from any of Queen Mary's lists of fans, suggest that it was kept with her clothes and other accessories, among the fans which were 'in use'.

The fan is likely to have been made in Berlin, where there was a revival of fan-making in the years around 1910.[245] The simple decoration and plain colours combine to produce an elegant effect.

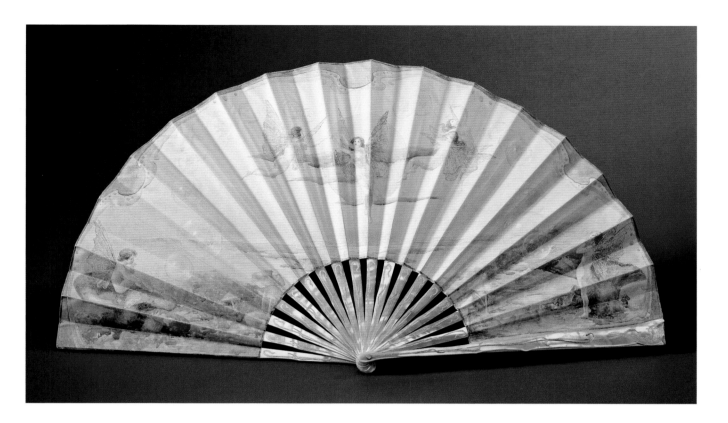

77. 'FAIRIES AND TOADSTOOLS'

FRENCH, c.1910

Both the painted leaves and the mother-of-pearl sticks and guards are typical of fans produced at the start of the twentieth century, the period of art nouveau and the *Belle Epoque*. The initials *VM* (for Victoria Mary) below the Prince of Wales's coronet suggest that the fan was made for the future Queen Mary between 1901 and 1910, and a brief description in one of Queen Mary's notebooks indicates that it was a gift from Queen Alexandra.[246] However, neither the maker's name nor the artist responsible for the charming painted leaves is known, and it is possible that it dates from the 1890s rather than around 1910; it could even have been a wedding present in 1893.[247]

In the late nineteenth and early twentieth centuries interest in fairies was particularly strong. In England they represented an alternative to the materialistic and rapidly changing world following industrialisation and great population growth. Charles Kingsley's *Water Babies* (1863) was followed by J.M. Barrie's *Peter Pan* (1904), with illustrations by Arthur Rackham (1906), and numerous 'Flower Fairy' books with illustrations by Cicely Mary Barker (from 1923). The illustration of fairies on this fan depicts an enchanting, happy and graceful world of fantasy and conveys the spirit of the times in dreams and longings for a magical world where wishes come true. The delicate pastel palette successfully conveys the sublime beauty of this fairy universe. The medium of watercolour enhances the fragile and fugitive nature of this supernatural world. The painting depicts light, air and magic. The gossamer wings, bubbles and toadstools combine to show a world of make-believe.

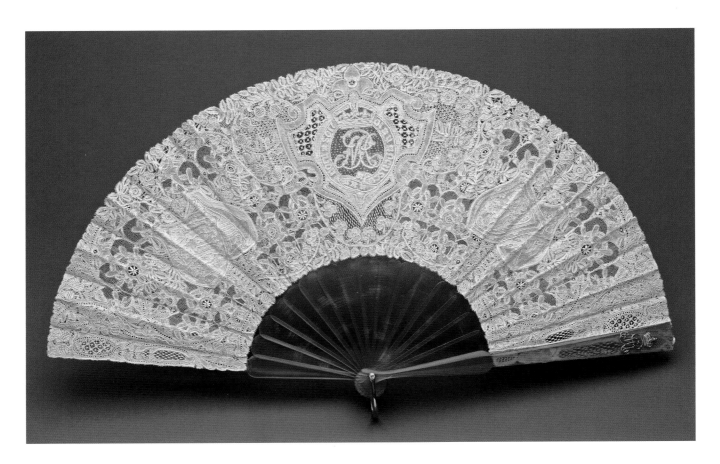

78. QUEEN MARY'S CORONATION FAN

ENGLISH, 1911

Whereas the Honiton lace fan given to the future Queen Mary at her wedding (no. 65) was presented by the lace-makers and ladies of Honiton, this fan – likewise made in Honiton, but for the Queen's coronation – was the gift of the Fan Makers Company. The formal circumstances of the gift are reflected in the royal and heraldic content of the lace design, with four shields of arms and decorative border containing the rose, thistle and shamrock. The fan was noted by Queen Mary as being 'in use'.[248] It was apparently taken by the Queen to India for use during the Durbar celebrations.[249]

According to information passed to *The Illustrated London News*, the fan was designed by the industrial designer, fan-maker and fan historian George Woolliscroft Rhead, and the leaf was made in the workshop of Miss Fowler of Honiton. The guards and sticks were carved by Robert Gleeson under the direction of Mr Joseph Ettlinger, Past Master of the Fan Makers Company.[250] Gleeson had also produced the sticks for Queen Victoria's Diamond Jubilee fan (no. 69). Although the original box has survived, it does not record the name of the firm responsible for making the fan.

The leaf is of very high quality and includes the full range of Honiton techniques, including raised outlines, whole and half-stitch, a variety of elaborate fillings and a delicate net ground worked with bobbins in imitation of a needle-made ground. By 1911 very little lace was being produced in Honiton. The problems involved in a design of such detail and intricacy – complicated by the fact that the lace is worked from the back – are suggested by the existence, at Honiton, of a piece of lace bearing the arms of England and Scotland (on the right in the finished leaf), erroneously worked in reverse.[251]

The Honiton lace-makers also produced a fan at the time of Queen Elizabeth's coronation in 1937.[252] That leaf – incorporating roses, thistles and ferns – was made and probably designed by Miss Ward, niece of Miss Fowler.

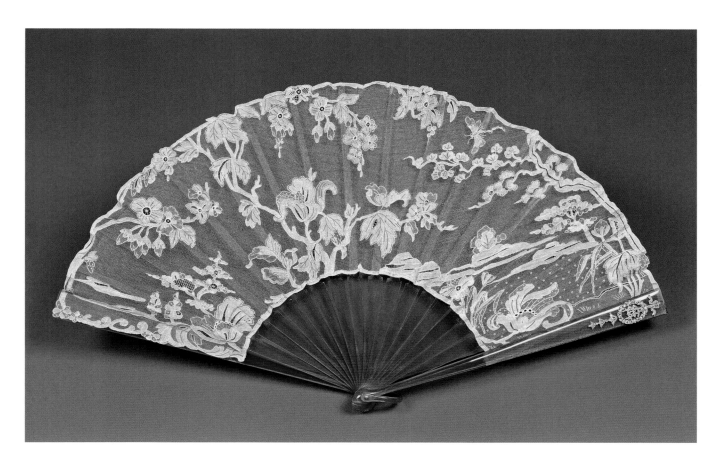

79. BRUSSELS LACE FAN

BELGIAN, *c.*1920

Like the Brussels lace fan given to Queen Mary at the time of her wedding in 1893 (no. 63), the leaf of this fan is worked in fine *point de gaze* needle lace – in this leaf in cotton, in the earlier leaf in linen thread. The mesh ground is denser and 'cloudier' here than in nineteenth-century examples. In addition, the design of the leaf is quite different, reflecting the then current art nouveau fashion for asymmetry and stylised rather than naturalistic forms. Only the jewelled monogram of the donors on the guards retains the earlier formality.

 The fan was presented to Queen Mary by King Albert I (1875–1934) and Queen Elisabeth (1876–1965) of the Belgians in the course of their State Visit to London in 1921. As Prince Albert of Belgium, the King had been one of the guests at Queen Mary's wedding in 1893. From the start of the Belgian monarchy, the bond between England and Belgium was strengthened by family ties: King Leopold I (grandfather of Albert I) was the uncle of both Queen Victoria and Prince Albert, and it had been his wife – born Princesse Louise d'Orléans – who had purchased fans in Paris for the young Queen Victoria in the late 1830s.[253] There was a close bond of friendship between the two royal families and the 1921 State Visit to London, three years after the end of the First World War, was followed by a return visit to Belgium in May 1922, much enjoyed by Queen Mary.[254] In the course of her stay in Brussels, Queen Mary purchased several pieces of modern Brussels lace.[255]

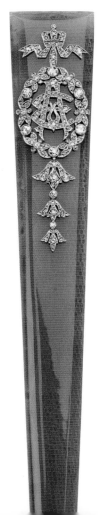

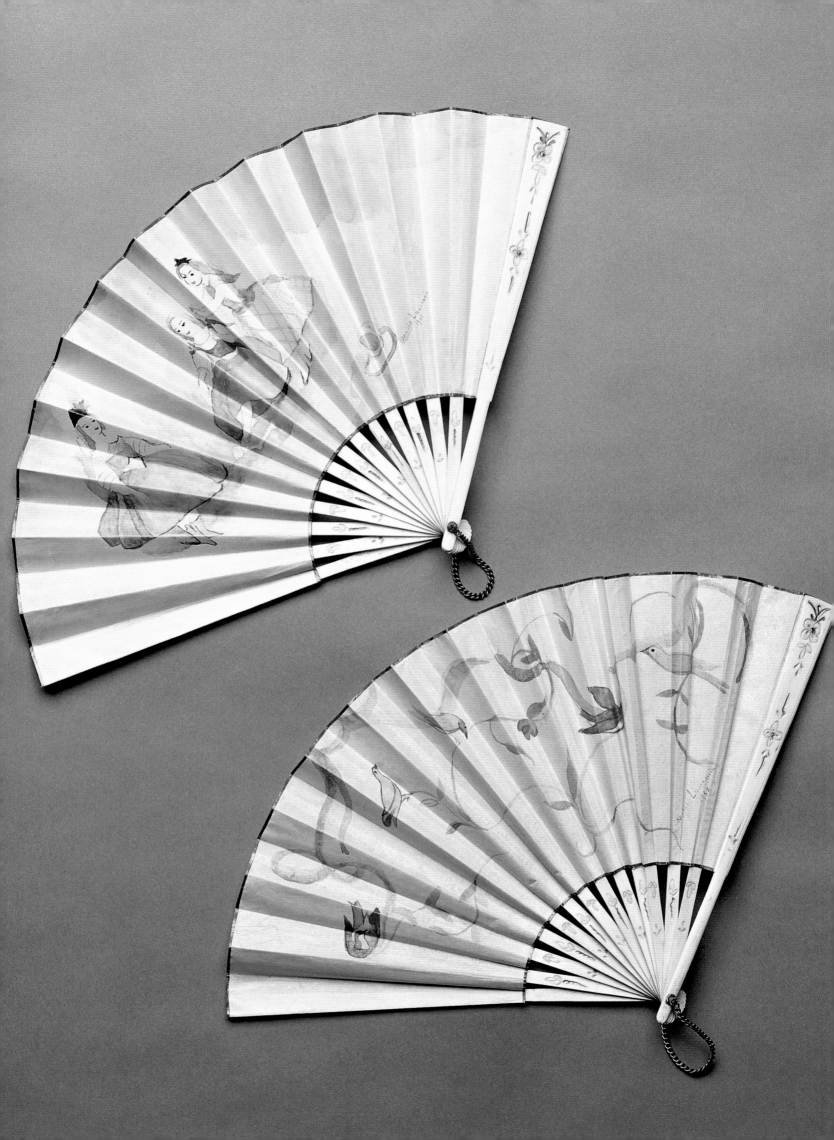

80. DOLL'S FAN

FRENCH, 1938

81. DOLL'S FAN WITH BLUE BIRDS

FRENCH, 1938

These fans belong to the extensive wardrobe of the two dolls France and Marianne (plate 80/81.1).[256] The dolls were given – with a large collection of clothes and personal accessories (including motor cars) – to Princesses Elizabeth and Margaret Rose (then aged 12 and 8 years respectively) at the time of the State Visit to France in July 1938 of their parents, King George VI and Queen Elizabeth. This was the first State Visit undertaken by the King and Queen, following the coronation in May 1937. All the most famous couturiers and craftsmen then active in Paris collaborated in the provision of the dolls' trousseaux. They were well aware that the gift would serve as a splendid advertisement for French fashion and handiwork. Outfits were provided for every occasion, from the morning walk to the yachting trip, from Ascot races to an evening reception. Duvelleroy provided four fans for the dolls' wardrobe: these two, both with paper leaves painted by Marie Laurencin (1885–1956); and two folding ostrich feather fans, one with blue feathers, the other with pink feathers (plate 80/81.2). The original boxes for all four fans have survived, each with the trade stamp of Duvelleroy inside the lid.[257] Other items were supplied by Worth, Lanvin, Vionnet, Vuitton, Hermès, Guerlain and Lancôme.

Following their arrival in England in November 1938, the dolls and their trousseaux were exhibited at St James's Palace, in aid of The Princess Elizabeth of York Hospital for Children and a French charity. The dolls, with a selection of their clothing and accessories, are now on public view in the area alongside Queen Mary's Dolls' House, at the entrance to the State Apartments in Windsor Castle.

The painter and designer Marie Laurencin specialised in the depiction of pretty young girls in soft pastel shades. She was the mistress of the art critic Guillaume Apollinaire, whose writings exercised such an influence on avant-garde poets and painters of the early twentieth century. Friendship with artists such as Picasso had a superficial influence on Laurencin's charming works.

Detail of no. 80 verso

Opposite: nos. 80 (above) and 81 (below)

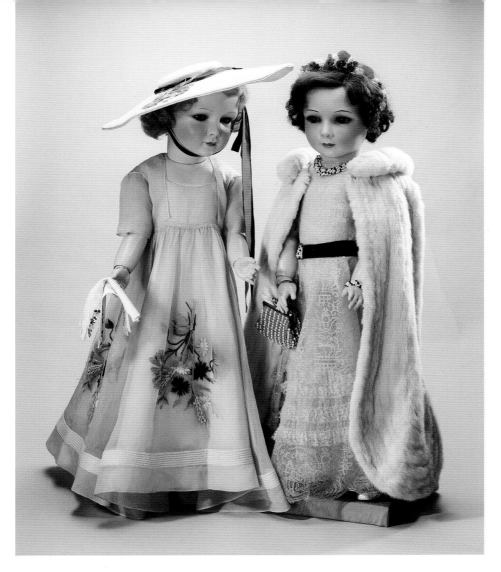

Plate 80/81.1. The dolls France and Marianne, presented to Princesses Elizabeth and Margaret Rose during the State Visit to France in July 1938.

Plate 80/81.2. Some of the accessories which accompanied France and Marianne, including one of the feather fans and fan boxes supplied by Duvelleroy in 1938.

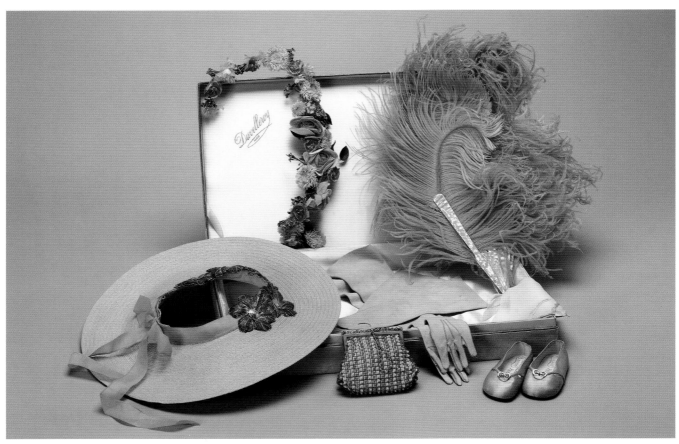

82. QUEEN ELIZABETH'S CORONATION FAN

ENGLISH, 1937

This fan was presented to Queen Elizabeth (later Queen Elizabeth The Queen Mother) shortly before the coronation in May 1937. It was the gift of the Worshipful Company of Fan Makers and the progress of its manufacture may be traced in the letter books of the Company.[258] According to the Company's records, the fan was to be made entirely of materials from the British Empire. It is a late and somewhat oversized version of the magnificent ostrich feather fans produced from the second half of the nineteenth century, a classic example of which is Queen Alexandra's curled ostrich feather fan of c.1901 (no. 72). The fan (and its box) was made by Charles Beale Gunner of 169 Regent Street, and the crowned double *E* on the front guard appears to have been supplied by Messrs Garrard.[259] It was exhibited at the Carlton Hotel, Haymarket, on 22 April 1937 for members of the Company to inspect prior to its formal presentation – by the Master (Mr William R. Heywood) and the Senior Past Master (Sir John Pakeman).[260] The crest of the Fan Makers Company (a hand holding a fan) is placed on the rear guard (plate 82.1).

Plate 82.1. The gold crest of the Worshipful Company of Fan Makers, from the rear guard of no. 82.

Plate 82.2. Nos. 82 and 72, to show relative sizes.

Overleaf: no. 82 recto

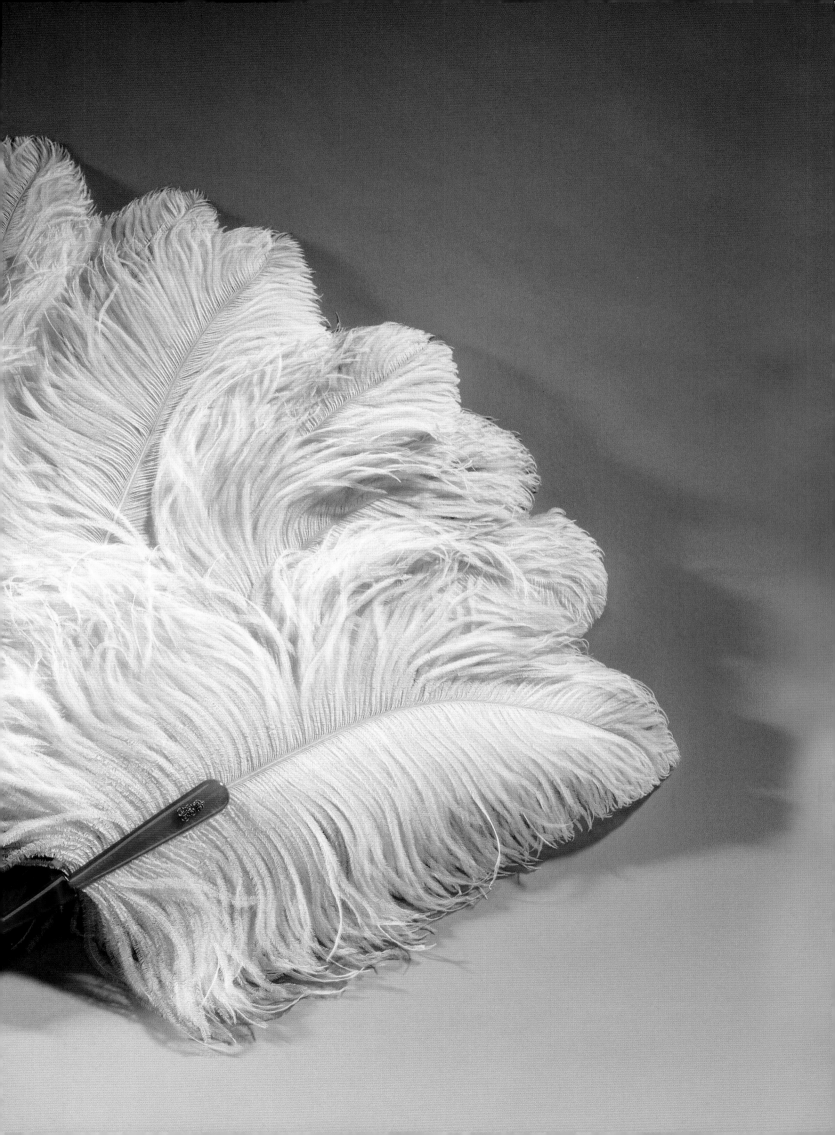

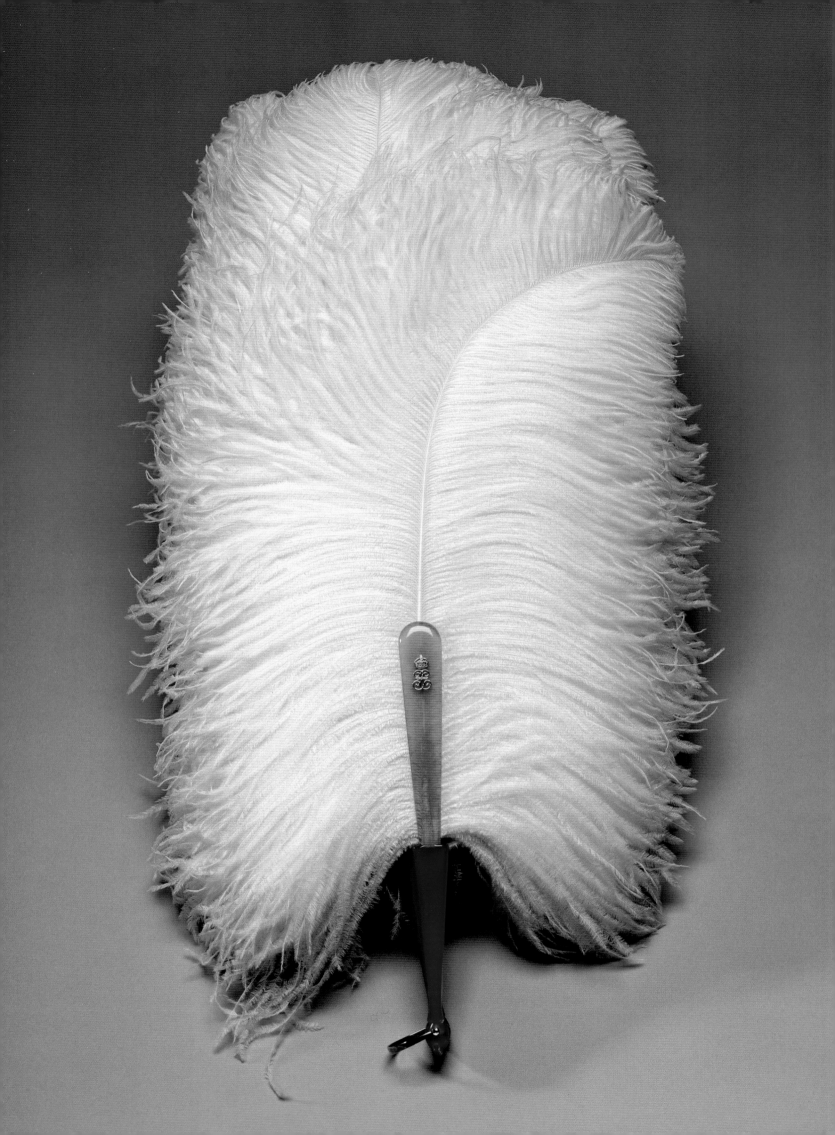

NOTES

1 Musée de la Renaissance, Ecouen; see Melville 1991, p. 6, figs. 3–4, and Trogan 1995 (with the date 1590–95). The fan is said to have belonged to Queen Marie-Antoinette (see Alexander 2002, p. 9).

2 Esther Oldham Collection, Museum of Fine Arts, Boston.

3 For instance, Isabetta Catanea Parasole, *Pretiosa gemma delle virtuose donne*, Rome 1598; Cesare Vecellio, *Corona delle nobili et virtuose donne*, Venice 1592. Several examples are illustrated in Levey 1983.

4 Hearn 1995, no. 136.

5 The second fan (plate 1.1) has a silk leaf painted with birds and flower heads, mounted on tortoiseshell sticks.

6 See RCIN 1047656.

7 See Armstrong 1992–4.

8 Rome, Galleria Borghese; Spear 1982, no. 52, pls. 173–5.

9 Spear 1982, p. 193

10 Including Volet 1994, no. 29 (M.V. 976) and Cust 1893, p. 6, no. 22. The house in the distance does not appear in the Borghese painting and is close to the type of buildings shown in prints such as those included in Jan Vredeman de Vries, *Artis Perspectivae . . . multigenis fontibus liber primus*, published in 1568.

11 Gibson 1927, p. 20.

12 Major Dent was the author of *Piqué: a Beautiful Minor Art*, published in 1923 (see Dent 1923). For a fan with silver *piqué* sticks, the field decorated with *The Triumph of Alexander*, see Hart and Taylor 1998, pl. 9 (French, 1670–1700); for one decorated with *The Abduction of Europa*, see Volet 1994, no. 1 (French, c.1710).

13 Lennox-Boyd 1982; Baker 2002, p. 76. However, the Oxford leaf has an elaborate decorative surround.

14 Phillips, London, 25 May 1999 (lot 9). The source of the composition has not been traced.

15 Eidelberg 2004, p. 252.

16 *Princely Patrons. The Collection of Frederick Henry of Orange and Amalia of Solms in The Hague*, exh. cat., The Hague, 1997–8, no. 29b, pp. 216–23.

17 For instance, Ezquerra del Bayo 1920, no. 9 (lent by Queen Cristina; attributed to N. Bertin).

18 *Burney Diary* 1904–5, IV, p. 73.

19 Mrs Whitelaw Reid also gave a fan (RCIN 25358) to Queen Mary on 26 May 1911. Jean Templeton Reid was a proficient tennis player, taking part in tournaments in Monte Carlo in both 1924 and 1925.

20 Staniland 1997, p. 91.

21 RA VIC/Y 7/18.

22 RA VIC/QVJ/1829: 26 December.

23 RA VIC/Y 7/25–6.

24 Particularly the gold-backed upper central motif on the recto, and the ultramarine on the stick to the left of the front guard.

25 The late sixteenth-century fan in Ecouen is also said to have belonged to Queen Marie-Antoinette (see no. 1, n.1, and Trogan 1995).

26 Blondel 1875, p. 85. A reproduction of the painted copy of the fan in the Bethnal Green Museum is included in Dunn 1901, after p. 96. In 1897 no. 5 was lent by Queen Victoria to the fourth Competitive Exhibition organised by the Fan Makers Company.

27 Green 1975, p. 117.

28 London 1870, nos. 104, 107; see also Melville 1991, pp. 13, 41, n.4, and no. 41 below.

29 RA VIC/Y 167/16.

30 For this see Staniland 1997, p. 21. A list of Princess Charlotte's clothes and accessories includes six fans – two tortoiseshell, two of carved ivory, and two of net and steel (Museum of London 74.100/21). Another fan from Princess Charlotte's collection (RCIN 25119) was bequeathed to Queen Mary in 1942.

31 See Cowen 2003, pp. 62–9 (from the 1670s).

32 See Hart and Taylor 1998, p. 69; Alexander 2001, nos. 4, 5.

33 DCO, Household Accounts, Vouchers vol. XIII. In the same account Goupy charged a further 10 guineas 'For Painting the leather of the Coronation at Presbourg', for mounting the two leaves, and for supplying and carving the sticks.

34 For instance, by Valerio Spada (see RCIN 723040, 723043, 723046).

35 Christie's, South Kensington, 12 December 1995 (lot 12).

36 Rosenberg and Prat 1996, no. 144; the drawing is in the collection of the National Gallery of Art, Washington (inv. 1988.1.1).

37 At the Museum he appears to have progressed from working as a packer or attendant, later photographer, to an administrative role.

38 He also gave the Museum some buckles to go with a livery (with buckles missing) that it had acquired. (Information for notes 37 and 38 from Chris Marsden, Victoria and Albert Museum.)

39 Williams's letter to Queen Mary on 17 September 1940, after a particularly severe raid, is RA GV/CC 47/1868.

40 Other examples of this type were included in the exhibitions at Karlsruhe in 1891, and Madrid in 1920.

41 No. 22043: see Volet 1986, pp. 105, 111, 133, no. 369. See also Duvelleroy 1929, p. 104.

42 At the Fan Museum in Greenwich (illus. *Hatch, Match and Despatch* 1992–3, no. 8); and in the collection of Maryse Volet (M.V. 582; see Volet 1994, no. 84).

43 RA VIC/QVJ/1840: 9 February.

44 QVL 13, 27, 52 ('at the marriage'), 69 and 78; identifiable as RCIN 25085, 25083, 25084, 25090 and 25091 (this fan). QVL 35 (also from Gotha, via the Prince) was bequeathed to the Crown Princess of Roumania. QVL 13 (RCIN 25085) is described in WC Fans (p. 20, no. 13) as having been presented at the marriage. For the Gotha collection of fans, see p.20.

45 Ernest II's gifts were QVL 7, 12, 23, 25, 26, 28, 29 and 55. Of these, only QVL 23 (RCIN 25097) is still in the Royal Collection; the remainder were bequeathed by Queen Victoria to other members of her family. QVL 28 and 29 are annotated with the date of the gift as 1836. Although Queen Victoria's list noted that QVL 11 (our no. 10) was 'from the collection of fans at Gotha', its provenance is Coburg, not Gotha.

46 Daquin 1753, p. 152.

47 QVL 11.

48 See also Diderot 1751, pl. IV, fig. 14; see here figs. 3–6.

49 It is possible that the fan was given to Queen Mary in the course of her afternoon visit to his London home, 16 Ulster Place, Regent's Park, on 16 March 1939 (RA GV/CC 47/1800).

50 Eidelberg 2004, *passim*.

51 Fowles 1977, p. 37.

52 Marlay's fans (MAR.M.235-1912 to MAR.M.249-1912) are mostly Continental, dating from the eighteenth and nineteenth centuries; their earlier provenance is not recorded. The paintings included in his bequest are described in W.G. Constable, *Catalogue of Pictures in the Marlay Bequest, Fitzwilliam Museum, Cambridge* (Cambridge 1927).

53 St Katharine's Lodge was the official seat of the ancient Anglican Royal Foundation of St Katharine by the Tower of London, founded in 1148. Since 1261 the Queen of England (or the Queen Dowager) has been patron of St Katharine's. Marlay's successful petition for the lease of St Katharine's Lodge was made to Queen Victoria (RA

VIC/Add J 222/Mar 10/88; see also RA VIC /Add K 568/July 7/82). Marlay's sister was the first wife of the 7th Duke of Rutland, and the mother of the 8th Duke of Rutland.

54 For a contemporary French *trompe-l'oeil* fan, where the lacy conceit occupies the whole leaf, see no. 11.

55 Volet 1994, no. 17 (M.V. 589). The ivory sticks are finely carved with flat curved tops below the gorge, and edges which create a further decorative effect (of a geometer putto) when the fan is closed.

56 RCIN 25243.

57 Hancock's fan box is RCIN 25218.b.

58 Savoy Hotel archives DM/40/743.

59 Harewood 1986, nos. 119, 120.

60 *Walpole Correspondence*, XX, p. 483.

61 Rhead 1910, p. 164.

62 See, e.g., Hart and Taylor 1998, pl. 15.

63 Cust 1893, pp. 31–2, nos. 144, 145.

64 Queen Mary acquired a second cabriolet fan (RCIN 3585) in 1936.

65 RCIN 25205; QMB, II, p. 59, no. 216.

66 *HMWP* 1947, no. 1793.

67 Schreiber 1888, no. 109; Cust 1893, p. 3, no. 8 (hand-coloured on ivory sticks, with a small landscape painted on the verso).

68 See Salisbury/Guildford/London 1985–6, no. 14A, and Harewood 1986, no. 13, on eleven wooden sticks; and Gostelow 1976, fig. 52.

69 See Mortier 1992.

70 See M. Winterbottom in *George III & Queen Charlotte* 2004, pp. 387, 389. The Duke of Sussex contracted two marriages in contravention of the Royal Marriages Act. The fans included in his posthumous sale (Christie's, London, 28 June – 3 July 1843, lots 768–9) may have belonged to one of his wives.

71 RCIN 400146; *George III & Queen Charlotte* 2004, no. 4; see also Walton 1975.

72 Levey 1995, Br. F. 3.

73 Alexander 1995, p. 22.

74 Dimond and Taylor 1987, pp. 69, 184 and no. 175.

75 The fragment was exhibited at the Capitoline Museum, Rome, and the National Gallery, Bologna, between September 2002 and January 2003.

76 Martin (J.R.) 1965, pls. 62 and 68.

77 Alexander 2001, no. 6. Another fan based on Reni's composition was reproduced by Rhead from Lady Northcliffe's collection (Rhead 1910, fig. 61, opp. p. 118).

78 These include examples in the following collections: British Museum, Schreiber Collection (Cust 1893, p. 124, no. 364); Victoria and Albert Museum, datable c.1700–1720 (65–1870; Hart and Taylor 1998, pl. 8, p. 22); Cooper-Hewitt Museum, New York. Another example, in the collection of the Fan Makers Company, is from the collection of Princess Alice, Countess of Athlone (no. AA).

79 Fraser 2004, p. 141 (referring to a letter dated 13 January 1792).

80 Fusconi 1994. A possible source for the image reproduced in this fan is the engraving by Mynde-Paderni, issued in 1740. Other fans decorated with this scene include one 'bought in Naples by Lady Ponsonby' (illus. Rhead 1910, fig. 63, between pp. 122 and 123) and another recently on the London art market (illus. Mayor 1991, p. 14).

81 Hart and Taylor 1998, pp. 20–22, fig. 3.

82 The signature and date (*Joseph Goupy, 1738*) on a fan leaf in the Schreiber collection with views of the Arches of Constantine and Titus, and the Forum, are spurious (Cust 1893, p. 120, no. 335).

83 These include an approximately contemporary fan with a similar view of the Pantheon in the centre, in the H. Alexander collection at the Fan Museum, Greenwich (Wilton and Bignamini 1996, no. 263).

84 The association is stated in Queen Victoria's fan list (QVL). Fans from Princess Augusta's collection bequeathed by Queen Victoria to King Edward VII were QVL 36 (the present fan), 56 (RCIN 25067), 77 (RCIN 25066) and 80 (?RCIN 25079). QVL 74, also from Princess Augusta's collection, was bequeathed to Princess Aribert of Anhalt (Princess Marie Louise).

85 *George III & Queen Charlotte* 2004, pp. 387, 389.

86 The 'aunts' fans bequeathed to King Edward VII were QVL 42 (?RCIN 25103) and 58 (?RCIN 25081). The fans bequeathed elsewhere were QVL 21, 63, 64 and 65.

87 The source was probably Gori 1732, pl. I.i, but the gem had also been included in the earlier publications by Galestruzzi and Montfaucon. The figure at left is also found in Gori (pl. I.76.5).

88 It is more legible on unmounted impressions such as that in the Schreiber collection (Schreiber 1888, no. 58 and p. 14; Cust 1893, p. 78, no. 76).

89 *Burney Diary* 1904–5, I, pp. 465–6.

90 No. 26 is Tuer 1882, II, p. 116, no. 987. Of the eighteen fan designs listed as the work of Bartolozzi, Tuer was only aware of four (including no. 26) that had been made up as fans. See also Rhead 1910, p. 268.

91 RA GEO/27708. The invoice is RA GEO/27712.

92 The Schreiber collection includes four examples, two painted (Schreiber 1890, no. 19; Cust 1893, p. 30, no. 139 and *ibid.*, no. 140) and two printed (Schreiber 1888, no. 127; Cust 1893, p. 9, no. 42 and Schreiber 1890, no. 20; Cust 1893, p. 30, no. 138). Other examples are reproduced in Rhead 1910, fig. 90, opp. p. 186; Staniland 1985, fig. 9; Kammerl 1989, nos. 64 and 66; Mayor 1991, p. 10; Barisch 2003, nos. 41, 42. See also Christie's, South Kensington, 9 February 1993 (lot 10; a Cantonese fan with the same subject as the present fan) and 15 February 2000 (lot 33). For ballooning fans see Malpas 1992.

93 London 1994, no. 61. The so-called 'fan leaf' of this subject in the British Museum (Schreiber 1888, no. 18; Cust 1893, p. 71, no. 34) is an impression of that print, trimmed to the shape of a fan, but never mounted. The preparatory studies by Ramberg, a Hanoverian pupil of Benjamin West, are now divided between the Royal Collection (RL 17878), the British Museum and the Courtauld Institute Galleries.

94 Another version of this leaf, printed on vellum, is in the British Museum (O'D, V, p. 11). A fan leaf entitled 'George III and his Family in one of the rooms of the Royal Academy' is listed among the engraved works of Bartolozzi; it is unclear to what this refers (Tuer 1882, II, p. 117, no. 990).

95 There are two unmounted examples of this later leaf in the Royal Collection: RCIN 502823 (printed in colours on vellum) and RCIN 604692 (printed in black ink on paper); other examples are in the British Museum (O'D, V, p. 11), in the collection of the Hon. Christopher Lennox-Boyd (Salisbury/Guildford/London 1985–6, nos. 23, 24, and Harewood 1986, no. 22), and on the London art market (Christie's, South Kensington, sale catalogue, 25 May 1999).

96 Hart and Taylor 1998, pl. 38, p. 75.

97 Willcocks 2000, p. 34. See also Rhead 1910, fig. 113, opp. p. 246.

98 *Burney Diary* 1904–5, IV, p. 285.

99 Hart and Taylor 1998, pl. 39 and pp. 75–6 (inv. T.203–1959). It was included in Queen Mary's collection listing (QMB, II, p. 107, no. 445) and was lent by her to the *Four Georges* exhibition (London 1931, no. 165).

100 The Museum of London (inv. 48.109/1; by descent from Miss Goff, to whom the fan was reputedly given in 1789), the Schreiber collection at the British Museum (Schreiber 1888, no. 110 and p. 25; Cust 1893, p. 52, no. 250), the Museum of Fine Arts, Boston, and the Dorothy Quincy Homestead, Quincy, Mass.

101 See Watkin 2004, p. 143. The Weld fan is now in the collection of the Rector

of Stonyhurst College, Lancashire. Another was acquired at auction in London and is now in the possession of Arthur and Georgette Tilley.

102 *Annual Register* for 1789, pp. 252–4. See also Fraser 2004, p. 123.

103 See *George III & Queen Charlotte* 2004, nos. 73–83. A printed fan in the Schreiber collection, entitled *Resting after Travelling*, engraved by H. Thielcke after a design by Princess Elizabeth, was published by H. Thielcke in 1810 at the Queen's (i.e. Buckingham) House (Schreiber 1888, p. 21, no. 93).

104 RCIN 25062 and Cust 1893, p. 3, no. 9; Rhead 1910, p. 246. See also Salisbury/Guildford/London 1985–6, nos. 25–70.

105 Walker 1992, no. 178.

106 RCIN 25079, 25267. For other fans with jasper-ware plaques, see *Wedgwood* 1995, no. B59, and Barisch 2003, no. 46.

107 For a similar fan with portraits of the French royal family see Volet 1994, no. 31 (M.V. 215).

108 The English ceremony is recorded in an Anonymous painting (RCIN 402495).

109 Quoted in Alexander 1995, pp. 22–3. See also Rhead 1910, p. 203. For two printed fans issued at the time of the marriage of the Duke of York, see Schreiber 1888, nos. 111 and 71; Cust 1893, p. 4, no. 11, and p. 67, no. 10.

110 The guards match the sticks very well. However, on the inside the ivory is of a slightly different shade.

111 PRO HO 73/18.

112 *Encounters* 2004, pp. 33–4 (Kunsthistorisches Museum, Vienna).

113 RCIN 3683.2.

114 RCIN 25389.1–2.

115 Iröns 1981, p. 132, no. 39: with crowned 'S', presumably for George IV's sister, Princess Sophia (1777–1848). See also Kammerl 1989, no. 79; Alexander 2001, no. 35; and Barisch 2003, no. 3.

116 For this embassy and the tentative identification of surviving imperial gifts in the Royal Collection, see *George III & Queen Charlotte* 2004, p. 382.

117 Christie's, South Kensington, 19 May 1998 (lot 139).

118 There are three in the Schreiber collection: *The Surrender of Valenciennes* (Schreiber 1888, nos. 112, 113; Cust 1893, p. 4, no. 12), *A New Puzzle Fan* issued on 1 March 1794 (Cust 1893, p. 63, no. 329) and *The New Caricature Dance Fan for 1794* apparently issued on 10 November 1798 (Schreiber 1888, no. 134; Cust 1893, p. 11, no. 51). A fourth fan with this imprint, entitled *Apollo*, is in the collection of the Hampshire Museums Service.

119 See *George III & Queen Charlotte* 2004, nos. 407, 408.

120 See Begent 1992–3 for the 1805

Installation.

121 Christie's, South Kensington, 1 December 1998 (lot 58).

122 McKechnie 1978, p. 203.

123 Christie's, South Kensington, 16 September 1997 (lot 42); now Paris, Musée de la Mode et du Costume, Palais Galliera. The original box, also with Giroux's trade label, has also survived. The labels give Giroux's address as Rue du Coq, St Honoré No. 7, Paris.

124 Similar sticks, also set with jewels, are found on a Chinese export ivory *brisé* fan in Bielefeld (Barisch 2003, no. 86).

125 Another fan from Queen Adelaide's collection was given by Queen Alexandra to her daughter, Maud, Queen of Norway.

126 Another Cantonese fan formerly in Queen Victoria's collection, on ivory sticks painted red, is in the collection of the Fan Makers Company (Princess Alice collection, no. R). This may be identifiable with QVL 34, which was bequeathed to the Duchess of Albany, the mother of Princess Alice, Countess of Athlone.

127 Barisch 2003, no. 6.

128 Martin (T.) 1875, I, pp. 174–5; see also extracts quoted in Millar (D.) 1995, I, p. 478, and II, pp. 83, 508.

129 Millar (D.) 1995, nos. 3132, 3133.

130 See Millar (D.) 1995, I, p. 32.

131 See also no. 5, acquired from Vanier by Queen Louise of the Belgians for Queen Victoria in 1839.

132 See Millar (D.) 1995, particularly vol. I, p. 33.

133 Compare Ormond and Blackett-Ord 1987, nos. 50, 56.

134 *QV Leaves*, p. 142. Curiously, the fan box bears an 1850s label from Duvelleroy's London branch.

135 See De Bellaigue 1975, p. 37. The fan purchased by Queen Victoria may be the Exposition Universelle souvenir fan, printed in colours (RCIN 25173). See also QVL 54 (bequeathed to Princess Beatrice of Coburg).

136 See Roberts 1987, p. 23; Millar (D.) 1995, no. 4631.

137 RA VIC/QVJ/1856: 24 May. Twenty-four years later, Queen Victoria noted among her Christmas presents a fan painted by her fifth daughter, Princess Beatrice, 'so nicely done' (*ibid.*, 1880: 24 December).

138 Fol 1875, p. 124. Fol illustrates Hamon's design for this fan leaf.

139 See the 'Amour médecin', dated 1856, in Bielefeld, and in particular the lid of the original fan box (Barisch 2003, no. 66). For other fine Alexandre fans see Alexander 2001, nos. 40, 41.

140 See Rhead 1910, pp. 279–80.

141 RCIN 25082; WC Fans, p. 2v, no. 94.

142 For another fan leaf by the same artist (signed *O.H. Ballue*) see Christie's, South Kensington, 17 September 1996 (lot 55).

143 An early printed example is the 1855 Exposition Universelle souvenir fan (RCIN 25173).

144 Queen Victoria's writing paper of this period incorporates an identical monogram.

145 Hessische Hausstiftung, Schloss Fasanerie, Fulda, K 809. The fan may have been presented to the Princess Royal at the time of her marriage in January 1858. Unlike no. 45, the edge of the fan leaf is decorated with soft feathers.

146 PRO LC 13/3. The address was given as 'No. 2 place des Palais Bourbon, Paris', rather than the 17 Rue Rousselet address on the box of no. 45.

147 Gibson 1927, p. 6.

148 See Volet 1986, *passim*.

149 Volet 1986, no. 346, pp. 56–7.

150 Other fans from the same source are RCIN 25122, 25123, 25140, 25178, 25179, 25222, 25247 and 25400. See also Barisch 2003, no. 108 (in a Garrards box).

151 Millar (D.) 1995, II, pp. 735–6.

152 RA PP2/53/2365/10 August 1861.

153 RCIN 25045. The quotation is from Russell 1864, p. v.

154 For goods supplied by Howell & James in March 1838 and March 1866 see Staniland 1997, pp. 99, 161. Nos. 14 and 30 in the present exhibition are both associated with Howell & James boxes.

155 For the fan leaf of a skating scene painted by Princess Louise, see n. 189 below.

156 For another fan signed *Gimbel*, with similar sticks to no. 48, see Christie's, South Kensington, 24 February 1998 (lot 63).

157 Inv. A642–5 and A638–641.

158 *Illustreret Tidende*, no. 186, 19 April 1863, p. 240; quoted in Bast 1951. A facsimile of the present fan was exhibited at the Paris exhibition of 1867.

159 Lady Worsley (1890–1963) was the daughter-in-law of the Earl and Countess of Yarborough (see no. 63). She was an Extra Woman of the Bedchamber to Queen Elizabeth from 1947, and was Chairman of the Victoria League 1948–53.

160 *Royal Fans* 2002, no. 59 (lent by Amalienborg Museum, Denmark).

161 The fan made for 'Minny' is now Leningrad, Hermitage Museum, inv. no. 12689, from the Anichkov Palace; see *Hermitage* 1997, no. 54.

162 Thyra's fan is reproduced (with its box) in Armstrong 1978, p. 113.

163 Her husband was Prince Ernest Augustus of Hanover. Their joint wedding present to the future Queen Mary is no. 61.

164 See entry in Willcocks sale catalogue, Phillips, London, 19 February 1992 (lot 273). For Rodeck see also no. 66.

165 Berkshire Record Office, R/AC1/2/6.

166 For Howell & James see no. 48.

167 See RA VIC/Add C 18/62; GV/AA 6/21; VIC/Add A 36/398.

168 See Roberts 1987, pl. 48.

169 Three such fans, described as Brazilian, and 'formed of white feathers with a humming bird in the centre', were included in the Edinburgh exhibition in 1878 (Edinburgh 1878, nos. 262–4). A number of fans similar to no. 53 have retained their original boxes, giving Brazil as their country of origin. See *Hermitage* 1977, no. 70 (from the Yusopov collection).

170 Plate 53.1 reproduces a lithographic copy of a photograph of the Princess of Wales at the 1871 ball; the lithograph erroneously associates the costume with the 1879 ball at Marlborough House, for which see Millar (D.), 1995, nos. 1964–7, 3158, 5952.

171 RA VIC/QVJ/1871: 5 July.

172 The text is transcribed in Martin 1875, II, p. 320.

173 RA VIC/Z 201/43.

174 Millar (D.) 1995, no. 33. The watercolour was later moved to London. It is now kept, unframed, in the Print Room at Windsor Castle.

175 RA VIC/Z 201/44.

176 The copy presented by Lady Alford to the Duchess of Cambridge is RCIN 1195708.

177 Millar (D.) 1995, nos. 36–8; see also *ibid.*, nos. 34, 35, from an album belonging to Princess Mary Adelaide, Duchess of Teck.

178 Millar (D.) 1995, I, p. 64.

179 Volet 1994, p. 123 and nos. 37–40. See also Willcocks 2000, illus. pp. 47, 48.

180 The Norwich Gates, designed by Thomas Jekyll of Norwich, had been exhibited at the International Exhibition of 1862.

181 RCIN 25413, formerly on loan to the Museum of London; see Staniland 1997, p. 159, fig. 188.

182 RCIN 25285.

183 Information from Lavinia Wellicome. The Duchess was Elizabeth, wife of the 9th Duke of Bedford; she was Mistress of the Robes to Queen Victoria 1880–83.

184 Salisbury/Guildford/London 1985–6, no. 151; Harewood 1986, no. 159; now Fan Museum, Greenwich. See also Nils's fan with a view of Witley Court, made for the Countess of Dudley (Christie's, South Kensington, 22 May 2001, lot 147).

185 Lugt 1921, no. 1959. The connection between the fan painter and drawings collector was made by Harley Preston of the Fan Museum, Greenwich.

186 'Chinese'. See Volet 1986, p. 91.

187 Volet 1986, no. 186, illus. p. 101: '*Un système d'éventail à tube perfectionné*'.

188 Volet 1994, pp.104–5.

189 The framed fan leaf (reproduced in *Queen Magazine*, 1871, p. 150) was formerly with the Maas Gallery, London; Princess Louise's preparatory study is RL K 808.

190 RCIN 25106, 25108. The pair to no. 56 is RCIN 25164; the tube of that fan is covered in cream rather than blue silk.

191 Patterson 1996, p. 182. The King received the Order of the Chrysanthemum; the Queen received the Precious Crown.

192 See Hutt and Alexander 1992, *passim*.

193 Mistress of the Robes Letter Book, PRO LC 13/4, p. 256 £19.17.6 qtr ending 31.3.1882; p. 262 £32.10 qtr ending 30.6.1882; p. 293 £19.19 qtr ending 31.3.1883. See also the references in Emily Loch's diary for 1881, noting that on 25 November Princess Christian brought an order from the Queen for Alice to paint two fans; and on 5 and 8 December Alice worked on the mistletoe and Christmas rose designs, respectively.

194 Marie Louise 1956, p. 98.

195 *Royal Fans* 2002, no. 50; *Garden of Fans* 2004, no. 43. The fan was in the collection of Lady Patricia Ramsay.

196 No. 58 was reproduced as the Royal Household Christmas card in 1990.

197 See Falluel 1995. A photograph of a fan with a leaf painted with *Le Bal masqué*, attributed to Lami c.1867, is in an album in the Musée de la Mode et du Costume, Paris. A fan leaf painted by Lami with the departure of the bride and groom was lent by Mrs de Rothschild to the 1870 exhibition (London 1870, no. 173); see Lemoisne 1914, pp. 180–81 for a fan leaf painted by Lami for Baroness James de Rothschild. For Madame Calamatta's copy of Lami's *Fontaine de Jouvence*, see no. 61 below.

198 Staniland 1997, pp. 146–7 (Queen Victoria's fancy dress for the Stuart Ball).

199 A number of Lami's views of Eu at the time of the 1843 visit had been presented to Queen Victoria and remain in the Royal Collection: see no. 41.

200 The front guard bears the initials *MA*; the recipient's full name was Marie Amélie Louise Hélène. The two-tailed dragon is used as a crest in the Portuguese coat of arms.

201 Rodien retired in 1903, when his stock was taken over by Duvelleroy (*Duvelleroy* 1995, p. 7). For another fan with sticks signed by Rodien, see no. 68. A flamingo feather fan from the collection of Queen Alexandra remains in its original Rodien box, with the address of 48 Rue Cambon Ancienne, Rue de Luxembourg, Paris (RCIN 25116).

202 *Hermitage* 1997, no. 47.

203 Rhead 1910, pp. 285–6.

204 RCIN 25049. See also the autograph fan of 1903 in the Danish royal collection (*Royal Fans* 2002, no. 60) and the Royal Autograph Fan in the collection of the Company of Fan Makers, with signatures of members of the Royal Family since Queen Victoria, who signed in 1897 (illus. Fowles 1977, opposite p. 48).

205 RCIN 25280. For other Houghton fans see Hart and Taylor 1998, pl. 62 and pp. 112–13; Volet 1994, no. 59; *Boston Fans* 1961, fig. VI, p. VIII–9; Melville 1991, fig. 56.

206 See letter sold (with a fan) Christie's, South Kensington, 23 February 1997 (lot 177) concerning four fans painted by Houghton for Tiffany, all of which were purchased by Mr Morehead of Cincinnati.

207 *Royal Fans* 2002, no. 4 (RCIN 25026).

208 Now H. Alexander collection, no. 826, *Royal Fans* 2002, no. 54. This was almost certainly the fan lent by the Empress to the South Kensington exhibition in 1870 (London 1870, no. 226). That leaf was painted by Madame Calamatta after a design by Eugène Lami.

209 See *Hermitage* 1997, p. 34. For other fans signed by Donzel see *Le Cirque*, c.1890 (*Hermitage* 1997, no. 35); *Les attributs de séduction*, c.1890 (Delpierre 1985, no. 3); *Venus triomphante au centre de l'armée des Amours*, c.1895 (Delpierre 1985, no. 4); a paper fan edged with lace, c.1880 (Sacchetto and Sassi 1989, no. 105); and an *éventail autoprotecteur*, painted with figures seated in landscape (Volet 1994, no. 82; M.V. 582).

210 A number of black lace and *brisé* fans associated with Queen Victoria have survived in the Royal Collection, including Levey 1995, Fan 3 (RCIN 25112) and Fan 4 (RCIN 25113), and RCIN 25119 (presented to Queen Victoria by Empress Augusta of Germany, who died in 1890).

211 See QMWP 1893. Sixteen of the forty fans listed (including nos. 63–65 in this publication) are described as 'lace'; the materials of several others are not mentioned. Lady Worsley, who 'returned' no. 49 to the Collection in 1949, was the daughter-in-law of the Earl and Countess of Yarborough.

212 Levey 1983, p. 92. For the following, see Rhead 1910, pp. 291–2, and Levey

213 A Youghal lace fan was awarded a prize at the Chicago exhibition in 1893 (see Levey 1983, fig. 47). For another Youghal lace fan see Volet 1994, no. 57.

214 Rhead 1910, *loc. cit.*; the present fan leaf, before mounting, is reproduced by Rhead as fig. 119 opposite p. 278.

215 RCIN 25307.

216 Rhead 1910, p. 292.

217 QMWP 1893, no. 326. The bride also received two Honiton lace handkerchiefs (Levey 1995, H.15–16).

218 Staniland and Levey 1983; Levey 1995, H.1–2; Staniland 1997, pp. 118–21. The trimmings to the baby basket used by Queen Victoria's children and Queen Mary's children were also of Honiton lace (Levey 1995, H.24–5).

219 Levey 1995, H.3–6.

220 Heinrich Larisch von Mönnich (1850–1918) was a leading Austrian industrialist. His father Johann (1821–84) died at Lamport Hall, Northamptonshire, the home of Sir Charles Isham, 16th Bt (1819–1903).

221 For Rodeck see also no. 50. A miniature feather fan in the form of a brooch is inscribed with the firm's name (RCIN 25016). A similar fan – with jay feathers and blond tortoiseshell sticks and guards, one of which bore the cipher of Queen Alexandra in diamonds – was formerly in the collection of the Princess Royal at Harewood (Christie's, London, 28 June 1966, lot 72). For other Rodeck fans see *Hermitage* 1997, nos. 34, 45.

222 Rhead 1910, pp. 289–90 and fig. 123. See also Gibson 1927, p. 3. The fan is RCIN 25004. Another fan, also made by Clark, was made for King George V in 1930, using 3,402 woodcock feathers (RA GV/MAIN/PRIV/ACC/BILLS/2171). In October 1934 Alfred Clark supplied King George V with a third fan (intended as a gift for his daughter-in-law), with 17 tortoiseshell sticks and incorporating 4,672 woodcock feathers, with a crowned initial *E* on the guards (RA GV/MAIN/PRIV/ACC/BILLS/2529); the fan is RCIN 25314.

223 Quoted in Rhead 1910, p. 289.

224 Possibly Count Geza Szapary (1828–98), Governor of Fiume and Croatia; Count Laszlo Szapary (1864–1939); or Count Frederick Szapary (1869–1935), grandfather of HRH Princess Michael of Kent.

225 Battiscombe 1969, pp. 191–2; see also pp. 180–81, 188.

226 For other fans signed by Lemaire, see *Les Roses*, c.1900 (Delpierre 1985, no. 49, fig. 18) and Christie's, South Kensington, 30 November 2004

(lot 18).

227 Millar (D.) 1995, no. 3568 and pp. 572–3.

228 These included nos. 5 and 23 in the present publication; in addition QVL 5 (which was bequeathed to Princess Christian) and QVL 50 (RCIN 25080). Four further fans were lent to the exhibition by the future Queen Mary, and seven by Princess Louise, Marchioness of Lorne.

229 Fowles 1977, p. 36.

230 RA PP/VIC/CSP/1897/19133.

231 Rhead mentions 'a number of charming lace mounts' made by Miss Oldroyd (Rhead 1910, p. 293). She was a Freewoman of the Fan Makers Company, to whom she presented three fans in 1941 (Fowles 1977, pp. 13, 15).

232 The manuscript list of Queen Mary's wedding presents includes 'Fan & 5 pieces of Maltese Lace' from 'Ladies of Malta & English Ladies' (RA GV/CC 64).

233 *Duvelleroy* 1995, p. 2.

234 The firm had specialised in *éventails de poche* in the 1860s. A number of dolls' trousseaux which include fans survive.

235 For another fan signed by Danys, see Christie's, South Kensington, 22 May 2001, lot 142. For Ernest Kees see Volet 1994, pp. 123–4.

236 'I also gave E. a tortoiseshell & Diamond fan with ostrich feathers which had belonged to Mama Alix' (Pope-Hennessy 1959, p. 585).

237 Rhead 1910, p. 287.

238 QMWP 1893, nos. 330 (from Mr J.J. Harrison), 340 (from the Crown Perfumery Company), 372 (from the Duchess of Sutherland), and 933 from the South Africans in England.

239 Barisch 2003, no. 112; Habsburg 1986, no. 482; Snowman 1962, pl. XVII; Christie's, South Kensington, 12 December 1995 (lot 98; the leaf signed by Baron von Liphart). All these have either a lace or a silk leaf. See also the bridal fan given by Tsar Nicholas II to the Grand Duchess Olga Alexandrovna on her marriage to Prince Peter of Oldenburg in 1901 (Bainbridge 1949, pl. 44), and a tortoiseshell fan with *point de gaze* lace leaf and the initial *AB* on the guards (Alexander 2001, no. 46).

240 Harewood 1986, no. 116 (lent by the Earl of Harewood). Princess Victoria (1868–1935), who never married, inherited her parents' interest in Fabergé and made a large collection of the firm's products.

241 See *Hermitage* 1997, pp. 5, 11–12. The first Russian fan manufactory was established in 1751 (*ibid.*, pp. 9–10). At the time of her wedding in 1893, the future Queen Mary's bridesmaids gave

her a Russian fan on birch sticks, the silk leaf (signed by I. Gille) painted with butterflies and roses (RCIN 25126).

242 De Guitaut 2003, pp. 15–20.

243 Including Solodkoff 1984, p. 31 (painted with a *scène galante* signed by A.E. Begnée); and an example in the Hermitage collection (MP–868).

244 Tillander-Godenhielm 2000, pp. 18, 156.

245 Some similar fans recently on the London art market have boxes with the label of H. Van Santen of Berlin.

246 QMN, p. 29.

247 The majority of the fans described in QMN were wedding presents. The use of the initials *VM* would have been more normal before 1901, and many of the 1893 gifts bore the Prince of Wales's coronet.

248 See annotation in Queen Mary's hand in a copy of Gibson 1927. A Honiton lace handkerchief made for the 1911 coronation is also in the Royal Collection (Levy 1995, H.20). For another Honiton lace fan leaf made for Queen Mary see Melville 1991, fig. 51 and pp. 21–2. Queen Mary lent two Honiton lace fans to the Paris exhibition in 1914, as nos. 655 and 656. The fans presented by Princess Alice, Countess of Athlone, to the Fan Makers Company include a Honiton lace fan incorporating the letter *A*, given by Queen Alexandra to Princess Alice.

249 Fowles 1977, p. 26.

250 *Illustrated London News*, 1 July 1911.

251 In the Allhallows Museum, Honiton; see Melville 1991, p. 24. For an illustration of the present fan before mounting see Melville 1991, fig. 51.

252 RCIN 25294; Melville 1991, front cover and p. 24.

253 See under no. 5.

254 Pope-Hennessy 1959, pp. 527–8.

255 Including Levey 1995, Br.D.2 (flounce of *Duchesse de Bruxelles* lace). The royal lace collection also includes a fan leaf of Brussels Duchess bobbin lace 'worked by Belgian Refugees . . . from Langemarck near Ypres. Given to Queen Mary, 1916' (Levey 1995, Br.D.3).

256 For a detailed study of the dolls and their wardrobe see Eaton 2002.

257 Eaton 2002, p. 119. There is a suggestion that Duvelleroy also supplied handbags for the dolls (see Eaton 2002, p. 38).

258 Guildhall Library, Fan Makers Letter Book 1936–7.

259 *Ibid.*, pp. 245, 286, 366, 372.

260 Beale Gunner was paid £122 10s for his work on the fan (*ibid.*, p. 444).

ILLUSTRATED DESCRIPTIONS

The left margin contains illustrations of the rectos, the right margin of the versos (if these were decorated). In the following, the material of the ribs (the extensions of the sticks) is not normally described. The ribs will normally be painted (if the fan is à l'anglaise) or covered by the second leaf.

1. FAN FROM THE STUART COLLECTION English, c.1600

Découpé leather leaf; bone guards and sticks, with traces of pigment and metal on the sticks (2 + 8); replacement brass and steel pin
Guard length 25.3 cm (9¹⁵/₁₆")
RCIN 25350 (RL WC 8)
PROVENANCE: [Charles I;] Dr Baldwin Hamey (d.1676); the family of his sister, Mrs Palmer; by inheritance to the Gundry family (Dorset); presented to Sir George Bingham; his widow, Lady Bingham; by whom given to Sir George's sister, Mary Still; bequeathed to her son, Captain John Still; his widow, Mrs C.M. Still; Sotheby, Wilkinson & Hodge, 16 June 1904 (lot 69); purchased by King George V, 18 June 1910 (Stuart Room Catalogue, p. 6, no. 11; the provenance is described on p. 3; the purchase was made through Mrs James Templer, daughter of Mrs C.M. Still)
REFERENCE: Mayor 1991, p. 14
EXHIBITED: London 1889, no. 453, part; London 1990–91, no. 114

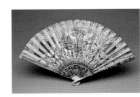

2. 'DIANA WITH NYMPHS AT PLAY' Italian, c.1700

Leather (kid) leaf with mica inserts, découpé and painted in watercolour and gold paint with figures in classical dress hunting in a landscape and nude figures bathing in the foreground, the reserves decorated with birds and flowers; ivory guards and sticks painted in an italianate style and varnished (2 + 19); brass and mother-of-pearl pin
Guard length 28.0 cm (11")
VERSO: leather (kid) leaf with a harbour scene painted in crimson monochrome watercolour in the central medallion, the reserves decorated with scrolls and stylised leaves
RCIN 25383 (BP MH 28)
PROVENANCE: presented by Queen Alexandra to Queen Mary on her forty-seventh birthday, 26 May 1914 (QMB, p. 145, no. 602; QMN, p. 38, QMF, no. 15)
REFERENCE: Gibson 1927, no. XXIV, p. 20; Armstrong 1992–4

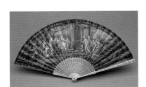

3. 'THE CONTINENCE OF SCIPIO' Italian, c.1700

Dark brown tinted vellum leaf, mounted à l'anglaise, painted in bodycolour, gold and silver paint, with figures in classical dress, inscribed N.F. at the base of the column; ivory guards and sticks decorated with silver clouté and piqué, the guard sticks reinforced with mother-of-pearl (2 + 22); silver pin
Guard length 26.8 cm (10⁹/₁₆")
RCIN 25382 (BP MH 27)
PROVENANCE: Major Herbert Dent of Cromer; Sotheby's, London, 11 February 1925 (lot 26; bought by Deacon, £45); Queen Mary, February 1925 (QMF, no. 26)
REFERENCE: Dent 1923, p. 18 and pl. XXIX; Gibson 1927, no. VIII, pp. 7–8 (as 'Joseph receiving his brethren')
EXHIBITED: Harewood 1986, no. 3; London 1989, case 1, no. 2

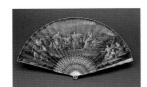

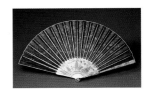

4. 'BLIND MAN'S BUFF' Italian, c.1700

Vellum leaf, mounted à l'anglaise, painted in bodycolour with figures in classical dress in a landscape, edged with gold paint; ivory guards reinforced with tortoiseshell at base; ivory sticks decorated with chinoiserie designs in gold paint and bodycolour with lacquer (2 + 21); brass and mother-of-pearl pin
Guard length 26.0 cm (10¹/₄")
VERSO: painted in silver and gold on a dark brown ground with a design based on acanthus leaves; the sticks painted with wavy gold lines; the gorge decorated in gold with an Oriental design including pagodas
RCIN 25063 (WC SE 4)
PROVENANCE: reputedly, Queen Charlotte (used at Worcester, 1788); the Hon. Lady Ward; by whom presented to Queen Mary, 1927 (WC Fans, p. 10, no. 91)
EXHIBITED: London 2004–5, no. 458

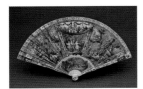

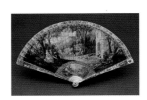

5. 'MARIE-ANTOINETTE'S FAN' French, c.1720–30

Ivory brisé fan; the guards (matching) of ivory and mother-of-pearl, decorated in bodycolour, watercolour, gold paint and gold leaf, with lacquer; the sticks decorated with Bacchanalian scenes and a floral border in bodycolour, watercolour, gold paint and gold leaf, with lacquer, and leather (kid) border painted with bodycolour and gold (2 + 29); brass and mother-of-pearl pin
Guard length 21.3 cm (8³/₈")
VERSO: decorated in bodycolour, watercolour, gold paint and gold leaf, with lacquer, to show the gathering and pressing of grapes
BOX: irregularly shaped wood covered with maroon leather tooled in gold, 3.0 × 25.0 × 5.0 cm (1³/₁₆ × 9¹³/₁₆ × 2") tapering to 4.0 cm (1⁹/₁₆"); lined with purple velvet and satin. On base, green leather trade label tooled in gold VANIER / PARFUMEUR/ 27 RUE CAUMARTIN / PARIS; paper label inscribed in ink 16
RCIN 25092 (240 WC 18)
PROVENANCE: reputedly, Marie-Antoinette, Queen of France (1755–93); Vanier Parfumeur, Paris; from whom obtained by Queen Louise of the Belgians for Queen Victoria, 1839; bequeathed to King Edward VII, 1901 (QVL 16); at Windsor Castle by 1927 (WC Fans, p. 1, no. 16; and see fig. 25)
REFERENCE: Arundel Society 1871, no. XIII; Blondel 1875, p. 85; Dunn 1901, pp. 92–6; Rhead 1910, p. 159; Green 1975, p. 105, fig. 33
EXHIBITED: London 1870, no. 272; Dublin 1872; London 1897

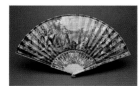

6. 'CLAUDIA PROVING HER INNOCENCE' Italian, c.1740

Leather (kid) leaf painted in watercolour, bodycolour and silver with figures in classical dress including the standing figure of Claudia (left of centre); gilded paper edge-binding; carved and pierced ivory and mother-of-pearl guards (identical, upper halves backed with red foil); carved ivory sticks painted and decorated with gold and backed with mother-of-pearl and red foil, with dancing figures and musicians in eighteenth-century dress, putti and scrollwork (2 + 20); replacement brass and mother-of-pearl pin

Guard length 29.5 cm (11⁵/₈")

VERSO: leather (kid) leaf painted in watercolour with a figure of a youth seated in a landscape

BOX: wood and paper board, covered with red book cloth and edged with gold paper, cream paper on base, 3.7 × 3.5 × 5.8 cm (1⁷/₁₆ × 1³/₈ × 2¹/₁₆"). Inscribed in ink inside lid *Had belonged to Pss Charlotte of Wales / Given the Queen by Mrs Louis*, and *No 2* (also on lid exterior). On base, paper trade label embossed in gold *J. Duvelleroy / Ltd. / LONDON / 121. NEW BOND STREET W1*

RCIN 25095 (240 WC 21)

PROVENANCE: Princess Charlotte of Wales; the Princess's dresser, Mrs Louis (d.1838); by whom presented to Queen Victoria, c.1838; bequeathed to King Edward VII, 1901 (QVL 2; WC Fans, p. 4, no. 2)

EXHIBITED: London 1870, no. 279; Edinburgh 1878, no. 5 (as 'Reception of Ceres')

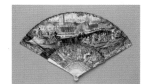
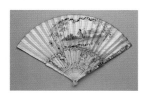

7. 'THE SIEGE OF BARCELONA, 1714' English, c.1740

Vellum leaf, mounted *à l'anglaise*, painted in watercolour, bodycolour and gold with figures in eighteenth-century military dress before the walls of a town, the floral border embellished with crushed mother-of-pearl; carved and painted ivory guards (matching) decorated with putti, a shepherdess and a dog, and pierced, carved and painted ivory sticks decorated with a central vignette of an arched and semi-circular colonnade, putti, figures and scroll decoration to right and left; when closed, the sticks show a crowned head (2 + 19); steel pin and mother-of-pearl washer

Guard length 25.6 cm (10¹/₁₆")

VERSO: painted in watercolour with a soldier marching

BOX: wood and paper board covered with black embossed leather (sheep), 2.0 × 28.0 × 3.4 cm (1³/₁₆ × 11 × 1⁵/₁₆"); lined with red velvet. On base, paper label inscribed in ink 86. Loose paper scrap inside box inscribed in ink *Fan belonged to the / Late Queen Louise of Denmark* and (on verso) *Brought from / Denmark / Feb – 1906*

RCIN 25088 (240 WC 14)

PROVENANCE: Queen Louise of Denmark (1817–98); her daughter, Queen Alexandra, for whom brought from Denmark, February 1906 (QAF, no. 15; WC Fans, p. 22, no. 86)

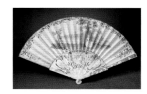

8. 'A HAWKING PARTY' Flemish leaf; French guards and sticks, c.1740/50

Vellum leaf, mounted *à l'anglaise*, painted in watercolour, bodycolour and gold with figures at the edge of a wooded landscape, some on horseback, a couple in the foreground with dogs; mother-of-pearl guards (identical) and sticks carved, incised, painted and embellished with gold, with figures, putti, cornucopia and scrollwork, the front guard backed with red foil (2 + 20); silver pin with paste head

Guard length 28.8 cm (11⁵/₁₆")

VERSO: painted in watercolour with a lady in bergère costume seated under a tree beside a lake; bordered with stylised flowers; the sticks lightly incised following the design on the recto

BOX: wood and paper board, covered with blue velvet edged with blue paper, cream paper on base, 4.9 × 32.0 × 4.4 cm (1¹⁵/₁₆ × 12⁵/₈ × 1³/₄"); lined with ivory silk. Stamped in gold inside lid *DUVELLEROY / PARIS / 17, PASSAGE-PANORAMAS.* Base inscribed in ink 4928; two paper labels, both inscribed in ink by Queen Mary, *Old French Fan / Louis XV – hunting / scene. Mother o' / pearl sticks slightly / coloured* and *From / T.D. Williams*

RCIN 25270 (Q 59)

PROVENANCE: presented by Mr T.D. Williams to Queen Mary

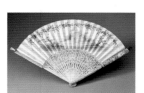

9. BATON FAN WITH BLACKAMOOR FINIALS French leaf; German guards and sticks, c.1750

Paper leaf painted in watercolour, bodycolour and gold with central vignette of a pastoral scene with a couple seated at the base of a classical column, left vignette of a figure on a bridge, right vignette of a couple seated by a column; carved ivory guards (identical) painted and decorated with bodycolour and gold in a chinoiserie design, with a couple, bagpipes, a dog and scrollwork, surmounted by a finial carved in the shape of a head in profile, and ivory sticks carved, pierced, painted and decorated with bodycolour and gold, the front guard backed with gold foil, the rear with silver foil (2 + 20); silver pin with rock crystal head

Guard length 28.7 cm (11⁵/₁₆")

VERSO: paper leaf painted in watercolour with a youth flying a kite

RCIN 25091 (240 WC 17)

PROVENANCE: ducal collection of fans at Gotha; Prince Albert; by whom given to Queen Victoria on the eve of their marriage, 9 February 1840; bequeathed to King Edward VII (QVL 78; WC Fans, p. 1, no. 78)

REFERENCE: Blondel 1875, fig. 32; Rhead 1910, pp. 202–3, pl. 98a; Duvelleroy 1929, p. 104

EXHIBITED: London 1870, no. 284; Edinburgh 1878, no. 1; London 1990–91, no. 111

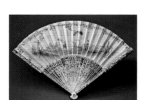

10. BATON FAN French leaf; German guards and sticks, c.1750

Paper leaf painted in watercolour, bodycolour and gold with central vignette of figures in front of a fountain in a landscape, a man to left plays the bagpipes, the reserves decorated with flowers, birds and butterflies; ivory guards (identical), carved, pierced and painted in bodycolour and gold and decorated with putti, musical instruments, flowers and scrollwork; and ivory sticks pierced, carved, painted and decorated with bodycolour and gold, with putti, musical instruments, chinoiserie figures, flowers, birds and scrollwork, the guards backed with green silk (2 + 18); silver pin with rock crystal head

Guard length 27.2 cm (10¹¹/₁₆")

VERSO: paper leaf painted in watercolour with a standing woman and a man carrying a fishing net

BOX: paper board covered with brown wood-effect glazed paper, base covered with green paper, all edged with yellow paper, 3.2 × 27.8 × 3.2 cm (1¹/₄ × 10¹⁵/₁₆ × 1¹/₄"); lined with pink paper. Paper label on lid inscribed in ink *Zu der Fürstin von Leiningen / vom Herzog von Coburg* and *11–*; inscribed inside lid in ink *no / 11*; inscribed on base in ink *Collection of fans at Coburg* and *N. 11*

RCIN 25093 (240 WC 19)

PROVENANCE: presented by the Duke of Coburg (either Franz Friedrich Anton, 1750–1806, or his son Ernest I) to Victoria (*née* Saxe-Coburg-Saalfeld), Princess of Leiningen (later Duchess of Kent, d. 1861), between 1803 and 1818; bequeathed to her daughter, Queen Victoria; bequeathed to Queen Alexandra, 1901 (QVL 11: 'From the collection of fans at Gotha' *sic*; WC Fans, p. 2, no. 11)

EXHIBITED: London 1870, no. 277

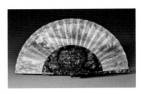

11. *TROMPE-L'OEIL* LACE FAN French, c.1750
Paper leaf painted in watercolour, bodycolour and gold with vignettes depicting figures in a landscape (to right) and figures with sea and boats behind (to left); the decoration on the reserves imitates lace; the guards (identical) and sticks of tortoiseshell carved, gilded and painted with a strip of similar lace (2 + 22); metal pin with garnet head
Guard length 26.9 cm (10⁹/₁₆")
VERSO: paper leaf painted in watercolour with four peasants picking grapes watched by two ladies
BOX: paper board covered with dark blue paper decorated with small gold stars, base covered with pink paper, 2.2 × 28.0 × 3.2 cm (⁷/₈ × 11 × 1¹/₄"); interior edged with pink paper. Inside lid inscribed in pen *This fan belonged to Queen Charlotte*. Base inscribed in ink *Fan belonged to Queen Charlotte*; paper label inscribed in ink by Queen Mary *Given to Queen Mary / by the late Honᵇˡᵉ Claud / Yorke – 1939 – / Tortoiseshell & gold sticks. Painted Arcadian Scene*
RCIN 25234 (Q 23)
PROVENANCE: reputedly, Queen Charlotte; the Hon. Claude Yorke; by whom presented to Queen Mary, 1939 (QMB, IV, p. 10, no. 19)
EXHIBITED: London 2004–5, no. 459

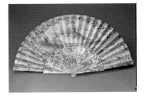

12. MARRIAGE FAN WITH A WEDDING FEAST French, c.1750
Paper leaf painted in watercolour, bodycolour and gold with figures in eighteenth-century dress seated under a canopy, children playing at left, food and drink at right; the guards (identical) and sticks of mother-of-pearl painted, carved and gilded (two-colour gold) with figures, putti, birds, dragonflies, musical instruments, flowers and scrollwork (2 + 22); silver pin with paste head backed with foil
Guard length 29.6 cm (11⁵/₈")
VERSO: paper leaf painted in watercolour with three figures on an island in front of an obelisk; the sticks partially incised
RCIN 25220 (Q 10)
PROVENANCE: purchased from Duvelleroy by the Worshipful Company of Fan Makers for presentation to Princess Elizabeth (HM The Queen) on her marriage, 20 November 1947 (HMWP 1947, no. 1792; Guildhall Library MS 21420/3, p. 523)

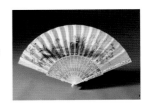

13. 'CUPID AND PSYCHE' English, c.1750
Vellum leaf, mounted *à l'anglaise*, painted in watercolour and bodycolour with a winged male figure (Cupid) and female figure (Psyche) seated on clouds above sea and coastline, gilded border; carved and pierced ivory guards (identical) decorated with a male figure holding a crook, and carved and pierced ivory sticks with a central vignette of a man by a tent (Hector) walking away from a woman and child (Andromache and Astyanax); the guards backed with gold foil (2 + 16); silver pin with paste head
Guard length 29.0 cm (11⁷/₁₆")
VERSO: painted in watercolour with a naiad crowned with reeds, seated on an island
RCIN 25369 (BP MH 14)
PROVENANCE: presented by Mr Brinsley Marlay to Princess Victoria Mary of Teck (later Queen Mary) on her marriage, 1893 (QMWP 1893, no. 357; QMB, I, p. 142, no. 582; see also QMF, no. 5)
REFERENCE: Hughes 1947, fig. 11 (as Dido and Aeneas)
EXHIBITED: London 1989, case 1, no. 7

14. 'THE ABDUCTION OF HELEN' English, c.1750
Vellum leaf, mounted *à l'anglaise*, painted in watercolour, bodycolour and gold with a group of figures on a quayside, a ship in the distance and putti in the sky; carved and pierced ivory guards (matching) and ivory sticks decorated with gold paint, crushed mother-of-pearl, with figures, tracery and scrollwork, the guards backed with foil (2 + 16); silver pin with (recto) head of pink topaz surrounded by diamonds, (verso) head of colourless zircon surrounded by diamonds
Guard length 26.8 cm (10⁹/₁₆")
VERSO: painted in watercolour and bodycolour with an Oriental domestic scene in the centre, birds and vase at either side; the ivory sticks decorated with gold paint
BOX: wood and paper board covered with blue velvet, cream paper on base, 4.0 × 30.8 × 4.8 cm (1⁹/₁₆ × 12¹/₈ × 1⁷/₈"); lined with blue silk and velvet. Stamped in gold inside lid *HOWELL, JAMES & Co. / SILVERSMITHS & JEWELLERS / TO HER MAJESTY / 6, 7 & 8 REGENT STREET*. Paper label on base inscribed in ink by Queen Mary *French fan belonged / to Queen Victoria – / Bought at late Duke / of Connaught's sale at / Bagshot Pᵏ / 1942*, and base inscribed in ink *By Queen Mary*
RCIN 25261 (Q 50)
PROVENANCE: Queen Victoria; bequeathed to her son, the Duke of Connaught (QVL 10: 'Old French fan'); Christie's, Bagshot Park, 27–30 July 1942 (lot 317; subject identified as 'Mars, Venus and other figures'); purchased for Queen Mary (£2 2s)

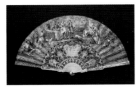

15. 'JACOB MEETING RACHEL AT THE WELL' ?Italian leaf; English guards and sticks, c.1750
Vellum leaf, mounted *à l'anglaise*, painted in watercolour and bodycolour with figures and sheep gathered near a well, the reserves decorated with flowers and scrolls embellished with gold; carved and pierced ivory guards (identical) decorated with female figures, flowers and a bird, and sticks decorated with gilded and painted highlights, with a central vignette of four figures under a tree, a basket of flowers and chinoiserie designs at either side, the guards backed with mother-of-pearl (2 + 21); brass and mother-of-pearl pin
Guard length 26.7 cm (10¹/₂")
VERSO: painted in watercolour with three shepherdesses
RCIN 25362 (BP MH 7)
PROVENANCE: presented by HE Senõr Don Cipriano del Mazo, the Spanish Ambassador to the Court of St James, to Princess Victoria Mary of Teck (later Queen Mary) on her marriage, 1893 (QMWP 1893, no. 1342; QMB, I, p. 143, no. 584; see also QMF, no. 7)
REFERENCE: Gibson 1927, no. XVI, p. 14
EXHIBITED: London 1989, case 1, no. 1

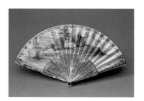

16. 'BACCHUS AND ARIADNE' French leaf, c.1750; English guards, mid-nineteenth century

Leather (kid) leaf painted in watercolour, bodycolour and gold with a central couple and figures dancing, making music and drinking, to left and right; with leather (sheep) edge-binding; gold guards (identical) decorated with mixed-cut diamonds, emeralds and pearls; lower part of guards backed with mother-of-pearl; mother-of-pearl sticks decorated with couples, putti and scrollwork (2 +18); silver pin with diamond head

Guard length 25.4 cm (10")

VERSO: paper leaf painted in watercolour, bodycolour and gold with a shepherd and two shepherdesses

BOX: wood and paper board covered with maroon leather, lid edged with single gold-tooled line, 3.5 × 28.2 × 3.5 cm (1³/₈ × 11¹/₈ × 1³/₈"); lined with ivory silk and velvet, with cut-out support. Stamped in black inside lid *HANCOCK / 39 BRUTON STREET / Jeweller & Silversmith, / TO THE / PRINCIPAL SOVEREIGNS / OF EUROPE*. Paper label on base inscribed in ink by Queen Mary *William IV / 10 –*

RCIN 25218 (Q 8)

PROVENANCE: given by William IV to his sister-in-law, Augusta, Duchess of Cambridge (d.1889); bequeathed to her granddaughter, Princess Victoria Mary of Teck (later Queen Mary); 'in use' in 1952 (see note in Queen Mary's hand in RA GV/CC 55/44)

REFERENCE: Gibson 1927, frontispiece, p. 1 (as 'Rinaldo in the garden of Armida')

EXHIBITED: London 1995

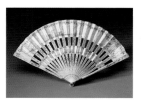

17. CABRIOLET FAN French, c.1755

Paper leaves painted in watercolour, bodycolour and gold, the outer leaf with a central male figure, a seated couple to the left, a lady driving a cabriolet (with fallen horse) to right, the inner leaf with windmill and figures, all surrounded by flowers and scrollwork; carved, painted, stained and gilded ivory guards (identical) with horse and carriage, scrolls and flowers, and ivory sticks with central vignette of horse and carriage, vignettes to either side of figures playing the bagpipes, surrounded by scrollwork, Chinese figures, flowers and musical instruments; the guard sticks backed with mother-of-pearl and red foil, with tortoiseshell inlay at base (2 + 18); brass and mother-of-pearl pin

Guard length 28.5 cm (11¹/₄")

VERSO: paper leaves painted in watercolour with indistinct landscape with ruin and floral border

RCIN 25380 (BP MH 25)

PROVENANCE: Ida, Countess of Bradford (d.1936; wife of 4th Earl of Bradford); purchased by Queen Mary (QMF, no. 29)

REFERENCE: Hughes 1947, fig. 13

EXHIBITED: York 1989

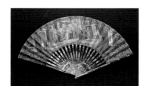
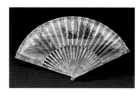

18. MARRIAGE FAN French, c.1760

Paper leaf painted in watercolour, bodycolour and gold with a wedding ceremony conducted before a flaming altar surrounded by an arcade and columns on high bases; the carved mother-of-pearl guards (matching) decorated in two colours of gold with a female figure, basket and flowers, and sticks carved and decorated with two colours of gold and silver leaf, with figures, flowers and butterflies (2 + 20); brass and silver pin with green paste head

Guard length 26.8 cm (10⁹/₁₆")

VERSO: paper leaf painted in watercolour with two figures in Arcadian dress seated at the base of an obelisk

BOX: tapering-shape paper board covered with floral patterned fabric and edged with gold-coloured paper, cream paper on base, 4.6 × 28.6 × 4.0 cm (1¹³/₁₆ × 11¹/₄ × 1⁹/₁₆") tapering to 2.6 cm (1"); lined with ivory silk. Stamped in gold inside lid *J. Duvelleroy Lᵈ / LONDON 167 REGENT STREET W / MANUFACTURED IN PARIS*

RCIN 25217 (Q 7)

PROVENANCE: presented by 'Mr J. Duvelleroy' to Princess Elizabeth (HM The Queen) on her marriage, 20 November 1947 (HMWP 1947, no. 880: 'made for the wedding of Louis XV and Marie Leczinska')

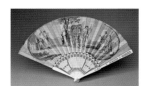
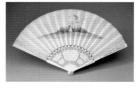

19. 'THE MARRIAGE OF KING GEORGE III AND PRINCESS CHARLOTTE OF MECKLENBURG-STRELITZ, 1761' English, 1761; Oriental guards and sticks

Paper leaf, printed with etching and hand coloured in watercolour and bodycolour, with central medallions containing bust portraits of George III and Queen Charlotte supported on a pedestal by three allegorical figures, figures holding horn of plenty (Commerce) and cap (Liberty) at left, and shield (Britannia) and triton (Neptune) at right; carved ivory guards (identical) and carved and pierced ivory sticks with Chinese-style flowers and birds (2 + 16); brass and mother-of-pearl pin

Guard length 27.0 cm (10⁵/₈")

VERSO: paper leaf painted in watercolour and bodycolour with the figure of Britannia

RCIN 25159 (KEW 4)

PROVENANCE: Queen Mary, by 1924; London Museum Loan, 1924–74 (D 394)

EXHIBITED: Kew 1976–96

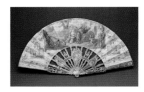
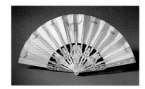

20. DUTCH MARRIAGE FAN Dutch leaf; French or Dutch guards and sticks, c.1770

Vellum leaf, mounted à l'anglaise, painted in watercolour, bodycolour and gold with a couple in classical dress surrounded by putti, and medallions to left and right painted with grisaille profile portraits, each supported by two putti; with gold-painted edge-binding; carved mother-of-pearl guards (identical) decorated with putti, urns and musical instruments, and *battoire* sticks in the form of classical columns, supporting three vignettes of amorous couples, surrounded by putti, decorated with silver and three colours of gold (2 + 13); silver pin with mother-of-pearl head

Guard length 28.2 cm (11¹/₈")

VERSO: painted in watercolour with two doves in a medallion beneath a lute and a lyre

RCIN 25366 (BP MH 11)

PROVENANCE: presented by the Hon. Mrs Halford to Princess Victoria Mary of Teck (later Queen Mary) on her marriage, 1893 (QMWP 1893, no. 359; QMB, I, p. 142, no. 583; QMF, no. 6; see also RA GV/CC 43/224/15 May 1893)

REFERENCE: Gibson 1927, no. XVIII, p. 16

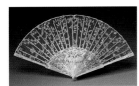

21. BRUSSELS LACE FAN Belgian lace, *c.*1770–80; English guards and sticks, *c.*1780
Cream silk needle-lace leaf; carved, pierced and incised mother-of-pearl guards (matching) and sticks, painted bamboo ribs (2 + 22); silver pin with paste head
Guard length 28.0 cm (11")
BOX: wood and paper board covered with blue velvet, 3.4 × 30.4 × 3.4 cm (1⁵⁄₁₆ × 11¹⁵⁄₁₆ × 1⁵⁄₁₆"); lined with cream silk, with cut-out support. Stamped in black inside lid *GARRARDS / Panton Str.* Paper label on base inscribed in ink *N. / 37* and *461*. Loose paper scrap inside box inscribed in ink *37* and larger scrap inscribed in ink *N. 37 / Given to the Queen / by the Duke of Sussex / before the Christening / of Princess Royal & / had belonged to Queen / Charlotte, who had always / used it at the Christenings / of her children*
RCIN 25098 (240 WC 24)
PROVENANCE: Queen Charlotte; [her daughter, Princess Augusta; her brother,] Prince Augustus, Duke of Sussex; by whom given to Queen Victoria before the christening of the Princess Royal, 10 February 1841; bequeathed to King Edward VII (QVL 37); Queen Alexandra; London Museum Loan, *c.*1912–25 (old D 138); Queen Mary (WC Fans, p. 7, no. 37)
EXHIBITED: London 2004–5, no. 461

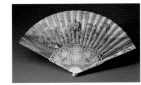

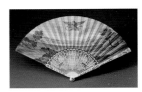

22. 'BACCHUS AND ARIADNE ON THE ISLAND OF NAXOS' Italian leaf; English guards and sticks, *c.*1780
Leather (kid) leaf painted in watercolour with figures in classical dress; a couple (Bacchus and Ariadne) stand before a lady reclining on a rock, figures dance and process behind; carved and pierced ivory guards (identical) decorated with a female figure, dog, flowers and scrolls, and carved and pierced ivory sticks decorated with couples, putti, flowers and scrollwork, guards backed with black-painted foil (2 + 20); brass and mother-of-pearl pin
Guard length 29.5 cm (11⁵⁄₈")
VERSO: vellum leaf painted in watercolour with Ganymede and the eagle
BOX: cylindrical paper board covered with pink toned paper, end of cylinder covered with beige paper, 3.0 × 30.3 × 3.6 cm (1²⁄₁₆ × 11¹⁵⁄₁₆ × 1⁷⁄₁₆"). Paper label inscribed in ink *82*; lid inscribed *1799*
RCIN 25077 (240 WC 3)
PROVENANCE: Queen Alexandra (WC Fans, p. 15, no. 82)

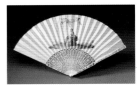

23. 'AURORA AND APOLLO' Italian leaf; English or Italian guards and sticks, *c.*1780
Vellum leaf painted in watercolour and bodycolour and bronze paint with figures in classical dress accompanying a chariot driven across the sky by a male figure (Helios) led by female figure (Aurora), signed *Trono F*, bottom right; carved and pierced ivory guards (identical) and sticks which when closed show foredge carvings of flaming hearts, arrows and quivers (2 + 20); silver pin with paste head
Guard length 29.9 cm (11³⁄₄")
VERSO: leather (kid) leaf painted in bodycolour and watercolour with a lady seated with an anchor (symbolising Hope) and putti above
BOX: wood and paper board covered with red book cloth and edged with gold-coloured paper, 3.7 × 35 × 5.9 cm (1⁷⁄₁₆ × 13³⁄₄ × 2⁵⁄₁₆"); inscribed inside lid in ink *Belonged to Queen Charlotte / Given to the Queen by the Duchess of Bedford* and *No. I*, and inscribed in ink on lid *1*, and on base *No. 1*
RCIN 25075 (240 WC 1)
PROVENANCE: [? Queen Charlotte; Christie's, London, 7 May 1819 (Day 2, lot 38, part, with two other fans; purchased by Pophyman, 3 guineas)] Anna Maria, Duchess of Bedford (wife of the 7th Duke); by whom presented to Queen Victoria, when the Duchess was Lady of the Bedchamber, i.e. 1837–41; bequeathed to King Edward VII, 1901 (QVL 1; WC Fans, p. 143, no. 1)
EXHIBITED: London 1870, no. 278; Dublin 1872; Edinburgh 1878, no. 6; London 1897; London 2004–5, no. 460

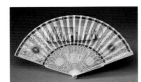

24. 'THE ALDOBRANDINI WEDDING' Italian leaf; English guards and sticks, *c.*1780
Leather (kid) leaf painted (possibly over printed outlines) in watercolour, bodycolour and gum heightening, with figures in classical dress; carved and pierced ivory guards (matching) decorated with a male figure and a putto and carved and pierced ivory sticks decorated with a central vignette of a seated female figure and three putti, a pair of birds in round medallions to right and left, surrounded by foliate decoration (2 + 20); silver pin with paste head
Guard length 27.5 cm (10¹³⁄₁₆")
VERSO: leather (kid) leaf, undecorated
RCIN 25364 (BP MH 9)
PROVENANCE: Princess Mary Adelaide of Cambridge, Duchess of Teck (d.1897); given (or bequeathed) to her daughter Princess Victoria Mary (later Queen Mary; QMB, I, p. 143, no. 10; see also QMF, no. 10)
REFERENCE: Gibson 1927, no. XI, p. 13
EXHIBITED: London 1989, case 1, no. 8

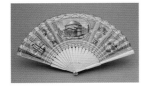

25. GRAND TOUR FAN Italian, *c.*1780
Leather (kid) leaf painted in bodycolour and watercolour with vignettes of classical Roman buildings and ruins, edged with gold paint; ivory guards and sticks (2 + 18); brass and mother-of-pearl pin
Guard length 27.5 cm (10¹³⁄₁₆")
VERSO: leather (kid) leaf, with a red line painted in bodycolour parallel to the edges of the leaf, and edged with gold paint
BOX: paper board covered with green paper and edged with gold-coloured paper, 3.4 × 28.3 × 4.1 cm (1⁵⁄₁₆ × 11¹⁄₈ × 1⁵⁄₈"). Paper label on base inscribed in ink *36*
RCIN 25073 (WC SE 14)
PROVENANCE: Princess Augusta; her niece, Queen Victoria; bequeathed to King Edward VII (QVL 36: 'had belonged to the Queens Aunt Princess Augusta'); Queen Alexandra; London Museum Loan, *c.*1912–26 (D 143); Queen Mary (WC Fans, p. 27, no. 36)
EXHIBITED: York 1989; London 2004–5, no. 463

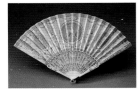
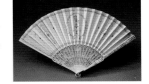

26. 'THE POWER OF LOVE' English, 1780

Leather (kid) leaf, printed with etching, and stipple and crayon manner engraving, painted in watercolour, bodycolour and gold with three medallions: in the centre Cupid riding a lion, to the right the infant Hercules, and to the left Cupid with a stick and ball, surrounded by classical decoration, with printed inscription *Published as the Act Directs March 1st 1780 by A. Poggi*; carved and pierced ivory guards (identical) with a paper backing covered in a pale blue ground (recto) and a ground of two shades of lilac (verso) and tortoiseshell inserts at base and carved and pierced ivory sticks (2 + 18); brass and mother-of-pearl pin

Guard length 27.5 cm (10¹³/₁₆")

VERSO: leather (kid) leaf painted in watercolour, bodycolour and gold, over graphite, with classical decoration; the figure of the goddess Diana in the centre

RCIN 25378 (BP MH 23)

PROVENANCE: Red Cross Gift House, London; purchased by Queen Mary, July 1916 (£20; QMB, I, p. 145, no. 600; QMN, p. 39; QMF, no. 23)

REFERENCE: Gibson 1927, no. IV, p. 3

EXHIBITED: London 1989, case 1, no. 6

27. MARRIAGE FAN French, c.1780

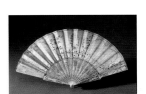

Watered silk leaf backed with silk gauze, painted in bodycolour, watercolour, and gold, decorated with gold spangles and tambour stitch in gold thread, with flaming altar between painted columns in centre, an amorous couple to left and musical instruments to right, surrounded by scrolling borders and flowers; carved and pierced ivory guards (identical) decorated with putti, female figure holding a bird, and musical instruments, and carved and pierced ivory sticks depicting an amorous couple seated by a plinth, with onlookers, sheep and goats, decorated with silver and three colours of gold, backed with mother-of-pearl (2 + 13); silver pin with paste head

Guard length 28.2 cm (11¹/₈")

VERSO: the shape of the two vignettes is traced in formalised green leaves, also painted with bright pink stylised flowers

BOX: tapering-shaped paper board covered with pale grey embossed paper, 4.6 × 31.0 × 4.8 cm (1¹³/₁₆ × 12²/₁₆ × 1⁷/₈") tapering to 3.4 cm (1⁵/₁₆"). Paper label inside lid stamped in gold *J. Duvelleroy / Ltd / BY APPOINTMENT / LONDON. 121, New Bond St, W.1.*; inscribed on base in ink *I*. Paper label formerly pasted on base, inscribed in ink by Queen Mary *Louis XVI fan of ivory, mother o' pearl, & gilt sticks / paintings of figures, doves & trophies – / From members of my family May 26 – 1948*

RCIN 25235 (Q 24)

PROVENANCE: presented to Queen Mary by members of her family on her eighty-first birthday, 26 May 1948

EXHIBITED: London 1954

28. 'THE ASCENT OF M. CHARLES'S AND M. ROBERT'S BALLOON, 1783' French, 1783

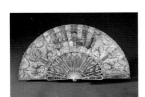

Silk leaf painted in bodycolour, watercolour and gold, decorated with sequins and spangles and tambour stitch in gold, silver and plain thread with a central vignette of figures in eighteenth-century dress watching a balloon flight; to left a plinth with a vase of flowers, and to right a plinth with doves, surrounded by swags of flowers; carved and pierced ivory guards (identical) decorated with female figures holding flowers, and carved and pierced ivory sticks with an amorous couple and a lady and a dog looking on, surrounded by scrollwork decoration, embellished with silver and three colours of gold, guards backed with pink silk (2 + 13); brass and mother-of-pearl pin

Guard length 28.0 cm (11")

VERSO: silk leaf, the folds reinforced with leather (kid), painted in watercolour with vignettes, columns and foliage, traced from recto in red

BOX: wood and paper board covered with ivory silk, edged with gold-coloured paper, cream paper on base, 4.1 × 32.3 × 6.0 cm (1⁵/₈ × 12¹¹/₁₆ × 2³/₈"); lined with ivory silk, edged with gold-coloured paper. Stamped in black inside lid *The Antique Art Galleries / 183 / Grafton Street, / Old Bond Street, / London W.1.* Loose paper scrap inside box, inscribed by Queen Mary, in ink *Louis XVI fan / purchased 1922.*, and in pencil *Montgolfier frères / with balloon.* On base, paper trade label embossed in gold *J. Duvelleroy / Ltd. / LONDON / 121, NEW BOND STREET W.1.*

RCIN 25244 (Q 33)

PROVENANCE: purchased by Queen Mary, 1922 (QMN, p. 42)

29. 'KING GEORGE III AND HIS FAMILY VISITING THE ROYAL ACADEMY, 1788' English, 1789

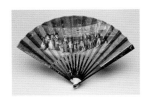

Paper leaf printed with stipple engraving and etching, painted in watercolour and bodycolour with George III, Queen Charlotte, their children and other figures in a room hung with many pictures, and decorated with pith and paper flowers appliqué; japanned bamboo guards and sticks with gold decoration (2 + 13); ivory pivot with tortoiseshell inserts at the base of each guard; steel and mother-of-pearl pin

Guard length 28.2 cm (11¹/₈")

VERSO: paper leaf, undecorated but inscribed in pencil *1788*

RCIN 25074 (WC SE 15)

PROVENANCE: Queen Mary, by 1927 (WC Fans, p. 30, no. 89)

EXHIBITED: London 1994, no. 60

30. PRINCESS ELIZABETH'S FAN English, 1789

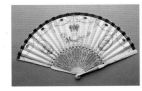

Leather (kid) leaf painted in watercolour, bodycolour, gold and silver with the initials *GR* surmounted by a crown, below these a rose and thistle, to left and right monochrome oval medallions with allegorical figures, inscribed in border *Health is restored to ONE and Happiness to Millions*; carved ivory guards (identical) and pierced ivory sticks, the guards decorated with silver *piqué* and *clouté* (2 + 20); brass and mother-of-pearl pin

Guard length 26.0 cm (10¹/₄")

VERSO: leather (kid) leaf, undecorated

BOX: paper board covered with black paper imitating watered silk, lid bordered with embossed gold paper, 3.5 × 30.8 × 4.3 cm (1³/₈ × 12¹/₈ × 1¹¹/₁₆"). Inside lid printed trade label *HOWELL / & JAMES / LIMITED / JEWELLERS, / Regent Street / LONDON* (stuck over German embossed trade mark), and inscribed *Given in Paris* (crossed through) and *24*. Loose paper scrap inside box inscribed in pen *N. 24 / Painted by the Queen's / Aunt Princess Elizabeth / Landgräfin of Hesse / Homburg*

RCIN 25087 (240 WC 13)

PROVENANCE: reputedly, presented to a guest at a party to celebrate George III's recovery in 1789; presented by Lady Holland to Queen Victoria on her Golden Jubilee, 1887 (see *Celebration of Her Majesty's Jubilee*, London, 1887, p. 155: 'An Old Ivory Fan, painted by the Princesses the daughters of George the Third on the occasion of his recovery from severe illness'); bequeathed to King Edward VII (QVL 24); Queen Alexandra; by whom presented to Queen Mary, 1911 (RA GV/CC 55/40; WC Fans, p. 24, no. 24)

REFERENCE: Roberts 1987, pp. 82–3

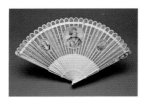

31. 'THE THREE ELDEST SONS OF KING GEORGE III' English, c.1787

Carved and pierced ivory *brisé* fan with three portrait miniatures painted in watercolour; the guards (identical) decorated with two blue Wedgwood jasper-ware plaques, strung cut-steel beads and applied marquisites, backed with gold leaf (2 + 28); silver pin with paste head
Guard length 24.8 cm (9³/₄")
RCIN 25373 (BP MH 18)
PROVENANCE: Sir Henry Paulet St John-Mildmay, 6th Baronet (1853–1916); by descent; Captain Sir Anthony St John-Mildmay, 8th Baronet; his sale, John D. Wood & Co., Dogmersfield Park, Winchfield, Hampshire, 11 May 1933, lot 1241; Queen Mary (Inventory of Curios 1916, RA GV/CC 87; QMF, no. 28)
EXHIBITED: London 2004–5, no. 468

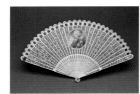

32. 'FREDERICK, DUKE OF YORK' English, c.1790

Carved and pierced ivory *brisé* fan with portrait miniature painted in watercolour and bodycolour (2 + 28); silver pin with paste cluster head
Guard length 24.6 cm (9¹¹/₁₆")
RCIN 25375 (BP MH 20)
PROVENANCE: Princess Augusta, Duchess of Cambridge (d.1889; sister-in-law of Frederick, Duke of York); her granddaughter, Queen Mary (QMB, I, p. 144, no. 591; see also QMF, no. 14)
REFERENCE: Gibson 1927, no. I, p. 2
EXHIBITED: Harewood 1986, no. 26; London 1989, case 1, no. 12; London 2004–5, no. 470

33. 'THE MARRIAGE OF FREDERICK, DUKE OF YORK, AND PRINCESS FREDERICA OF PRUSSIA, 1791' English, 1791

Carved and pierced ivory *brisé* fan, the central vignette depicting the Duke of York, below the Prince of Wales's coronet (*sic*), at either side the royal arms and the arms of Prussia, the guards set with strung cut-steel beads (2 + 26); metal pin with paste head
Guard length 25.7 cm (10¹/₄")
BOX: paper board covered with white textured paper, 3.4 × 28.5 × 7.0 cm (1⁵/₁₆ × 11¹/₄ × 2³/₄"). Lid stamped in black *BY APPOINTMENT / YAMANAKA & CO. LTD. / 127 NEW BOND STREET / LONDON. W.* Paper label on base inscribed in pen 88
RCIN 25094 (240 WC 20)
PROVENANCE: Frederica, Duchess of York. Acquired by Queen Mary, by whom 'given . . . to the collection of fans, 1927' (WC Fans, p. 2, no. 88)
EXHIBITED: London 1990–91, no. 113; London 2004–5, no. 471

34. IVORY COCKADE FAN Cantonese, c.1790

Carved and pierced ivory *brisé* fan with royal coat of arms at top and Chinese decoration (2 + 58); brass pin with silver head in the shape of a flower
Diameter 38.0 cm (14¹⁵/₁₆")
HANGING BOX: carved and pierced ivory, with the Prince of Wales's feathers and cipher *GPW* surrounded by Chinese decoration, 26.2 × 6.5 × 3.0 cm (10⁵/₁₆ × 2⁹/₁₆ × 1³/₁₆")
RCIN 3683.1 (BP MH 42)
PROVENANCE: Prince of Wales (later George IV)
EXHIBITED: London 2004–5, no. 469

35. 'ROYAL CONNECTIONS' English, 1794

Paper leaf, mounted *à l'anglaise*, printed (etched), with printed text describing the card game Connections, surmounted by a coronet and edged by a border incorporating the symbols of the four card suits and printed lettering *Published as the Act directs Janʸ [?]11 1794 by Mess.'s Stokes Scott & Cr[o]skey Nᵒ. 19 Friday Strᵗ. London*; bronze-painted edge-binding; plain boxwood guards and sticks (2 + 18); brass pin with ivory head
Guard length 25.2 cm (9¹⁵/₁₆")
RCIN 25171 (F 8)
PROVENANCE: probably Queen Mary; at Frogmore House, Windsor, by late 1970s

36. GARTER FAN English, 1805

Blue plain weave silk leaf painted in bodycolour and silver paint with the Garter Star surmounted by a crown, decorated with silver sequins fixed with blue silk thread, inscribed *GR Royal, Windsor, Installation HONI. SOIT. QUI. MAL Y. PENSE April 23 1805*; with silver-coated paper edge-binding; japanned wood guards and sticks decorated with gold paint (2 + 16); brass and mother-of-pearl pin
Guard length 20.0 cm (7⁷/₈")
VERSO: blue silk leaf, undecorated
RCIN 25156 (KEW I)
PROVENANCE: probably Queen Mary; at Frogmore House, Windsor, before 1953
EXHIBITED: Kew Palace from 1953, and 1976–96; London 2004–5, no. 472

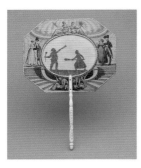

37. SILHOUETTE HANDSCREEN: LADY WITH A BROOM English or French, c.1820

Paper ground, etched and engraved, with some roulette work, hand-coloured with watercolour, depicting two couples in early nineteenth-century dress at the top of a double staircase; linen gauze over central opening which contains two silhouette figures cut from black painted card: a man with fire irons and a woman with a broomstick; turned and carved ivory handle; brass lever
Height 35.2 cm (13⁷/₈")
VERSO: coloured paper border around lever block, decorated with a book-binder's tool
RCIN 54244.1 (F 35)
PROVENANCE: probably Queen Mary; at Frogmore House, Windsor, by 1979 (typescript inventory)

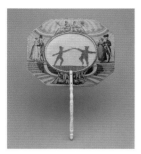

38. SILHOUETTE HANDSCREEN: THIN MAN AND FAT MAN English or French, c.1820

Paper ground, etched and engraved, with some roulette work, hand-coloured with watercolour; linen gauze over central opening which contains two silhouette figures cut from black painted card: two men sword-fighting; turned and carved ivory handle; brass lever

Height 35.2 cm (13⁷/₈")

VERSO: coloured paper border around lever block, decorated with a book-binder's tool

RCIN 54244.2 (F 36)

PROVENANCE: probably Queen Mary; at Frogmore House, Windsor, by 1979 (typescript inventory)

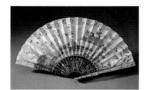

39. QUEEN ADELAIDE'S FAN French leaf and sticks; English guards, c.1830

Leather (sheep) leaf painted in watercolour, bodycolour and gold with figures in Chinese-style dress and a Chinese-style building; faces painted on ivory; mother-of-pearl laid over painted backgrounds and foil appliqué for the clothes; silk net in the windows; with gilt covered paper edge-binding; gold guards each with the crowned monogram *AR* in enamel and set with Siberian amethysts and Burmese rubies; japanned and gilded wooden sticks decorated with mother-of-pearl and coloured foil (2 + 18); gold pin with ruby heads

Guard length 27.5 cm (10¹¹/₁₆")

VERSO: paper leaf with black (?ink) stipple surface

RCIN 25104 (240 WC 30)

PROVENANCE: Queen Adelaide (d.1849); Queen Victoria; bequeathed to her daughter, Princess Christian of Schleswig-Holstein, 1901 (QVL 9); her daughter, Princess Marie Louise; by whom presented to Queen Mary, 'for the family collection of fans in Windsor Castle, 1948' (WC Fans, p. 2 verso, no. 95)

EXHIBITED: London 1870, no. 285; Dublin 1872

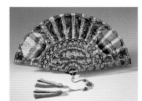

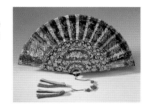

40. 'MACAO' Cantonese, c.1840

Paper leaf painted in bodycolour, watercolour and silver with a central vignette of figures in Chinese dress and views of Macao to right and left; faces painted on ivory and clothes made of silk; with gold edge-binding; lacquered bamboo guards and sticks with figures in Chinese dress and Chinese-style decoration (2 + 14); silk tassel supporting beads of pink tourmaline and 'Peking' glass

Guard length 31.7 cm (12¹/₂")

VERSO: paper leaf painted in bodycolour, watercolour and ochre, with numerous figures similarly decorated to the recto, bordered with animals, bats and birds on a silver background

BOX: irregular-shaped lacquered wood, with detachable lid, all richly decorated to match the fan, 5.2 × 6.7 × 8.6 cm (2¹/₁₆ × 2⁵/₈ × 3³/₈"); lined with red and blue silk, with cut-out support; inside the lid the silk is painted in bodycolour with figures in Chinese dress; inside edge of box decorated in gold paint on black lacquer; printed trade label on inside base of box *VOLONG / Canton.* Paper label on base of box inscribed in ink *49.*, pasted over paper label inscribed in ink *N. 18*

RCIN 25072 (WC SE 13)

PROVENANCE: Queen Victoria; bequeathed to King Edward VII, 1901 (QVL 18; WC Fans, p. 25, no. 49)

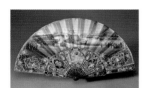

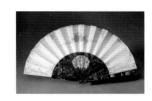

41. 'QUEEN VICTORIA'S ARRIVAL AT TRÉPORT, 1843' French, 1843

Paper leaf painted in bodycolour, watercolour and gold with a harbour scene showing the royal party arriving and crowds of onlookers, the border painted with flowers and musical instruments mainly in gold; guards (identical) and sticks of carved tortoiseshell backed with mother-of-pearl and decorated with gold and silver, depicting figures and musical instruments (2 + 12); replacement silver pin with red paste head

Guard length 27.8 cm (10¹⁵/₁₆")

VERSO: leather (kid) leaf painted in watercolour with a medallion containing the date *2 Septembre 1843*

BOX: irregular-shaped wood and paper board covered with maroon leather, decorated with gold-tooled lines, 3.2 × 31.6 × 5.2 cm (1¹/₄ × 12⁷/₁₆ × 2¹/₁₆") tapering to 3.1 cm (1¹/₄"); lined with maroon silk, cut-out support at one end. On base, leather trade label embossed in gold *VANIER / PARFUMEUR / 27 RUE CAUMARTIN / A PARIS;* paper label inscribed in ink *30*

RCIN 25344 (RL WC 2)

PROVENANCE: presented by Marie-Amélie, Queen of the French, to Queen Victoria, ?1844; bequeathed to King Edward VII, 1901 (QVL 30); Queen Alexandra; London Museum Loan, c.1912–26 (D 137); Queen Mary (WC Fans, p. 11, no. 30)

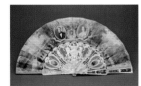

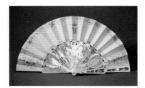

42. 'EMPEROR NAPOLEON III AND EMPRESS EUGÉNIE' French, 1855

Paper leaf painted in watercolour, bodycolour and gold, over graphite under-drawing with bust-length oval portraits of Emperor Napoleon III and Empress Eugénie and views of Versailles and Saint-Cloud to left and right inscribed on the ribbon *AOUT. SOUVENIR DE VERSAILLES ET DE ST CLOUD. 1855;* the two portraits painted on separate sheets, and let into the fan leaf; carved mother-of-pearl guards (matching) set with plaques enamelled with flowers and putti over a metal guilloché ground; mother-of-pearl sticks, each stick carved with a crown, in the centre of the gorge the British royal arms, to left and right small oval miniatures painted in oil with tall masted ships, signed *E.C.* and *Eᵀ.C* (2 + 13); gold pin with natural pearl heads

Guard length 28.5 cm (11¹/₄")

VERSO: leather (kid) leaf painted with the monogram *VR* beneath a crown, with a multicoloured floral border

BOX: wood and paper board covered with red velvet, with a crown above the initials *V.R.* embossed in gold on the lid, 3.5 × 31.5 × 5.5 cm (1⅛ × 12⅜ × 2³/₁₆"); lined with white silk and velvet with cut-out support at each end. Inside lid printed trade label *DUVELLEROY / 167, Regent Street / 1851 / FAN MANUFᴿ TO THE QUEEN / & HRH THE DUCHESS OF KENT / 1851,* inscribed in ink *.6.* Paper label on base inscribed in ink *N. 6*

RCIN 25101 (240 WC 27)

PROVENANCE: reputedly, purchased by Queen Victoria at the Exposition Universelle, Paris, 1855, but probably presented by the Empress Eugénie to Queen Victoria; bequeathed to King Edward VII, 1901 (QVL 6); Queen Alexandra; London Museum Loan, c.1912–26 (D 139); Queen Mary (WC Fans, p. 10, no. 6)

EXHIBITED: reputedly, Paris 1855; London 1870, no. 268

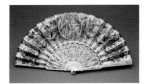

43. THE PRINCESS ROYAL'S FAN English, 1856

Leather (sheep) leaf, painted in watercolour, bodycolour and gold, over graphite under-drawing, with letters spelling
VICTORIA linked by swags of ribbon inscribed with names and birth dates, in the centre a roundel with two angels and a
ribbon inscribed *MAY 24ᵗʰ 1856*, cornucopia and crown beneath, flowers and foliage either side; pierced and carved ivory
guards backed with mother-of-pearl, and carved ivory sticks (2 + 16); replacement brass and silver pin with paste head
Guard length 26.7 cm (10¹/₂")
VERSO: leather (sheep) leaf painted in watercolour, bodycolour and gold over graphite under-drawing, with the letter *V* against
a blue sky with moon and stars in a roundel surrounded by a wreath and tied with a ribbon inscribed *MAY 24 1856 . VICTORIA
. delt.*; putti to left and right
BOX: no box associated with this fan is known. However, there is a loose paper label inscribed in pen *44*
RCIN 25102 (240 WC 28)
PROVENANCE: presented by Victoria, Princess Royal, to Queen Victoria, for her thirty-seventh birthday, 24 May 1856
(WC Fans, p. 32, no. 44)
REFERENCE: Roberts 1987, p. 125, pl. 12

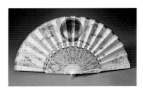

44. 'LA BALANÇOIRE' French, 1857–8

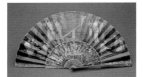

Paper leaf, with leather (kid) extension to leaf on left guard, painted with watercolour, bodycolour and gold over graphite
under-drawing with putti on a see-saw and female figures in classical dress to left and right, inscribed *P. HERVY, / d'apres /
HAMON / 1857* and (twice) *ALEXANDRE*; mother-of-pearl guards (matching) decorated with cabochon rubies and gold
(French control mark of eagle's head signifying 18-carat gold, on recto and verso of guards), supporting small porcelain
plaques painted with (recto) a putto holding a sheaf of corn (symbolising Summer) and (verso) a putto holding a bunch of
grapes (symbolising Autumn); carved mother-of-pearl sticks with three colours of gold, decorated with figures (symbolising
Learning, War and Peace, with a central crowning scene, river gods and naiads), scrollwork and garlands (2 + 20); gold pin
with cabochon ruby head
Guard length 29.0 cm (11⁷/₁₆")

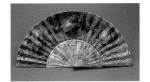

VERSO: paper leaf painted in bodycolour and some watercolour with tropical vegetation surrounding three grotto vignettes,
each containing tiny figures, inscribed *H. BALLUE 58*
RCIN 25027 (SH 3)
PROVENANCE: presented to Queen Alexandra (d.1925) by Lord Calthorpe (either Somerset John, 7th Baron, d. 1912; or
Somerset, 8th Baron, d. 1940; QAF, no. 1)

45. QUEEN VICTORIA'S BIRTHDAY FAN French, 1858

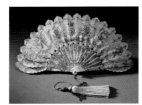

Cream silk leaves painted in watercolour, bodycolour and gold with swags of lily-of-the-valley between which are bouquets of
roses, thistles and shamrocks, in the centre a crown over the initials *VR*; guards (matching) and sticks of carved and pierced
mother-of-pearl with floral designs and scrollwork highlighted with gold, vignette in centre of gorge with the date *May 24 / 1858*
incised under a monogram and crown (2 + 16); brass pin; silver loop; tassel of silk and gold thread
Guard length 28.0 cm (11")
VERSO: cream silk leaf, undecorated; verso of guards and sticks lightly incised with floral motifs
BOX: palmette-shaped paper board covered with cream watered silk, cushioned lid painted in bodycolour with crown and
monogram *VR* surrounded on two sides by roses and foliage, base covered with cream paper, 3.8 × 29.8 × 9.2 cm
(1¹/₂ × 11³/₄ × 3⁵/₈") tapering to 4.1 cm (1⁵/₈"); lined with cream silk. Printed paper trade label on base *M.ᵐᵉ REBOURS /
ÉCRANS. EVENTAILS / Raccommodages / 17, Rue Rousselet, / Faub.ᵍ S¹-Germain*; base inscribed in ink *N. 68*
RCIN 25411 (QM LM 30)
PROVENANCE: presented by Prince Albert to Queen Victoria on her thirty-ninth birthday, 24 May 1858 (according to list of
items in the Victorian Rooms, Kensington Palace); bequeathed to King Edward VII, 1901 (QVL 68: 'Bought by the Queen
painted at Paris, 1858'); London Museum Loan, 1956–97
REFERENCE: Staniland 1985, illus. front cover; Staniland 1997, p. 153
EXHIBITED: London 1997, no. 176

46. 'APRÈS LES VENDANGES' French, c.1860

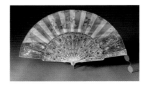

Paper leaf, printed with lithograph and painted in watercolour, bodycolour and stencilled gold, with figures in eighteenth-
century costume dancing while a man makes music; mother-of-pearl guards (identical) and sticks pierced, incised and
decorated with different colours of applied gold foil depicting flowers, foliage and birds (12 + 2); silver pin with paste head;
silver-gilt loop. A gold-rimmed lorgnon with a French nineteenth-century maker's mark containing the letter *D*
Guard length 27.0 cm (10⁵/₈")

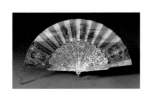

VERSO: paper leaf, lithographed and painted in bodycolour and stencilled gold with an elegant family beside a lake; verso of
sticks pierced and incised with leaf design, decorated with applied gold foil
RCIN 25367 (BP MH 12)
PROVENANCE: Princess Mary Adelaide, Duchess of Teck (d.1897); given (or bequeathed) to her daughter, Princess Victoria
Mary (later Queen Mary; QMB, I, p. 144, no. 593; see also QMF, no. 16)
REFERENCE: Gibson 1927, no. VI, p. 6
EXHIBITED: London 1987

47. 'OSBORNE HOUSE' English, 1861

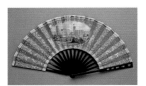

Paper leaf, painted in watercolour, bodycolour and gold, with gold leaf, with central vignette of Osborne House, surrounded
by scroll design, signed *Em Roberts*; the tortoiseshell guards set with ten hand-coloured photographic portraits (albumen prints)
in tiny silver-gilt frames; tortoiseshell sticks (2 + 16); gold and metal pin with foiled amethyst heads
Guard length 27.8 cm (10¹⁵/₁₆")

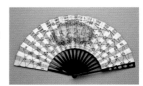

VERSO: leather (kid) leaf painted in bodycolour and watercolour with floral trellis and garland of flowers (forget-me-nots and
heartsease) containing the word *SOUVENIR*, signed *Em Roberts*
BOX: wood, covered with purple leather, 3.8 × 32.7 × 4.7 cm (1¹/₂ × 12⁷/₈ × 1⁷/₈"); lined with purple velvet and silk, with cut-out
support
RCIN 25385 (BP MH 30)
PROVENANCE: Queen Victoria (probably commissioned as a wedding gift for Princess Alice, but not presented); London
Museum Loan, 1956 (for Kensington Palace); at Windsor by c.1980
EXHIBITED: Salisbury/Guildford/London 1985–6; Harewood 1986, no. 87; Rochester 1991, no. 109

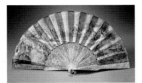
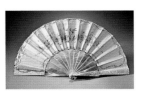

48. 'A SKATING SCENE' French leaf; English guards and sticks, 1863

Leather (sheep) leaf painted in bodycolour, watercolour and gold with figures in eighteenth-century dress skating on a pond, to the left a ball scene and to the right figures playing and listening to musical instruments, inscribed *Gimbel*; carved mother-of-pearl guards (identical) with traces of gold decoration and the royal arms of Princess Alexandra, and motto beneath surmounted by the Prince of Wales's coronet; mother-of-pearl sticks carved with interlaced *AA* in the centre and Prince of Wales's feathers and motto at either side, intertwined with the rose, thistle and shamrock, surmounted by the Prince of Wales's coronet, and embellished with gilt highlights (2 + 13); gold pin with coral heads; gold loop formed of the initials *A* and *E*

Guard length 29.1 cm (11⁷/₁₆")

VERSO: leather (kid) leaf painted in bodycolour, watercolour and gold with naturalistic roses, shamrocks and thistles and a scroll border, signed *Jenny Boucher*

RCIN 25029 (SH 5)

PROVENANCE: presented by Feodora, Princess of Hohenlohe-Langenburg, to Princess (later Queen) Alexandra on her marriage, March 1863 (erroneously, QAF, no. 3, states that it was a gift from the Emperor Alexander III of Russia and Empress Marie Feodorovna)

REFERENCE: Russell 1864, p. v

49. PRINCESS ALEXANDRA'S DANISH FAN Danish, 1863

Ivory *brisé* fan carved and pierced with medallions depicting figures in classical dress, the central medallion containing the interlaced letters *AA* surmounted by the Prince of Wales's coronet, a frieze of figures in classical dress processing behind, and a chariot below, the gorge set with filigree panels; the ivory guards (identical) with applied pierced gold decoration, signed and dated on recto guard *I.G. Schwartz & Són. Kjóbenhavn 1863*, signed and dated in blue paint on verso of stick 14 *Louis Griesling, 1863* (2 + 25); gold pin with turquoise head

Guard length 25.4 cm (10")

RCIN 25033 (SH 9)

PROVENANCE: presented by a group of Danish ladies to Princess (later Queen) Alexandra on her marriage, 1863 (but not mentioned in Russell 1864); her daughter, Princess Victoria; by whom given to Queen Alexandra's goddaughter, Alexandra, Lady Worsley ('as a souvenir'), 1927; by whom given to Queen Elizabeth, 1949 (QAF, no. 23)

REFERENCE: Arundel Society 1871, no. XVII; Rhead 1910, p. 278; Bast 1951, pp. 54–5

EXHIBITED: London 1870, no. 458; Copenhagen 1951; Rochester 1991, no. 108; Copenhagen 2001

50. *BRISÉ* LEATHER FAN Austrian, *c.*1866

Black lacquered composite board with inlaid engraved gold and silver on blue and red leather (sheep), the decoration depicting the Prince of Wales's coronet surmounting two shields, supported to left and right by a lion and a unicorn; guards of black leather-covered board, the front guard set with the name *ALEXANDRA* beneath the Prince of Wales's coronet in coloured enamel (2 + 17); brass pin and loop; blue silk tassel

Guard length 22.6 cm (8⁷/₈")

RCIN 25407 (QM LM 15)

PROVENANCE: Alexandra, Princess of Wales (later Queen); Queen Mary; London Museum Loan, 1926–97 (D 438)

EXHIBITED: Copenhagen 2001

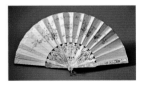

51. THE READING FAN English leaf; ?French sticks, 1870

Paper leaf painted in watercolour, bodycolour, gold and silver, the centre decorated with intertwined letters *AA* beneath the Prince of Wales's coronet and flanked by the arms and motto of the Princess of Wales and those of Reading, together with views of Reading School and Abbey, inscribed *MARCUS WARD DELT.* and *HOWELL JAMES & CO.*; mother-of-pearl guards (identical) pierced and carved with a putto in a niche, flowers and scrolls, the front guard bears the applied Prince of Wales's motto and feathers and at the top, interlaced letters *AA* beneath the Prince of Wales's coronet of silver-gilt; mother-of-pearl sticks pierced and carved with a central vignette depicting cupid and winged putto on clouds, with identical vignettes of hat, sheaf of corn and pitchforks to right and left, surrounded by scrolls and flowers (2 + 14); gilt metal pin with paste head; chased gold loop

Guard length 28.4 cm (11³/₁₆")

VERSO: leather (sheep) leaf painted in watercolour and bodycolour. The date *1 July 1870* surrounded by a garland of roses

BOX: irregularly-shaped wood covered with blue velvet, with coronet stamped in gold on lid, 4.4 × 31.6 × 10 cm (1³/₄ × 12⁷/₁₆ × 4"), tapering to 7.5 cm (2¹⁵/₁₆"); lined with pale blue silk and blue velvet, and fitted with separate slots for the fan, and for the vinaigrette and miniature fan (both missing). Stamped in gold inside lid *HOWELL, JAMES & CO / GOLDSMITHS & JEWELLERS / TO THE QUEEN / & PRINCE & PRINCESS OF WALES / 6, 7 & 9 REGENT STREET*

RCIN 25409 (QM LM 18)

PROVENANCE: presented by the Mayor and Corporation of Reading to Alexandra, Princess of Wales (later Queen), 1 July 1870 (QAF, no. 10); London Museum Loan, 1926–97 (D 443/2)

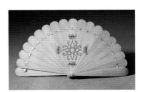

52. PHOTOGRAPHIC FAN Austrian; decorated in England, 1871

Wood (maple) *brisé* fan painted in bodycolour and gold with swags of roses and ribbons, Prince of Wales feathers and five oval frames, mounted with albumen print photographic portraits of the children of the Prince and Princess of Wales (later King Edward VII and Queen Alexandra), the front guard inscribed *Many / happy / returns / of the / Day / Dec. 1 / 1871* and *ALEXANDRA* spelt out in rose garlands beneath the Prince of Wales's coronet (2 + 17); silver pin with mother-of-pearl head

Guard length 23.2 cm (9¹/₈")

VERSO: four intertwined letters *A* each surmounted by the Prince of Wales's coronet

RCIN 25193 (F 30)

PROVENANCE: presented to Alexandra, Princess of Wales (later Queen), on her thirty-seventh birthday, 1 December 1871; at Frogmore House, Windsor, by late 1970s

REFERENCE: Dimond 2004, p. 45

EXHIBITED: London 1989, case 2, no. 12; Copenhagen 2001

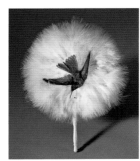

53. HUMMING-BIRD FAN Brazilian, c.1870

Circular handscreen of white feathers (turkey or chicken) sewn onto a gauze base; in the centre a stuffed Brazilian Ruby humming-bird (*Clytolaema rubricauda*); handle of turned bone

Height 33.0 cm (13")

RCIN 25415 (QM LM 16)

PROVENANCE: by 1871, Alexandra, Princess of Wales (later Queen); Queen Mary; London Museum Loan, 1926–2001 (D 439)

REFERENCE: Staniland 1985, illus. inside front cover

EXHIBITED: London 2001

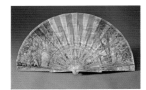

54. 'NATIONAL PROGRESS' English, 1877

Paper leaf (with skin extension on left guard) painted in watercolour, bodycolour and gold with domed classical building in background, figures in classical and medieval dress in foreground and angels to right and left, inscribed *ARS LONGA VITA BREVIS SCIENTIA INFINITA* and *GEOLO[GY] AND MECHANICS / [KNO]WLEDGE IS POW[ER] / [E]DUCATION OF WOMEN*; with leather (kid) edge-binding, painted gold; mother-of-pearl guards (identical) carved with scrolls and ears of corn with applied crown and monogram *VRI*, mother-of-pearl sticks backed with mother-of-pearl, carved with trophies of scientific and musical instruments and decorated with silver and gold (2 + 14); verso of front guard inscribed *Jonel. Spsit* (for Jorel); silver-gilt pin with natural pearl head

Guard length 29.5 cm (11⁵/₈")

VERSO: leather (kid) painted with a trellis of grapes and vine leaves in watercolour, bodycolour and gold, inscribed *THE PICTURE OF A MOST HEALTHY NATIONAL PROGRESS *** EDUCATION AND SCIENCE DIRECTING EXERTION *** THE ARTS WHICH ONLY ADORN LIFE, BECOMING LONGED-FOR / BY A PROSPEROUS AND EDUCATED PEOPLE. EDINBURGH – 1850*

BOX: wood covered with blue velvet with applied silver-gilt monogram *VRI* on lid, cream paper on base, 5.3 × 33.4 × 6.8 cm (2¹/₁₆ × 13¹/₈ × 2¹¹/₁₆"); lined with pale lilac silk, with cut-out support at each end. Printed in gold inside lid *PARIS DUVELLEROY PARIS / LONDON, 167, REGENT STREET*. Paper label on base inscribed in ink 83

RCIN 25071 (WC SE 12)

PROVENANCE: commissioned by Queen Victoria (WC Fans, p. 29, no. 83)

REFERENCE: Millar (D.) 1995, no. 33

EXHIBITED: Edinburgh 1878, no. 4; Harewood 1986, no. 96

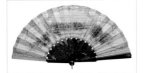

55. 'SANDRINGHAM' English, c.1880

Paper leaf, painted in watercolour, bodycolour and gold, panels drawn in charcoal with views of Sandringham Church, Sandringham House and the Norwich Gates; signed *Cte Nils*; plain tortoiseshell guards and sticks (2 + 14); brass pin with bone head; tortoiseshell loop

Guard length 31.0 cm (12¹/₁₆")

VERSO: black silk

RCIN 25048 (SH 24)

PROVENANCE: Alexandra, Princess of Wales (later Queen; QAF, no. 21)

EXHIBITED: Rochester 1991, no. 105

56. SILK COCKADE FAN French, c.1880

Stiffened silk painted in bodycolour with a floral design; paper board tube covered in blue silk and edged with brass ferrules; when the lower tassel is pulled the pleated leaf and inner tube retract into the handle

Tube length 14.0 cm (5¹/₂")

RCIN 25166 (F 3)

PROVENANCE: Princess Louise, Duchess of Argyll (note in Queen Mary's hand); at Frogmore House, Windsor, by late 1970s

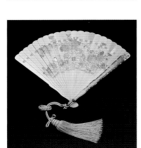

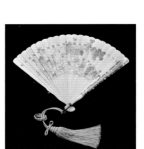

57. JAPANESE IVORY AND LACQUER FAN Japanese, c.1880

Ivory *brisé* fan decorated with raised gold lacquer work (*takamaki-e*), with chrysanthemum design (2 + 20); silver pin and engraved silver loop, cream silk tassel

Guard length 25.7 cm (10¹/₈")

VERSO: recto design reversed

BOX: wood covered with black lacquer (*urushi*) decorated with raised gold lacquer work (*takamaki-e*), with chrysanthemum design on lid, 5.0 × 32.5 × 9.5 cm (1¹⁵/₁₆ × 12¹³/₁₆ × 3³/₄"); lined with ivory silk, with cut-out support; contains card printed *Princess Chichibu* and inscribed in ink (?by Queen Mary) *1937*

RCIN 25182 (F 19)

PROVENANCE: presented by Princess Chichibu to either Queen Mary or Queen Elizabeth, 1937; at Frogmore House, Windsor, by late 1970s

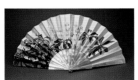
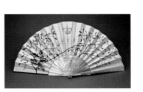

58. CHRISTMAS FAN English, 1881

Pale green satin leaf painted in bodycolour with Christmas roses, signed *A.H. LOCH*; plain mother-of-pearl guards and sticks (2 + 16); silver pin with mother-of-pearl head
Guard length 40.5 cm (15¹⁵/₁₆")
VERSO: pale green satin leaf painted in bodycolour with mistletoe and holly, and in the centre *ALIX* beneath the Prince of Wales's coronet, painted in gold, dated *1881*
BOX: paper board covered with off-white paper, 5.0 × 41.8 × 4.5 cm (1¹⁵/₁₆ × 16⁷/₁₆ × 1³/₄"). Printed trade label inside lid
PARIS J. DUVELLEROY LONDON / BY APPOINTMENT / LONDON: 167 Regent Street, 167 / EVENTAILS ARTISTIQUES, MODERNES, ANTIQUES ET POUR MARIAGE. / FANS REPAIRED. The base inscribed in ink *The Queen* and 8886
RCIN 25197 (F 34)
PROVENANCE: commissioned by Queen Victoria as a present for Alexandra, Princess of Wales (later Queen), Christmas 1881; at Frogmore House, Windsor, by late 1970s
EXHIBITED: Rochester 1991, no. 106

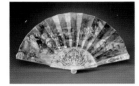
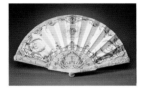

59. EU FAN French, 1886

Paper leaf painted in watercolour, bodycolour and gold, over graphite under-drawing, with a coach and horses before a red brick building and figures in seventeenth-century dress, signed and dated *Eugène Lami, 1886*; with gilded paper edge-binding; carved ivory guards, with gilded highlights decorated with putti, shells and scrolls; front guard with applied silver-gilt mounts with diamonds, rubies and sapphires to form the letters *MA* beneath a ducal coronet and dragon; incised on verso *Mᵐᵉ A. RODIEN*; back guard carved with a figure of Apollo; sticks of pierced, carved and painted ivory with French and Portuguese arms surmounted by a ducal coronet and silver-gilt dragon, and the date *Mai 1886* (2 + 11); silver-gilt pin with diamond heads
Guard length 31.0 cm (12³/₁₆")
VERSO: leather (kid) leaf painted in watercolour, bodycolour and gold with decoration including a mask of Apollo. Inscribed *HOMMAGE de la SEINE INFERIEUR.* The back of the front guard inscribed in purple *313*, on paper label.
BOX: wood and paper board covered with ivory silk and edged with gold-coloured paper, cream paper on base, 4.5 × 40.1 × 6.3 cm (1¹/₄ × 15¹³/₁₆ × 2¹/₂"); lined with ivory silk. Stamped in gold inside lid *FAUCON / EVENTAILS ANTIQUES / RÉPARATIONS / 61. Passage des panoramas / PARIS.* Loose paper scrap inside box inscribed in ink by HM The Queen *Fan left to Queen Mary by / Queen Amelie of Portugal. / It was given her at her wedding. / Brought by Comte de Paris Aug. 1954*
RCIN 25213 (Q 3)
PROVENANCE: presented by the people of Seine Inférieur to Princess (later Queen) Amélie d'Orléans (1865–1951) on her marriage to King Carlos I of Portugal, 1886; bequeathed by Queen Amélie to Queen Mary (d.1953); delivered by the Comte and Comtesse de Paris to HM The Queen, 1954

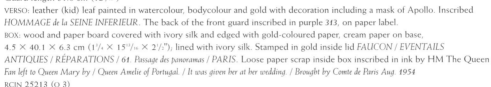

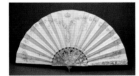
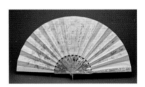

60. AUTOGRAPH FAN English, c.1887

Leather (sheep) leaf painted in watercolour and bodycolour with roses and forget-me-nots in the shape of the letter *V* surmounted by a crown, signed *F Houghton*; leather (sheep) edge-binding; carved and pierced mother-of-pearl guards with a male figure, musical instruments and applied gold crown and flowers, and carved and pierced mother-of-pearl sticks with central vignette of two couples in eighteenth-century dress, surrounded by ribbons and musical instruments, with thin mother-of-pearl backing pieces to the central eight sticks (2 + 14); brass and mother-of-pearl pin; mother-of-pearl loop
Guard length 33.6 cm (13¹/₄")
VERSO (illustrated on pp. 146–7): leather (sheep) leaf painted in watercolour with roses and forget-me-nots, signed *F. Houghton*, with numerous signatures added in pen and ink
BOX: wood covered with dark cream leather, 4.0 × 37.4 × 6.5 cm (1⁹/₁₆ × 14³/₄ × 2⁹/₁₆"); lined with cream velvet and silk, with cut-out support, lid edged with single gold-tooled line. Printed trade label in lid *V. GIVRY. / 39 CONDUIT Sᵀ / LONDON. W.* Paper label on lid inscribed in ink *84*. Paper scrap in box inscribed in ink by Queen Alexandra *We gave this fan to the Queen / by her own wish / Left me by the Queen / A.*
RCIN 25064 (WC SE 5)
PROVENANCE: presented by the Prince and Princess of Wales to Queen Victoria, 1887; bequeathed to Queen Alexandra (WC Fans, p. 29, no. 84)
EXHIBITED: London 1990–91, no. 112

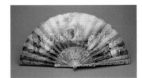
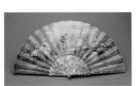

61. 'LA FONTAINE DE JOUVENCE' French, c.1890

Paper leaf painted in watercolour, bodycolour and gold, with figures in eighteenth-century dress arriving at a grotto, the lintel over the entrance inscribed *Fontaine de jouvence*; figures exiting to right with putti playing with swags of flowers; signed *DONZEL*; with gilded paper edge-binding; carved and pierced mother-of-pearl guards (identical) depicting male figure with shepherd's crook and bird, scrolls and flowers and carved and pierced sticks decorated with three colours of gold leaf, with amorous couples in central vignette and female figures to left and right, surrounded by scrollwork and flowers (2 + 16); brass and mother-of-pearl pin; gold loop
Guard length 35.0 cm (13³/₄")
VERSO: paper leaf painted in watercolour and bodycolour with a garden scene, an elegant youth digs beside a statue of Cupid, figures to left and right and putti in clouds; signed *DONZEL*
BOX: wood and paper board covered with ivory-coloured silk, edged with gold paper, cream paper on base, 5.0 × 38.7 × 5.2 cm (1¹⁵/₁₆ × 15¹/₄ × 2¹/₁₆"). Paper label inside lid inscribed in ink *For dear May / from her affectionate / Uncle Ernest Augustus and / Aunt Thyra.* Base of box inscribed in ink *HRH / The Duchess of Cumberland* and *H.R.H. Duke & / Duchess of Cumberland. 1893 / 1903* [crossed through] and *61609*; paper label inscribed in ink *14.* over *8* [crossed through]. In box, paper scrap inscribed in ink *Duke and Duchess / of / Cumberland*; and description of fan on J. Duvelleroy (London) headed paper, to which has been added *This fan was Carried by Queen Mary at / The Wedding of Princess Victoria Louise / of Prussia and Prince Ernest Augustus / of Cumberland Berlin 24 May 1913*
RCIN 25138 (WC QM 14)
PROVENANCE: presented by the Duke and Duchess of Cumberland to their niece, Princess Victoria Mary of Teck (later Queen Mary), on her marriage, 1893
EXHIBITED: Harewood 1986, no. 100

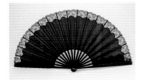

62. QUEEN VICTORIA'S FAN French, c.1890

Black silk leaf edged with machine lace; carved ebony guards (identical) and sticks (2 + 16); steel pin and brass loop
Guard length 37.5 cm (14³/₄")
RCIN 25181 (F 18)
PROVENANCE: Queen Victoria (see note on accompanying scrap of mourning paper inscribed in ink *Fan used at the last moments*); at Frogmore House, Windsor, by late 1970s
EXHIBITED: Rochester 1991, no. 110

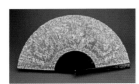

63. *POINT DE GAZE* LACE FAN Belgian lace; mounted in France, c.1893

Cream linen needle-lace leaf; plain tortoiseshell guards and sticks (2 + 16); the front guard decorated in diamonds in silver settings with the monogram *VM* beneath a royal ducal coronet; gold pin with diamond head; gold loop

Guard length 35.0 cm (13³/₄")

BOX: wood and paper board covered with ivory silk and edged with gold-coloured paper, cream paper on base, 6.0 × 37.0 × 5.0 cm (2³/₈ × 14⁹/₁₆ × 1¹⁵/₁₆"); lined with ivory silk. Inside lid stamped in gold *PARIS DUVELLEROY PARIS / LONDON, 167. REGENT STREET.* Base inscribed in ink *Blk fan, diamond monogram* and (by Queen Mary) *Ld.& Ly Yarborough / 1893,* with the figure *I.*

RCIN 25129 (WC QM 1)

PROVENANCE: presented by the Earl and Countess of Yarborough to Princess Victoria Mary of Teck (later Queen Mary) on her marriage, 1893 (QMWP 1893, no. 341, as 'In personal use by HRH The Duchess of York')

EXHIBITED: London 1989, case 2, no. 3

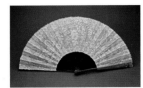

64. IRISH LACE FAN Irish lace; mounted in France, c.1893

Cream linen and cotton needle-lace leaf with silk gauze backing; blond tortoiseshell guards, the front guard with the monogram *VM* with shamrocks in gold and diamonds beneath a royal ducal coronet in gold, diamonds, emeralds, natural pearls and a ruby; blond tortoiseshell sticks (2 + 16); gold and silver pin set with diamond heads

Guard length 35.2 cm (13⁷/₈")

BOX: wood, covered with cream floral-patterned fabric, 6.4 × 41.0 × 7.9 cm (2¹/₂ × 16¹/₈ × 3¹/₈"); lined with ivory silk, with cut-out supports at either end. Inside lid stamped in gold *J. DUVELLEROY, / Fanmaker by Appointment, / 20, MOTCOMBE STREET, BELGRAVE SQUARE, S.W. / Established to Promote Irish Industries.* Paper label on base inscribed in ink *Given by* [in Queen Mary's hand] *Lord Houghton / now* [original hand] *Lord Crewe / 1893* and in another hand, in red ink, *3*

RCIN 25131 (WC QM 3)

PROVENANCE: presented by Lord Houghton (later Marquess of Crewe), Viceroy of Ireland, to Princess Victoria Mary of Teck (later Queen Mary) on her marriage, 1893 (QMWP 1893, no. 331)

REFERENCE: Rhead 1910, pp. 278 and 292

EXHIBITED: Harewood 1986, no. 101; London 1990–91, no. 110

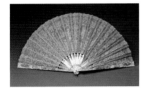

65. HONITON LACE FAN English, 1893

Cream cotton and linen lace leaf, backed with silk gauze, mounted *à l'anglaise,* incorporating putti supporting a ribbon bow within the letter *M,* surmounted by a crown, to either side cornucopia containing branches of may blossom, infilled with motifs depicting roses, shamrocks and thistles; carved, pierced and incised mother-of-pearl guards decorated with birds, musical instruments, flaming torches and pastoral symbols; mother-of-pearl sticks incised and decorated in two colours of gold and silver with a border of stylised flowers, musical instruments and pastoral symbols in the centre; pierced bone ribs (2 + 16); gold-cased pin and loop

Guard length 32.0 cm (12⁵/₈")

RCIN 25398 (QM LM 3)

PROVENANCE: presented by the Lacemakers and Ladies of Honiton and Neighbourhood to Princess Victoria Mary of Teck (later Queen Mary) on her marriage, 1893 (QMWP 1893, no. 326); London Museum Loan, 1926–97 (D 226A, later D 138)

REFERENCE: Staniland 1985, fig. 26

EXHIBITED: London 1910; London 1999–2000; London 2002, no. 5; London 2002–3

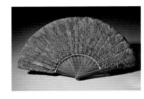

66. JAY FEATHER FAN Austrian, c.1893

Leaf of small blue wing feathers backed by large black tail feathers; blond tortoiseshell guards, the front guard bearing the monogram *MAY* in diamonds set in silver-gilt beneath an enamel silver-gilt crown in continental form, set with diamonds and enamelled in white and red; blond tortoiseshell sticks, threaded with cream silk ribbon (2 + 15); silver-gilt pin with diamond heads

Guard length 26.5 cm (10⁷/₁₆")

BOX: palmette-shaped wood and paper board covered with black leather, cloth on base, 7.8 × 38.4 × 11.1 cm (3¹/₁₆ × 15¹/₈ × 4³/₈") tapering to 6.1 cm (2³/₈"); lined with red silk, with cut-out support and quilted inside lid. Tooled in gold inside lid *GBR. RODECK [K.K.] / . HOFLIEFERANTEN.* Paper label on base inscribed in ink *6–*

RCIN 25134 (WC QM 6)

PROVENANCE: presented by Count and Countess Henry Larisch to Princess Victoria Mary of Teck (later Queen Mary) on her marriage, 1893 (QMWP 1893, no. 362)

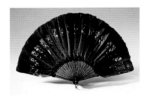

67. CAPERCAILLIE FEATHER FAN Austrian, c.1893

Leaf of double-layered brown and white feathers; carved, pierced and incised tortoiseshell guards, the front guard with the monogram *VM* in diamonds set in silver surmounted by a royal coronet in diamonds set in silver and decorated with enamel, and carved and pierced tortoiseshell sticks, with three diamonds inset into each (2 + 18); silver pin with diamond head; silver loop, set with diamonds

Guard length 32.7 cm (12⁷/₈")

BOX: wood covered with red velvet, 6.7 × 42.2 × 8.8 cm (2⁵/₈ × 16⁵/₈ × 3⁷/₁₆"); lined with watered satin, with cut-out support; paper label in lid inscribed in ink by Queen Mary *From / Count Szapary / July 6ᵗʰ / 1893* and *4.*

RCIN 25132 (WC QM 4)

PROVENANCE: presented by Count Szapary to Princess Victoria Mary of Teck (later Queen Mary) on her marriage, 1893 (QMWP 1893, no. 335)

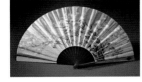

68. 'LILIES' French, c.1895

Paper leaf backed with leather (kid), mounted *à l'anglaise,* painted in watercolour and bodycolour with white lilies on a blue background, inscribed *Madeleine Lemaire;* gilded paper edge-binding; blond tortoiseshell guards and sticks, the sticks verso inscribed *A. Rodien, Paris;* on the front guard, the arms of France, on the rear guard the arms of Savoy both in gold, enamel and diamonds (2 + 16); gold pin

Guard length 37.5 cm (14³/₄")

VERSO: blank

BOX: wood and paper board covered with red silk and edged with gold paper, cream paper on base, 5.5 × 39.3 × 4.5 cm (2³/₁₆ × 15¹/₂ × 1³/₄"); lined with red silk. Base inscribed in ink by Queen Mary *From Hélène Duchess of Aosta*

RCIN 25043 (SH 19)

PROVENANCE: presented by Princess Hélène, Duchess of Aosta, presumably to Queen Mary

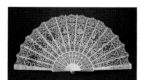

69. QUEEN VICTORIA'S DIAMOND JUBILEE FAN English, 1897

Cream silk bobbin lace with simulated gold thread incorporating flowers, anchor, star, harp, shamrock, rose, thistle, moon, star and Maltese Cross, ornamented with gold beads and spangles; carved and pierced ivory guards (identical) and sticks with applied gold, decorated with foliage and scrollwork, the front guard signed on the verso *R. Gleeson* (2 + 14); gold pin
Guard length 34.0 cm (13⅜")
BOX: wood covered with red velvet, with crown and initials *VR* in gilt metal, 5.8 × 37.3 × 7.5 cm (2⁵/₁₆ × 14¹¹/₁₆ × 2¹⁵/₁₆"); lined with red silk with cut-out supports, inside lid stamped in gold *PARIS DUVELLEROY PARIS / LONDON, 167. REGENT STREET*
RCIN 25065 (WC SE 6)
PROVENANCE: presented by the Worshipful Company of Fan Makers to Queen Victoria on the occasion of her Diamond Jubilee, June 1897; Queen Alexandra; London Museum Loan, c.1912–26 (D 141); Queen Mary (WC Fans, p. 26, no. 85)
REFERENCE: *Daily Graphic*, 25 June 1897, p. 7; *Queen*, 3 July 1897, p. 18; Rhead 1910, p. 293
EXHIBITED: London 1897; London 1953

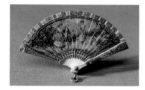
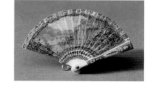

70. MINIATURE *BRISÉ* FAN French, c.1900

Bone *brisé* fan painted in oil, watercolour and gold with three figures in eighteenth-century dress in a landscape, inscribed *DANVS* [sic for *Danys*], painted ribbon edging, lower section of guards faced with mother-of-pearl (2 + 15); brass pin and hanging attachment
Guard length 5.5 cm (2⅛")
VERSO: a classical temple beside a lake
RCIN 25013 (SH 46)
PROVENANCE: Alexandra, Princess of Wales, later Queen

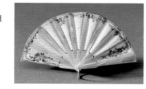

71. MINIATURE FAN French, c.1900

Leather (kid) leaf, backed with paper, mounted *à l'anglaise*, painted in watercolour, bodycolour and gold with figures in a paved courtyard outside a classical building, a couple dance in the centre; gold-painted leather (kid) edging; mother-of-pearl guards and sticks (2 + 8); brass pin; brass loop
Guard length 5.5 cm (2⅛")
VERSO: a scroll border incorporating pink and blue flowers
RCIN 25005 (SH 38)
PROVENANCE: Alexandra, Princess of Wales, later Queen

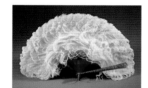
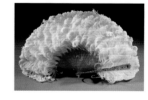

72. QUEEN ALEXANDRA'S OSTRICH FEATHER FAN English, c.1901

Leaf of curled white ostrich feathers; tortoiseshell guards and sticks; the front guard decorated with roses, shamrock and thistles in diamonds set in silver, the back guard with the letter *A* beneath a crown, in diamonds set in silver (2 + 18); silver pin with diamond head in the shape of a rose; silver loop set with diamonds
Guard length 24.0 cm (9⁷/₁₆")
BOX: wood covered with white paper in imitation of leather, 7.0 × 28.8 × 14.3 cm (2¾ × 11⁵/₁₆ × 5⅝"); lined with white embossed paper with cut-out support. Paper label inside lid inscribed in ink by Queen Mary *For darling Elizabeth in / remembrance of Coronation Day / 12ᵗʰ May 1937, from her loving / Mama / Mary. / This fan formerly belonged / to Queen Alexandra*
RCIN 25279 (CH 9)
PROVENANCE: Queen Alexandra; Queen Mary; by whom given to Queen Elizabeth at the time of the coronation, 1937

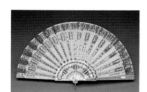

73. QUEEN ELIZABETH'S FABERGÉ FAN Russian, c.1900

Cream silk and silk gauze leaf decorated with silver coloured sequins and spangles with flower and leaf design; silver-painted paper edge-binding; front guard mother-of-pearl and two-colour gold enamelled in pink and white over a guilloché ground decorated with diamonds (set in silver); mark of Michael Perchin with gold mark of 56 *zolotniks* (1896–1908) and scratched mark *4341* on side of front guard; sticks and back guard of pierced mother-of-pearl with silver *piqué* decoration, and bone ribs (2 + 16); silver pin with diamond heads and gold loop with mark of Michael Perchin and gold mark of 56 *zolotniks* (1896–1908)
Guard length 24.2 cm (9½")
BOX: wood covered with black leather, 2.9 × 26.3 × 5.0 cm (1⅛ × 10⅜ × 1¹⁵/₁₆"); lined with ivory silk and velvet, inside lid stamped in black with royal coat of arms and *BY APPOINTMENT / TO THE LATE KING GEORGE V / SPINK & SON Lᵀᴰ / 5, 6 & 7. KING Sᵀ / Sᵀ JAMES'S. S.W.1.*
RCIN 25298 (CH 29)
PROVENANCE: Queen Elizabeth The Queen Mother (the box, but not the fan, was supplied to Queen Elizabeth by Messrs Spink in 1996)

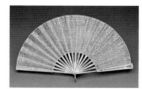

74. QUEEN ALEXANDRA'S FABERGÉ FAN Russian, c.1904

Cream silk gauze leaf, mounted *à l'anglaise*, decorated with gold-coloured sequins and spangles with leaf designs; front guard of mother-of-pearl and three-colour gold enamelled in white over a guilloché ground, decorated with an arrow of gold and silver embellished with diamonds, swags of gold intertwined around the shaft, with cabochon Burmese rubies at the intersections; scratched mark *9449* on side of front guard; mark of Henrik Wigström with gold mark of 56 *zolotniks* (1896–1908) on top of front guard; back guard and sticks of mother-of-pearl with gold decoration, and bone ribs (2 + 16); silver pin with diamond head; loop in two colours of gold, with mark of Henrik Wigström
Guard length 21.8 cm (8⁹/₁₆")
BOX: wood (birch), varnished with white shellac polish, 4.4 × 27.3 × 5.1 cm (1¾ × 10¾ × 2"); lined with ivory silk and velvet, with cut-out support; stamped inside lid with Russian imperial arms and K. Fabergé, St Petersburg, Moscow, Odessa, in Cyrillic characters. Paper fragment inside box inscribed in ink by Queen Mary *Fan made by Fabergé. Sᵗ Petersburgh. / belonged to Queen Alexandra – / given to Princess Elizabeth of York / by her grandmother Queen Mary / . 1932.*
RCIN 25219 (Q 9)
PROVENANCE: purchased through Fabergé's St Petersburg branch by the Dowager Tsarina Marie Feodorovna, 24 December 1904 (325 roubles); by whom given to Queen Alexandra; Queen Mary; by whom presented to Princess Elizabeth of York (HM The Queen), 1932
EXHIBITED: Edinburgh/London 2003–4, no. 251

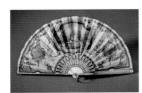

75. QUEEN MARY'S FABERGÉ FAN Russian, c.1912

Plain weave cream silk leaf, backed with silk gauze, painted in watercolour, bodycolour and gold with central vignette depicting a couple in eighteenth-century dress seated by a lake, further views of lakes in vignettes at either side; gold-painted silk edge-binding; front guard of mother-of-pearl with two-colour gold enamelled in blue and white over a guilloché ground, decorated with two Burmese cabochon rubies; scratched mark *17524* and mark of Henrik Wigström with gold mark of 56 *zolotniks* (1908–17) on top of front guard; back guard and sticks of mother-of-pearl with painted gold decoration (2 + 16); gold pin; gold loop, with the mark of Henrik Wigström, and *Fabergé* (in Cyrillic characters)

Guard length 21.6 cm (8¹/₂")

BOX: wood (birch), 4.4 × 25.2 × 4.6 cm (1³/₄ × 9¹⁵/₁₆ × 1¹³/₁₆"); lined with ivory silk and velvet, with cut-out support; stamped inside lid with Russian imperial arms and Fabergé, St Petersburg, Moscow, Odessa, in Cyrillic characters. Paper label on base inscribed in ink by Queen Mary *From Queen / Alexandra / Xmas 1912 –* and *12*.

RCIN 25136 (WC QM 12)

PROVENANCE: purchased from Fabergé's London branch by Queen Alexandra, 24 December 1912 (£26 10s; 118 roubles; stock number 17524); by whom given to Queen Mary, Christmas 1912 (see note in Queen Mary's hand on base of box, and QMN, p. 35)

EXHIBITED: London 1989, case 2, no. 5; London 1995–6, no. 235; Edinburgh/London 2003–4, no. 250

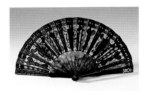

76. BLACK EVENING FAN German, c.1910

Black silk and black silk net leaf, decorated with black sequins and spangles; plain tortoiseshell guards and sticks, with wooden ribs; front guard with the letter M in seed pearls set in gold beneath an enamelled gold crown set with diamonds (2 + 14); brass pin with pressed amber head

Guard length 28.5 cm (11¹/₄")

BOX: wood covered with brown leather, 5.9 × 31.4 × 4.7 cm (2³/₁₆ × 12³/₈ × 1⁷/₈"); lined with white silk. Paper labels on base inscribed in ink by Queen Mary *Black fan with / pearl mono-gram*, and *No. I*

RCIN 25251 (Q 40)

PROVENANCE: Queen Mary

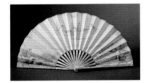

77. 'FAIRIES AND TOADSTOOLS' French, c.1910

Leather (sheep) leaf painted in watercolour, bodycolour and bronze paint with fairies blowing bubbles by toadstools on the seashore, other fairies fly in the sky above; bronze-painted leather edge-binding; mother-of-pearl guards and sticks, front guard carved with the head and wings of an angel and stylised leaves decorated with gold; rear guard with gold monogram *VM* beneath the Prince of Wales's coronet (2 + 16); brass and mother-of-pearl pin

Guard length 27.5 cm (10¹³/₁₆")

VERSO: leather (sheep) painted in watercolour and bodycolour; a seashore scene with flowers, seagulls and toadstools

RCIN 25241 (Q 30)

PROVENANCE: presented by Queen Alexandra to Queen Mary (as Princess of Wales), by 1910 (QMN, p. 29)

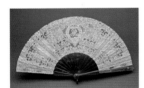

78. QUEEN MARY'S CORONATION FAN English, 1911

Cream cotton lace leaf, worked in cotton with initials *MR* under crown within Garter with words *Honi Soit [qui m]al y pense*, shields containing the arms of Ireland and Wales, England and Scotland to left and right, floral decorative surrounds; plain blond tortoiseshell guards and sticks; front guard with applied gold monogram *MR* surmounted by a crown (2 + 15); gold pin with diamond heads; gold loop

Guard length 27.4 cm (10¹³/₁₆")

BOX: wood covered with blue leather, edged with gold-tooled border, 6.0 × 35.3 × 7.8 cm (2³/₈ × 13⁷/₈ × 3¹/₁₆"); lined with ivory silk and velvet, with upright support. Paper scrap inside box inscribed in ink by Queen Mary *Coronation lace / fan / June 22ⁿᵈ / 1911 –*. Paper label on base inscribed in ink *11 –*; base blind-stamped *K*

RCIN 25135 (WC QM 11)

PROVENANCE: presented by the Worshipful Company of Fan Makers to Queen Mary on the occasion of the coronation, 22 June 1911; London Museum Loan, 1926–?33 (D 417)

REFERENCE: *Illustrated London News*, 1 July 1911; Gibson 1927, no. VII, p. 7; Melville 1991, p. 24

EXHIBITED: London 1953; London 1986; London 1989, case 2, no. 2

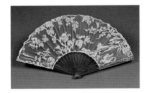

79. BRUSSELS LACE FAN Belgian, c.1920

Cream cotton lace leaf with floral design; blond tortoiseshell guards and sticks; front guard supporting the monogram *AE*, within a border beneath a crown, in platinum set with diamonds (2 + 16); brass pin (replacement); blond tortoiseshell loop

Guard length 26.3 cm (10³/₈")

BOX: wood and paper board covered with ivory-coloured suede with applied metal crown on lid, 5.5 × 29.0 × 4.3 cm (2³/₁₆ × 11⁷/₁₆ × 1¹¹/₁₆"); lined with ivory silk. Paper label inside lid inscribed in ink by Queen Mary *From the King + / Queen of the Belgians / on their State visit / to London / 1921*. Paper label on base inscribed in ink *20 –*

RCIN 25143 (WC QM 20)

PROVENANCE: presented by King Albert I and Queen Elisabeth of the Belgians to Queen Mary during their State Visit to England, July 1921 (QMN, p. 41)

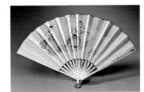

80. DOLL'S FAN French, 1938

Paper leaf, mounted *à l'anglaise*, painted in watercolour over graphite under-drawing with three girls, signed and dated *Marie Laurencin 1938*; paper edge-binding painted in gold metallic paint; bone guards and sticks, carved and painted in pink, yellow and gold, with paper-covered wooden ribs (2 + 12); brass pin with green paste head; brass chain and loop

Guard length 20.6 cm (8¹/₈")

VERSO: signed *DuvEllEroy, PAris*

BOX: tapering-shaped wood and paper board covered with ivory silk and edged with gold-coloured paper, 4.0 × 22.0 × 3.5 cm (1⁹/₁₆ × 8¹¹/₁₆ × 1³/₈") tapering to 2.2 cm (⁷/₈"); lined with ivory silk. Inside lid printed *37. BOULᴰ MALESHERBES / DUVELLEROY / ANCIENNEMENT 22. Bᴰ DE LA MADELEINE*

RCIN 25150 (DH 7)

PROVENANCE: presented by the children of France to Princess Elizabeth (HM The Queen) and Princess Margaret, 1938

REFERENCE: Eaton 2002, pp. 36–7

EXHIBITED: London 1938, no. 9 (glass case containing numerous items, including four fans by Duvelleroy); London 1990–91, no. 109

81. DOLL'S FAN WITH BLUE BIRDS French, 1938

Paper leaf, mounted *à l'anglaise*, painted in watercolour over graphite under-drawing with birds and ribbons, signed and dated *Marie Laurencin / 1938*; paper edge-binding painted in gold metallic paint; bone guards and sticks, carved and painted in pink, yellow and gold, with paper-covered wooden ribs (2 + 12); brass pin with green paste head; brass chain and loop.
Guard length 20.8 cm (8³/₁₆")

BOX: tapering-shaped wood and paper board covered with ivory silk and edged with gold-coloured paper, 4.0 × 22.0 × 3.5 cm (1⁹/₁₆ × 8¹¹/₁₆ × 1³/₈") tapering to 2.2 cm (⁷/₈"); lined with ivory silk. Inside lid printed 37. *BOULᴰ MALESHERBES / DUVELLEROY / ANCIENNEMENT 22. Bᴰ DE LA MADELEINE*
RCIN 25149 (DH 6)

PROVENANCE: presented by the children of France to Princess Elizabeth (HM The Queen) and Princess Margaret, 1938
REFERENCE: Eaton 2002, pp. 36–7
EXHIBITED: London 1938, no. 9 (glass case containing numerous items, including four fans by Duvelleroy)

82. QUEEN ELIZABETH'S CORONATION FAN English, 1937

White ostrich feathers; blond tortoiseshell guards and sticks, the front guard supporting intertwined letters *EE* beneath a crown in gold, the back guard with the crest of the Fan Makers Company in gold (2 + 16); gold pin with diamond heads; gold loop
Guard length 26.5 cm (10⁷/₁₆")

BOX: wood and paper board covered with purple leather, tooled in gold on the lid *PRESENTED TO / HER MAJESTY QUEEN ELIZABETH / ON HER CORONATION / BY / THE WORSHIPFUL COMPANY OF FANMAKERS, 1937*; 7 × 78.8 × 41.7 cm (2³/₄ × 31 × 16⁷/₁₆"); lined with cream silk, fitted
RCIN 25323 (CH 52)

PROVENANCE: presented by the Worshipful Company of Fan Makers to Queen Elizabeth on the occasion of her coronation, 1937

CONCORDANCE

RCIN	Exh. no.	RCIN	Exh. no.	RCIN	Exh. no.
3683.1	34	25129	63	25261	14
25005	71	25131	64	25270	8
25013	70	25132	67	25279	72
25027	44	25134	66	25298	73
25029	48	25135	78	25323	82
25033	49	25136	75	25344	41
25043	68	25138	61	25350	1
25048	55	25143	79	25362	15
25063	4	25149	81	25364	24
25064	60	25150	80	25366	20
25065	69	25156	36	25367	46
25071	54	25159	19	25369	13
25072	40	25166	56	25373	31
25073	25	25171	35	25375	32
25074	29	25181	62	25378	26
25075	23	25182	57	25380	17
25077	22	25193	52	25382	3
25087	30	25197	58	25383	2
25088	7	25213	59	25385	47
25091	9	25217	18	25398	65
25092	5	25218	16	25407	50
25093	10	25219	74	25409	51
25094	33	25220	12	25411	45
25095	6	25234	11	25415	53
25098	21	25235	27	54244.1	37
25101	42	25241	77	54244.2	38
25102	43	25244	28		
25104	39	25251	76		

GLOSSARY

à l'anglaise	A fan leaf of single thickness; literally, 'in the English manner'
battoire	A folding fan with wide sticks resembling a tennis racquet in shape
bodycolour	Opaque watercolour medium in which pigments are mixed with white gum and other thickeners; gouache
brisé	A fan comprising sticks and guards but no leaf; the sticks are joined by a ribbon or cord at the upper edge and are held by a rivet at the base
cabriolet	A fan with two or more concentric leaves, one above the other, similar to the section of a wheel of a cabriolet (a fashionable carriage in the late eighteenth century)
clouté	Inlaid work of semi-precious stones or mother-of-pearl on tortoiseshell or ivory
cockade	A fan at full circle (360°), usually with guards that extend to form handles
découpé	Cut out or stamped out to make a decorative, lacy pattern
gorge	Area of the fan between the pin and the leaf
guards	The two outer sticks of a fan, which protect it when the fan is closed; they are generally heavier and more elaborate than the inner sticks
leaf	The portion of the fan above the gorge; normally made of vellum, leather, silk or lace, it is pleated and attached to the upper part of the sticks. The fan may have a double or a single leaf (see *à l'anglaise*)
leather	Animal skin (particularly from sheep, or kid – a young goat) that has been tanned, tawed or otherwise dressed and prepared, to make a thin fan leaf suitable as a support for painting
loop	Curved attachment, both ends joined to the pin; it enables a fan to be suspended from a cord or ribbon
mica	A mineral which can be cleaved into thin transparent layers
pin	The rivet or pivot, usually made of metal, that holds the sticks and guards together at their base
piqué	Inlaid work of gold or silver in point or strip on tortoiseshell or ivory
recto	The front (obverse) of the fan
reserve	The outer portions of a fan leaf, normally adorned with a different type of decoration (e.g. floral) from that of the main leaf design
reticella	Term applied to the open geometric cutwork and to the associated needle lace built up on a ground of laid threads. ('Reticella' is the diminutive of *rete*, the Italian word for net or lace)
ribs	The upper part of the sticks, supporting the leaf. These are often made of a thinner material than the sticks. The best ones are made from whalebone, which is very flexible
spangle	A small, thin, glittering plate of metal; a sequin (after the Italian coin *zecchino*) is a circular spangle
sticks	The long rigid pieces which make up or support the main structure of the fan, between the guards
trompe-l'oeil	Painted to deceive the eye; a flat surface painted to look like a three-dimensional object
vellum	Animal skin (of a sheep, goat or calf) that has been treated by liming, dehairing, stretching and scraping to make a thick, translucent membrane suitable as a support for writing or painting
verso	The back (reverse) of the fan
vinaigrette	A small container for aromatic vinegar or smelling-salts
vignette	A small painted scene

BIBLIOGRAPHY AND ABBREVIATIONS

Alexander 1995
H. Alexander, 'English Fans', *FCI Bulletin*, no. 61, pp. 14–28

Alexander 2001
H. Alexander, *The Fan Museum*, London

Alexander 2002
H. Alexander, *Fans*, Shire Albums no. 243, Buckingham; 2nd edn

Armstrong 1978
N. Armstrong, *The Book of Fans*, London and New York

Armstrong 1992–4
N. Armstrong, 'The Enigma of the Four Découpé Fans', *FCI Bulletin*, nos. 52–6

Arnold 1988
J. Arnold (ed.), *Queen Elizabeth's Wardrobe Unlock'd*, Leeds

Arundel Society 1871
Arundel Society, *Fans of all Countries. A Series of Twenty Photographs . . . for the Use of Schools of Art and Amateurs*, with an introduction by S. Redgrave, London

Bainbridge 1949
H.C. Bainbridge, *Peter Carl Fabergé*, London

Baker 1999
C. Baker, 'Filippo Lauri's *Rape of Europa*: " . . . an ingenious trifling Branch of the Painting Business . . . "', *Apollo*, June, pp. 19–24

Baker 2002
C. Baker, *Christ Church Picture Gallery, Oxford*, Oxford

Barisch 2003
M.-L. and G. Barisch, *Fächer. Spiegelbilder ihrer Zeit*, Munich

Bast 1951
J. Bast, *Schwartzerne i Svaertegade*, Copenhagen

Battiscombe 1969
G. Battiscombe, *Queen Alexandra*, London

Begent 1992–3
P. Begent, 'The Feast of St George as observed on 23rd April 1805', *Report of the Society of the Friends of St George's*, II, no. 4, pp. 141–9

Bennett 1988
A.G. Bennett, *Unfolding Beauty. The Art of the Fan, the Collection of Esther Oldham and the Museum of Fine Arts, Boston*, Boston

Blondel 1875
S. Blondel, *Histoire des Eventails*, Paris

Borenius 1935
T. Borenius, 'Treasures from Her Majesty's Collection', *The Queen*, 22 May 1935

Boston Fans 1961
Fan Leaves, published by the Fan Guild of Boston

Boucher 1986
François Boucher 1703–1770, exh. cat., New York

Burney Diary 1904–5
Diary and Letters of Madame D'Arblay (1778–1840), ed. C. Barrett and A. Dobson, 6 vols., London

Cowen 2003
P. Cowen, *A Fanfare for the Sun King. Unfolding Fans for Louis XIV*, exh. cat., London

Cust 1893
L. Cust, *Catalogue of the Collection of Fans presented to the British Museum by Lady Charlotte Schreiber*, London

Daquin 1753
P.-L. Daquin, *Siècle littéraire de Louis XV*, Amsterdam and Paris

DCO
Duchy of Cornwall Office, London

De Bellaigue 1975
G. de Bellaigue, 'Queen Victoria buys French in 1855', *The Antique Collector*, April 1975, pp. 37–41

De Guitaut 2003
C. de Guitaut, *Fabergé in the Royal Collection*, exh. cat., London

Delpierre 1985
M. Delpierre et al., *L'Eventail. Miroir de la Belle Epoque*, exh. cat., Paris

Dent 1923
H.C. Dent, *Piqué: a Beautiful Minor Art*, London

Diderot 1751
D. Diderot, *Encyclopédie, ou dictionnaire raisonné des sciences, des arts, et des métiers*, VI, Paris

Dimond 2004
F. Dimond, *Developing the Picture. Queen Alexandra and the Art of Photography*, London

Dimond and Taylor 1987
F. Dimond and R. Taylor, *Crown and Camera. The Royal Family and Photography 1842–1910*, London

Dunn 1901
D. Dunn, 'Fans', *Connoisseur*, no. 1, pp. 92–6

Duvelleroy 1929
G. Duvelleroy, *Annotations annexées au Livre: Histoire des Eventails*, Paris

Duvelleroy 1995
Duvelleroy, King of Fans, ed. H. Alexander, exh. cat., London

Eaton 2002
F. Eaton, *Dolls for the Princesses. The Story of France and Marianne*, London

Eidelberg 2004
M. Eidelberg et al., *Watteau et la fête galante*, exh. cat., Valenciennes, Paris

Encounters 2004
Encounters. The meeting of Asia and Europe 1500–1800, ed. A. Jackson and A. Jaffer, London

Ezquerra del Bayo 1920
J. Ezquerra del bayo, *El abanico en Espana*, exh. cat., Madrid

Falluel 1995
F. Falluel, 'Felix Alexandre et la Maison Alexandre (1845–1903)', *Colloque du Cercle de l'Eventail*, pp. 11–17

Fol 1875
W. Fol, 'Jean-Louis Hamon', *Gazette des Beaux-Arts*, XI, pp. 119–34

Fowles 1977
A.W. Fowles, *The Revised History of the Worshipful Company of Fan Makers 1709–1975*, London

Fraser 2004
F. Fraser, *Princesses. The Six Daughters of George III*, London

Fusconi 1994
G. Fusconi, *La fortuna delle 'Nozze Aldobrandini': dall'Esquilino alla Biblioteca Vaticana (Studi e testi 363)*, Vatican City

Garden of Fans 2004
A Garden of Fans, exh. cat., London

George III & Queen Charlotte 2004
George III & Queen Charlotte. Patronage, Collecting and Court Taste, exh. cat., ed. J. Roberts, London

Gere 2004
C. Gere, 'How Queen Mary collected Queen Charlotte', *Apollo*, August, pp. 50–53

Gibson 1927
E. Gibson, *Some Fans from the Collection of Her Majesty The Queen*, London; reprinted from articles in *The Connoisseur*, LXXVIII, pp. 3–9, 67–73, 131–7

Gori 1732
A.F. Gori, *Gemmae Antiquae ex Thesauro Mediceo et Privatorum Dactyliotheci, Florentinae*, Florence

Gostelow 1976
M. Gostelow, *The Fan*, London

Green 1975
B. de V. Green, *Fans over the Ages*, London

Habsburg 1986
G. von Habsburg, *Fabergé. Hofjuwelier der Zaren*, exh. cat., Hamburg

Hart and Taylor 1998
A. Hart and E. Taylor, *Fans*, London

***Hatch, Match and Despatch* 1992–3**
Hatch, Match and Despatch, exh. cat., London

Hearn 1995
K. Hearn (ed.), *Dynasties. Painting in Tudor and Jacobean England 1530–1630*, exh. cat., London

***Hermitage* 1997**
Imperial Fans from the Hermitage, The Fan Museum, Greenwich, London

Hind 1955
A. Hind, *Engraving in England in the Sixteenth and Seventeenth Centuries. II: The Reign of James I*, Cambridge

***HMWP* 1947**
Marriage of HRH The Princess Elizabeth and Lieutenant Philip Mountbatten, RN. List of Wedding Gifts, exh. cat., London

Hood 1914
A.N. Hood, *Buckingham Palace. A Short History of the Royal Palace Compiled chiefly from Notes Collected by Queen Mary*, privately printed, London (RCIN 1114823)

Hughes 1947
G.B. Hughes, 'Enamels and Fans: illustrated by Examples from the Collection of Her Majesty Queen Mary', *Country Life*, 3 January, pp. 28–33

Hutt and Alexander 1992
J. Hutt and H. Alexander, *Ogi. A History of the Japanese Fan*, London

Iröns 1981
N.J. Iröns, *Fans of Imperial China*, Hong Kong

Kammerl 1989
C. Kammerl, *Der Fächer. Kunstobjekt und Billetdoux*, exh. cat., Karlsruhe

Lemoisne 1914
P.A. Lemoisne, *L'Oeuvre d'Eugène Lami*, Paris

Lennox-Boyd 1982
C. Lennox-Boyd, 'A Roman Baroque Fan Painting and Frame', *Bulletin of the Fan Circle International*, no. 21, p. 36

Levey 1983
S. Levey, *Lace. A History*, London

Levey 1995
S. Levey, 'The Royal Lace Collection. A Summary Catalogue' (typescript; RCIN 1114460)

London Museum Loan
Loans to the London Museum made by Queen Alexandra, c.1912, and by Queen Mary from c.1924, displayed initially at Kensington Palace and Lancaster House; many of the fans in Queen Mary's loan remained at the Museum of London (at its London Wall site) until 1997

Lugt 1921
F. Lugt, *Les Marques de Collections de dessins et d'estampes*, Amsterdam

MacGregor 1989
A. Macgregor (ed.), *The Late King's Goods*, Oxford

McKechnie 1978
S. Mckechnie, *British Silhouette Artists and their Work, 1760–1860*, London

Malpas 1992
E. Malpas, 'Balloon Fans', *Bulletin of the Fan Circle International*, nos. 50–52

Marie Louise 1956
Princess Marie Louise, *My Memories of Three Reigns*, London

Marschner 1997
J. Marschner, 'Queen Caroline of Ansbach: Attitudes to Clothes and Cleanliness, 1727–1737', *Costume*, no. 31, pp. 28–37

Marschner 2000
J. Marschner, 'Mary II: her Clothes and Textiles', *Costume*, no. 34, pp. 44–50

Martin (J.R.) 1965
J.R. Martin, *The Farnese Gallery*, Princeton

Martin (T.) 1875
T. Martin, *The Life of HRH The Prince Consort*, London

Mayor 1980
S. Mayor, *Collecting Fans*, London

Mayor 1991
S. Mayor, *The Letts Guide to Collecting Fans*, London

Meaume
E. Meaume, *Recherches sur la vie et les ouvrages de J. Callot*, 2 vols., Paris, 1860

***Mecklenburg* 1995**
1000 Jahre Mecklenburg. Geschichte und Kunst einer europäischen Region, exh. cat., ed. J. Erichsen

Melville 1991
B. Melville, *The Fan and Lace*, Cullompton

Millar (D.) 1995
D. Millar, *The Victorian Watercolours and Drawings in the Collection of Her Majesty The Queen*, 2 vols., London

Millar (O.) 1963
O. Millar, *The Tudor, Stuart and Early Georgian Pictures in the Collection of Her Majesty The Queen*, 2 vols., London

Millar (O.) 1969
O. Millar, *The Later Georgian Pictures in the Collection of Her Majesty The Queen*, 2 vols., London

Millar (O.) 1992
O. Millar, *The Victorian Pictures in the Collection of Her Majesty the Queen*, 2 vols., London

Mortier 1992
B.M. du Mortier, *Waaiers en Waaierbladen: Fans and Fan Leaves 1650–1800*, exh. cat., Amsterdam

Northumberland 1926
The Diaries of a Duchess. Extracts from the Diaries of the First Duchess of Northumberland (1716–1776), ed. J. Greig, London

O'D
F. O'Donoghue and H.M. Hake, *Catalogue of Engraved British Portraits in the British Museum*, 6 vols., London, 1908–25

Ormond and Blackett-Ord 1987
R. Ormond and C. Blackett-Ord, *Franz Xaver Winterhalter and the Courts of Europe 1830–70*, London

Parthey
G. Parthey, *Wenzel Hollar, Beschreibendes Verzeichniss seiner Kupferstiche*, Berlin 1853; revised R. Pennington, *A Descriptive Catalogue of the Etched Work of Wenceslaus Hollar*, Cambridge 1982

Patterson 1996
S. Patterson, *Royal Insignia. British and Foreign Orders of Chivalry from the Royal Collection*, exh. cat., London

Pope-Hennessy 1959
J. Pope-Hennessy, *Queen Mary 1867–1953*, London

***Private Life* 1979**
The Private Life of The Queen by one of Her Majesty's Servants, 1st edn, 1897, Old Woking

PRO
Public Record Office, Kew

QAF
List of Fans which belonged to Her Majesty Queen Alexandra, 1926. Manuscript catalogue, with later annotations, at Sandringham

QMB
Catalogue of Bibelots, Miniatures and Other Valuables. The Property of Queen Mary, 4 vols: I, 1920; II, 1921–31; III, 1932–7; IV, 1938–45 (illustrated typescript; RCIN 1114504–9)

QMF
Catalogue of Queen Mary's Fans

(in the Fan Case Screen) of Historical Interest. Typescript catalogue made for Queen Mary, 1921, with later additions (RA GV/CC 74; RCIN 1156034)

QMN
Queen Mary's Notebook concerning the Parasols, En Tout Cas, Umbrellas, Walking Sticks and Fans in her Collection. Manuscript, commenced 1910 (RA GV/CC 73)

QMWP 1893
Descriptive Catalogue of the Wedding Gifts to H.R.H. The Duke of York, K.G. and H.S.H. The Princess May of Teck, exh. cat., London. (See also RA F&V/weddings/ 1893/GV: Catalogue of Wedding Gifts)

Quiet Conquest 1985
The Quiet Conquest. The Huguenots 1685 to 1985, exh. cat., London

QVJ
Queen Victoria's Journal in the Royal Archives, Windsor Castle

QVL
Manuscript 'List of Fans' belonging to Queen Victoria, with named allocations, probably a copy of an original of *c*.1901 (RA GV/CC 55/41)

QV Leaves
Queen Victoria, *Leaves from a Journal being a Record of the Visit of the Emperor and Empress of the French to the Queen and of the Queen and HRH the Prince Consort to the Emperor of the French*, privately printed, 1855

RA
Royal Archives, Windsor Castle

RCIN
Royal Collection Inventory Number. The reference given in parenthesis following the RCIN relates to the previous numbering system

Reynolds 1999
G. Reynolds, *The Sixteenth and Seventeenth-Century Miniatures in the Collection of Her Majesty The Queen*, London

Rhead 1910
G.W. Woolliscroft Rhead, *The History of the Fan*, London

Roberts 1987
J. Roberts, *Royal Artists*, London

Rococo 1984
Rococo: Art and Design in Hogarth's England, ed. M. Snodin, exh. cat., London

Rosenberg and Prat 1996
P. Rosenberg and L.-A. Prat, *Antoine*

Watteau 1684–1721. Catalogue raisonné des dessins, 3 vols., Milan

Roumania 1934
Marie, Queen of Roumania, *The Story of my Life*, 2 vols., London

Royal Fans 2002
Royal Fans, exh. cat., London

Russell 1864
W.H. Russell, *A Memorial of the Marriage of the Prince of Wales and Alexandra, Princess of Denmark*, London

Sacchetto and Sassi 1989
A.F. Sacchetto and L.T. Sassi, *Un Soffio di Vanità*, exh. cat., Padua

Schreiber 1888
C. Schreiber, *Fans and Fan-Leaves – English*, London

Schreiber 1890
C. Schreiber, *Fans and Fan-Leaves – Foreign*, London

Smart 1992
A. Smart, *Allan Ramsay. Painter, Essayist and Man of Enlightenment*, New Haven and London

Snowman 1962
A.K. Snowman, *The Art of Carl Fabergé*, London

Solodkoff 1984
W. von Solodkoff et al., *Masterpieces from the House of Fabergé*, New York

Spear 1982
R.E. Spear, *Domenichino*, New Haven and London

Staniland 1985
K. Staniland, *Fans*, ed. V. Cumming, London

Staniland 1997
K. Staniland, *In Royal Fashion. The Clothes of Princess Charlotte of Wales and Queen Victoria 1796–1901*, London

Staniland and Levey 1983
K. Staniland and S. Levey, 'Queen Victoria's Wedding Dress and Lace', *Costume*, no. 17

Strong 1969
R. Strong, *The English Icon: Elizabethan and Jacobean Portraiture*, London

Stuart Room Catalogue
A Catalogue of the Relics in the Stuart Room at Windsor Castle, 1916. Typescript catalogue, illustrated with black and white photographs (RCIN 1126945.a)

Tillander-Godenhielm 2000
U. Tillander-Godenhielm et al., *Golden*

Years of Fabergé. Drawings and Objects from the Wigström Workshop, Paris

Trogan 1995
R. Trogan, 'A Sixteenth-century Fan in the Ecouen Museum', *Colloque du Cercle de l'Eventail*, pp. 44–53

Tuer 1882
A.W. Tuer, *Bartolozzi and his Works*, 2 vols., London and New York

Volet 1986
M. Volet, *L'Imagination au service de l'éventail. Les brevets déposés en France au 19ème siècle*, Vésenaz

Volet 1994
M. Volet, *Eventails Européens/European Fans*, exh. cat., Musée d'art et d'histoire de Genève

Walker 1992
R. Walker, *The Eighteenth and early Nineteenth Century Miniatures in the Collection of Her Majesty The Queen*, Cambridge

Walpole Correspondence
The Yale Edition of Horace Walpole's Correspondence, ed. W.S. Lewis, 48 vols., New Haven and London, 1937–83

Walton 1975
K.-M. Walton, 'Queen Charlotte's Dressing Table', *Furniture History*, XI, pp. 112–13

Watkin 2004
D. Watkin, *The Architect King. George III and the Culture of the Enlightenment*, London

WC Fans
Catalogue of Fans in the Royal Collection, Windsor Castle. Typescript catalogue, illustrated with black and white photographs of the fans, produced for Queen Mary in 1927, with later additions (RCIN 1126906)

Wedgwood 1995
The Genius of Wedgwood, exh. cat., ed. H. Young, London

Wheatley 1989
I. Wheatley, *The Language of the Fan*, exh. cat., York

Willcocks 2000
C. and Y. Willcocks, *Fans and Fan Makers*, London

Wilton and Bignamini 1996
A. Wilton and I. Bignamini (eds.), *Grand Tour. The Lure of Italy in the Eighteenth Century*, exh. cat., London

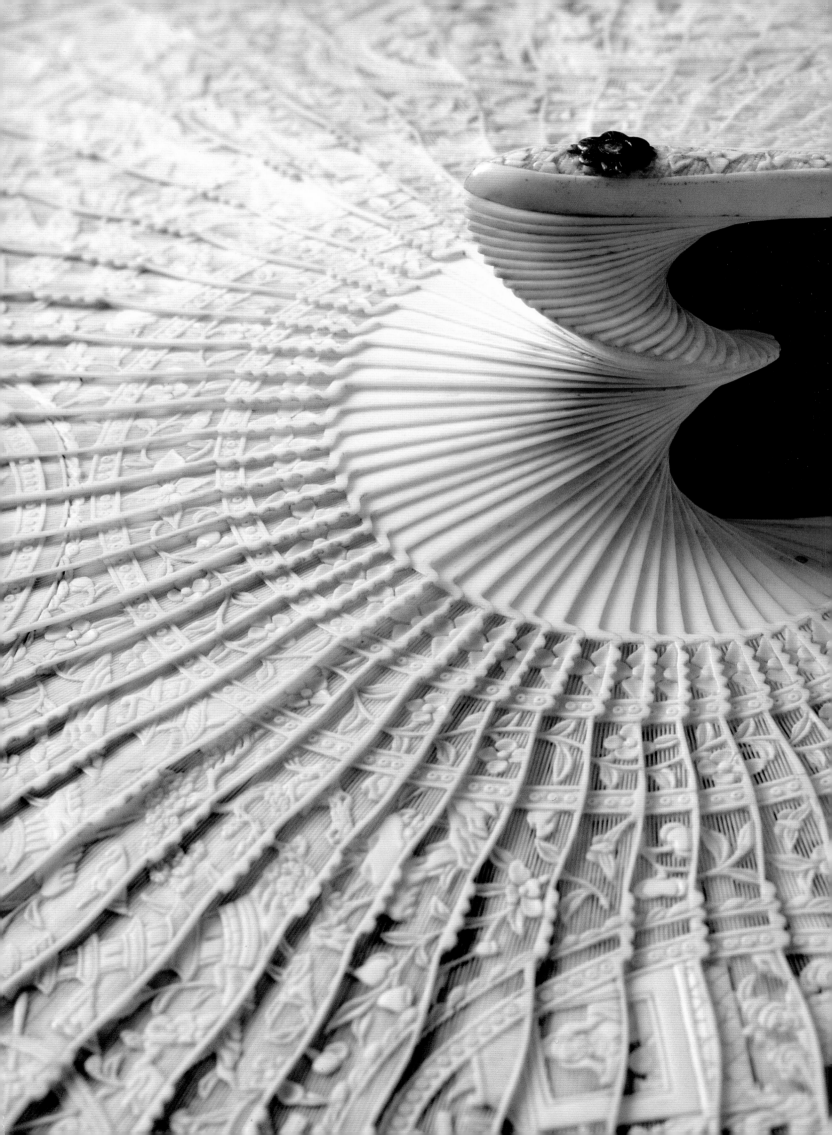

EXHIBITIONS

1855 PARIS *Exposition Universelle par categories d'industries avec notices sur les exposants*

1870 LONDON *The Loan Exhibition of Fans*, South Kensington Museum

1872 DUBLIN *Dublin Exhibition of Arts, Industries, and Manufactures and Loan Museum of Works of Art* (Queen Victoria's loans to this exhibition are listed in RA PP/VIC/CSP/1872/11250A)

1878 EDINBURGH *Loan Collection of Art Fans*, Edinburgh Museum of Science and Art

1889 LONDON *Exhibition of the Royal House of Stuart*, New Gallery, Regent Street

1897 LONDON *Fourth Competitive Exhibition of Fans*, Fan Makers Hall

1910 LONDON *Japan – British Exhibition*, White City

1914 PARIS *Arts Décoratifs de Grande-Bretagne et d'Irlande*, Musée du Louvre

1931 LONDON *The Four Georges*, 25 Park Lane

1938 LONDON [Display of the dolls France and Marianne, with their trousseaux] St James's Palace

1951 COPENHAGEN Exhibition of fans at I.G. Schwartz & Son

1953 LONDON Coronation Display at Fan Makers Hall, 23 October

1954 LONDON *Queen Mary's Art Treasures*, Victoria and Albert Museum

1976–96 KEW Display in the Museum Rooms at Kew Palace

1985–6 SALISBURY/GUILDFORD/LONDON *Royal Fans*, exhibition organised by The Fan Circle International and shown at the Salisbury and South Wiltshire Museum (July–August 1985); Guildford House Gallery (September–October 1985); (in reduced form) at the Court Dress Collection, Kensington Palace (November 1985 – January 1986). For the final showing (in extended form) at Harewood House, Leeds (March–September 1986), see HAREWOOD 1986

1986 HAREWOOD *Royal Fans*, Harewood House. See also SALISBURY/GUILDFORD/LONDON 1985–6

1986 LONDON *The Rhead Family*, Geffrye Museum

1987 LONDON Display in the Court Dress Collection, Kensington Palace, to celebrate the centenary of Queen Victoria's Golden Jubilee

1989 LONDON Display in the Court Dress Collection and State Apartments, Kensington Palace, including 24 fans from the Royal Collection

1989 YORK *The Language of the Fan*, Fairfax House

1990–91 LONDON *A Royal Miscellany from the Royal Library, Windsor Castle*, The Queen's Gallery, Buckingham Palace

1991 ROCHESTER *The Imperial Years*, The Guildhall Museum

1994 LONDON *Gainsborough & Reynolds: Contrasts in Royal Patronage*, The Queen's Gallery, Buckingham Palace

1995 LONDON *Collectors' Choice*, The Fan Museum, Greenwich

1995–6 LONDON *Fabergé*, The Queen's Gallery, Buckingham Palace

1997 LONDON *In Royal Fashion*, Museum of London

1999–2000 LONDON [Display at Kensington Palace]

2001 COPENHAGEN *Vifter fra Det Glücksborgske Kongehus*, Royal Danish Collection, Amalienborg Palace

2001 LONDON *Brazil in Mind*, Museum of London

2002 LONDON *Royal Fans*, The Fan Museum, Greenwich

2002–3 LONDON *A Century of Royal Wedding Dresses 1840–1947*, State Apartments and Royal Ceremonial Dress Collection, Kensington Palace

2003–4 EDINBURGH/LONDON *Fabergé in the Royal Collection*, The Queen's Galleries, The Palace of Holyroodhouse and Buckingham Palace

2004–5 LONDON *George III & Queen Charlotte. Patronage, Collecting and Court Taste*, The Queen's Gallery, Buckingham Palace

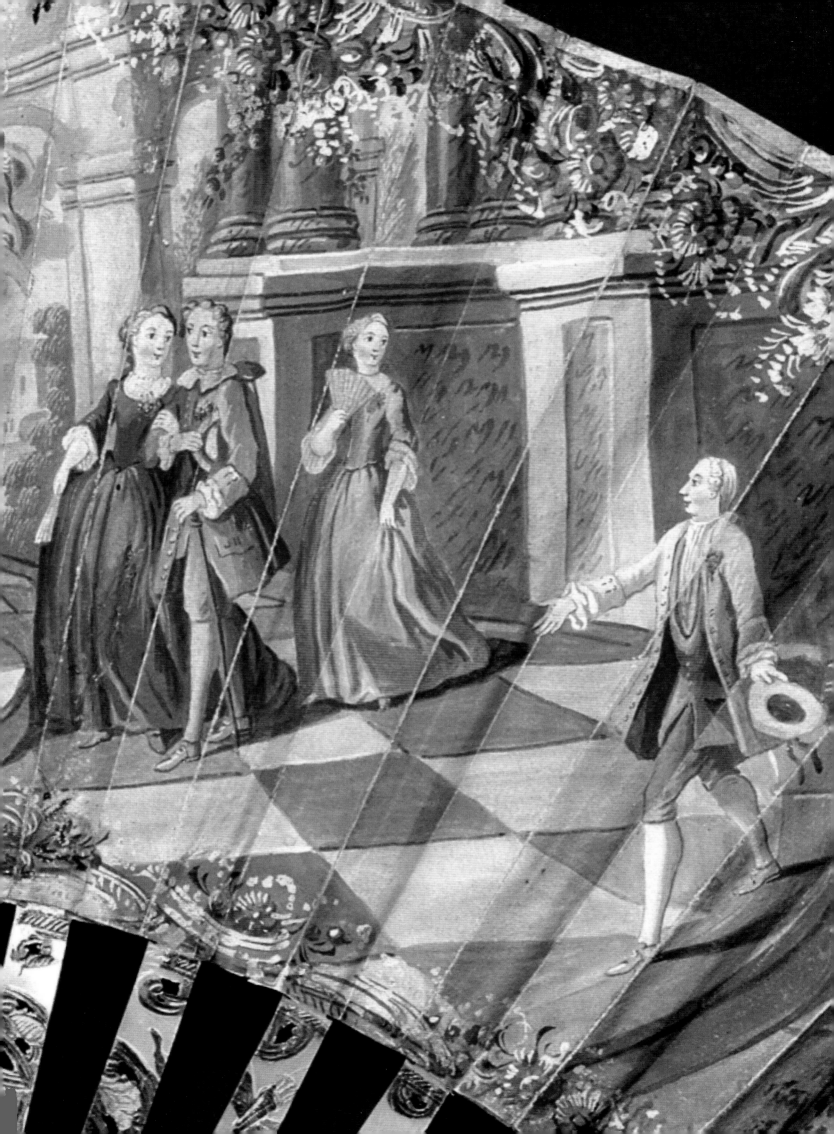

INDEX

ACKNOWLEDGEMENTS

We are indebted to the late Betty Hodgkinson MBE, the Hon. Christopher Lennox-Boyd, Hélène Alexander and the staff of the Fan Museum, for their invaluable help with the catalogue. We are also grateful for the support of Christie's.

We would like to thank the following colleagues in the Royal Household for their generous assistance during the preparation of this catalogue: Angeline Barker, Samantha Baxter, Alice Bircher, Pamela Clark, Martin Clayton, Jacky Colliss Harvey, Jean Cozens, Allison Derrett, Frances Dimond, Alan Donnithorne, Gemma Entwistle, Caroline de Guitaut, Lisa Heighway, Angela Kelly, Jill Kelsey, Annaleigh Kennard, Roderick Lane, Karen Lawson, Sabrina Mackenzie, Theresa-Mary Morton, Daniel Partridge, Shruti Patel, Janice Sacher, Adrian Smith, Emma Stuart, Elaine Ward, David Westwood, Lucy Whitaker, Matthew Winterbottom, Rhian Wong, Bridget Wright, Eva Zielinska-Miller.

Grateful thanks are also due to the many other people who have assisted in various ways, including Lady de Bellaigue, Anne-Marie Benson, Gaye Blake Roberts, Julian Brooks, Laurence and Anne Brown, Sylvia Catz, Christopher Cavey, Robert Cook, Alexia Coronini von Cronberg, Jen Cruse, Andreas Dobler, Elisabeth Dobritzsch, Katherine Duerden, Edwina Ehrman, Alison Fairbank, Flora Fraser, Scott Furlong, Joanna Gemes, Mike Gent, Jonathan Gestetner, Ian Green, Peter Greenhalgh, Gay Hamilton, Avril Hart, Michael Heseltine, Julia Hutt, Nigel Israel, Ian Jenkins, Alan Jobbins, Valerie Kaufmann, Doris Kay, Emma Laws, Alex Lay, Santina Levey, Davina, Lady Loch, Rupert Maas, Lynda McLeod, Joanna Marschner, Beryl Melville, the late Lady Millar, Ian Morton, Charles Noble, Susan North, Sheila O'Connell, Godfrey Omer-Parsons, Stephen Parkin, Julia Poole, Duncan and Judith Poore, Harley Preston, Camilla Purdon, John Ratcliffe, Percy Reboul, Amelia Roberts, Luisa Sambin, Veronique Scorer, Ursula Sdunnus, Marnie Shaw, Kay Staniland, Elizabeth Stuart, Jeremy Taylor, Jo Taylor, Arthur and Georgette Tilley, Mr and Mrs Uwe Jens Wandel, Lavinia Wellicome, Ming Wilson, and the staff at the Natural History Museum, Tring.

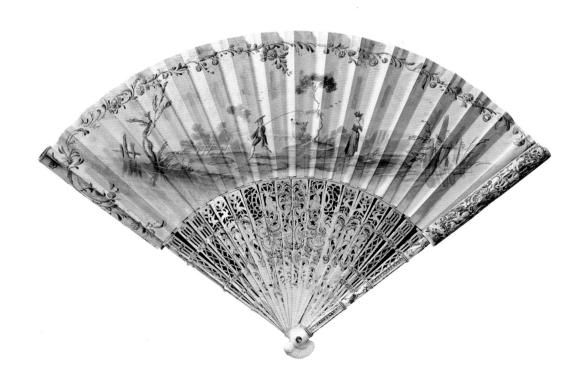